FROM NINEVEH TO NEW YORK

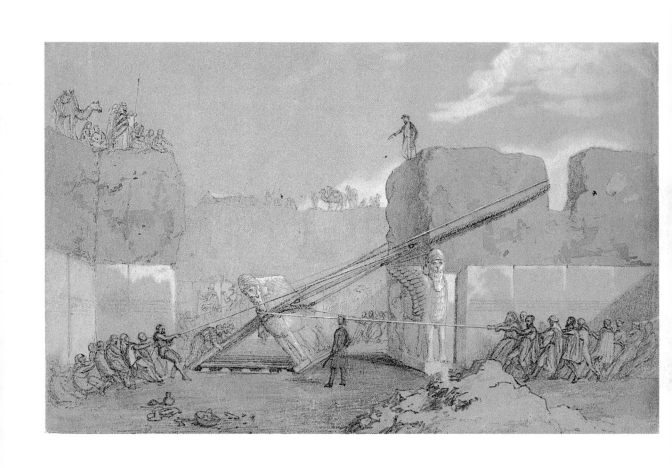

FROM NINEVEH TO NEW YORK

The Strange Story of the Assyrian Reliefs in the Metropolitan Museum
and the Hidden Masterpiece at Canford School

John Malcolm Russell

With contributions by
Judith McKenzie
and
Stephanie Dalley

YALE UNIVERSITY PRESS
NEW HAVEN AND LONDON
in association with
THE METROPOLITAN MUSEUM OF ART
NEW YORK

To the memory of another remarkable woman,
Barbara E. Russell, M.D., Ph.D., F.A.A.P.
(1922–1993)

Designed by Sally Salvesen
Set in Sabon by Best-set Typesetter Ltd., Hong Kong
Printed in Hong Kong

Library of Congress Cataloging-in-Publication Data

Russell, John Malcolm
From Nineveh to New York: the strange story of the Assyrian reliefs in the Metropolitan
Museum and the hidden masterpiece at Canford School / John Malcolm Russell
with contributions by Judith McKenzie and Stephanie Dalley.
p. cm.
Includes bibliographical references and index.
ISBN 0-300-06459-4 (cloth)
1. Assyria—Antiquities. 2. Sculpture, Assyro-Babylonian.
3. Metropolitan Museum of Art (New York, N.Y.)
4. Nineveh (extinct city)
I. McKenzie, Judith. II. Dalley, Stephanie.
III. Metropolitan Museum of Art (New York, N.Y.) IV. Title
DS69.5.R84 1997
935—dc21 96-44544
 CIP

Frontispiece: Layard and Rassam supervising the removal of one of the bulls from Nimrud,
18 March 1847, pen, ink and wash (British Museum)

CONTENTS

ACKNOWLEDGEMENTS

This study, which is near the periphery of my own field of ancient Near Eastern art, could not have been accomplished without the help of a large number of very generous people. Foremost among these is the late Viscount Wimborne, who made Lady Charlotte Guest's diaries in the Wimborne family archive freely available to me. His noble and generous spirit is sorely missed. I am also grateful to his mother, the late Dowager Viscountess Wimborne, to the late Earl of Bessborough, and to John S. Guest for their ready assistance with questions of family history. Viscount Wimborne's assistant, Mme. Marie-Louise Leblond, was a tremendous help as I worked my way through the diaries.

I am also very grateful to the staff and governors of Canford School for sharing the Nineveh Porch and Porch-related aspects of school history with me. In particular, I wish to thank the former Headmaster, Martin Marriott, the Headmaster, John Lever, the Bursar, Commander Michael Chamberlain, Kathleen Shackleton, Robin Whicker, and School Governors Air Marshal Sir John Curtiss and Ann Smart for their hospitality and assistance with a variety of matters. Likewise, this study is greatly enriched by the contributions of its two coauthors, Judith McKenzie and Stephanie Dalley, who were in the right place at the right time, and then generously agreed to share their unique perspectives on the Porch. My special thanks also to Julian Reade of the British Museum, whose important role in this story is described herein.

I drew heavily on several museums and archives in researching this story, foremost among which are the British Museum and the Metropolitan Museum of Art. At the British Museum, I wish to acknowledge particularly the assistance of John Curtis, Christopher Walker, Judy Rudoe, and Ken Uprichard, as well as the very efficient staff of the British Library Manuscripts Division. At the Metropolitan Museum, Prudence Harper, Kim Benzel, Cynthia Wilder, Mary Doherty, and Jeanie James provided access to archives and photographs. Barbara Burn of Metropolitan Museum Publications assisted me in securing a publisher, Yale University Press, to whose editor, John Nicoll, I am likewise grateful. Thanks also to Sandra Raphael and Sally Salvesen for their enthusiasm about the book as they moved it through the press, and to other members of the Yale staff.

I am also very grateful to Darwin Stapleton, Valerie Komor, and Tom Rosen-

baum of the Rockefeller Archive Center, North Tarrytown, New York; to Alessandro Pezzati of the University Museum Archives, Philadelphia; to John Larson of the Oriental Institute Archives, Chicago; to Amy Brauer and Sean Hemingway of the Harvard University Art Museums; to David C. Reeve of the Dorset County Record Office, and to the staffs of the Royal Institute of British Architects Library and Drawings Collection, London, and the National Monuments Record, London.

This research was commenced with the support of a J. Paul Getty Postdoctoral Fellowship in the History of Art, and continued with a summer research grant from the Columbia University Council for Research in the Humanities. I am very grateful to both organizations for their confidence in this project. At Columbia University, I received invaluable assistance from Gregory Schmitz on photographic questions, from Kathleen Davis of Interlibrary Loan, and from my research assistants Aimée Bessire and Erhmei Yuan. I would like to express my appreciation to the University Seminars at Columbia University for assistance in the preparation of the manuscript for publication. Material drawn from this work was presented to the University Seminar on the Archaeology of the Eastern Mediterranean, Eastern Europe, and the Near East.

Many people helped with specific questions along the way, among them Richard D. Altick, Frederick Bohrer, Michael Darby, Christine Insley Green, Noriyoshi Horiuchi, Nanette Kelekian, Mogens Trolle Larsen, Roger Moorey, Stefan Muthesius, and Robin Middleton. My sincerest apologies to anyone I have neglected to mention. A number of people read drafts of all or part of this manuscript: Frederick Bohrer, Richard Brilliant, Peter Machinist, Michelle Marcus, Judith McKenzie, Robin Middleton, Allen Staley, Phoebe Stanton, David Stronach, Clive Wainwright, and Irene Winter. If I have succeeded in melding a very heterogenous body of source material into a coherent narrative, it is due to their generous contributions of time and expertise. If not, the responsibility is mine alone.

INTRODUCTION

The sale at auction in July 1994 of a recently discovered ancient Assyrian sculpture for £7.7 million ($11.9 million), more than triple the previous record price for an antiquity, drew worldwide media attention. In market terms, this sale established Assyrian art as not only the most costly ancient art, but put it in a price range formerly occupied almost exclusively by important paintings of major masters. The press reports focused on the unprecedented price, on the opposition to the sale by the Republic of Iraq, and on the story of the sculpture's discovery in an English private school's tuck shop (commissary). The press did not mention that the tuck shop was itself a very remarkable structure.

That building, the "Nineveh Porch," is a unique expression of a singular episode in the history of taste—the English popular reception of ancient Assyria in the middle of the nineteenth century. The Nineveh Porch was one product of this process, which represents a successful campaign on behalf of a little-known culture against powerful prejudices, and serves as a remarkable illustration of the way in which a style may find acceptance through the efforts of a small group of dedicated individuals. The principal players in this drama were Lady Charlotte Guest, translator and editor of the collection of medieval Welsh stories known as the *Mabinogion* and wife of one of the wealthiest industrialists in Britain, her cousin Austen Henry Layard, the excavator of Nineveh, and Charles Barry, architect of the Houses of Parliament.

I was drawn to the project by a curiosity about the Nineveh Porch, which has received only passing—and often erroneous—mention in the literature on nineteenth-century British architecture and Assyrian antiquities. And yet before it was dismantled in the early twentieth century, the collection of Assyrian sculpture in the Nineveh Porch, which now forms the bulk of the spectacular Assyrian collection in the Metropolitan Museum of Art, was one of the finest in the world. The Nineveh Porch, built to house that collection, is surely the most unusual setting ever conceived specifically for the display of Ninevite treasures. Recent studies by Bohrer, Jenkins, and Larsen have investigated the phenomenon of the English reception of the newly-discovered art of ancient Assyria in the mid-nineteenth century.[1] The focus of these studies, however, has been on the public reception of Assyria, in the press, the British Museum, and popular culture. The Nineveh Porch, by contrast, represents a very private response to Assyrian art. Intrigued by the very idea

of a "Nineveh Porch," I embarked upon this study with the goal of presenting the Nineveh Porch in the context of the English reception of Assyria, and simultaneously asserting its significance as the first and most striking embodiment of Assyrian style in a Western context.

In the spring of 1992, I had been working on three projects. The first was a manuscript on Assyrian palace inscriptions and their architectural context.[2] One group of texts that interested me was inscribed on threshold slabs in the palace of king Assurnasirpal II (883–859 BC) at Nimrud, ancient Kalhu, in what is now northern Iraq. After assembling all the data, I discovered that threshold slabs were missing from two doorways that must once have had them. One of these doorways had originally been decorated on the jambs with a pair of colossal human-headed bulls, and the other with a pair of human-headed lions. Layard, who had excavated this palace from 1845 to 1847, had sent one colossus from each doorway to the British Museum. His published description of the moving of this lion and bull is very detailed, filling 32 pages in his narrative account of his excavations, *Nineveh and Its Remains*.[3] The procedure he described there did not appear to necessitate the removal of the threshold slabs, so I began to search for his published description of the moving of the other two colossi, which are now in the Metropolitan Museum. I did find his description of the removal of a second pair for the British Museum, not as long as the first account, but still occupying some five pages in his second excavation report, *Nineveh and Babylon*.[4] Given this considerable attention devoted to the two British Museum pairs, I was surprised to find that the removal of the Metropolitan Museum examples was not mentioned at all. It was difficult to avoid the feeling that this was one pair of colossi for which Layard was not anxious to take public credit. I was curious about why this should be, and a bit of research turned up the information that these colossi were originally part of a large collection of Assyrian sculptures that had been on display in something called the Nineveh Porch at Canford Manor in Dorset.

My second project was a study of the endurance and revivals of the idea of Nineveh in the period from the fall of the city in 612 BC until the end of the nineteenth century. This Nineveh Porch seemed a good candidate for an example of Ninevite revival in the nineteenth century. The problem was that the published references to the Nineveh Porch were very sketchy and often contradictory. The published information gave a sense of neither its appearance nor its chronology, and the published illustrations were limited to general plans of the entire house and a single poor photograph of the doors. By far the best published account of the Porch was written in 1960 by William S. Smith, Curator of Egyptian Art at the Boston Museum of Fine Arts, on the occasion of the acquisition of two of the Canford reliefs by his museum. Smith's brief but largely accurate sketch of the circumstances that led to the construction of the Nineveh Porch concludes: "Unhappily [Lady Charlotte's] journals never give any details about the reliefs. Perhaps some day a drawing will be found which shows the arrangement of the 'marbles' in the Nineveh Porch."[5] It didn't appear I would be able to get very far with the Nineveh Porch using the published sources.

My third project was a report of my excavations on the palace of king Sennacherib (704–681 BC) at Nineveh in 1989 and 1990. Since I had worked in

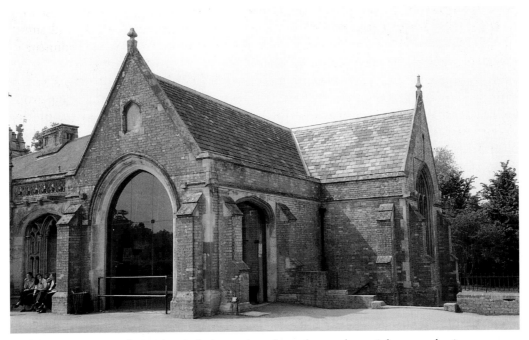

1: Nineveh Porch, angle front view, from the southeast (photo: author)

the same areas that the assyriologist L. W. King had excavated in 1903–4, and since his work had never been published, I spent the late spring of 1992 studying the King archives in the British Museum in order to be able to incorporate his results into my report. In the course of this research I ran across an inventory he had made of the sculptures in the Nineveh Porch. I now had something to contribute to the literature on the Porch. I felt fairly certain that with the aid of the inventory I could trace most of the reliefs, but it seemed to me that this exercise would be useful only if I could place the reliefs in the context of the structure itself. This would require a visit to the Nineveh Porch in order to take photographs and make a measured plan of the architectural setting of the reliefs.

Having arrived in London in mid-April, I soon had a free day due to the closing of the British Museum for the early May Bank Holiday. What a delight to discover that since Canford School was a private (English "public") school it did not observe the holiday! The secretary at Canford assured me that I would be most welcome to visit that day. I found a willing traveling companion in Dr. Julian Reade, Assistant Keeper in the Department of Western Asiatic Antiquities at the British Museum, a scholar who has written more on Assyrian art than anyone else, and the owner of a very serviceable car. Dr. Reade suggested that I bring along a copy of King's inventory, but since I knew that most of the Assyrian sculptures had been removed to the Metropolitan Museum and that the remainder had been sold at Sotheby's in 1959, there seemed no need to do so.

On 4 May 1992 we visited Canford. Once there, we had no difficulty locating the "Ninevah tuck shop," which was clearly marked on the visitors' map at the gate (fig. 1). The Porch itself was a delightful surprise. Mrs. Kathleen Shackleton, the

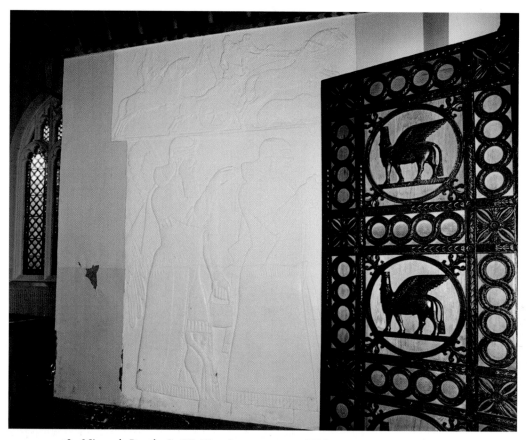

2: Nineveh Porch, L. W. King inventory no. 27 (a cast, at top) and no. 28
(upper half original, lower half a cast), before cleaning; dimensions of no. 28: 239 × 187 cm
(photo: Judith McKenzie)

proprietress of the tuck shop, made us very welcome and we spent some two hours looking around and taking photographs and measurements. We were struck by the beauty of the little structure and by its excellent state of preservation, its iron doors and stained-glass windows appearing as though they might have been installed only yesterday. I was particularly pleased to find two casts still in place, directly to the right of the door, since this would serve as a guide to how the missing sculptures and casts had been placed on the other walls (fig. 2). After finishing with the Nineveh Porch, we visited Canford Magna church and the graves of Lady Charlotte and Henry Layard in its burial ground. It was a day of delightful surprises.

The biggest surprise, however, came the next day. Back in the Western Asiatic Students' Room, I decided to see what the King inventory said about the two casts we had seen in the Porch. No. 27: "*Cast* of bull hunt." Indubitably. No. 28: "lower half of panel made up with plaster cast—upper half genuine." This was unexpected. Dr. Reade's photograph of No. 28 confirmed that the upper part was not a cast of any known slab. He identified it as the upper half of Slab 6 from Room C of Assurnasirpal's palace at Kalhu, a slab previously thought to be lost. King's statement that it was genuine seemed very probable. Fortunately, another bank holiday was

3: Mr. Ken Uprichard
testing for stone
(photo: author)

coming up. I wrote of our suspicions to Mr. Martin Marriott, Headmaster of the School, and he invited us to return. Dr. Reade agreed to accompany me again. This time we were prepared. Dr. John Curtis, Keeper of Western Asiatic Antiquities at the British Museum, who had himself recently rediscovered a lost Assyrian lion hunt slab, arranged for Mr. Ken Uprichard, head stone conservator at the museum, to accompany us.

On 25 May 1992 we returned to Canford. Again Mrs. Shackleton made us welcome, and this time found us a tall ladder to facilitate additional measurements and photography. Mr. Uprichard removed several layers of paint from a small area of the slab in question and pronounced it to be stone (see figs. 3, 44). Mr. Marriott stopped by to greet us, bringing with him a small fragment from Sennacherib's palace carved with three severed heads (see fig. 113). He reported that it had been discovered during work on the foundations. Layard had presented Lady Charlotte with a "Ninevite head" on one of his first visits to Canford in 1848, and I wondered if this might be the same piece, but Dr. Reade sensibly pointed out that this piece was clearly "Ninevite heads." We departed Canford pleased with our discovery of not just one but two new Assyrian reliefs, but concerned that these might now be sold as the other Canford reliefs had been.

THE SOURCES

Before launching into the story proper, a few words about the sources that were consulted will give some sense of the possibilities and limits of this project. The physical sources are the Nineveh Porch itself, and the Nineveh Porch sculptures, all but one of which were removed from Canford and are now in the Metropolitan Museum and other collections. The original arrangement of the sculptures in the Porch was determined from the uncatalogued, undated inventory of the collection compiled shortly before 1919 by L. W. King, and now among the King papers in the archives of the Department of Western Asiatic Antiquities at the British Museum. Two other archival sources provided most of the information on the origins of *Monuments of Nineveh* and the Nineveh Porch: Lady Charlotte's diaries (here abbreviated "Diary") in the Wimborne family archive and the Layard Papers in the British Library, London.

Lady Charlotte was a prolific and faithful diarist. The typed transcript of her diary, which is the only complete version now extant, covers with only a few gaps the period 1822 to 1891, in 17 volumes containing over 10,000 pages.[6] A selection of the entries from the period of concern here, roughly 1848 to 1856, was published by her grandson, the Earl of Bessborough (Guest 1950, Schreiber 1952), but the great majority are unpublished. Her diary for this period appears to provide a detailed daily record of virtually everything she did and much of what she felt. Because of its chronological arrangement and seemingly comprehensive coverage, it was an extremely informative source for this book, as it is for many aspects of nineteenth-century life. These two apparent strengths of the diary are closely tied to its two most significant limitations, at least from the point of view of my research: chronological unevenness of coverage and brevity in the recording of many events.

Concerning the first point, though Lady Charlotte's diary has a separate entry for each day, she makes it clear that she didn't always, or even usually, write in her diary every day. Frequently she mentions that it has been some days or weeks since her last entry and then she records each missing day as well as she can reconstruct it. The entries for those days tend to be briefer than those written closer to the day they record, and their focus tends to be on a few major or new events, such as might be recalled with the aid of an engagement calendar, rather than on the trivial or everyday events that figure prominently in the more timely entries. The effect of this is that ongoing projects, such as the Nineveh Porch, may receive only a single summary mention in an entry that is recalling the events of a week or two, instead of the daily progress reports that one might prefer.

The second limitation, brevity in the record of many events, requires little comment. Even in those entries written on or immediately after the day they record, some events—presumably the ones Lady Charlotte considered less noteworthy—are referred to only in passing. Nevertheless, the total volume of information recorded, both momentous and trivial, is tremendous. The period of primary interest for this study—15 February 1848, when Lady Charlotte first met Layard after his return from Nineveh, to 29 August 1856, when her oldest son attained his majority and inherited Canford—fills over 2300 typed pages, and the number would be larger except that no diary survives for most of 1855. Of this total,

perhaps some 20 pages deal with Assyrian subjects, including the Nineveh Porch. Though this seems a relatively meager total in view of her very considerable involvement with Assyrian affairs, these are 20 of the most interesting pages to come out of the nineteenth-century rediscovery of ancient Assyria, and constitute an important and unique chapter in that story.

The Layard Papers fill some 240 volumes in the Manuscript Collection of the British Library. A few of these contain material of interest for this study, including copies of the prospectus for *Monuments of Nineveh*, Nineveh excavation accounts and diaries, and personal and professional correspondence. The principal limitation of the Layard Papers as a source for the period of interest here is that most of the correspondence is letters *to* Layard—only exceptionally, as in his correspondence with H. J. Ross and G. T. Clark, are originals or copies of Layard's own letters included. Furthermore, Lady Charlotte's letters to Layard are not among the Layard Papers, and Layard's penmanship, though acceptable enough in documents he considered important, such as expense accounts and official letters, was very poor when he was writing only for himself.

Another archival source, the Barry family papers in the Royal Institute of British Architects Library and Drawings Collection, London, includes engagement diaries of Charles Barry beginning with 1853 and a few letters dealing with Canford. These provided little new information, but occasionally corroborated points in the other sources. The secondary sources I consulted most frequently were the biography of Lady Charlotte by Guest and John (1989), Waterfield's biography of Layard (1963), Alfred Barry's biography of his father, Charles Barry (1867), and Fleetwood-Hesketh's assessment of Barry's career (1963).

I drew on the archives of the University Museum, Philadelphia, the Metropolitan Museum of Art, New York, the Oriental Institute of the University of Chicago, and the Rockefeller Archive Center to follow the course of the sculptures after they were removed from the Nineveh Porch. In 1993, as a result of being taken there by Ann Smart, another scholar, Judith McKenzie, also became interested in the Nineveh Porch and its sculptures. At Canford School Commander Chamberlain provided Dr. McKenzie with a considerable amount of archival material that dealt with the recent history of the Nineveh Porch. Since her research was of great interest for the story I was telling, she agreed to write that section for this book. She also supplied excellent photographs of the door and ceiling of the Nineveh Porch and one of the reliefs.

Two final notes: First, Layard and his contemporaries generally referred to all of the Assyrian discoveries as coming from "Nineveh," regardless of whether they actually came from Nineveh, Nimrud, or Khorsabad. This was due not to carelessness, but rather to the belief that ancient Nineveh encompassed all of these cities and that they all shared a "Ninevite" culture. In this spirit, I will be similarly imprecise in my usage of the terms "Nineveh" and "Ninevite." Second, due to the death of her first husband and her subsequent remarriage, Lady Charlotte's surname changed in 1855 from Guest, her name as translator and editor of the *Mabinogion*, to Schreiber, the name under which she and Charles Schreiber built the Schreiber porcelain collection, now in the Victoria and Albert Museum. To minimize confusion, I will generally refer to her simply as Lady Charlotte.

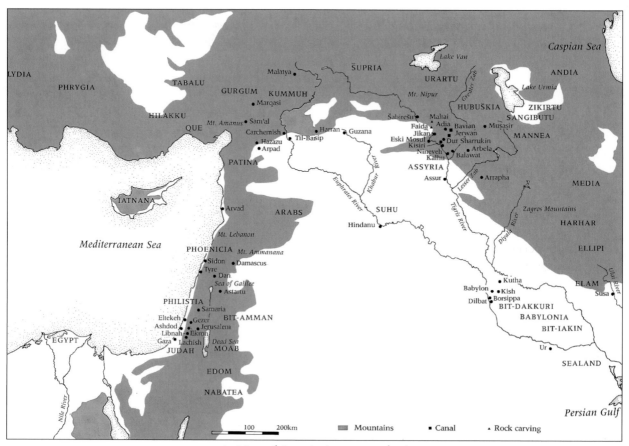

4: Map of Assyria (source: author)

CHAPTER 1

NINEVEH ON THE TIGRIS

IMAGES OF NINEVEH

The story of the Nineveh Porch is a part of the larger story of the European redis-
covery of ancient Assyria and its fabled capital, Nineveh, in the mid-nineteenth
century. In the early 1840s, no one could read Assyrian cuneiform and only frag-
ments of Assyrian remains were known. By the late 1850s, the language had been
deciphered and six Assyrian palaces had been excavated. Though the memory of
Nineveh as the center of a great empire and as a fearsome foe of the Hebrews had
been perpetuated in the works of Classical historians and especially the Bible, these
images proved to bear little resemblance to the historical Nineveh. The story of the
rediscovery of Nineveh is the story of the reconciliation of cherished religious
legends with hard archaeological facts, and of the threat to cherished Classical aes-
thetic norms from an entirely new style of art. The Canford marbles, among the
first Assyrian sculptures brought to England, and the Nineveh Porch, the first
expression of the Assyrian Revival, played major roles in this realignment of values.

The city of Nineveh has at least three histories. The first is its history as a place
where people lived, a period of some 5000 years of occupation that culminated in
its elevation in 704 BC to be the capital of the Assyrian empire. Then, as the chief
residential and administrative city of the Assyrian kings, it became the capital of
the world, center of the four quarters of the earth. The second is its history as a
memory, the legends of Nineveh that grew up after its physical destruction and
abandonment in 612 BC. The third is its history as an archaeological site since
its rediscovery by A. H. Layard in 1847, a complex puzzle that generations of
scholars hoped (and still hope) would reward care, diligence, and patience with
authentic images of the past.

ANCIENT NINEVEH

The ancient Assyrians were the people of Assur, state god of the land of Assur
(Assyria). The Assyrian heartland was the part of northern Mesopotamia (now Iraq)
centered on the upper Tigris river valley, bounded on the north and east by the

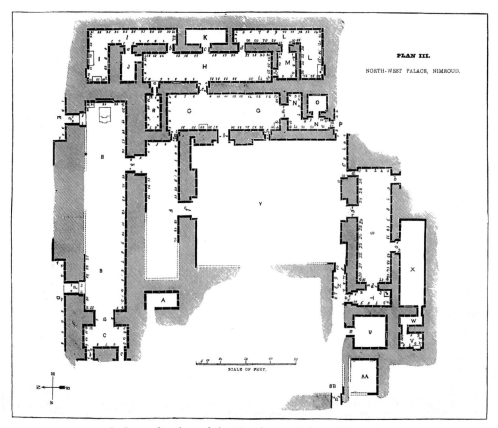

5: Layard's plan of the Northwest Palace, Nimrud
(Layard 1849a, I, facing p. 62)

Zagros mountains and on the south and west by arid plains (fig. 4). The Assyrians appear in the historical record as traders at the beginning of the second millennium BC and continue as an important regional and then world power until the fall of the Assyrian empire in 612 BC. From the ninth through the seventh centuries BC, the so-called Neo-Assyrian Period, Assyria expanded from a small nation state into an empire larger than any previously known, encompassing at its maximum extent all of what is now Iraq, Syria, Jordan, Israel, and Egypt, and large parts of Turkey and Iran.

Assurnasirpal II (883–859 BC), one of the most powerful kings of the ninth century, pursued a successful policy of territorial expansion and also carried out substantial building projects in the traditional capital cities of Assur and Nineveh. His primary architectural and artistic activity, however, was lavished on a new capital city, the former Middle Assyrian provincial capital of Kalhu (modern Nimrud, biblical Calah, Xenophon's "Larissa"), on the east bank of an ancient bed of the Tigris river, some 35 kilometers south of Mosul. Around his fifth year, Assurnasirpal moved the chief royal residence and administrative center of the realm from Assur to Kalhu and began rebuilding it on a massive scale, constructing a new city wall some 7.5 km in circumference, a palace, and nine temples. The most elaborate of these structures was the palace—called the Northwest Palace in the modern lit-

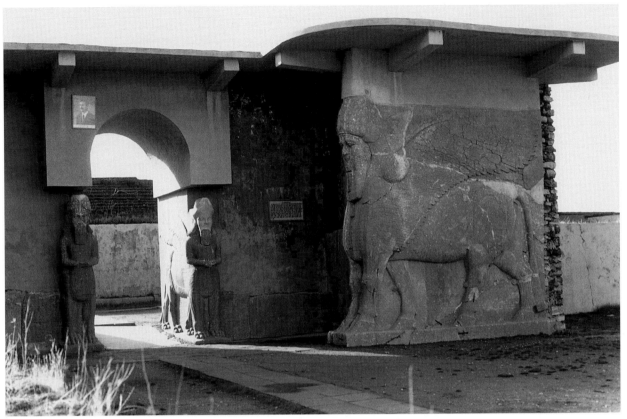

6: Nimrud, Northwest Palace, Court E with throne-room entrance *c*,
present state (photo: author)

erature—which filled most of the northwest quarter of the citadel mound (fig. 5).
Its known area measures 200 meters north to south and 120 meters east to west,
and it may originally have extended further to the south and east.

Its northern third was a large outer courtyard, not shown in fig. 5, the south side
of which was the throne-room façade (marked D and E on the plan). This, along
with several other major entrances in the palace, was decorated with human-headed
bull and lion colossi (fig. 6). Apart from their size—the largest were nearly six
meters in length and height—their most striking feature is their combination in a
single figure of two distinct relief images: a static frontal view showing two legs
and a striding side view showing four legs, the result being a five-legged creature.
The spaces between the legs and behind the tails of these colossi were carved with
a text that identifies the king and summarizes some of his accomplishments. The
walls to either side of the two preserved entrances, *c* and *d*, in the throne-room
façade were lined with stone slabs carved in relief with foreigners bringing tribute
before the king.

Beyond this was the throne-room suite (Rooms B and F), which opened onto a
smaller inner courtyard (Y). This courtyard was lined on its other three sides with
suites of large state apartments, each entered through a large doorway flanked by
human-headed bull or lion colossi: G and H to the east, S and X to the south, and

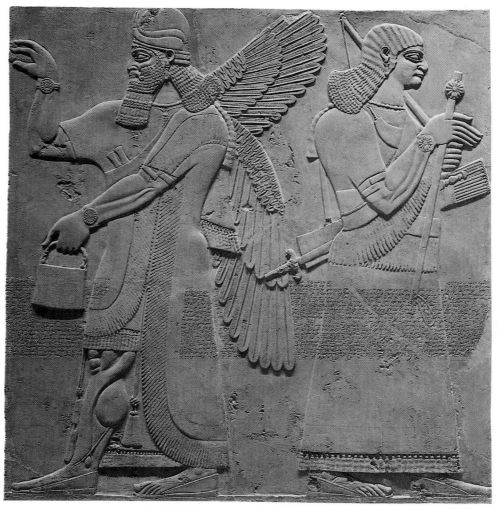

7: Nimrud, Northwest Palace, Room G, Slab 7;
Metropolitan Museum 32.143.6; 232 × 237 cm; L. W. King no. 20
(photo: Metropolitan Museum of Art, Gift of John D. Rockefeller, Jr., 1932)

an unmarked suite of rooms to the west. The walls of all the rooms in this part of the palace were lined with stone slabs. Most of these were carved with relief images, many of which survive relatively intact. Also carved on each slab was a text that we call the "Standard Inscription," which gave the name, titles, and epithets of the king, summarized his military achievements, and described the appearance of the palace (see Appendix 6).

Taken as a whole, the relief decoration of the palace seems to be intended as a visual expression of the main points of Assurnasirpal's royal ideology. Within this overall scheme, the relief subjects vary from suite to suite. This may perhaps be explained in part by hypothesizing different primary functions for each suite. The relief decoration in the principal rooms of the west suite (Rooms WG and WK/BB, not shown in fig. 5) was poorly preserved, largely because many of its wall slabs had been removed in the seventh century BC for use in a new palace nearby. The slabs that do survive from these rooms show royal military campaigns and royal

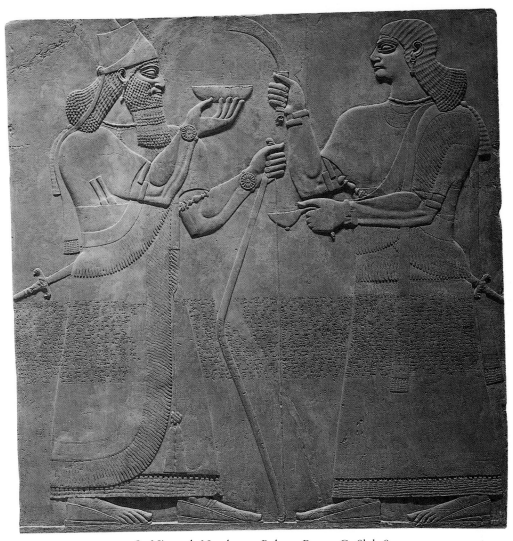

8: Nimrud, Northwest Palace, Room G, Slab 8;
Metropolitan Museum 32.143.4; 232 × 228 cm; L. W. King no. 10
(photo: Metropolitan Museum of Art, Gift of John D. Rockefeller, Jr., 1932)

lion hunts. If this sample is representative of the decoration of the entire suite, then the theme in these rooms was royal power: the king's ability to subdue the enemies of Assyrian order, both man and beast. Since this was the only suite in the palace that overlooked the Tigris, and was therefore well-ventilated and scenically sited, we may imagine that these would have been the rooms of choice for court activities that did not require the formal setting of the main throne room, possibly being used as a secondary throne room and for such occasions as state banquets. The relief images on the walls of these rooms would have served their occupants both as reminders of the effectiveness of the power at the disposal of the king and as statements of the king's tireless activity as protector of Assyria from its enemies.

The east suite housed what I believe may be the palace shrines. Here, the decoration of the two large outer rooms, G and H, features the king, shown sitting or standing, usually holding a bow in his left hand, and accompanied by attendants. In half of the representations in Room G and all of those in Room H (figs. 7, 8),

he holds a bowl in his right hand and is engaged in an activity that may most plausibly be identified as pouring libations. In the other half of the images from Room G, the king holds two arrows in his right hand and is flanked by two winged deities who extend an unidentified implement towards him. The two small rooms at the back (I and L), which on the evidence of their unusual L-shaped plan, paved floors, and wall niches may perhaps be shrines, were decorated with reliefs that showed winged human figures, some with bird heads and others with the horned crown of deities, pollinating or sprinkling a stylized palm tree with the same implement seen in Room G. This subject recurs throughout the palace and in most cases the figures are the entire height of the slab. In Room I, however, the slabs were divided into two registers of relief with the Standard Inscription in between (see fig. 38). Similar deities are described in seventh-century BC texts, where they are identified as *apkallu* or "sages," and are invoked for their protective powers. In the context of the palace reliefs, the tree evidently symbolizes Assyria, shown under the care of protective deities. If this interpretation is correct, then the east wing could be the location of royal rituals that involved liquid offerings to Assyrian deities, offerings that are depicted in the two outer rooms and that may actually have been made in the smaller back rooms that were lined with apotropaic figures.

The main room in the south suite (Room S) was decorated exclusively with images of the human- and bird-headed *apkallu* flanking the stylized tree, except that one of the end walls showed the king standing, flanked by attendants. In effect, the image of the king presided over images of protective deities who assured the well-being of Assyria. Since the meaning of the images in this suite is less obvious to outsiders than those of either the western or eastern suite, and since this suite is the furthest removed from the palace entrance, we may speculate that this suite was used for private or strictly court-related functions. The decoration of the three suites around Court Y, then, seems to emphasize three different aspects of Assurnasirpal's rule: military success in the west wing, service to the gods in the east wing, and Assyrian prosperity in the south wing.

In the relief decoration of the throne-room suite, all three of these ideals were brought together. All of the doors in Room B (the throne room) were lined with human-headed bull or lion colossi flanked by winged protective deities. The slabs opposite the main door and at the east end behind the throne base showed the king together with winged deities attending the stylized palm tree, and the tree with deities appeared in the corners as well. The remaining stretches of wall were covered with hunting and military reliefs (figs. 9, 10), divided into two registers separated by the Standard Inscription. The area above the wall reliefs in the throne-room was decorated with wall paintings and glazed bricks, which may have given an effect something like that of fig. 81. The reliefs in Room C, a shallow alcove that opened off the west end of the throne room directly opposite the throne base, showed the king holding a bowl, again apparently pouring libations, accompanied by attendants. Room F, the large room directly behind the throne room, was also decorated with the stylized tree flanked by bird-headed winged deities.

The decoration of the throne-room, therefore, expresses the same ideology of power, piety, and prosperity that was developed individually in each of the three

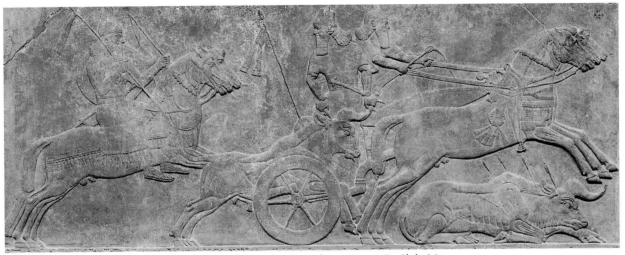

9: Nimrud, Northwest Palace, Room B, Slab 20;
British Museum WA 124532; 89 × 224 cm. L. W. King no. 27 is a cast of this slab

10: Nimrud, Northwest Palace, Room B, Slab 19;
British Museum WA 124534; 86 × 222 cm. A lost cast of this slab was L. W. King no. 1
(photos: Trustees of the British Museum)

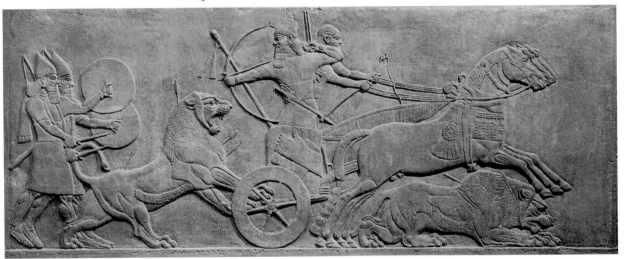

inner suites of rooms. To this mixture, the throne-room façade adds the further ideal of the peaceful delivery of tribute from subject peoples at the extremity of the empire. The message seems to be that the maintenance of order, as shown inside the throne-room and in the inner suites of the palace, will assure prosperity in the form of the flow of wealth from the outer reaches of the empire into its capital.

Kalhu continued as the chief Assyrian royal residence until Sargon II (721–705 BC) built a new capital north of Nineveh at Dur Sharrukin (modern Khorsabad). Immediately upon Sargon's death, however, Sennacherib (704–681 BC), best known today for his unsuccessful siege of Jerusalem in 701 BC, moved the capital to Nineveh, one of the oldest and most important cities of ancient Assyria. Once on the Tigris, Nineveh is now about a kilometer east of the river, directly opposite

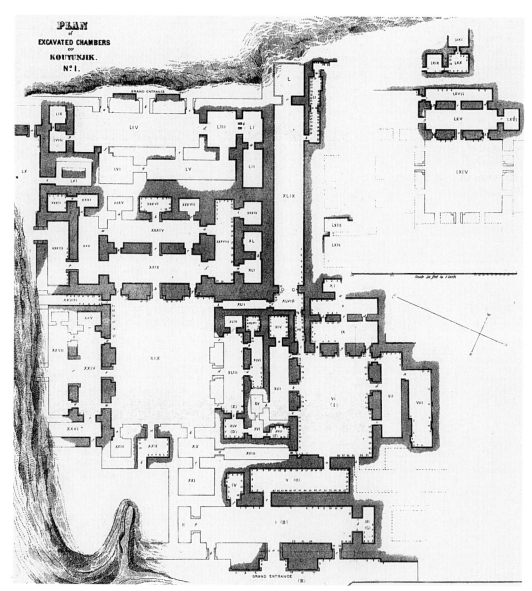

11: Layard's final plan of the Southwest Palace, Nineveh
(Layard 1853a, facing p. 67)

modern Mosul. Sennacherib made Nineveh the largest city in the known world, building a new city wall with 18 gates, a huge new palace, an arsenal, temples, roads, bridges, and canals. Sennacherib's new palace, which he called "The Palace Without Rival," was the largest of the Assyrian palaces (fig. 11). It was built in the oldest part of the city, along the southwest side of the large citadel mound of Kuyunjik, overlooking the former junction of the Tigris and Khosr rivers. According to Sennacherib's texts, the terrace for this new palace measured 914 by 440 cubits (about 500 by 240 meters) in extent. As in the palace of Assurnasirpal II, only

12: Nineveh, City Wall, Nergal Gate, bull colossus; ca. 4.5 m high (photo: author)

13: Nineveh, Southwest Palace, Room VIII, Slab 12; Boston, Museum of Fine Arts 60.134; 64 × 84 cm; L. W. King no. 7 (photo: Courtesy of the Museum of Fine Arts, Boston)

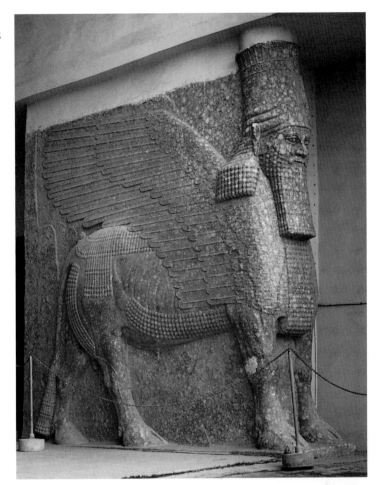

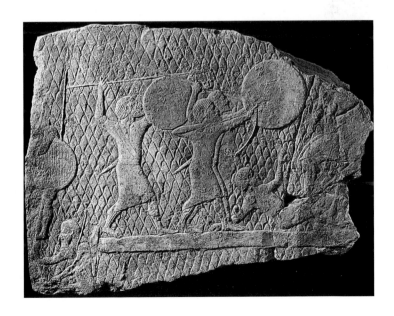

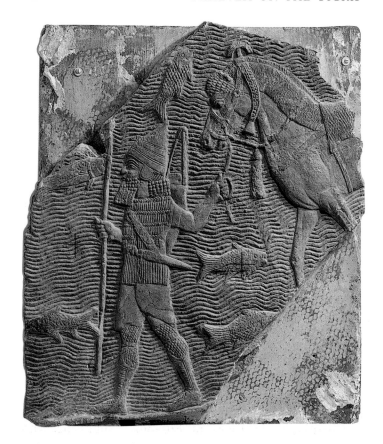

14: Nineveh, Southwest Palace, Room XXXVIII, no slab number; Metropolitan Museum 32.143.18; 65 × 57 cm; L. W. King no. 12 (photo: Metropolitan Museum of Art, Gift of John D. Rockefeller, Jr., 1932)

rooms in or around major reception suites were decorated with wall reliefs and gateway colossi, but the number of such rooms in Sennacherib's palace was considerably larger: some 70 rooms covering an area about 200 meters square at the palace's southwest end, from which a total of some 9880 feet (3011 meters) of wall reliefs was recovered during excavations.

As in Assurnasirpal's palace, Sennacherib's throne-room was decorated with human-headed bull colossi, also inscribed with texts in the spaces between their legs. An interesting innovation is that these colossi have only four legs—one of the front legs in the side view having been eliminated—which gives them a more naturalistic appearance than that of their five-legged predecessors. Bull colossi also occurred in a number of other major palace doorways, and a well-preserved example was found in the Nergal Gate in the city wall (fig. 12). The vast majority of the wall reliefs throughout the palace showed military campaigns, depicted in a lively manner that employed relatively convincing perspective effects (figs. 13, 14). Other subjects included the procurement of palace building materials and royal processions. The only texts that intrude on any of Sennacherib's reliefs are brief captions inscribed next to the king or the cities he encounters. The palace had been thoroughly burned at the fall of Nineveh and most of the reliefs were badly cracked and scarred by the heat.

Assur fell to the Medes in 614 BC and Nineveh and Kalhu followed in 612 BC.

The three capitals were sacked and burned, their populace of foreign deportees went home, and the remnants of the Assyrian court and army fled to Harran and were finally defeated in 609 BC. The deserted ruins of the Assyrian palaces were filled in with blown sand or were leveled and built over. Everything the world had come to admire and fear as Assyrian vanished almost without trace. Though gone, the Assyrians were not forgotten: they lived on in the Bible and in the writings of Classical historians, waiting for their day to come again.

THE LEGEND OF NINEVEH

The second history of Nineveh is the body of stories that were told about it after its fall. So complete was its destruction that Xenophon, who passed by it in 400 BC, was unable to find anyone who knew its ancient name, and so took it to be a Median city destroyed by the Achaemenids. The primary sources for these stories are historical and moralistic texts that were written in the centuries after Nineveh had ceased to exist as a major city. They include Classical authors (Herodotus, Ctesias, Arrian, Berossus, Strabo, Pliny the Elder, Lucian, Philostratus, Tacitus, Ptolemy, and others) and the Old Testament (Genesis, Jonah, Nahum, Zephaniah) and Apocrypha (Tobit, Judith).

These were the sources for accounts of the Assyrian empire as the first in a succession of five great empires chronicled in a series of universal histories that aimed to demonstrate that the rise and fall of empires is a natural cycle, and therefore the rise of the fifth empire—Rome in the histories of Polyhistor, Diodorus, and Dionysius of Halicarnassus, and Christianity in those of Eusebius, Augustine, and Orosius—was inevitable. These were still the only sources available to nineteenth-century historians such as Hoefer (1852) and Niebuhr (1857), who drew on the entire Classical and biblical corpus in compiling their great synthetic histories of Assyria and Babylonia. The problem with all these "histories" is that their authors neither had first-hand knowledge of the cultures they were recording, nor could they read cuneiform, so their accounts seem today little more than anthologized legends. They are of interest because, for two and one half millennia, they were all that was available to even the most educated scholar.

Concurrent with this "historical" tradition, and for a time supplanting it almost completely, was the Christian exegetical tradition, which was based exclusively on references to Nineveh in the Bible. Its foremost exponent was Saint Jerome, whose commentaries on Jonah, Nahum, and Zephaniah laid the groundwork for all subsequent Christian exegesis on these prophets. Nineveh plays a unique role in this tradition as a gentile city that was both saved by God's incomprehensible mercy (Jonah) and destroyed by God's unimaginable wrath (Nahum, Zephaniah). Reliefs on the west portal of Amiens Cathedral, for example, show the forgiven Nineveh, represented as a contemporary European city, as part of the Jonah story, while the destroyed Nineveh illustrates Nahum and Zephaniah. Clearly, the model of urban Nineveh is equated with urban Amiens. Nineveh's role as a moral example falls somewhere between that of two other great biblical cities, Jerusalem, which generally evoked positive associations, and Babylon, whose reputation was very unfavorable.

There are other bodies of tradition about Nineveh in the period between its fall and rediscovery. One is the medieval Hebrew Midrashic and Rabbinic tradition—R'Bachya, Ibn Ezra, Radak, Rambam, Rashi, and others—which flourished especially from the eleventh to the thirteenth centuries and influenced Christian exegesis of the period. Another is the tradition of the Arab geographers—Mas'udi, Ibn Hawqal, Muqaddasi, Ibn Zubayr, Ibn Battuta, and others—who correctly identified the ruins of Nineveh as they appeared in their own day. Interestingly, though the people who lived in the neighborhood of Nineveh knew its two large mounds by several names, most commonly Kuyunjik ("little lamb") and Nebi Yunus ("Prophet Jonah"), they never ceased referring to both mounds as "Nineveh" (in contrast to the Classical historians, who could not even agree on whether Nineveh had been on the Tigris or the Euphrates).

Still another is the tradition of the European travelers from the twelfth to early nineteenth centuries—Benjamin of Tudela, Ricoldo Pennini, Leonhard Rauwolff, John Cartwright, Carsten Niebuhr, C. J. Rich, and others—all of whom accurately identified Nineveh's site. Loosely tied to this is the European geographic tradition, inspired by the Crusades and voyages of exploration. This produced such works as the *Histoire ancienne* (ca. 1210) and Munster's *Cosmographia* (1550), both of which give imaginary physical descriptions of Nineveh, and Ortelius's *Thesaurus geographicus* (1596), which based its nearly correct location of the site on accounts of European travelers.

Finally there is the European romantic tradition of Rubens (*Defeat of Sennacherib*, Munich, Alte Pinakothek, 1616–18), Byron (*Sardanapalus*, 1821), and Delacroix (*Death of Sardanapalus*, Paris, Louvre, 1827), who drew on both the Classical and biblical traditions for their strikingly original and powerfully expressive renditions of Ninevite subjects. The most memorable of these, Byron's "The Destruction of Sennacherib" ("The Assyrian came down like the wolf on the fold / And his cohorts were gleaming in purple and gold . . ."), was penned in 1815, twenty-five hundred years after Sennacherib's siege of Jerusalem, the event it recounts. Thirty-two years later, Layard discovered Sennacherib's own account of the siege, and Byron's biblical source was confronted with the first serious competition it had faced since the fall of Nineveh.

THE DISCOVERY OF NINEVEH

The third history is the story of the major role Nineveh and Nimrud played in the creation of an image of Assyria that was based on records—texts, architecture, and sculptures—of the Assyrians themselves. In 1847, no one in the world could read Assyrian cuneiform. In 1857, four prominent Assyriologists were given identical copies of an unpublished Assyrian inscription, and all four arrived independently at essentially identical translations. In 1843, only a few Assyrian cuneiform texts were known and only fragments of Assyrian remains had been excavated. By 1853, the palaces of Assurnasirpal II, Tiglath-Pileser III, Sargon II, Sennacherib, Esarhaddon, and Assurbanipal were all at least partially excavated, and tens of thousands of cuneiform texts had been uncovered. In 1852, Hoefer published his

comprehensive history *Babylonie, Assyrie, Chaldée, Mésopotamie* without using a single cuneiform source. Rawlinson's *Outlines of Assyrian History*, published in the same year, was based entirely on cuneiform sources.

From Sennacherib's account of the siege of Jerusalem inscribed on sculptures in the door of his throne-room to the picture of the Assyrian victory at the biblical Lachish, from George Smith's discovery in the British Museum of a large piece of the Deluge tablet to the astonishing success of his search for the rest of the story, Nineveh was the source of discoveries that stirred the imagination of the general public. The documentary value of the new discoveries was not lost on visual artists of this period. In works such as George Hedgeland's *Jonah* windows in Ely Cathedral (1858) and Ford Madox Brown's *The Dream of Sardanapalus* (Wilmington, Delaware Art Museum, 1871), the generic oriental trappings of Rubens and Delacroix were replaced by a Nineveh taken directly from the Assyrian palace reliefs. For an informed viewer, these images carry the conviction of the Assyrian monuments themselves.

Though the image of Nineveh that was formed on the basis of the new archaeological discoveries may have been more factual, it was in many respects no more ideologically neutral than those founded on the misinformation of the legends of Nineveh or the imperial propaganda of ancient Nineveh. Nineveh was the natural pivot between the old biblical traditions and the emerging Assyrian historiography, and discoveries at Nineveh were often valued more for the reassuring light they threw on the Old Testament than for the new history they supplied. Reliance on the traditional sources died hard. Thus in the preface to the second edition of his best-selling *Nineveh and Its Palaces* (1853), Joseph Bonomi stated that his purpose was to pursue "a regular and systematic course through the ruined [Assyrian palace] chambers, reading the sculptures upon the walls together with the Scriptures as I progressed." It was not until the 1870s that the largely futile exercise of harmonizing the Classical-biblical chronology of Assyria with the new one provided by the Assyrian documents ceased to be a major concern for historians, subordinated in the later nineteenth century to other concerns—the nature of historical inquiry, the origin of linguistic groups, and, chillingly, assertions about the inherent inferiority of the Semitic Assyrians compared with their Aryan neighbors.

The success of the Assyrian imperial program as it was embodied in the city of Nineveh can best be judged by looking at the ideas Nineveh generated. Images of Nineveh—center of the world, symbol of empire, moral model, proof of religious truth, encyclopedia of the past—are formed by the beliefs and needs of those who imagine them. They are not physical entities, but reflections of their creators. At the same time they are an enduring testament to the evocative power of Nineveh. Whether from the period of ancient Nineveh, the legendary Nineveh, or the rediscovered Nineveh, the significance of these images lies not in their relative truth, but rather in their indication that Nineveh was once so important that after it was gone people found they could not manage without it, and so continued to recreate it in their own image. The Nineveh Porch, which lies on the threshold between the legendary and rediscovered Ninevehs, is one such image.

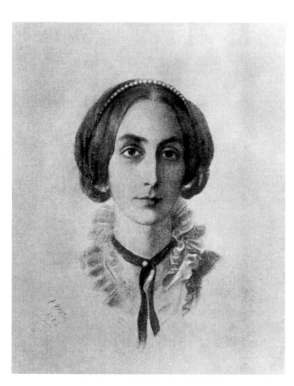

15: Lady Charlotte Guest, portrait by G. F. Watts, 1854, collection of Viscount Wimborne (Schreiber 1952, frontispiece)

16: Sir John Guest, from an engraving by R. J. Lane of the painting by Jacob Thompson, undated, collection of Viscount Wimborne (Guest 1950, facing p. 254)

THE ENGLISH RECEPTION OF ASSYRIA

CANFORD MANOR

In early 1846 Sir John Guest (1785–1852), principal owner of the great Dowlais Iron Company in Glamorgan, South Wales, and his wife, Lady Charlotte Bertie Guest (1812–95), daughter of the ninth Earl of Lindsey (figs. 15, 16), purchased Canford Manor, on the River Stour just north of Poole in Dorset, from W. F. S. Ponsonby, the first Baron de Mauley, for the very considerable sum of £335,000.[1] The manor at that time consisted of a large fifteenth-century kitchen building, traditionally known as "John of Gaunt's Kitchen," a Gothic Revival house built by Edward Blore between 1825 and 1836, and 10,000 acres of land. In April 1847 the architect Thomas Hopper was commissioned to enlarge and improve the house at an estimated cost of £6000.[2] Costs mounted "alarmingly," however, and Lady Charlotte seems to have been dissatisfied with the progress of the work. At the beginning of October she wrote, "George Clark [a close family friend] . . . accompanied Merthyr [her nickname for Sir John] to see [the architect Charles] Barry about our Canford alterations. We find it will be impossible to go on with Hopper. He has not the slightest taste in Gothic decoration."[3]

Charles Barry's reputation was then at its peak (fig. 17). In 1836 his design had been selected in a competition for the rebuilding of the Houses of Parliament, a project that occupied most of his time for the next 20 years. Work on the Houses of Parliament was well-advanced when, in late November 1847, Lady Charlotte wrote: "Merthyr . . . had called upon Barry and arranged for him to undertake finishing Canford. We have quite given up on Hopper whose taste is hopeless. Barry talks of coming down in Christmas week."[4] Barry spent the Christmas holidays at Canford with the Guests discussing the improvements. In late March 1848 Lady Charlotte visited the House of Lords to see Barry's work: "We were there just long enough to see the House lighted up, which certainly has a very fine effect. We afterwards walked through some portions of the building. I think some hints may be taken from the robing room for our Hall at Canford."[5]

On 7 April 1848 Lady Charlotte had "a long visit from Mr. Barry with plans of Canford as it is at present, and plans of the mode in which he suggests altering it.

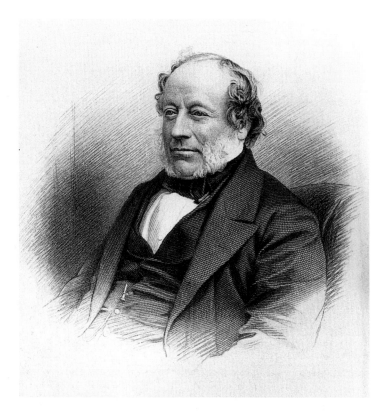

17: Charles Barry, engraved after a photograph, undated (Barry 1867, frontispiece)

18: Canford Manor, general view of south side of the house today, with the Nineveh Porch at right (photo: author)

19: Canford Manor, general view of the south side of the house (Barry 1867, following p. 136)

20: Canford Manor, plan of the house with the Nineveh Porch at right (adapted by the author from Barry 1867, following p. 136)

Generally speaking I like them very much indeed, but I fear the alterations will be very costly. If executed I am sure they will be a very great improvement on the present state of the house and grounds, but I do not know whether the expense may not be greater than we are justified in incurring."[6] Barry's plan expanded the house to the north from Blore's southern rank of rooms, adding a great hall, grand staircase, entrance gallery, porch tower, and service courtyard (figs. 18, 19, 20). An extensive set of these plans, dated 7 April 1848 and signed by Charles Barry, is preserved in the Dorset County Record office in Dorchester.[7]

A week later, Lady Charlotte's fears about expense were realized: "Barry was with us this afternoon and we went over the subject of the plans a little more in detail with him. He says the expense will be about £14,000, which is more than I hoped."[8] Though Lady Charlotte approved the plans, she continued to have doubts about the cost. In mid-June she visited the Houses of Parliament with Barry: "It was a very great treat; we all enjoyed it much, and were greatly interested in his explanations and elucidations. Merthyr joined us at the House, and afterwards went with me and G. Clark to Mr. Barry's to go with him a little into the Canford estimates. I do not think the financial part of the business was very satisfactory. But the plans are beautiful."[9]

The construction was carried out by the well-known builder Thomas Cubitt. Work dragged on throughout 1848 and into 1849, with the house uninhabitable and the costs rising dramatically. In February 1849 the Guests visited Canford, staying in the local inn since the house was still under construction. Lady Charlotte

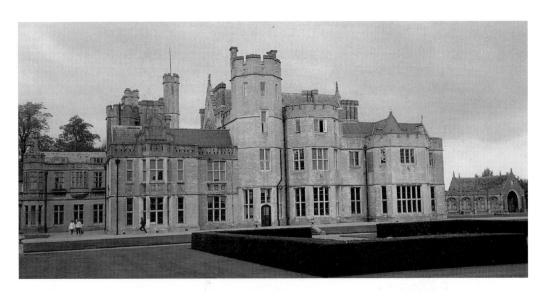

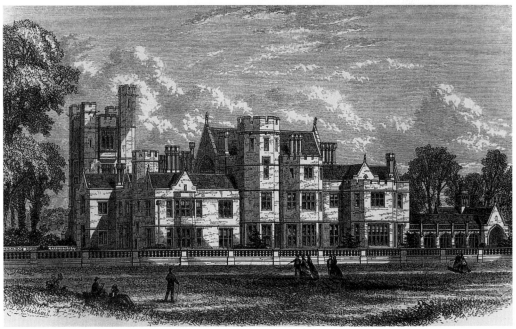

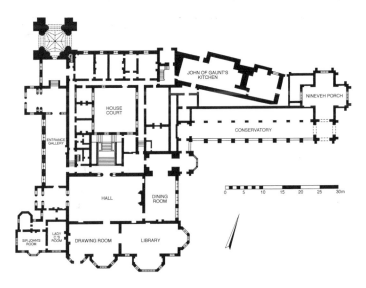

ENTRANCE GALLERY

HOUSE COURT

JOHN OF GAUNT'S KITCHEN

NINEVEH PORCH

CONSERVATORY

HALL

DINING ROOM

SIR JOHN'S ROOM

LADY C'S ROOM

DRAWING ROOM

LIBRARY

0 5 10 15 20 25 30m

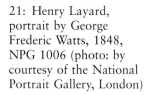

21: Henry Layard, portrait by George Frederic Watts, 1848, NPG 1006 (photo: by courtesy of the National Portrait Gallery, London)

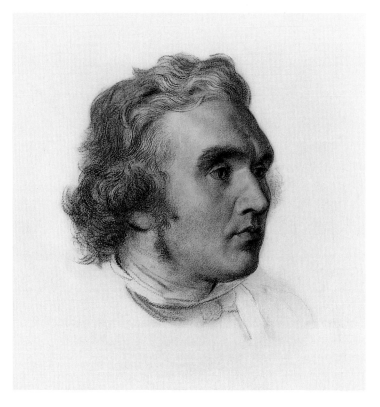

lamented that Sir John, whose health was suffering, seemed uninterested in the progress of the work: "He feels . . . bitterly the expense which he has been almost unconsciously led into, and although it is no inconvenience to him, he doubts whether so large a sum, which would otherwise have been put by for the children, ought to be spent in bricks and mortar."[10]

In mid-May Lady Charlotte wrote: "Merthyr made an offer of a sum of £30,000 for Cubitt to execute the whole of Mr. Barry's drawings and plans from beginning to end, including what has already been done." The next day she reported that Cubitt had "conceded to the terms Merthyr offered yesterday, so it will all proceed forthwith. It is a heavy outlay, but it will be a noble work when done."[11] By July the Guests were buying pictures for Canford and at the end of the month the family and household were able to move into the house for the summer and fall.[12] Work continued for another year, however. Only in July 1850 did Lady Charlotte report that the workers were finally out of the house.[13] The first large party in the renovated house, 140 to dinner on the occasion of the annual Agricultural Show, was on 22 October 1850.[14]

In fact, though Lady Charlotte devoted less space in her diary to Canford improvements after 1850, it is clear both from her diary and from Barry's papers in the collections of the Royal Institute of British Architects that Barry continued to work on various projects there until Lady Charlotte left Canford in 1856.[15] Examples of the type of work still going on a year later are given in two letters in the Barry archive from late September 1851, which deal with decorative details for

the house. The first concerns the glass screen doors for the entrance gallery and the second reports: "The cost of carving 4 gargoyles & two shields with the arms of Bertie & Guest on them would be Seven Pounds (7£)."[16] Barry was still very much on the scene, therefore, when in the following month Lady Charlotte persuaded Sir John to build a garden pavilion for the Assyrian sculptures that had been sent to them by Henry Layard. But I am getting ahead of my story.

HENRY LAYARD

In early November 1845, a 28-year-old adventurer, Henry Austen Layard (fig. 21)—supported by a private grant of £100 from Stratford Canning, the British ambassador to the Ottoman Empire—began to uncover the ruins of the ancient Assyrian capital city Kalhu near the village of Nimrud, some 35 km south of Mosul. His most notable discovery there was the remains of the palace of king Assurnasirpal II (883–859 BC; see fig. 5). There he found sculptured and inscribed stone slabs, human-headed winged bull and lion colossi, and small objects of ivory and bronze. The Frenchman Paul Émil Botta had made similar discoveries in 1843 at Khorsabad (ancient Dur Sharrukin), the capital of the Assyrian king Sargon II (721–705 BC), some 20 km northeast of Mosul.[17] Layard's finds were the first such to be made by an Englishman, however, and Canning, anxious that the work continue unhindered, secured from the Grand Vizier of the Ottoman Sultan a letter that gave Layard very free rein:

There are . . . in the vicinity of Mosul quantities of stones and ancient remains. There is an English gentleman who has come to those parts to look for stones of this kind, and has found on the banks of the Tigris, in certain uninhabited places, ancient stones on which there are pictures and inscriptions. The British Ambassador has asked that there shall be no obstacles put in the way of the above-mentioned gentleman taking the stones which may be useful to him, . . . nor of his embarking them to have them transported to England. The sincere friendship which firmly exists between the two governments makes it desirable that such demands be accepted. Therefore no obstacle should be put in the way of his taking the stones which . . . are present in desert places, and are not being utilized; or of his undertaking excavations in uninhabited places where this can be done without inconvenience to anyone; or of his taking such stones as he may wish amongst those which he has been able to discover.[18]

In Canning's words, the letter gave Layard authority "to excavate and export to your heart's content."[19] As far as the Grand Vizier was concerned, any "stone" not currently being utilized was of no importance to the Ottoman empire.

The historical interest of the objects and inscriptions, combined with national rivalry with the French, prompted the Trustees of the British Museum to provide Layard with £2000 in September 1846 to enable him to continue the work and to transport representative objects to the British Museum. Layard dispatched several shipments of objects, including one bull and one lion colossus, which he managed to remove and ship intact just before he quit Nimrud in April 1847. In May and June he shifted his attentions to Kuyunjik, a large mound across the Tigris from Mosul, which proved to be ancient Nineveh. There he discovered the remains of

22: Layard's first plan of the Southwest Palace, Nineveh
(Layard 1849a, II, facing p. 124)

the palace of Sennacherib (704–681 BC), the largest known Assyrian palace, where he also excavated wall reliefs and colossi (fig. 22).

At the end of June 1847, having exhausted his funds and his health, Layard departed for England. In the same month, his first shipment of Assyrian sculptures—eleven wall reliefs and a colossal head—arrived at the British Museum and was put on temporary display with other miscellaneous antiquities in the hallway to the left of the main entrance, now the bookshop. Their arrival marks the beginning of what might be called the first phase of the English reception of Assyria, which lasted until the publication of Layard's *Nineveh and Its Remains* at the end of 1848. Compared to what would follow, this phase was relatively low-key: the public gradually became aware of Layard's finds, either by searching them out in the British Museum, which had some 900,000 visitors in 1848, or through occasional reports in the press.[20]

Five sculptures from this first shipment were reproduced in a two-page article in the *Illustrated London News*, the most popular news magazine of the day, with a weekly circulation of nearly 70,000. The accompanying text asserted that Layard's

finds excite "the curiosity not only of the antiquarian but of all scriptural students, for the illustration which they afford of passages in Holy Writ." As Bohrer observed, "all scriptural students" meant every thoughtful person.[21] The article thereby displaced the sculptures from the elite, classically oriented realm of the antiquarian—where they fared poorly because they did not conform to classical aesthetic norms—to the universally shared realm of Christian "curiosity."

Layard himself had a very high opinion of Ninevite art, which he first expressed in an article in the *Athenaeum* in 1845 that reported on Botta's finds at Khorsabad:

[The Assyrian sculptures] are immeasurably superior to the stiff and ill-proportioned figures of the monuments of the Pharaohs. They discover a knowledge of the anatomy of the human frame, a remarkable perception of character, and wonderful spirit in the outlines and general execution. In fact, the great gulf which separates barbarian from civilized art has been passed.[22]

Or in reference to his own finds in a letter to his mother in 1846 from Nimrud:

[The Assyrians'] knowledge of the Arts is surprising, and greatly superior to that of any contemporary nation. . . . The lions lastly discovered, for instance, are admirably drawn, and the muscles, bones, and veins quite true to nature, and portrayed with great spirit. There is also a great *mouvement*—as the French term it—in the attitude of the animal, and "sa pose est parfaite"; excuse the phrase; we have no equivalent.[23]

Layard's opinion was not widely shared at first. The traditional aesthetic view was expressed by the British consul in Baghdad, Henry C. Rawlinson, the most important figure in the decipherment of cuneiform and one of Layard's earliest official supporters, who wrote to Layard in 1846:

I still think the Nineveh marbles are not valuable as works of art. . . . Can a mere admirer of the beautiful view them with pleasure? Certainly not, and in this respect they are in the same category with the paintings and sculptures of Egypt and India. . . . I admit a certain degree of excellence in the conception and execution of some of the sculptures, but when we come to value, *a certain degree* won't do. We have specimens of the very highest art— and anything short of that is, as a work of art . . . valueless, for it can neither instruct nor enrapture us. I hope you understand this distinction and when I criticise design and execution, will understand I do so merely because your winged God is not the Apollo Belvedere.[24]

Seven years later, in July 1853, Sir Richard Westmacott, Professor of Sculpture at the Royal Academy and Sculpture Advisor to the British Museum Trustees, expressed a remarkably similar opinion upon being questioned by a Parliamentary committee about the marbles on display in the British Museum:

Question: "Are the Elgin marbles as much the subject of interest and admiration now as they were in former years?"
Westmacott: "With all persons conversant with art they must be and will be always, because they are the finest things in the world; we shall never see anything like them again."
Question: "Do you think there is no fear that by introducing freely into the institution objects of more occasional and peculiar interest, such for instance as the sculptures from Nineveh, may deteriorate the public taste, and less incline them than they otherwise would be to study works of great antiquity and great art?"
Westmacott: "The Nineveh marbles are very curious, and it is very desirable to possess

them, but I look upon it that the value of the Nineveh Marbles will be the history that their inscriptions, if ever they are translated, will produce; because if we had one-tenth part of what we have of Nineveh art, it would be quite enough as specimens of the arts of the Chaldeans, for it is very bad art . . . ; but as monuments of a period eight hundred years before Christ, they are very curious things."

Question: "Do you think that as many persons attend and take an interest in the Elgin Marbles, when they are side by side with the Nineveh sculptures, as would take an interest in them if the Elgin Marbles were alone?"

Westmacott: "No; persons would look at the Nineveh Marbles and be thinking of their Bible at the time they were looking at them; they would consider them as very curious monuments of an age they feel highly interested in; but the interest in the Elgin Marbles arises from a distinct cause; from their excellence as works of art."

Question: You would not therefore fear that any corruption of the public taste would ensue from the juxtaposition of such works as the Elgin Marbles and such works as the sculptures from Nineveh?"

Westmacott: "No, I think not; I do not think that any consideration of the sculptures of Nineveh would affect a man who looked at the Elgin Marbles."[25]

Westmacott's assessment of Ninevite art as "curious," a pointedly nonaesthetic evaluation, seems to have been the only type of response available to a connoisseur of traditional art for whom the Elgin Marbles were "the finest things in the world."

Viewed in this context, the report on Layard's speech to the French Académie des Inscriptions et Belles Lettres when he passed through Paris in December 1847 on his way home from Nineveh is particularly astonishing: "The lions and horses [in the Nimrud reliefs] are remarkable for beauty: the horses faithfully exhibit the admirable type of the purest Arabian breed, and may, with advantage, be compared with the most beautiful models left by Greek antiquity, without excepting even the horses of the Parthenon."[26] This was followed by a bracketed question mark [?] in the German version of this report, added by an editor who evidently couldn't quite believe he'd understood correctly! It is not clear whether Layard himself made such remarks or whether they are the opinion of the French author of the report. In any event, Layard is not associated with such extreme remarks after he was back in England; he was surely aware that a British audience would consider such comments an affront both to British pride, as possessors of the Elgin Marbles, and British aesthetics.

Whether or not they admired the Assyrian sculptures, however, the officers and Trustees of the British Museum recognized that these works constituted a crucial link in what was conceived of as the chain of art, that is, the linked succession of styles that led to the supreme accomplishment of the Elgin Marbles. In 1850, Sidney Smirke, architect of the British Museum, argued on the basis of comparison between Assyrian and Greek ornament that Assyria, not Egypt, was the true precursor of Greek art, and a year later Charles Newton, a staff member in the Antiquities Department, praised the museum's Egyptian and Assyrian sculpture collections "for the illustration of that primeval period in the history of art which precedes, as it is believed, the earliest productions of Greek civilization, and reveals thus two distinct sources from which that civilization may have been derived."[27] In other words, the historical importance of Assyrian art was not really in doubt, but rather its aes-

thetic merit as art and its relationship to Greek art, namely whether it influenced the formation of Greek art or merely preceded it.

Even Westmacott acknowledged the religious interest of the Assyrian sculptures, and it was this, not beauty, that was the initial basis for their popular appeal. English society at this time was characterized by strong religious conservatism. In scholarly circles, the Bible was generally considered to be an infallible source of historical information. Bishop James Ussher's chronology, which placed the creation of the world around 4000 BC, was accepted as fact.[28] All students at the universities of Oxford and Cambridge were required to sign the 39 articles of Anglican doctrine upon matriculation. Heinrich Heine, who represented the more liberal Continental tradition, observed in 1830 that even the stupidest Englishman can say wise things about politics, but even the wisest Englishman will say the stupidest things about religion.[29] Layard's finds were not valued as proof of the Bible—the Bible did not require proof. Rather, they were seen as literal illustrations of known biblical facts. Layard's finds were "curious" because they were a bridge to the biblical past, illuminating obscure passages with the authority of contemporary eyewitnesses.

Layard was skilled at exploiting this curiosity. In mid-1845, prior to making his own discoveries at Nimrud, he had written an article in the *Penny Magazine* which claimed that Botta's finds at Khorsabad "singularly accord with a description in the twenty-third chapter of Ezekiel."[30] Following his return from Nimrud, Layard developed this idea much more fully in *Nineveh and Its Remains*, where he cited numerous biblical parallels to his finds. He drew attention especially to parallels with Ezekiel 1:10, which describes winged figures with the features of a man, a lion, an ox, and an eagle, and Ezekiel 23:14–15, which describes images on the wall of an Assyrian palace.[31] He stressed these same parallels in conversation with friends and patrons.

The Monuments of Nineveh

In early December 1847 Layard arrived back in England, having stopped briefly in Italy and Paris along the way. He reported on his trip home to Henry J. Ross, whom he had left in charge of the excavations at Nineveh: "At Paris the savants were immensely civil and treated me with great honor. I am to be elected a corresponding member of the Institute. Botta was exceedingly kind and attentive—his work on Khorsabad is splendid, but the 'Museum of Nineveh' in the Louvre, with the exception of the two Bulls (which have been admirably restored) and the two giants strangling the Lions, most miserable. I had no idea it was so poor—we shall beat them hollow."[32] In November 1848 another shipment of reliefs and other objects reached London, including the so-called "Black Obelisk" of king Shalmaneser III (858–824 BC; fig. 23). The bull and lion, however, the most eagerly awaited of the Assyrian antiquities, were long delayed and did not arrive until October 1850, by which time Layard was back at Nineveh.

Because of his limited funds and a shortage of exhibition space in the British Museum, Layard was able to send only a small fraction of his finds of 1845–47 to

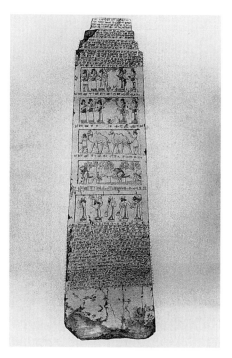

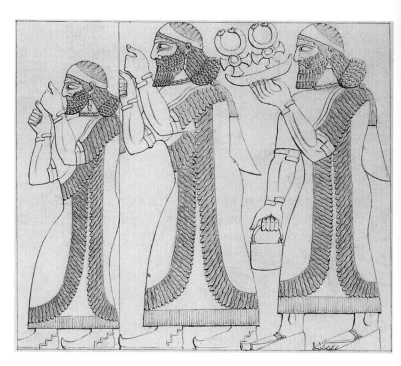

23: Nimrud, the "Black Obelisk" of Shalmaneser III, front side (Layard, *Monuments of Nineveh*, 1849, pl. 53)

24: Nimrud, Northwest Palace, Room E, Slabs 3–4, drawing by Layard; British Museum, Western Asiatic Antiquities, Original Drawings, vol. III, no. NW 37 (photo: Trustees of the British Museum)

England. Much of the remainder he recorded in several hundred drawings of the sculptures (fig. 24) and a thick notebook of copies of inscriptions. Canning had encouraged Layard in this pursuit. In April 1846, as Canning prepared to depart Constantinople for home leave in London, he urged Layard to send him some drawings, "the more drawings the better, as they strike the eye and interest folks in England." And in May he asked Layard to send "more drawings and a few copies of inscriptions, and anything else which may enable me to inspire into others the interest which we ourselves take in this enterprise."[33] For Canning, Layard's drawings were tools to be used in the promotion of the excavation back home, a promotion effort that succeeded in enlisting the sponsorship of the British Museum. As we will see, he showed the drawings in other, more private quarters as well.

Layard's drawings of this unfamiliar material aroused considerable interest. Referring to the stop in Italy on his trip home, he wrote to Ross: "All those who have seen my drawings in Italy are very much astonished. They cannot make them out."[34] The results of Botta's excavations, as Layard would have discovered when he passed through Paris, were being published at government expense in five folio volumes: two devoted to drawings, two to inscriptions, and one to a description of the finds.[35] Layard was anxious that his drawings be published too, as well as his copies of cuneiform inscriptions and a narrative account of his discoveries. In December 1847, just after his return to England, he wrote to Ross: "The officers

of the Museum will ask for funds for the publication of my drawings and inscriptions—but all is uncertain. The first batch of Nimroud things are placed temporarily in the Museum, but in so bad a position that they cannot be seen. I am told that a wing will be built expressly for my Antiquities. My drawings have surprised people much."[36]

As it turned out, only the inscriptions were actually published by the Museum. This volume, *Inscriptions in the Cuneiform Character from Assyrian Monuments, Discovered by A. H. Layard* (1851a), was edited from Layard's copies by Edward Hawkins, Keeper of the Department of Antiquities of the British Museum, and prepared for publication by Layard, Samuel Birch, who was Hawkins's assistant, and Henry C. Rawlinson. The publication of the inscriptions volume must have been in large part due to Rawlinson's official influence. Layard's references in his letters to this volume are brief but optimistic. "I have had a capital type cut for the inscriptions," he wrote in May 1848, and two months later: "The Inscriptions for the British Museum are getting on."[37] The volume did not finally appear until 1851, when Layard was back in Mesopotamia.

The Museum was less receptive to Layard's drawings of the sculptures, which would be so expensive to publish that a substantial subsidy would be required from the Treasury. The drawings also lacked a strong advocate with government connections, such as Rawlinson had been for the inscriptions. As Rawlinson wrote to Layard, "I regard inscriptions as of infinitely greater value than sculptures—the latter may please virtuosi—they have no doubt a certain degree of intrinsic interest but the tablets are bona fide histories and very shortly I feel perfectly certain they will be completely intelligible."[38] Furthermore, as we have seen, the Assyrian sculptures, and in consequence the publication of the drawings, might not appeal to classically oriented connoisseurs.

Bohrer has fully documented the course of the deliberations by the Trustees of the British Museum concerning the publication of Layard's drawings.[39] To summarize, on 8 January 1848, Edward Hawkins, Keeper of the Department of Antiquities, presented the Trustees with a proposal from the publisher Smith, Elder & Co. to publish the drawings in 200 folio plates, produced in the least expensive form—outline engravings with a minimum of explanatory text—at an estimated printing cost of £2400. On 22 January a subcommittee of the Trustees resolved to accept this plan and further resolved to apply to the Treasury for a grant of £4000 to proceed. On 19 February the Trustees announced that this grant had been denied, and Museum involvement with the project then ceased. On 25 February Smith, Elder & Co. wrote directly to Layard to propose a more modest publication: a selection of the drawings in 100 folio plates, the printing costs to be offset by a personal grant from Layard for £300–£400 and the total profits from the narrative account of his discoveries. As Layard wrote to Ross:

The state of the finances and the events occuring on the Continent [bloody riots in Paris and the abdication of Louis Philippe] have driven Nineveh and all other antiquities out of people's heads. The recommendation of the Trustees that £1000 [*sic*] should be given by the Government for the publication of my drawings, which would have been attended to at any other period, has been rejected and I am inclined to think that nothing will be done.

25: Sculptures and inscriptions from Persepolis
(Ouseley 1821, II, pl. 46)

I am now trying to see what may be done in the way of subscriptions and personal sacri-
fices but my stay in England is so limited that I don't expect I shall be able to settle
anything.[40]

But by then, other schemes were taking shape.

Four days before the British Museum Trustees abandoned the publication
of the drawings, Lady Charlotte, who was in London at the time, wrote in her
diary: "I received a visit from . . . Henry Layard, the Eastern explorer."[41] She had
known of her cousin's discoveries for some time—somewhat over a year previously,
in December 1846, Canning had shown her Layard's drawings, possibly in an effort
to raise funds. She reported:

Sir Stratford and Ly. Canning added to the party to-day. She shewed me drawings of antiq-
uities found by Henry Layard at Nineveh. They are curious, but chiefly repetitious of those
engraved in Sir W. Ouseley's Travels, as discovered at Persepolis [fig. 25]. Sir Stratford had
taken the young man by the hand and befriended him extremely. He had now obtained him
a grant of £2,000 from the Government to excavate and bring away some of these antiq-
uities for the British Museum. He is my Uncle Henry's son.[42]

Though the tone of these diary entries makes it clear that Lady Charlotte was
not in close touch with her cousin, she apparently invited Layard, who was still
recovering from his eastern illness, down to Canford. On 2 March she wrote:

"Henry Layard (the Ninevite) arrived . . . In the evening, [he] shewed . . . some of his drawings but he seemed so ill that he could hardly give any explanation of them." Her interest increased rapidly. The following day she wrote: "I went to the library in all gravity and composure, and spent the morning looking over drawings done by Henry Layard in Nineveh, very curious and interesting indeed." And the next day: "I joined the whole party assembled in the Library. . . . Henry Layard opened the proceedings by giving us a general view of art, as far as could be made out from the commencement of building to the time of the Saracens. . . . I meanwhile copied some of the Ninevite drawings." By 5 March, Lady Charlotte seems to have decided to assist Layard with the publication of the drawings: "There is a good deal going on in the house which is very diverting . . . [including] a prospectus to be propounded for the publication of Henry Layard's Ninevite drawings. . . . I did not go to church this afternoon, but sat over the drawing room fire talking with Henry Layard about his publishing prospects."[43]

It may seem surprising that Lady Charlotte, who before 2 March had evidenced no particular interest in Henry Layard's affairs, had within three days decided to help him publish the drawings that she had previously dismissed as merely repetitions of Persepolis. There were a number of factors, however, that may have predisposed her in favor of Layard's petition. Presumably the fact that they were first cousins—Layard's father was the brother of Charlotte's mother—partially accounts for her interest. Beyond that, she had a long-standing interest in the East. This was evidenced particularly by her interest in Persian, the language that had proven to be the key to Rawlinson's decipherment of cuneiform. While a teenager, she had studied Persian and Arabic on her own at home. In London she met Sir Gore Ouseley, the elderly Persian scholar and former ambassador to Persia, who encouraged her interest by sharing books and manuscripts with her and telling her of the East.[44] In 1834, not long after her marriage, Lady Charlotte reported that Ouseley paid her a long and "very amusing" visit: "He gave me quite a lesson in Persian pronunciation. He says the Persians have no sound 'a', that therefore, when the Persian Ambassador spoke of his Caucasian slave girl, he always called her his 'sleeve'."[45] She studied the language with sufficient seriousness that later that year, shortly after the birth of her first child, she was able to write: "The report of the Oriental [Translations] Committee came down to-day. It contains some very civil speeches on my becoming a member. But alas for Persian now! Baby leaves but little time for anything, and that time must be spent on Welsh."[46]

In addition, as a devout Christian, she was struck by the parallels between the Bible and the drawings. Shortly after Layard's arrival at Canford, she wrote: "We had a dull evening. I tried to find spirits for everybody but failed, and I tried to interest them in some of H. Layard's illustrations of Ezekiel, from his discoveries, but all were tired or thoughtful." In her diary, she occasionally remarks on these biblical parallels: When she invited Layard to address the 500 "most intelligent" workmen, clergymen, and teachers at Dowlais, she reported that he spoke "of his discoveries with many allusions to the corroborations of the Holy Scriptures." On another occasion, she hosted a soirée for workers at the Dowlais ironworks: "The

chief amusements of the evening in addition to drawings, plans, fossils &c. as heretofore were, the microscope, and one of the Ninevite marbles which I had brought from Canford for the occasion. With this last they were really pleased, the more religious portion of the company especially."[47]

Another factor must have been the exciting character of Layard's Eastern adventures and his skill at relating them. He found the atmosphere at Canford conducive to writing: "This mild Dorsetshire air does me good and enables me to write."[48] He apparently completed his "Eastern Journal" (as he referred to the narrative account of his excavations) while at Canford and tried parts of it out on the Canford audience: "We spent this morning as we had done its predecessor. H. Layard began reading us passages from his Eastern Journal."[49] And the following day: "Mr. Layard amused us by reading to us while we worked or drew."[50] This was published the following year as *Nineveh and Its Remains* and became an immediate bestseller. Layard was a great storyteller. Lady Charlotte often mentions how much her children loved to listen to him: "When service was over we started a large party to walk. . . . The children clustered round Henry Layard and got him to tell them stories about the East."[51]

Still another factor was that her acquaintance with Layard gave Lady Charlotte ground-floor access to the Nineveh discoveries, which had begun to command a considerable amount of attention with the English press and public. Layard regularly gave her personal viewings of the antiquities as they arrived in London. In March 1848 she wrote: "Went early with Merthyr, Henry Layard and Maria to the British Museum. . . . We had a delightful morning, and are greatly interested in seeing the sculptures Henry has brought from Nineveh. Some minute ivory carvings he found there of a more recent date than the sculptures, but very old, were great objects of admiration." And in November of the same year, a few days after another shipment arrived: "Merthyr went with me and Hy. Layard to see the marbles which had lately reached the Museum. Hy. was very eloquent about his black obelisk, which really is a most curious beautiful thing and quite unique as a specimen of Assyrian art" (see fig. 23).[52]

As a celebrity, Layard was also an interesting treasure to be shown off in society: "On reaching town I found . . . an invitation for Lady Palmerston's. I had to write for leave to take Henry there. . . . Ly. Palmerston's was one of her gayest pleasantest parties. I quite enjoyed it for it is long since I have been in Society."[53] And: "Henry Layard . . . accompanied Merthyr to the Levée which was a very full one."[54]

Another factor may well have been Layard's considerable social grace, to which Lady Charlotte frequently alludes: "After tea we acted Charades, at which Henry Layard was very clever indeed. Some of them were very good."[55] He regularly participated in musical evenings: "Music in the evening, Mozart. H. Layard accompanying me on the flute."[56] In late April she began going for afternoon drives with him, accompanied only by one of the children.[57] Layard wrote approvingly of Lady Charlotte as well:

I have been spending a few days with my relations in different parts of England and am now with Lady Charlotte Guest at Canford—a fine old mansion in Dorsetshire. These comfortable places and the pleasures of English country life spoil one for the adventures and

privations of the East. I find a great improvement in the upper classes—much more information, liberality of opinion and kindness towards those beneath them. I think that on the whole things are much better than could be expected.[58]

Neither Lady Charlotte nor Layard ever indicated in their writings that their feelings for one another ran deeper than friendship and mutual admiration. By the end of April 1848, however, Sir John was growing suspicious. The last Sunday in April, Lady Charlotte stayed home from church in the afternoon:

At church in the morning. I had some writing to do and moreover I did not feel very well so I did not go a second time. I had looked forward to a pleasant ramble when the rest returned. But how was I doomed to be disappointed! Alas in one hour how much sorrow was precipitated. In the innocence of my heart how little could I have anticipated these cruel, unjust suspicions. It was as though a thunderbolt had fallen at my feet. All that I suffered in those two hours no one can guess, and though now the wound has seamed over I feel that it can never be effaced. But it was too extravagant, for the moment it really seemed a sort of frenzy. In the midst of all this wretchedness Merthyr insisted on my walking out [i.e. taking a family walk].[59]

Though Layard is not mentioned by name, he was there and would seem to be the only possible source of this unpleasantness. Over the next few days Lady Charlotte notes that she is still miserable and Layard left Canford at the end of the week. Presumably she did her best to make Sir John feel miserable also, for within the week she was able to turn the episode to her advantage and gain an important concession from Sir John, which raises another factor.

A final reason that helps to explain Lady Charlotte's receptivity to Layard's cause is that at the beginning of 1848 she was at a loose end. Lady Charlotte was most happy when closely involved with events going on around her, and she particularly enjoyed furthering the "prospects" of those she considered to be deserving. Layard was clearly deserving. Several years later, when Sir John was suffering from his final illness, she wrote: "Henry Layard and I had a long walk on the Terrace—Talking of all sorts of plans and prospects—I think he looks forward (though very modestly) to a brilliant future—and I trust his hopes and aspirations for usefulness and good may be realized—Dark as my own prospect is, how pleasant it is to have an interest in others' successes."[60]

One week before Layard first called on Lady Charlotte in London, she and Sir John had a disagreement over Canford improvements. She noted in her diary that she was recovering from a bad cold and was therefore already in low spirits; then: "In the afternoon it was fine and very mild. I walked with Merthyr to the brickyard and had a promise that some trees for which I interceded in a piece of land being set out anew, should be spared."[61] The next day, however:

We came back by the highroad, passing the brickyard. The trees for which I had interceded were cut down. I have interfered too much. I am to do so no more. Another source of interest is cut off and now even Canford is to be to me a dead letter. Merthyr I know will do better without any intervention, of mine. He has a true and enlightened spirit of improvement, and I have fond, narrowminded, romantic prejudices. So it is best that I should not meddle. But somehow it seems hard to be led into one pursuit after another, and then find them vanish from before me. I sit now a great deal upstairs.[62]

Things were no better after Layard's arrival at Canford. In mid-March she took a long afternoon walk with Sir John: "It had been a pleasant walk, but so many subjects are forbidden. Everything indeed that has reference to arrangements and improvements at Canford which would seem like interference, that there was much heaviness of heart attending it."[63]

That changed after Sir John gave vent to his "cruel, unjust suspicions." Apparently realizing that Lady Charlotte was determined to meddle, and possibly thinking that her interference in Canford affairs was preferable to a deeper involvement with this young adventurer, he relented. The day Layard departed, Lady Charlotte wrote: "Henry Layard left us. Merthyr had expressed a great desire that I should forget all that was passed, all the [*illegible*] of Febry. and the events of the last week, and once more take an interest in things around me."[64]

Whatever the reasons for Lady Charlotte's interest in Layard's drawings, during the period in which she had been forbidden to interfere with Canford she worked to get the drawings published. By mid-March 1848 Layard had written to Smith, Elder & Co., rejecting their offer because of his "friends' wishes that Mr. [John] Murray should undertake the publication" of the drawings.[65] Towards the end of March, while in London, she wrote: "In the evening . . . Henry and G. Clark came in. Henry had sent me two more portfolios of drawings to look over."[66] In late March or early April Layard's uncle, Benjamin Austen, wrote to Hawkins of the British Museum:

My nephew is coming to town tomorrow & will be with me at Montague Place at 1/2 past 3 with some of his friends in the country who are very crazy about starting the publications of the drawings. He thinks his cousin Lord Lyndsey & Lady Charlotte Guest will do it. Could you without inconvenience meet them at my house as I should like them to have your opinion.[67]

On 7 April, the same day Barry presented the Guests with the plans of his proposed renovations at Canford, Lady Charlotte reported: "Henry Layard came, accompanied by Mr. Murray the publisher. I had promised to see him about publishing the drawings Henry had made at Nineveh. Murray has undertaken his Journal with illustrations. But all his friends are anxious that facsimiles of about 250 beautiful drawings he made on the spot should appear also. I am to hear more of it again."[68] Apparently Murray was convinced, for a week later, the same day that Barry met with the Guests to discuss the estimated cost of the Canford improvements, she noted: "Murray has agreed to publish Henry's drawings in the manner I suggested on the 7th, so that interview was productive of good."[69] The exact nature of the understanding between Lady Charlotte and Murray is uncertain. According to Bohrer, Murray's account books record no payment from Lady Charlotte, but she apparently agreed to recruit subscribers.[70]

Three successive versions of Murray's prospectus for this volume, entitled *The Monuments of Nineveh*, are preserved in the Layard Papers. None is dated, but their sequence is clear from the number of subscribers listed, which increases from 34 in the first to 58 in the second to 63 in the third. According to Murray's account books, 600 copies of the prospectus were printed by 30 June 1848, and this pre-

26: Layard, *Monuments of Nineveh*, 1849, title page

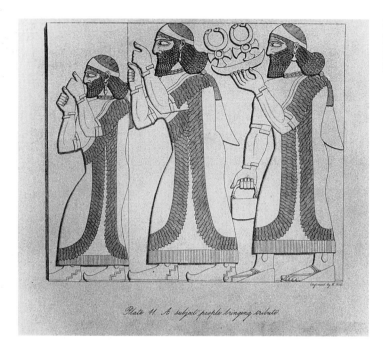

27: Nimrud, Northwest Palace, Room E, Slabs 3–4 (Layard, *Monuments of Nineveh*, 1849, plate 41)

Plate 41. A subject people bringing tribute.

sumably refers to the earliest version.[71] Though Lady Charlotte apparently hoped that all 250 of Layard's drawings would be included, as in the British Museum plan, the book described in the prospectus, and actually published, is essentially the version proposed by Smith, Elder & Co., namely a selection of only 100 folio plates, most of which were rendered in simple outline. Since the prospectus not only makes it clear how the book was marketed but also gives some sense of the level of Lady Charlotte's involvement, and since it is not published elsewhere, its full text is reproduced here as Appendix 1.

The most significant feature of the first version of the prospectus, at least for our purposes, is the list of 34 subscribers, which includes a fair selection of Lady Charlotte's friends and relations. In addition to a proof copy for Sir John and a plain one for herself, the list includes the Earl of Lindsey, her brother; the Earl of Aboyne, her brother-in-law; the Rev. William Pegus, her stepfather; the Bishop of Peterborough, a family friend; Lord de Mauley, the former owner of Canford; H. C. Sturt, owner of an estate near Canford; and the Marquis of Exeter, who was presumably added to the list following dinner at the Guests' on 15 June 1848: "Our dinner part were Ld. and Ly. Exeter, Ld. and Ly. Westminster, Ld. and Ly. Zetland, Ld. and Ly. Leicester, Ly. Chtte. Egerton, Mr. Talbot, Hy. Layard, and Bertie [the Earl of Lindsey]. It went off well. After dinner we looked over some of Henry's drawings, which filled up the time till the musick began."[72]

Other subscribers not named in her diary may have been introduced to the drawings in this way, as Lady Charlotte seems to have taken advantage of every opportunity to show them off. At Canford, "Mr. Hunt and Mr. Bridgeman Simpson breakfasted here to see H. Layard's drawings with which they were delighted." In London, "At four Miss Williams came to see Henry Layard's drawings . . . [at

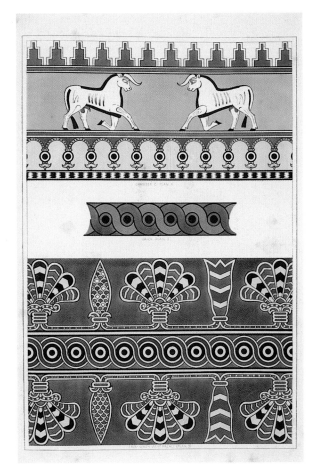

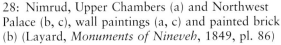

28: Nimrud, Upper Chambers (a) and Northwest Palace (b, c), wall paintings (a, c) and painted brick (b) (Layard, *Monuments of Nineveh*, 1849, pl. 86)

29: Nimrud, Upper Chambers, wall paintings (a, c, e), and Northwest Palace, painted bricks (b, d) (Layard, *Monuments of Nineveh*, 1849, pl. 87)

dinner] Barry was interested also in seeing Henry's drawings." At Dowlais, "Henry Layard's drawings have caused quite a sensation here. Last night they were the great source of amusement for the whole evening. Today they have been sent over for poor Mrs. Waddington's inspection."[73]

The initial prospectus seems to have served its purpose. By the time the second version was printed, probably about a month later, there were 58 subscribers and a total of 99 copies subscribed, including 40 for the East India Company.[74] Toward the end of July, Layard was able to report: "My big book is progressing. I have now about one hundred subscribers—the East India Company very liberally taking 40 copies, (100 guineas)."[75] And by the following February, to his friend George Clark, also a close friend of Lady Charlotte: "The subscription list for the large work too, has increased to 170. I think, this will consequently pay and I am released from all uneasiness."[76] *Monuments of Nineveh* was printed in March 1849 and

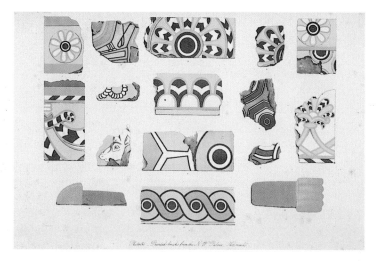

30: Nimrud, Northwest Palace, painted bricks and a clay fist (Layard, *Monuments of Nineveh*, 1849, pl. 84)

31: Assyrian Designs (Jones, *Grammar of Ornament*, 1856, pl. 12)

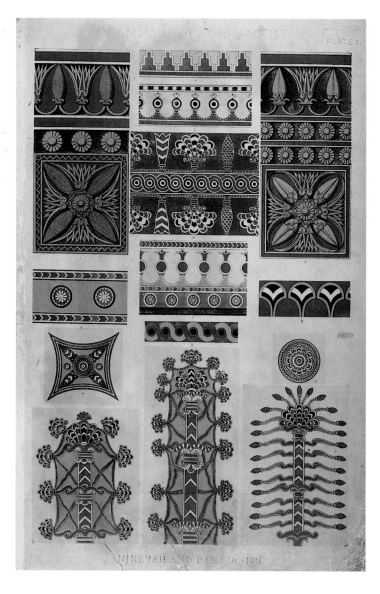

sold nearly 300 copies that year, a remarkable figure for an expensive elephant folio (fig. 26).[77] Early in 1850, Layard wrote to Clark from Mosul: "Even the Folio has paid and well I may say. I cannot express my gratitude to yourself and Lady Charlotte. Had it not been for you I should probably have left England as I left it in many respects."[78]

Monuments of Nineveh had an impact comparable to that of the Assyrian reliefs themselves, though its sphere of influence was smaller. Together with Botta and Flandin's *Monument de Ninive*, which appeared in the same year, it provided high-quality illustrations of an entirely new style of art. Most of its plates were devoted to drawings of Assyrian reliefs (fig. 27). These served as a reference tool for the Nimrud reliefs, many of which could be seen in the British Museum, and as valuable records of the Nineveh reliefs, only a few small fragments of which were brought to England. The most influential part of the book, however, was the color plates, lithographed by the printer Ludwig Gruner. These illustrated the decorative patterns of Assyrian wall paintings, none of which were physically brought to England, and painted bricks, which had tended to fade after exposure to light (figs. 28, 29, 30). Only in the book, therefore, was it possible to appreciate fully the variety and colorful impact of Assyrian design.

Unlike the Assyrian reliefs, which were never widely valued as artistic models, Assyrian patterns were easily adaptable to new contexts. The utility of these designs would soon be acknowledged by Owen Jones in his enormously influential historical dictionary of pattern, *The Grammar of Ornament* (1856), which reproduced 19 illustrations from *Monuments of Nineveh*, albeit with the caveat that in his opinion "the Assyrian was a borrowed style, possessing none of the characteristics of original inspiration, but rather appearing to have been suggested by the Art of Egypt, already in its decline, which decline [the Assyrians] carried still farther" (fig. 31).[79] The first use of Assyrian designs in a modern context, however, was in a much more private setting, at Canford.

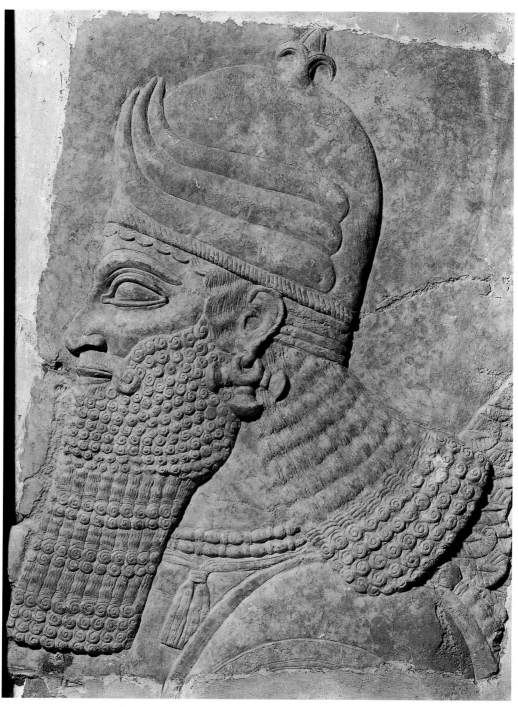

32: Lady Charlotte's "Ninevite head"; Nimrud, Northwest Palace,
Room B, fragment of Slab 22;
Cambridge, Mass., Sackler Museum, inv. no. 1940.13; 63 × 46 cm
(photo: Harvard University Art Museums)

NINEVITE MARBLES FOR
CANFORD MANOR

In October 1848, Lady Charlotte reported that at the Poole Agricultural Meeting she displayed "the Ninevite head which H. Layard had presented me with in the Spring" (fig. 32).[1] Though Lady Charlotte apparently didn't mention this gift at the time she received it, Layard presumably gave it to her in early February at the time of his first visit to Canford, perhaps as a hospitality gift. She evidently considered it to have some aesthetic merit: "The beautiful head which Henry gave me when he was here was borrowed by the Poole people on Tuesday night, when they had a lecture on Nineveh at their Institute."[2] The sculpture was described in the *Literary Gazette* as a relief fragment from Nimrud that showed "a colossal head with a pointed helmet, which has three clasping horns, and is ornamented with a fleur-de-lis (Rem. of Nin. II. 462). The eardrop is in the form of a Maltese cross. The dimensions are 2 ft. 1 in. by 1 ft. 7 in." (63.5 × 48 cm). This can readily be identified with a Nimrud relief fragment that Lady Charlotte owned but did not install in the Nineveh Porch (fig. 32).[3] This was the first, but by no means the last, Assyrian sculpture to arrive at Canford.

In late March 1848—four days after Charlotte's first trip to the British Museum with Layard to see the sculptures from Nimrud, and eleven days before the meeting with Murray—Layard wrote to Ross at Nineveh with an unusual request:

Lady Charlotte Guest, my cousin, is very anxious to have some specimens from Nimroud or from any other place they can be got without interfering with the British Museum. I have promised her to do what I can and I should feel greatly obliged if you would direct Bainan to proceed immediately to Nimroud and to employ a few men in securing the following specimens. The two priests kneeling before the sacred tree and the two eagle headed figures with the tree between them, both in the long room where the alabaster vases were found—of course you remember. The King with his attendant eunuchs—two large slabs from the hall in which the king was seated on his throne—the slabs to be moved entire—cutting off, of course, from the back. One large winged figure—that opposite the one already moved at the entrance in the Throne Chamber.

The above sketch will shew you what I mean. If you could secure me a specimen or two from Kouyounjik with horses, chariots or anything in that line, pray add them to the above. The whole to be sawed and packed as mine were—only remember never to put matting in any position where it may come in contact with the sculptured face of the slab as it marks

the marble. I will endeavor to let you know in this letter to whom they are to be directed in England and how you are to draw—if I cannot get the particulars before sealing I will by next post and in the meanwhile draw upon me. I hope this will not trouble you—Put everything into Baynam's hands. I am very anxious that it should be done—make him choose the best specimens.[4]

Bainan was Layard's stonemason, "a Jacobite, or Syrian Christian, who was a skilful marble-cutter, and a very intelligent man."[5]

It is clear from Layard's sketch and description which Nimrud slabs he means (see fig. 6). The "long room where the alabaster vases were found" is Room I, though Layard did not specify which slab Ross was to send and his description would be appropriate for most of the slabs in that room.[6] "The hall in which the king was seated on his throne" is Room G.[7] The sketch indicates that Slabs 7 and 8 are the ones intended. The "large winged figure—that opposite the one already moved at the entrance in the Throne Chamber" is indicated on Layard's sketch as the slab on the north jamb of Door e (labeled "2" in the sketch plan and "1" on his published plan). This is the slab that had already been sent to the British Museum, however, and so presumably Layard actually meant Ross to remove the slab on the south jamb.

Coming at a time when only the British Museum and the Louvre owned Assyrian sculptures, and only a few examples at that, this seems a remarkably large order for an individual. The question would later arise, more than once, of whether Layard had the authority to dispose of these sculptures, which after all had been excavated with British Museum funds. It is not clear what prompted Layard to make this request, but the timing suggests that it helped him to secure Lady Charlotte's patronage.

Two months later, Layard wrote to Ross again: "I am anxious to hear of your success in Kouyunjik after recommencing the excavations. . . . Do not forget the sculptures from Nimroud for Guest."[8] In late May, Ross replied:

20 May. I was very glad to get yours from London of 27th March. . . . I have just come from Kouyunjik. . . . The only things that I may succeed in saving are—the woman on a mule, the castle and millet field, two separate led horses, with the accompanying soldier to each, and a pair of beautiful horses' heads belonging to a chariot, a little procession of figures, a woman, two prisoners manacled and a soldier driving them with his uplifted sword. . . . [May] 29th. I have been to Nimrood, and pointed out to Behnan the pieces he is to move.[9]

I have found no record that refers to the actual shipment of these sculptures, but there would seem to be only one possibility. Though it was relatively easy to arrange transportation of sculptures by river as far as Basra, it was very difficult to get them from Basra to London. According to Gadd, the British Museum Trustees inquired of the Admiralty in 1850 about the availability of naval vessels for this purpose and were informed "that there was no place with which so little traffic was maintained as the Persian Gulf," an interesting contrast with the situation nowadays.[10] The only documented shipment of Assyrian sculptures that fits the Canford chronology was aboard the naval sloop *Clive*, which departed Basra for Bombay in January 1849 with 23 cases of sculptures for the British Museum, and presumably the Canford sculptures as well. In Bombay the sculptures were transferred to H.M.S. *Meeanee*, which arrived in England in August 1849.[11] After a journey apparently lasting some-

thing over a year, this group of Nimrud sculptures finally arrived at Canford on 18 October 1849, the same day that Layard returned to Nimrud.

During the remainder of 1848, until his return to Constantinople in mid-November, Layard saw a great deal of the Guests, not at Canford, which was uninhabitable because of Barry's work, but almost everywhere else the Guests happened to be. In London he called on them almost daily. In August he visited them at Dowlais, and again in early October for the introduction ceremony for the final part of Lady Charlotte's *Mabinogion*. In September he accompanied them on vacation in Scotland. In late October, the Guests persuaded Layard to attend the Poole Agricultural Meeting and show. Barry was also there, and they all stayed with the Canford estate agent, Mr. John Pyne.[12] Lady Charlotte described the meeting, which was held in the Poole Town Hall:

We had brought in the Ninevite head which H. Layard had presented me with in the Spring. It was looked at with great wonderment, and then Merthyr said that as the gentleman who had excavated it was present perhaps they would like to hear from him some account of his discoveries in the East. Hy. Layard then got up and made a most animated and entertaining speech, with a slight sketch of what had been done including the anecdote of the first finding of the colossal head. The audience were delighted. It was so brilliant, so interesting and so unexpected, that it was quite *the* event of the evening, and all separated I think well pleased.[13]

This was apparently the first of a number of such speeches that Layard was to make at functions sponsored by the Guests.

On 14 November, the day before he was to depart for Constantinople to resume his position as unpaid Attaché in the embassy, Layard breakfasted with the Guests. Lady Charlotte wrote that they

had a very pleasant talk with Hy. Layard about the state of Europe. . . . I could not help saying how I wished he could see Ld. Palmerston before he went, and how I wished he could have an opportunity of saying to him all he had just said to us. Alas poor Henry was to sail on the morrow! It seemed impossible. But . . . we heard Ld. Palmerston was in town and Merthyr and I most strongly urged him to try and get an interview to take leave before he went . . . Hy. Layard came to tea in the evening . . . in high spirits. He had had an interview after we parted in the morning with Lord Palmerston, who had received him very kindly and kept him talking some half hour on European politicks.[14]

Palmerston already knew of Layard, having appointed him to and then accepted his resignation from the Boundary Commission. This was nevertheless an important meeting, as Palmerston would soon be instrumental in securing another paid government appointment for Layard in Constantinople and in urging the Trustees of the British Museum to fund further work by Layard at Nineveh.

NINEVEH AND ITS REMAINS

The third of Layard's three books on his excavations, his "Eastern Journal," had no difficulty finding a publisher—apparently John Murray was interested in it from the start. Layard was, however, anxious to finish the project before returning to the East. Already in July 1847, Stratford Canning had written to Layard to inform him that Lord Palmerston, the Foreign Minister, had appointed him as a paid member

of the Turco-Persian Boundary Commission and the appointment was formalized late that year.[15] A week before his first meeting with Lady Charlotte, Layard wrote to Ross: "I regret to say that I am ordered out in March, to be on the frontiers in May—this gives me no time to prepare, as I should have wished, my books, drawings and inscriptions for publication. I must now hurry through them and cannot expect much credit from them."[16] Though he would not in fact leave for Constantinople until mid-November, and then not as a member of the Boundary Commission, he could not have predicted that in February.

The occasion to reflect and write that Canford gave him must have been welcome and timely, as one of his letters quoted earlier makes clear. Since Layard's first visit to Canford at the beginning of March lasted only a week, it seems unlikely that he wrote the entire book while he was there.[17] He may well have finished it there, however, as Murray had received, read, and accepted the manuscript by 21 March, and Layard was able to report: "My book is advertised but the publication of the drawings is put off until next year."[18] This delay in the publication of the folio *Monuments of Nineveh* was by design, as it would allow the expensive book to profit from the publicity accorded to the more commercial narrative work.[19]

Production of the new book, which was to be a heavily illustrated two-volume set, proceeded rapidly. In May 1848 Layard wrote to Ross: "I trust that my journal will be out in two months from this."[20] By July, one volume was apparently ready: "It is now my intention to leave on the 27th of next month for Stamboul but it is just possible that I shall be so pressed for time with my book, only one volume of which is thro' the press, that I may be compelled to ask for an additional fortnights leave. . . . [It] will, I hope be printed tho' not published, before I leave England."[21] On November 14 Lady Charlotte wrote: "Henry brought me a copy of his Nineveh Journal to look at."[22]

Layard departed for Constantinople the next day. On board ship he wrote: "I am anxious to learn the success of my book, as much will depend upon it—it is published by this time."[23] *Nineveh and Its Remains: With an Account of a Visit to the Chaldaean Christians of Kurdistan, and the Yezidis, or Devil-Worshippers; and an Inquiry Into the Manners and Arts of the Ancient Assyrians* was published at the end of December 1848. This event marks the beginning of the second, more overt phase of the English reception of Assyria. It immediately became a bestseller, with nearly 8000 copies sold by the end of 1849. "His discovery of *Nineveh* is the talk of the day," wrote Lady Charlotte. "No one speaks of any other book but *Nineveh*," wrote his uncle, Benjamin Austen. "The most extraordinary work of the present age," according to the review in the *Times* (written by Layard's aunt, Sara Austen). "The greatest achievement of our time in pari materia," wrote Lord Ellesmere, a prominent statesman whose opinion carried great weight in matters of art. Edwin Norris, a friend from the Foreign Office, congratulated Layard "on having published *the book* of the season. Certainly none is so much spoken of and whenever the question is 'What do you think of Layard's book?' Nobody asks 'Have you read it?', that is taken for granted."[24]

The reasons for the tremendous success of *Nineveh and Its Remains* have been discussed at length by Bohrer.[25] In essence, it was due to Layard's skillful combination of religious commentary, ethnographic observations, criticism of government

niggardliness, adventure-filled anecdotes, and geographic description, in the midst of all of which is Layard as the persistent, self-effacing, and ultimately successful hero. There was something for everyone: for supporters of the government, it was an example of enlightened patronage in the furtherance of national prestige; for opponents of the government, it showed the triumph of an individual in the face of official indifference; for the Christian curious, it was a gold mine of information about religion—not just the Old Testament, but also the modern Christians and "devil-worshippers" in the region. It was filled with great stories, skillfully drawn characters, the flavor of the Orient, and the tension between East and West. The public loved it and acclaimed both the discovery and the discoverer—henceforth, Henry Layard was "Layard of Nineveh."

The effects of this enthusiastic reception for *Nineveh and Its Remains* were clearly felt at the British Museum. The Nineveh antiquities had just been given their own temporary gallery in the basement under the Lycian Gallery. It was hardly an ideal display—accessible only via a temporary wooden staircase and, in the words of a Museum official, "so small that we are obliged to rail off the people from going in front of [the sculptures], . . . the public can therefore only see them diagonally." Nevertheless, the Museum was delighted, wrote Layard, "at the crammed houses which the new entertainment brought them." The *Illustrated London News* marveled at "the number of visitors who daily throng the room . . . in which they are deposited." Aunt Sara reported that the Nineveh room was always full and Uncle Benjamin wrote that Layard had brought more people to the Museum "than any ten previous contributors."[26]

Books on Nineveh began to appear at a great rate: John Blackburn's *Nineveh: Its Rise and Ruin; As Illustrated by Ancient Scriptures and Modern Discoveries* (1850), W. S. W. Vaux's *Nineveh and Persepolis* (1850), James Fergusson's *The Palaces of Nineveh and Persepolis Restored* (1851), James Buckingham's *The Buried City of the East: Nineveh* (1851), Joseph Bonomi's *Nineveh and Its Palaces: The Discoveries of Layard and Botta Applied to the Elucidation of Holy Writ* (1852), and Layard's own *Discoveries in the Ruins of Nineveh and Babylon* (1853). The intended Christian appeal of some of these titles is obvious. Murray also published a cheap one-volume abridgement, *A Popular Account of Discoveries at Nineveh* (1851), which sold 12,000 copies by mid-1853.[27]

Nineveh influenced popular entertainment as well. It was the subject of two panoramas in London: Frederick Cooper's moving "Diorama of Nineveh," which opened at the Gothic Hall in May 1851, and Robert Burford's "Panorama of Nimroud," which opened in the upper circle of his Leicester Square Panorama in late December 1851 and ran for 18 months. Layard's discoveries also served as the stimulus for Charles Keane's new production of Byron's *Sardanapalus*, which opened in June 1853 and was performed 92 times over two years, and for which the sets and costumes were based on actual Assyrian artifacts. Finally, when the Crystal Palace opened at Sydenham in June 1854, it included nine Fine Arts Courts, each devoted to one of the world's great styles of architecture. One of these was the Nineveh Court, an attempt to create an authentic life-size reconstruction of a suite of rooms from an Assyrian palace, complete with original sculptures brought for it from Nimrud.[28]

As Layard wrote to Clark: "I am lost in wonder at the puffs I see of my humble work, and half suspect someone has been hoaxing me, vide Examiner, for instance. This is a monstrous deal of credit for very little. . . . Murray seems pleased and of this I am really glad. He talks of a second edition—for which I am correcting various errors, inaccuracies and inelegancies in the first."[29] Meanwhile back in England, Lady Charlotte seems to have been perceived by at least one reviewer as something of an authority on Layard: "Sir Dd. Brewster had written to ask me for some account of Henry Layard's early career for a Review he was about to write in the North British."[30]

As Layard carried out his second campaign at Nineveh, sales of his narrative mounted at home. He wrote to Clark in March 1850: "Murray mentions you in his last letter. . . . By the way what a friend the said John is—fancy the five editions and the balance sheet—you may judge of my own surprise for *you* know that my doubts on the subject of success were not a few."[31] And at about the same time he wrote to Edward Mitford, the traveling companion with whom in 1839 he had originally set out for Ceylon:

In every way the most sanguine expectations of my friends (I will not say my own, for I had none) have been surpassed. Of notoriety I have plenty, and the very liberal arrangement of my publishers has enabled me to realise a *very handsome* sum. Nearly 8000 copies were sold in the year—a new edition is in the press, and Murray anticipates a continual steady demand for the book, which will place it side by side with Mrs. Rundell's Cookery, and make it property.[32]

Though sales began to slacken in 1850, *Nineveh and Its Remains* remained so popular that unauthorized editions began to appear.[33] Soon after Layard's return to London from his second campaign at Nineveh, Lady Charlotte wrote: "We went to the Great Northern Station, and there waited on the platform for above an hour the train being late. We amused ourselves with various things and amongst others with the Bookstall where I met with the pirated prohibited edition of Nineveh. I bought it, after frightening the shopman with visions of informations laid—surprised and delighted him by showing him Henry Layard."[34] Murray's answer to the pirated editions was an authorized cheap one-volume abridgement, entitled *A Popular Account of Discoveries at Nineveh*, published in October 1851 in "Murray's Reading for the Rail" series.[35] Of this Layard wrote to Ross: "You will, I am sure, be glad to hear that my last work has had great success. Nearly 12,000 copies have already been sold and 3000 more will be shortly printed. As it was published at a very cheap rate it does not pay so well as the first."[36]

Meanwhile, Lady Charlotte continued her advocacy, pursuing a translation into Welsh: "Rees of Llandovery . . . has agreed to undertake the publication of Mr. Layard's Nineveh in Welsh, and has taken it on the most liberal terms. . . . I had enlisted Tegid in the cause, and he had begun a translation, but Rees did not think a specimen he sent me sufficiently popular, and so it is to be put in other hands."[37] And she recommended it to others, for example, to one of the classes for workers at Dowlais: "The next minute too brought Brigden for whom (in the midst of all) I had sent for Layard's Nineveh (the little book) that he might have something to read in the Mutual Instruction Class while they drew."[38] This combination of pro-

motion of Layard and concern for the instruction for the lower classes seems to have rubbed off on her oldest daughter, Maria: "In the afternoon I sat in the Library with Henry Layard. Maria came and consulted him about the little abstract she talks of making of his book for the Working Classes."[39]

All in all, though none of his books really ever approached the success of Mrs. Rundell's Cookery (which was in its 73rd printing by 1849), Murray and Layard were both pleased with the success of Layard's books.[40] Even in late 1852, Layard could write to his uncle Benjamin Austen: "Murray's sale took place yesterday with results beyond all anticipation—of the new narrative *4100* were taken—of the new folio *108*—of the 2 vol 8vo. *84*—of the abridgement 1450, of the old Monuments 8 or 10. Murray is delighted."[41]

LAYARD'S RETURN TO NINEVEH

When Layard left London to resume his position as unpaid Attaché in Constantinople, his prospects for either a diplomatic career or renewed archaeological excavations were not promising. *Nineveh and Its Remains* changed all that. As Benjamin Austen wrote to Layard: "No one speaks of any other book but *Nineveh* & of its modesty. . . . Till your book was read no one knew how much the Government was indebted to you. . . . Lord Ellesmere said it ought to be alluded to in Parliament; his name is a tower of strength in the world of Fine Arts."[42]

Frances Egerton, the first Earl of Ellesmere, was a prominent statesman and a Trustee of the National Gallery, and in matters of art his opinion carried great weight. In early February Lady Charlotte wrote that she, Sir John, and her sister Mary "talked over Henry Layard's prospects. Ld. Ellesmere has taken a great interest in him from reading his book which is most popular. Indeed his discovery of Nineveh is the talk of the day." The next day, Lady Charlotte received "a long visit from Mr. Pegus who was going to see Ld. Ellesmere about H. Layard." The following day, Pegus reported to her that Lord Ellesmere had promised to advance Layard's prospects.[43]

Two days later, Lord Ellesmere wrote to Charles Arbuthnot in praise of Layard:

I feel very confident that if you find time to read Layard's book you would understand the interest which I take in a man I never saw . . . The discovery and the most able and successful exploration of the Palaces of the successive dynasties of that Empire constitute the greatest achievement of our time in pari materia—the Man who has done all this and who has told the story of his achievements with singular modesty and simplicity has damaged his health, spent his money and is now an unpaid Attaché at Constantinople. . . . I really think that Lord Palmerston who, I understand, showed him personal kindness and consideration lately in England, would do himself much honour on the Continent as well as here by bringing forward such a man.[44]

Arbuthnot forwarded Ellesmere's letter to Lord Palmerston, who was, as we have seen, already favorably disposed toward Layard. Soon thereafter, Palmerston and Canning upgraded Layard's position in the embassy to that of paid Attaché.[45]

At the same time, plans for a second expedition to Assyria were taking shape. Immediately after his return to England from his first excavation campaign in Assyria, Layard wrote to the Trustees to propose a major British expedition to

Mesopotamia, similar to the Lepsius expedition to Egypt, to excavate ruins throughout Assyria, Babylonia, and Susiana for the benefit of the British Museum collections. He judged that such an undertaking would require £4000–£5000 for the first year and that it should be funded for at least three years.[46] In July the Trustees finally responded with an offer to send Layard back to Assyria at £20 per month. Layard refused and there the matter rested. When Layard left London in November 1848 to resume his position as unpaid Attaché in Constantinople, he had no expectation of returning to Nineveh.

The success of *Nineveh and Its Remains* and the prodding of Palmerston, Ellesmere, and others finally convinced the British Museum Trustees to send Layard out to excavate in Assyria again. Layard's uncle, Benjamin Austen, wrote him that Hawkins of the British Museum had told him that Lord Palmerston and Lord John Russell were pressing the Trustees to apply to the Treasury for a grant of £20,000 to allow Layard to carry out his plan.[47] The plan actually adopted by the Trustees was, characteristically, much more modest: Lady Charlotte reported at the end of March that she wrote "a letter to Henry Layard to congratulate him, for Mr. Pegus told me to-day that he had been made paid Attaché, had £1500 a year for two years given, and was, if he pleased to resume his excavations at Nineveh, to be attended by a physician and a first rate naturalist. We were all extremely pleased at his success, but I am very anxious to have an official confirmation of it."[48]

Lady Charlotte's report proved to be accurate in all but one particular: instead of a naturalist, Layard was to be accompanied by an artist. The selection of the artist was apparently made by the Austens, who undertook the job of outfitting their nephew's second expedition to Nineveh.[49] William Holman Hunt, who was very anxious to see the East, had applied for the position, but according to his own account "had lost the appointment of draftsman to [Layard's] expedition only by being one day too late in my application."[50] Instead, the Austens selected Frederick Charles Cooper, who because of illness and homesickness had to be sent home after less than a year, once again leaving to Layard the task of drawing the finds.[51]

Unfortunately, the salary and expenses of the artist, the doctor (who also proved to be unreliable), and Layard's assistant, as well as the outfitting expenses, a total of £660, all had to come from the £1500 appropriated for the first year. Upon learning these details, Layard complained that by the time the excavation expenses had been met, there would be only £300–£400 left to pay for the transport of his finds to Basra, less than he had received during the first expedition and far less than he needed.[52] Layard's lack of funds to send objects to the British Museum may have influenced his subsequent decision to offer further sculptures to the Guests, since experience had taught him that sculptures left *in situ* were liable to be destroyed by limeburners. On 28 August 1849 Layard's party left Constantinople. They arrived in Mosul on the last day of September and first visited Nimrud on 18 October, the same day that Ross's shipment of sculptures arrived at Canford.[53]

When Layard wrote to Ross from Canford in March 1848 to request Assyrian sculptures, only a few examples were in England and little published information was available about them. When Lady Charlotte's sculptures arrived a year and a half later, Nineveh was all the rage. On 11 October 1849 she wrote: "The marbles

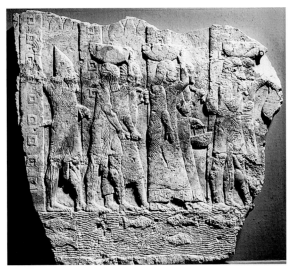

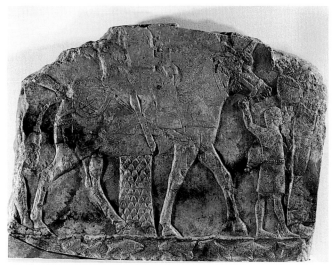

33: Nineveh, Southwest Palace, Room LI, no slab number; Oxford, Ashmolean Museum 1979.994; 69 × 76 cm; L. W. King no. 6 (photo: Ashmolean Museum)

34: Nineveh, Southwest Palace, Room LI, no slab number; Bible Lands Museum Jerusalem no. 1112; 60 × 83 cm; L.W. King no. 21 (photo: Bible Lands Museum Jerusalem)

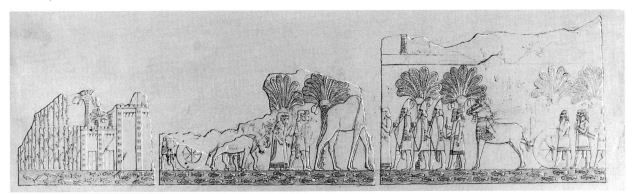

35: Nineveh, Southwest Palace, Room LI, drawing by Layard;
British Museum, Western Asiatic Antiquities, Original Drawings, vol. I, no. 51
(photo: Trustees of the British Museum)

which Henry had ordered to be sent from Nineveh for me have been some time in England. Today we had a letter from Purnell [of Dowlais Iron's London office] to say they were landed, but he gives a melancholy account of their condition, and I fear from what he says that they are so injured as to be almost valueless."[54] About a week later, bad weather kept her close to home: "Accordingly we went first to the railway station to enquire about the Ninevite marbles."[55] And the following day: "The marbles having arrived, began to be brought over. They are of great size and weight."[56]

During the remainder of the month, Lady Charlotte unpacked and repaired the

marbles, and tried to find a way to display them. The day after the sculptures arrived at Canford Manor,

I amused myself early in unpacking one of the Ninevite cases (one of the smaller ones) and found the marbles in every one of them more or less broken. . . . The afternoon I devoted to the marbles. We opened the five small cases in the course of the day. Only one (the smallest a group of horses heads) was uninjured. The rest were more or less cracked in pieces but not much displaced. I got two of them put together before dark and brought into the house. We stuck them together with plaster (having luckily some clever people at hand working at the Tower) and the joints being good and not chipped the cracks hardly show. The other two small slabs were much more broken, being in about 20 pieces and some little fragments being missing: but still they seemed recoverable.[57]

It appears from this that Lady Charlotte received five small sculptures in this shipment, each packed in its own case: a small unbroken fragment showing horses' heads, and four larger pieces, two of them cracked, the other two badly broken.

All of the pieces in this shipment were described in detail in an article in the *Literary Gazette*, which reported on the arrival of these sculptures at Canford.[58] With the assistance of this and Ross's letter to Layard of May 1848, quoted above, it is possible to identify all but one of these sculptures. Ross's shipment must have been drawn from either the throne-room area or the area immediately around Room LI of Sennacherib's palace, since these were the only parts excavated by the time he left Nineveh. His "castle and millet field" and "woman on a mule" can readily be identified with two fragments from Canford (figs. 33, 34). Both are probably from Ross's own excavations in Room LI. When he later returned to Nineveh, Layard drew the sculptures remaining in this room, including the other half of the slab with the "castle and millet field" (fig. 35). The Canford fragments must originally have been in one or both of the gaps that are shown separating the slabs in the drawing, but by the time Layard saw the room those slabs had already been removed to England.

Ross's "little procession of figures" can also easily be recognized in one of the Canford fragments (fig. 36). The original location of this slab in Sennacherib's palace is uncertain, but a hint is provided by the male prisoners in the procession, who wear the animal-skin cape of Zagros mountain-dwellers. Royal campaigns in these areas were the relief subjects in Rooms V and XLV, both of which had already been excavated by Layard. This fragment could have come from either room.

Ross's letter also mentioned "two separate led horses." Three fragments with "led horses" were in the Canford collection, but two of these were from Room XXXVIII, which had not been excavated by the time Ross left Mosul. According to the article in the *Literary Gazette*, the remaining led horse was definitely in this shipment (fig. 37). Its original location in the palace is uncertain, but the setting would be appropriate for any room in the throne-room area, and this must be one of Ross's "two separate led horses." A second led horse was not mentioned by the *Literary Gazette*, is not among the known sculptures from Canford, and cannot now be identified. Since Lady Charlotte and the *Literary Gazette* only reported a total of five small sculptures in this shipment, and since five can be accounted for without the second led horse, it may be that this fragment was never sent or was lost in transit.

36: Nineveh, Southwest Palace, room unknown, possibly V or XLV; Metropolitan Museum 32.143.17; 44 × 41 cm; L. W. King no. 17 (photo: Metropolitan Museum of Art, Gift of John D. Rockefeller, Jr., 1932)

37: Nineveh, Southwest Palace, possibly Room XLV; Oxford, Ashmolean Museum 1959.378; 76 × 70 cm; L. W. King no. 5 (photo: Ashmolean Museum)

Ross's "pair of beautiful horses' heads belonging to a chariot," must be the same as the small "group of horses heads" that Lady Charlotte reported receiving. It cannot be recognized among the known Canford reliefs, since it was not placed on permanent display with the remainder of the collection, perhaps because of its small size. It is, however, described in the article in the *Literary Gazette*: "Two horses heads, similar to those in Remains of Nineveh, (II. 353), except that in the Canford Marbles the horses are without the plume and tassel. A fragment. Dimensions, $8\frac{1}{2}$ in. by $7\frac{1}{2}$ in." (21.5 × 19 cm).

On the evening of the day she unpacked the small sculptures, Lady Charlotte had 28 to dinner. The Assyrian marbles participated: "As soon as my specimens of Ninevite Art were in their places, I ran up to dress for our dinner, but did not get down till all were assembled. . . . After dinner we had . . . the Ninevite marbles and various talk in the drawing room, and it was not over till near midnight."[59] A few days later she unpacked the larger slabs:

We uncovered today the large Ninevite cases, four in number. The slabs in them are about eight feet square, of a much finer style of sculpture than the smaller ones. Two of the slabs represent two figures on each. A third has two bands of sculptured figures (sacrificing) with inscriptions between the two bands. The fourth when uncovered disclosed Nisroch himself to my delighted eyes. All these four were broken over in four places, but I trust they are not seriously injured. There are inscriptions upon them all. The sandals still retained the red paint which had ornamented them, but this we find rubs off.[60]

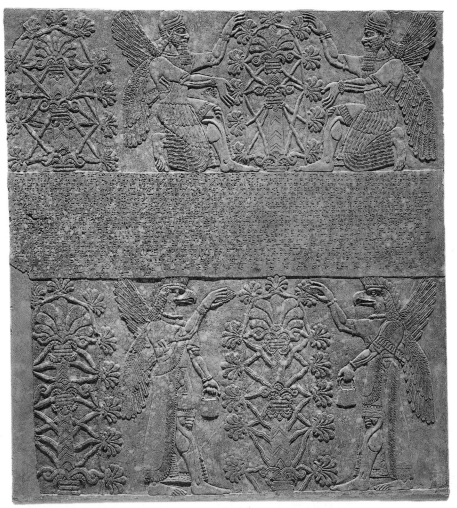

38: Nimrud, Northwest Palace, Room I, Slab 30;
Metropolitan Museum 32.143.3; 229 × 211 cm; L. W. King no. 26, right part
(photo: Metropolitan Museum of Art, Gift of John D. Rockefeller, Jr., 1932)

These slabs can be identified with the help of Layard's letter to Ross of 27 March 1848, quoted above. From Room G, "the hall in which the king was seated on his throne," Ross sent Slabs 7 and 8, which are exactly the ones Layard requested (see figs. 7, 8). From Room I, "the long room where the alabaster vases were found," Ross selected a well-preserved slab close to the door, No. 30 (fig. 38). In the case of the "large winged figure—that opposite the one already moved at the entrance in the Throne Chamber," however, Ross sent not the winged human-headed figure from Door e that Layard intended, but instead the bird-headed figure from Door d of the same room (fig. 39). It is not clear whether or not this substitution was intentional. In each of these doors, one jamb figure had already been removed to the British Museum, so Ross may simply have been uncertain about which door was meant. Layard's sketch that accompanied his letter is very clear, so it seems more likely that Ross deliberately sent a different figure—perhaps the figure Layard

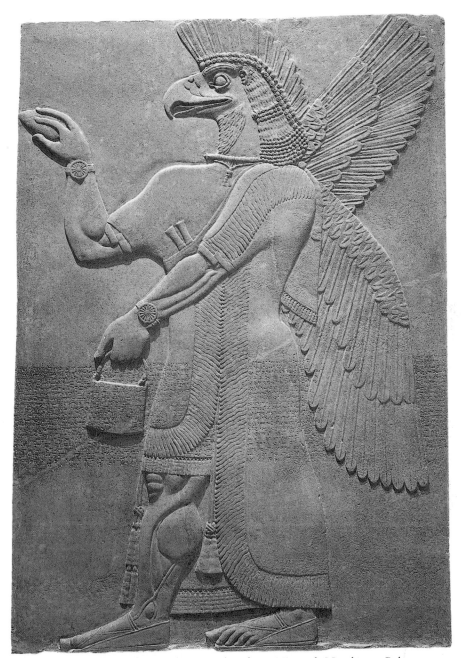

39: Supposed figure of "Nisroch," from Nimrud, Northwest Palace,
Room G, Door d, Slab 2; Metropolitan Museum 32.143.7, 236 × 163 cm; L. W. King no. 2
(photo: Metropolitan Museum of Art, Gift of John D. Rockefeller, Jr., 1932)

designated had been damaged since his departure. However that may be, Lady
Charlotte was clearly pleased to have her own colossal "Nisroch." This was another
supposed biblical parallel: Layard (incorrectly) identified this bird-headed figure as
the biblical Nisroch, the Ninevite god in whose temple Sennacherib was murdered
(II Kings 19:37).[61]

Now Lady Charlotte owned the largest—indeed, with the exception of a few odd fragments, the only—private collection of this suddenly extremely popular new type of art. She was naturally eager to arrange a permanent display for her new acquisitions and so consulted Barry at once: "Mr. Barry arrived somewhat unexpectedly. We had written to urge his coming as soon as he conveniently could do to make some arrangements about placing the marbles."[62] Barry's visit "resulted in some very promising ideas of his for furnishing the Eastern side of the house. He is to consider them further and let me know more about it."[63] This probably has nothing to do with the sculptures, however, as a few days later Lady Charlotte reported that she had been

very busy superintending the removal of the Ninevite marbles. The four large slabs have been placed on the ground in front of the gallery, and we had hoped Mr. Barry might have been able to decide at once which would be the best place for them to occupy in the House and would have had them built into the wall at once. This however he was unable to do when down on Saturday, so we have had them freed from the remains of the frail cases in which they came, and deposited at one end of John of Gaunt's Kitchen for the present.[64]

Two years later they were still there. As Lady Charlotte lamented "it is a shame to let these fine marbles we have, lie in a dark corner of the kitchen floor."[65] Meanwhile in London, visitors to the British Museum crowded into a small basement room to catch a diagonal glimpse of the national collection of Assyrian sculptures, while anxiously awaiting the arrival of the two greatest trophies of Layard's expedition: the bull and lion.

A BULL AND A LION FOR CANFORD

If *Nineveh and Its Remains* is read as a novel of archaeological discovery, then its most prominent theme is the acquisition of a pair of gateway colossi—a human-headed bull and a human-headed lion—for the British Museum. One such colossus was among the first sculptures to be discovered—the story of this event occupies seven pages and is the subject of a vividly evocative engraving. Layard contrasts the wild reactions of his local workmen ("they have found Nimrod himself!") with his own sober musings ("What more sublime images could have been borrowed from nature, by men who sought, unaided by the light of revealed religion, to embody their conception of the wisdom, power, and ubiquity of a Supreme Being?"). A number of further such figures were excavated in the course of his work at Nimrud. Two examples are the subjects of full-page engravings in *Nineveh and Its Remains*, one of which also served as the front cover illustration. Layard states that the British Museum Trustees had not provided him with sufficient funds to move any of these colossi and that, with no thought of the damage these unique sculptures might suffer after his departure, had instructed him to cover them up and leave them behind. The excavation narrative culminates with Layard's personal decision to move two of the colossi anyway, followed by a breathtaking 32-page account of the actual process.[66]

The reader has been ready for this moment from the beginning—the frontispieces of both volumes are tinted lithographs that show the lowering and transport of

these figures, and the preface scathingly expresses Layard's regret that "the great winged bull and lion, which, I had hoped, would have speedily formed an important portion of the national collection, are still lying at Busrah; and there is little prospect, at present, of their being brought to this country."[67] All of this generated considerable public interest in seeing the bull and lion safely home, and a specially modified transport vessel was sent to collect them. The *Illustrated London News* now took over the task of chronicling the further stages of their journey, reporting on their embarkation in July 1850, their arrival in England at the end of September, and their erection in the neoclassical front hall—then, as now, the most public space in the British Museum—by the end of October.[68] The eager anticipation of the arrival of this new national treasure is the backdrop for another of Lady Charlotte's remarkable Assyrian acquisitions.

Despite Layard's absence in Constantinople and Mosul, he and Lady Charlotte stayed in touch. Though I have not been able to locate the correspondence between Lady Charlotte and Layard for this period, there are regular references to it in her diary and in his letters to their mutual friend George Clark.[69] In addition to the letter of congratulations of 30 March 1849 cited earlier, Lady Charlotte reported in August: "I have received such a beautiful scarf from Constantinople as a present from Henry Layard, in elegant taste though very magnificent."[70] And in March 1850: "Sir James Clark came in the afternoon and he shewed me a tracing from one of Henry Layard's drawings of a vase he had found at Nineveh. His discoveries there have lately been most interesting, he seems to have opened on the Treasury of one of the Kings. I had a most interesting letter from him a few days ago."[71]

Within a month of his return to Nimrud, Layard had begun to work on obtaining further sculptures for Canford. To Clark he wrote: "I have also by me a long and kind letter from Lady Charlotte (Guest), which I must answer by today's post—particularly as I wish to obtain positive instructions as to the removal of a further collection of antiques for them. Those I have already sent are, with a very few exceptions, very fine specimens."[72] In a letter to Clark a few months later he provided further details: "I was very glad to find that Lady Charlotte and Sir John were pleased with the specimens of Assyrian antiquities which were sent to them by my directions, altho' by all accounts they appear to have suffered much by the way. I am waiting to hear from them on the subject of the removal of two very large sculptures (a Lion and Bull) which would certainly be very original and fine ornaments to Canford. As soon as I receive their instructions I will proceed to move them" (figs. 40, 41).[73]

Overleaf

40: Human-headed lion colossus, from Nimrud,
Northwest Palace, Room G, Door b, no. 1;
Metropolitan Museum 32.143.2; 314 × 277 × 69 cm

41: Human-headed bull colossus, from Nimrud,
Northwest Palace, Room S, Door e, no. 2;
Metropolitan Museum 32.143.1; 312 × 312 × 66 cm
(photos: Metropolitan Museum of Art,
Gift of John D. Rockefeller, Jr., 1932)

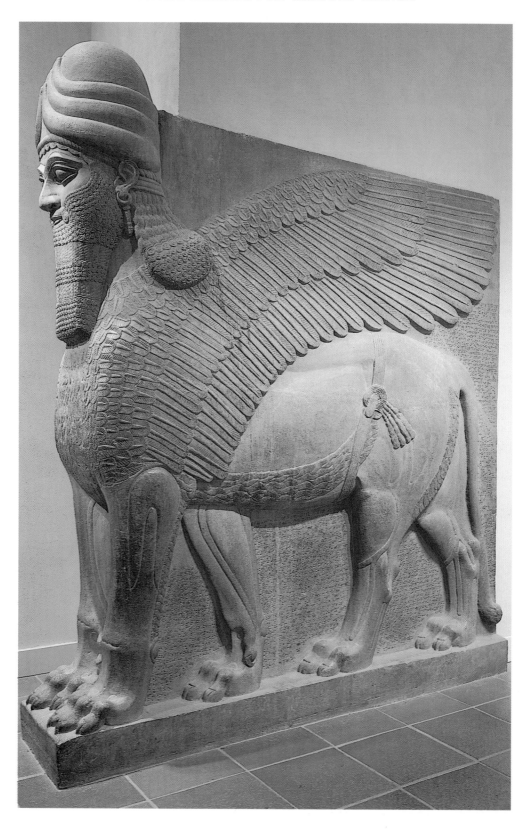

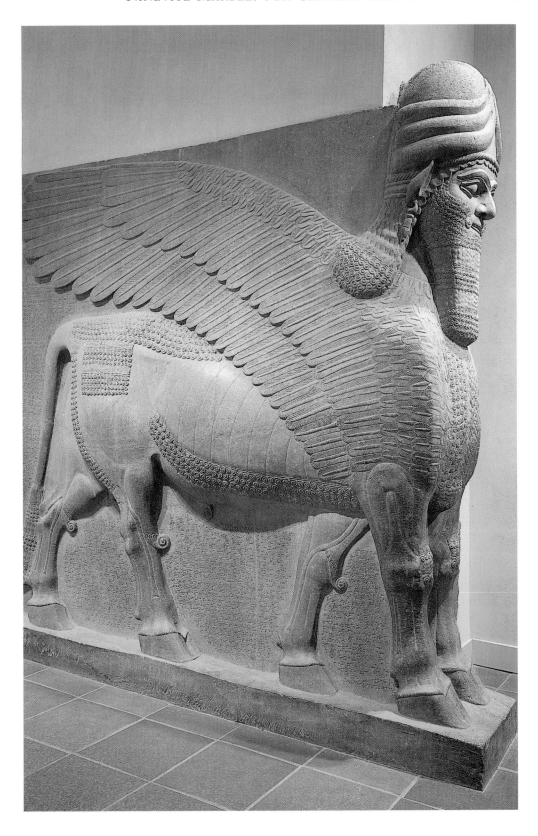

The bull and lion in question were in fact the counterparts to the two that were *en route* to the British Museum, and were therefore identical to the pair that Layard had described as the noblest achievement of Assyrian art. The mates to those eagerly anticipated national trophies would make "very original and fine ornaments" indeed! Later, Lady Charlotte would make it clear that she understood the uniqueness and importance of these pieces, but she never seems to have doubted her right to own them. As with the slabs that had already arrived, it apparently didn't bother her that there were two major collections of Assyrian antiquities in England, one for her and the other for everyone else. Presumably, the fact that such universally admired antiquities could be hers alone was part of their appeal.

By May 1850 Layard had received the go-ahead to send the bull and lion to Canford: "Lady Charlotte seems much pleased with the Assyrian antiquities already sent, and as I have now received definite instructions I am going to set about moving the Lion and the Bull for them."[74] And again a month later: "In consequence of several mishaps I have been hitherto prevented from moving the Lion and Bull for the Guests—but I think the coast now appears to be clear and there will be no difficulty in securing these sculptures for them."[75] In July 1850 Lady Charlotte and her oldest daughter went "to the British Museum where I wanted to see Mr. Hawkins about getting our marbles restored."[76]

I have found no reference in Layard's papers to the lowering of the bull and lion or their transfer to the riverbank, but the job had evidently been completed by January 1851. On 10 January Christian Rassam, who was supervising the Nimrud excavations while Layard was absent exploring Babylonia, wrote to Layard: "I sent out for Behnam. . . . The Lion & Bull he has sawed and buried. Will you give your further instructions what is to be done with them."[77] In February Layard was in Baghdad, recuperating from a severe illness he had contracted in Babylonia. Shortly before leaving for Mosul, he wrote to Clark: "I have heard a few days ago from Lady Charlotte. My first care on returning to Nineveh will be to pack and despatch the Lion and Bull, which are sawn and ready for removing. They will be shipped at Busrah for England in the summer."[78]

Apparently because of the difficulties and delays Layard had already encountered in shipping whole colossi to England (the first lion and bull, the counterparts of the Canford examples, took three and a half years to travel from Nimrud to London), he decided to saw each of the Canford colossi into quarters. At the end of March 1851, he again wrote to Clark: "I am now superintending the moving, sawing, packing and embarking of Lady Charlotte's Lion and Bull. They will be off, I hope, in the middle of next month. Pray tell her Ladyship so and that I do not write until I can announce their departure and my own."[79] On 19 April 1851, Layard noted in his pocket diary: "raft leaves Nimroud with Bulls for the Guests." A few pages further on are notes of the marks on the sculpture crates: "8 for Guest & one Box marked IG."[80] Presumably these are the eight quarters of the bull and lion, and perhaps some additional fragments in the box as well.

Layard kept a detailed account, separate from his British Museum accounts, of the expenses he incurred in removing the bull and lion from Nimrud. Presumably this was submitted to Lady Charlotte for reimbursement. Because it gives an inter-

42: The Nineveh Salon in
the Louvre, 1847 installation
(*Le Magasin pittoresque* 16,
1848, p. 135)

esting view into the organizational skills required to move these large stones, it is given here in full as Appendix 2. The final figure in this account, 7935 piastres, is repeated in Layard's excavation accounts, which include a summary of his private expenses at Mosul. After the last dated entry, of 26 April 1851, is a final entry: "Expenses on the Lion and Bull last sent to England—8,135/20"; beneath which is the note: "Deduct raft for B.M. p[iastres] 200."[81]

The Layard Papers also include a list of money exchanges from English pounds into Turkish piastres, which helps put these amounts in perspective. A number of transactions are listed as taking place on 8, 19, 31 March and 7 April. No year is given, but the list is bound after the last excavation accounts, so it may refer to 1851. These dates are consistent with Layard's travel schedule in 1851, since he returned to Mosul around 7 March from an extended visit to Babylonia. On the first two dates the exchange rate was 100 piastres to the pound, and on the latter two 107 and 106.5 piastres to the pound respectively, less a 1 percent commission.[82] Therefore, the cost of shipping the Canford colossi down the Tigris to Baghdad was about £79. In Baghdad, the colossi were presumably transferred to river boats for the trip to Basra.[83] There they were shipped, together with a large

consignment for the British Museum, on the schooner *Apprentice*, which departed in autumn 1851 and arrived in England in February 1852.[84]

While Layard worked on securing colossi from Nimrud for the Guests, the Guests did their part at home to promote his researches. In December 1850 Lady Charlotte wrote: "They are making a private subscription to enable Henry Layard to complete his researches at Nineveh, his Government funds being exhausted. Major Rawlinson called to ask Merthyr, who has given £100, to be on the Committee. Prince Albert has promised to join."[85] Layard heard of this only in April 1851 as he was preparing to leave Mosul for England. He thought that private sponsorship might lead to rivalry with the British Museum, so he wrote to Canning: "The plan appears to me objectionable in many respects and I have declined availing myself of funds so collected."[86] Though this plan apparently came to nothing, in 1853 Layard became involved with a similar subscription fund, the Assyrian Excavation Fund, to which Lady Charlotte donated £100.[87]

Also in April 1851, Lady Charlotte wrote, "Col. Rawlinson told me yesterday that owing to the Queen's interference on his behalf, Henry Layard has had an additional grant of £3500 by the Trustees of the British Museum. He added that Henry was expected in England in the course of the summer."[88] It was again too little, and far too late. On 28 April 1851, weakened by illness and embittered by the parsimony of the museum Trustees, Layard left Nineveh, never to return.

By this time, the first bull and lion were on display in the British Museum, but Lady Charlotte seems not yet to have seen them. She did, however, see the bull colossi from Khorsabad in the Louvre (fig. 42) and wrote: "I had energy left to ask to see the Nineveh marbles which being closed for the day they kindly had opened for me. Nothing can be better than the arrangement of these Marbles; several of the slabs are of the same character as those we have, and they ought to be put up in the same way. The colossal Bulls look magnificent in the centre of the Room, but if those that are coming over to us are of the same size as these I do not know what we can possibly do with them."[89]

CHAPTER 4

THE NINEVEH PORCH

LAYARD THE LIONIZER

On 1 July 1851 Lady Charlotte wrote: "I was agreeably surprised this morning at receiving a visit from Henry Layard. He had just arrived from Nineveh and came to us, straight from the train, to enquire after and about everybody after so long an absence. Poor fellow he is sadly altered and tells me he has suffered much and been very ill. We engaged him to come to dinner with us."[1]

Layard arrived in London two months after the opening of the Great Exhibition, held in Joseph Paxton's Crystal Palace in Hyde Park. This immense structure of glass and iron must itself have seemed to the Guests a monument to the success of the British iron industry. On 1 May the Exhibition was opened by Queen Victoria, and Lady Charlotte was there: "It was a noble sight; she stood on the raised dais, in front of the Chair of State on which she sat not, even for a moment. . . . Around her, the highest names of England, and thousands less renowned but no less loyal; and all this pomp and panoply were called together to do honour to the industry of millions, whose toils, erst scorned upon, seemed suddenly ennobled! . . . As the wife of the largest manufacturer in the world I could not but feel this to be a most impressive sight."[2]

Despite his precarious health, Layard seems to have been more than willing to assist his cousin in entertaining the various gatherings of people that she from time to time sponsored. The first of these took place from 21 to 25 July, when Lady Charlotte hosted a group of 200 workers from Dowlais and Canford to see the Exhibition and London. Layard gave them all a tour of the British Museum, beginning with the Nineveh room: "Henry Layard was most kind in Lionysing and explaining as much as he possibly could—After going through the antiquities we went over the other collections, Natural History, Geology, Egyptian etc.—and the Library." During the party that followed, Layard again came to the rescue when one worker inadvertently caused offense: "Henry Layard . . . diverted the general attention from the subject by an amusing popular speech."[3]

A month later Layard was visiting at Dowlais, where he was also to give a lecture. Lady Charlotte provided an unusually detailed account of his preparations for this

talk. "It having been announced that there would be a workmen's soirée on Friday, and that Henry Layard would be expected to speak, he suggested that it would add to the interest of the Meeting to show some drawings on the occasion—And forthwith he set himself to search for canvas, paint and other materials and to commence the work—The first undertaking was a Nisrock, which he sketched on a piece of canvas duly prepared and laid out on the floor of the business room." After a break for lunch and an outing, "they all set to work at Nisrock—to paint and beautify him—till dinner."[4] And on the day of the lecture: "All day long they painted both in the business room and in the boys schoolroom—Henry Layard, his ally Mr. Harrison—the two Miss Seymours, Ivor, Maria, Katherine—even Mr. Seymour, even I—We had a Nisrock full size—a King to match—A colossal lion for the centre 12 feet square—by dint of hard and unceasing toil, the three marvels were finished and sent up to the pattern shop before our dinner—which to-day took place between 4 and 5 o'clock."[5] Of the lecture itself Lady Charlotte reported:

My poor people were to have one of their intellectual feasts to-night—from 500 to 600 had been invited—All the most intelligent workmen, etc. of Dowlais—The Dissenting Ministers and most enlightened men in each congregation—The head classes of our Schools—our young men's instruction classes—our Bible classes—our Library Subscribers and one or two strangers. . . . We had in addition the two little marbles from Nineveh—and a model of the Nineveh obelisk, which I took them for inspection. . . . [Henry Layard] gave us a sort of narrative of his discoveries with many allusions to the corroborations of the Holy Scriptures—The beautiful paintings had hitherto been kept covered over with a sheet, hung up against them—But this sheet was now suddenly dropped and he made use of the figures in explanation of his descriptions—Everybody crowded round and we had some difficulty in keeping any space clear near him—There was the most hushed attention though many did not understand English—and the admiration seemed universal. . . . [The rector of St. John's church, Dowlais,] Mr. [Evan] Jenkins now got up and thanked Mr. Layard (who by the bye to my mind spoke less well than I had ever heard him) then Stephens of Merthyr read aloud an ode he had composed in his honour which our glee singers forthwith sang in full chorus.[6]

In October, Layard was again at Dowlais. On the evening of the 10th, Lady Charlotte hosted a party for 400 local guests: "The great Lion, and the King, and Nisrock were hung up again. We took them the Obelisk also. . . . When the evening was drawing to a close Henry Layard was requested to say a few words in explanation of the large drawings—as there were many persons present who had not heard him on the former occasion (Aug. 22). He spoke above an hour very clearly and very well—much better than last time. Mr. Jenkins afterwards rendered some of it into Welsh."[7]

Later that month, Layard was again at Canford at the time of the annual Agricultural Show: "We sat down to dinner in the Great Hall, 205, and were not at all too full. . . . The speech of the day was that of Henry Layard, who drew an amusing contrast between the present Meeting and the first we had held, which he happened to be at, in 1848. Then, he remarked, 'we dined in a barn, which was reached by wading through a puddle', and he complimented us on our improvement. . . . He spoke well with great fluency and confidence, and kept the audience in a state of breathless attention."[8]

There were also numerous private opportunities for Lady Charlotte to learn the

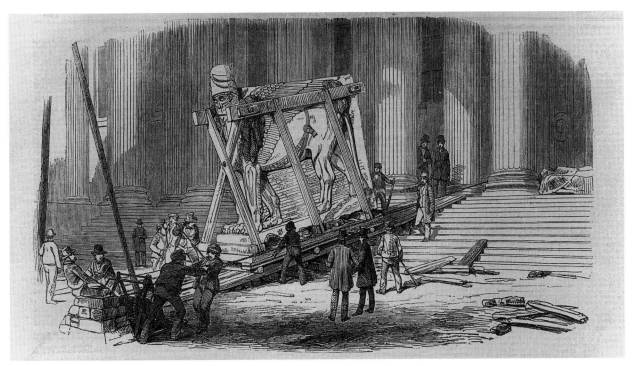

43: A Nimrud colossus dragged into the British Museum
(*Illustrated London News*, 28 February 1852, p. 184)

latest news from Nineveh. As before, Layard invited her to the British Museum to see new Ninevite antiquities. For safety, Layard had brought some of the small finds from his second expedition home in his personal baggage. A few days after his arrival, he invited Lady Charlotte to the museum to help unpack: "I went to the British Museum where Henry had gone on before to see some of the fresh antiquities which had just arrived. . . . I found them all busily unpacking—Boxes full of fragments—of the Cylindrical archives, of the Metal vessels, dishes, etc. They set me to unpack one box that was completely full of minute articles of extreme interest—So full however that although I worked hard that one box occupied me without a moment's respite till dinner time."[9]

In August 1851 the first shipment of sculptures from the second expedition arrived in England aboard the *Fortitude*.[10] Again, Lady Charlotte was invited to inspect the new arrivals: "George Marsh and Henry Layard called early to see if I would go with them to the British Museum—to look at the new importations which are being unpacked. . . . [They] showed me some beautiful things—Many sculptures (many of them much spoilt in the transport) but above all some of the bronze vessels that have been cleaned, and exhibit most interesting figures chased or rather engraven upon them."[11]

Among the Assyrian sculptures brought to the British Museum (fig. 43) aboard the *Fortitude* and the *Apprentice* (which also carried the Guests' colossi) were a pair of human-headed lion colossi excavated by Layard at Nimrud and a pair of human-headed bull colossi acquired from Khorsabad by Rawlinson, all of them

larger than Layard's first pair.[12] In late March 1852, about a month after the arrival of the *Apprentice*, Layard again gave Lady Charlotte a private viewing:

We proceeded with Henry Layard to the Museum, where I had not seen yet the newly arrived large Bulls. They are very fine indeed. We went down into the Cellars where the interesting occupation of repairing the many broken Sculptures was proceeding. Also revisited Mr. Doubleday's room where we saw the bronze dishes etc. the beautiful cylinders—which are so delicately engraved. Mr. Doubleday gave me some fragments of glass from Nineveh—scales but of wonderful coloring. We ended our expedition by visiting the Ninevite treasures up-stairs—the small objects.[13]

After his return from Nineveh in mid-1851, Layard became for the Guests much more than just a celebrity, however; he increasingly took on the responsibilities of a trusted family friend. During Layard's absence in Assyria, Sir John had begun to suffer from bladder stones, the ailment that would eventually kill him, and by 1851 his health seemed precarious. Shortly after Layard's return, Lady Charlotte wrote: "We were to have dined together at the Duke of Somerset's but Merthyr felt poorly and so I had to go there alone. There was but a small party—Henry Layard, Col. Rawlinson, [Anthony] Panizzi, The Rajah Sir James Brooke etc—but we were all full of talk and the evening passed quickly."[14]

By late 1851, Layard was even taking on occasional parental responsibilities, as in the case of a crisis at school involving Ivor, the Guests' eldest son, which occurred while the Guests were in Dowlais. Lady Charlotte recorded the event in detail:

To-days post brought me a letter from Dr. [Charles] Vaughan recommending that Ivor should be removed from Harrow at Christmas and saying that he was not getting on there. . . . He added what shocked and startled me beyond measure, that Ivor was considered a promoter of evil in others and was accused of using wicked language—Now this I do not believe to be at all well-grounded. . . . That he is idle, thoughtless, dilatory, very unpopular and wants energy to keep himself up with his books I well know—but he has no vice—The best course seemed to be to write at once to Vaughan. . . . This I did and then enclosed Vaughan's letter and a copy of my answer to Henry Layard asking him to make a point of going down to Harrow to sift all this to the bottom.[15]

Two days later, she had a reply from Layard, who had immediately gone to the school to talk with the headmaster. His letter, written hurriedly to make that day's post with a promise of more to follow, raised more fears than it allayed:

The charge of bad language etc. he [Layard] said he could find no foundation for—though he cross-questioned Dr. Vaughan who answered very frankly . . . but there was one expression in this hurried note which alarmed me so much that I was very near setting off alone the next morning to see Henry Layard upon it and consult whether there was any ground for proceeding to Harrow and removing him at once. . . . However when I considered how difficult it is for me to leave my dear husband who though pretty well, depends upon me for something every moment of the day I finally determined to await the result of Henry Layard's explanatory letter which I could not receive before Tuesday morning.[16]

Fortunately, the Tuesday post "brought with it very long letters from Henry Layard—not giving me any particulars—but assuring me that I need not be under alarm."[17]

One of the by-products of friendship with Layard was the opportunity of making the acquaintance of various interesting people he had encountered in the course of his Ninevite experiences. In August 1851, Layard arrived for a visit in Dowlais with "the old king of Oude," or "the Nawaub," with whom he had stayed on his last trip from Baghdad to Mosul. The Nawab Ekbal ed Dowleh was an exiled Indian prince, "according to the laws of his country, the legitimate king of Oudh; but the Government of India, had, for political reasons, changed the order of succession, and, after being a short time on the throne, he was deposed and compelled to leave India."[18] Layard was very fond of him. In October, Layard arranged for George Scharf to join him at Canford:

Just before dinner there also arrived Mr. Barry and Mr. Scharf. . . . Mr. Scharf is a professional acquaintance of Henry Layard's—He did the woodcuts for his first book [*Nineveh and Its Remains*]—The history of his coming to us was that the Poole Institute having requested Henry to give them a lecture he declined it, but offered if they liked to get a friend to do it for him—In which capacity Mr. Scharf has come down accordingly—The lecture being fixed for Monday—We thought it, under the circumstances, but courteous to invite him to Canford and were repaid by making the acquaintance of a talented, well-informed, unassuming young artist who formed a pleasant ingredient in our varied party.[19]

With Layard, Barry, and Scharf at Canford, the time was right for a solution to the problem of what to do with Lady Charlotte's Assyrian sculptures.

THE NINEVEH PORCH

Almost from the start, Layard had followed Barry's activities as architect of Canford Manor. In April 1848, just a few days after Barry presented his plans for the house to the Guests, Layard saw them as well. Lady Charlotte wrote from London: "Soon after six Henry Layard called. He staid dinner with us, and spent part of the evening. . . . They looked over Barry's plans for the alterations in which Ivor took much interest."[20] Eighteen months later, Layard wrote to George Clark from Nimrud: "I am delighted to learn that Canford has answered so well and that they are all pleased with Barry's performance. I hope it will be our fate to meet there again."[21] Layard and Barry evidently got on well together. Like Layard, Barry had visited the Middle East as a young man, traveling through Constantinople, Egypt, Palestine, Jerash, Baalbeck, and Damascus in 1818–19.[22] By an interesting coincidence, in 1847 Barry had assisted in the design of the new British Embassy building in Constantinople, where Layard had been posted.[23] They had met at Canford on a number of occasions and now they were about to begin a project there together.

27 October 1851 was a big day at Canford. It is certainly one of the days around which this narrative pivots, but more than that, it is a day that witnessed the convergence of a remarkable number of Lady Charlotte's Ninevite activities and interests. The day began very well:

Monday. I did not get up early—Merthyr wanted to discuss a great many things and so we talked them over before coming down—I thought I had *lost* my precious morning hour, but I gained, what was of infinitely greater value, his consent to build a room (in the garden,

but connecting with the house) to receive the Nineveh Marbles—This will be, if ever accomplished, a very great addition in every point of view—Henry Layard and Mr. Barry are quite anxious for it and executed by the joint talent of two such men it cannot fail to be in itself a beautiful and interesting object independent of the use it will be of in an architectural sense to finish up that side of the building—Besides it is a shame to let these fine marbles we have, lie in a dark corner of the kitchen floor. . . . I came down that morning better pleased than I have done for many a day. Henry had gone off at daybreak with Mr. Scharf to Poole to hang up the diagrams in the Town Hall and to arrange everything for the evening's lecture, when they returned about noon they found Mr. Barry in full discussion with me on various little details connected with the Nineveh Porch—Henry Layard came in just at the proper time to assist in the imaginary arrangements of the sculptures, and the conversation continued with increased interest till the carriages came round to take us to Kingston Lacy which we had arranged to go and see.[24]

Kingston Lacy, the home of William J. Bankes, had been remodeled by Barry in 1835. The most distinctive feature of the estate was an obelisk that had been brought by Giovanni Belzoni from Philae in 1815 and set up in the garden at Kingston Lacy in 1839.[25] Lady Charlotte wrote: "It was a treat to me to see this place with Mr. Barry—The alteration of it was the first thing he ever did. . . . The best thing about it is the green expanse leading to the Obelisk, which has really an imposing effect—We did not fail to visit the Obelisk and we lingered there some time."[26] It is of interest here that the feature of Kingston Lacy that most appealed to Lady Charlotte was the ancient Oriental monument in the garden, since just that morning she had commenced work on a similar project for her own garden at Canford.

The Bankes obelisk, the first obelisk to leave Egypt since antiquity and the only one in private hands, is in some respects comparable to Lady Charlotte's Assyrian bull and lion, to this day the only Assyrian colossi to have been owned by a private individual. In terms of sheer scale, the Bankes obelisk is unique among Egyptian objects in English private collections, with Sir John Soane's alabaster sarcophagus of Seti I, another of Belzoni's finds, a distant second. While exotic styles, such as the Egyptian and Indian, were widely imitated in English architecture and decorative arts in the first part of the nineteenth century, the physical appropriation of authentic major monuments was a project of a different order, one that few private individuals had the resources, and perhaps the inclination, to pursue.[27] Rather, the collection and display of monumental works of Egyptian art, such as the colossal red granite head of Tuthmosis III brought from Karnak by Belzoni, were primarily the provenance of the British Museum. Most of the Assyrian colossi from Nimrud and Khorsabad were likewise destined for the British Museum and the Louvre. However enamored England may have been of ancient Assyria, Lady Charlotte was the only person with the opportunity and the means to express this fascination by collecting and displaying original Assyrian colossal sculptures.

That evening, George Scharf delivered his lecture on Nineveh at the Poole Institute:

Of [Mr. Scharf's] lecture I can only say that it was very good and the diagrams excellent—and that I was sound asleep, with my eyes open, during the greater part of it—or rather perhaps I should say that I composed myself into an attitude of profound attention—After

the lecture, Henry Layard spoke, and spoke very well, for about an hour—I believe the audience were pleased—and certainly they had reason to be so—Some of the spectators lingered about on the platform (where we were) to examine the diagrams after it was all over—and in due time we returned home and discussed the evening and its incidents over a merry supper.[28]

The subject of conversation at supper was one that is still a favorite with eastern travelers today:

One fertile topic too, was the various venomous or unamiable insects to be met with in the East—On which Mr. Layard, Mr. [Danby] Seymour and Mr. Scharf were exceedingly eloquent—I could not help thinking how much more amused our good friends of Poole would have been with our supper talk than with the solemn and eminently instructive lecture they had been listening to—and so much of Eastern Manners and customs and adventure became mingled with the theme that I hardly think it conveyed less information than the disquisitions on Nineveh, all which they might have read in Henry's Books—Well, altogether it was a pleasant and right metter [sic] supper.[29]

The advantages of Lady Charlotte's status as a Ninevite insider are here abundantly clear: thanks to her Eastern friends, Nineveh is no longer a remote object of wonder, but rather a place that she has experienced with them.

The next day, work was begun in earnest on the Nineveh Porch, though Sir John does not seem to have shared his wife's enthusiasm for the project: "Merthyr went out shooting to-day—Mr. Barry, Mr. Layard and I went systematically into the question of the Nineveh Porch. . . . While we were at luncheon Lord and Lady Milton and Mr. Rose called. She was anxious for them to make Henry Layard's acquaintance. After luncheon we took them to see the marbles we have."[30]

A few days later, Layard and the Guests were back in London. Layard had apparently decided that the Nineveh Porch would require more sculptures than were already at Canford. As it happened, he had quite a collection to choose from. In August, his own sculptures had arrived in England on the same ship that was carrying a consignment for the British Museum. By mistake, Layard's crates were taken to the British Museum with the others, and once there, they could not be released to him without an order from the Trustees. This was evidently a source of some irritation to Layard, who now felt himself obliged to justify his ownership of these pieces. He wrote to Henry Ellis, Principal Librarian of the Museum:

Amongst the cases of sculpture recently brought to England by the "Fortitude" and deposited in the British Museum, were twenty nine cases marked HL & three marked S.R. which contain fragments of sculptures & other objects. They are my property, were sent by separate means of conveyance to Mossul & are entered, with the exception of two, in separate bills of lading, now in my possession. Contrary to my original direction they were sent to the British Museum, & having once been deposited there cannot be removed without the sanction of the Trustees. Two Bas-reliefs were obtained from Nimroud & have been given by me to the University of Oxford. They are mere duplicates of others already in the British Museum. The others are likewise duplicates or mere fragments of little value which I have selected for myself. I venture to hope that the Trustees will give such directions as will enable me to remove the cases indicated.[31]

The reply was quick and positive: "The Trustees have authorized Mr. Hawkins to

deliver to your order the 29 cases marked HL and the 3 cases marked S.R. now at the Museum and referred to in your note of 12th inst."[32]

Though the Trustees' response was just what Layard hoped for, the request drew attention to Layard's practice of using his private resources to remove duplicate sculptures for his own purposes. This evidently did not sit well with at least some of the Trustees, and a few months later they seized on another such instance as a pretext to demand an explanation from him. In his reply, Layard referred not only to the case in question, but to his own collection as well:

I have to acknowledge your letter of the 17th March [1852] in which you inform me that the Trustees of the British Museum require some explanation upon the subject of an alleged present of Assyrian antiquities to the Jerusalem Society. . . . I believe that I am not incorrect in stating that I was directed in [the Trustees'] instructions not to send down[?] duplicates of sculptures or inscriptions already in the possession of the British Museum. I had hoped that such being the case the Trustees would not have deemed the presenting of a few fragments of sculpture & inscribed bricks to a society such as that [*illegible*] at[?] Jerusalem [objectionable]. . . . Had they remained on the spot they would probably have been all destroyed by the Arabs. The expenses were paid out of my own pocket.[33]

He adds that the sculptures sent to England for himself were duplicates with no peculiar features different from those in the British Museum, and then concludes: "I cannot refrain from adding that it was only by actual want of means that I was prevented from sending more sculptures to the Museum and that, whilst the Trustees seem to be suspicious about a few insignificant specimens sent by me to Europe, a large number of highly interesting bas-reliefs . . . still remain at Kuyunjik."[34] This last caught the Trustees' attention, and later that year they dispatched Hormuzd Rassam to Nineveh to retrieve some of the more interesting remaining sculptures.

But to return to the story of the Nineveh Porch, in early November 1851 Layard's own sculptures were still being stored in the British Museum. Eight days after Sir John approved the Porch, Lady Charlotte wrote:

I introduced Henry Layard to Mr. Purnell and they made an appointment forthwith to meet at the British Museum—and to arrange the transport of some more marbles to Canford, which Henry is so good as to contribute towards completing the Porch—I tell him I only hold them in trust for him, and to be considered removable should he want them himself at any future time—but at least for the present they will form a valuable addition to those we possess—To-day he gave me Bill of Lading of a Large Lion and Bull he has had transported on purpose for us—and now I am beginning to fidget lest anything might befall them on their passage—I feel as if such marvellous and precious relics of a bygone age could never come safely into my possession—If we do get them safe and if the room is ever finished it will be as interesting a little spot of ground that Porch as any in England.[35]

This is Lady Charlotte's fullest statement of her feelings about the Nineveh Porch.

In addition, it is clear here that Lady Charlotte makes a distinction between the sculptures she owns, namely the lion and bull and the reliefs already at Canford, and those contributed by Layard, which she considers merely to be on loan from him. There is no evidence, however, that Layard himself made this distinction. I have not found any list of sculptures donated by Layard to the Porch at this time,

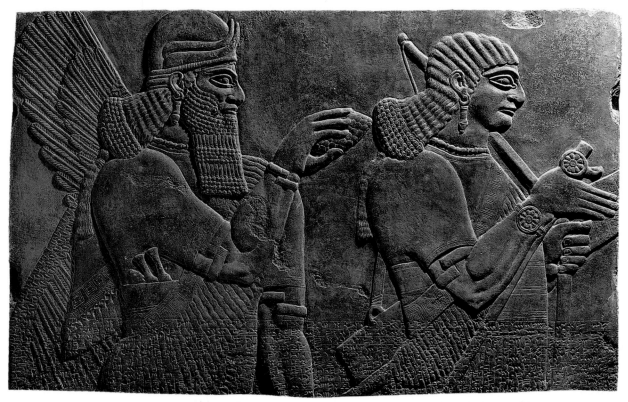

44: Nimrud, Northwest Palace, Room C, Slab 6; Kyoto, MIHO Museum; 114 × 183 cm.
This slab is the upper half of L. W. King no. 28 (photo: Christie's)

45: Nimrud, Northwest Palace, Room C, Door b, Slab 2; Metropolitan Museum 32.143.8; 234 × 207 cm; L. W. King no. 4 (photo: Metropolitan Museum of Art, Gift of John D. Rockefeller, Jr., 1932)

46: Nimrud, Northwest Palace, Room C, Slab 8; Metropolitan Museum 32.143.11; 113 × 94 cm; L. W. King no. 24 (photo: Metropolitan Museum of Art, Gift of John D. Rockefeller, Jr., 1932)

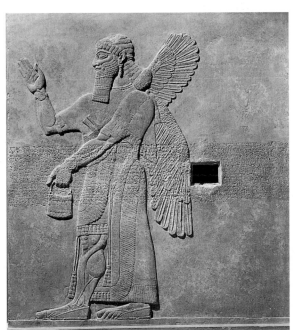

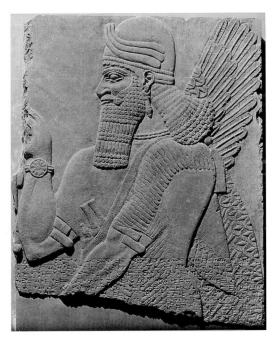

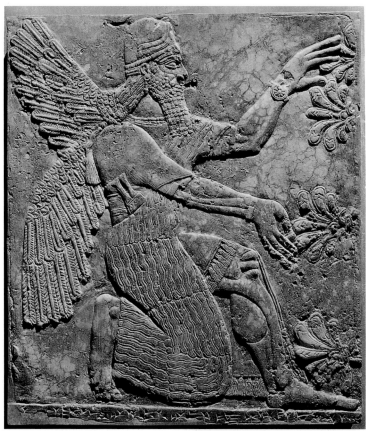

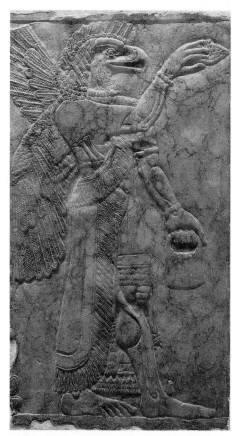

47: Nimrud, Northwest Palace, Room I, Slab 28; Metropolitan Museum 32.143.14; 78 × 67 cm; L. W. King no. 26, upper left part

48: Nimrud, Northwest Palace, Room I, Slab 1; Metropolitan Museum 32.143.12; 105 × 60 cm; L. W. King no. 26, lower left part

49: Nimrud, Ninurta Temple, Door 1, lower left; Metropolitan Museum 32.143.9; 133 × 69 cm; L. W. King no. 14

50: Nimrud, Ninurta Temple, Door 1, lower right; Metropolitan Museum 32.143.10; 134 × 69 cm; L. W. King no. 16 (photos: Metropolitan Museum of Art, Gift of John D. Rockefeller, Jr., 1932)

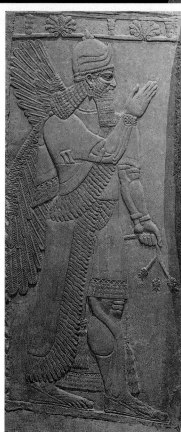

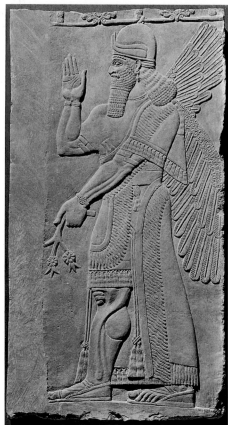

51: Nineveh, Southwest Palace, Room VIII, Slab 12; Bible Lands Museum Jerusalem no. 1063; 46 × 71 cm; L. W. King no. 23 (photo: Bible Lands Museum Jerusalem)

52: Nineveh, Southwest Palace, Room XIX, Slab 3; Boston, Museum of Fine Arts 60.133; 66 × 85 cm; L. W. King no. 8 (photo: Courtesy of the Museum of Fine Arts, Boston)

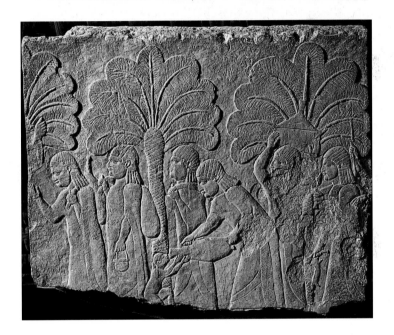

but at least 17 new sculptures, in addition to the lion and bull, joined those already at Canford before the Nineveh Porch was completed, and all of these must have come from Layard. They include five slabs—three from Room C (figs. 44, 45, 46) and two from Room I (figs. 47, 48)—from the palace of Assurnasirpal II at Nimrud (see fig. 5) and two slabs from the Ninurta Temple, also at Nimrud (figs. 49, 50). Also included were nine fragments from Sennacherib's palace at Nineveh (see fig. 11): two each from Rooms VIII (figs. 13, 51), XIX (figs. 52, 53), and XXXVIII (figs. 14, 54), one from Room XXXII (fig. 55), and two from uncertain locations (figs. 56, 57). With the exception of the reliefs from Assurnasirpal's palace and possibly one of the uncertain slabs from Sennacherib's palace (fig. 57), all of these sculptures were from areas excavated by Layard during his campaign of 1849–51.[36]

The additional sculptures were duly dispatched. Layard spent Christmas 1851

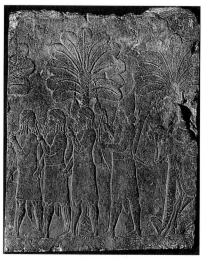

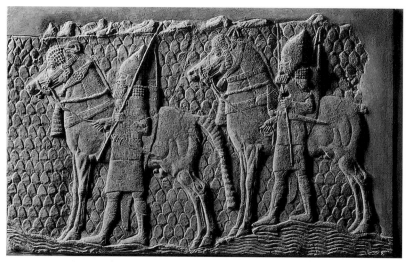

53: Nineveh, Southwest Palace, Room XIX, Slab 8; British Museum WA 132814; 82 × 67 cm; L. W. King no. 22 (photo: Trustees of the British Museum)

54: Nineveh, Southwest Palace, Room XXXVIII, Slab 13; Metropolitan Museum 32.143.16; 51 × 85 cm; L. W. King no. 15 (photo: Metropolitan Museum of Art, Gift of John D. Rockefeller, Jr., 1932)

55: Nineveh, Southwest Palace, Room XXXII, Slab 2; Metropolitan Museum 32.143.15; 83 × 60 cm; L. W. King no. 11 (photo: Metropolitan Museum of Art, Gift of John D. Rockefeller, Jr., 1932)

56: Nineveh, Southwest Palace, room unknown; Metropolitan Museum 32.143.5; 51 × 46 cm; L. W. King no. 13 (photo: Metropolitan Museum of Art, Gift of John D. Rockefeller, Jr., 1932)

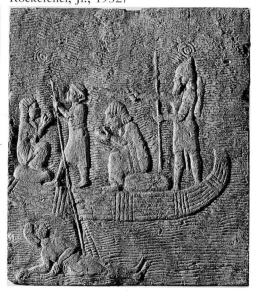

and New Year's Day 1852 at Canford, and one of his projects while there was the unpacking of these pieces. On the last day of the year, Lady Charlotte reported that she and Layard "fetched Mr. Pyne and arranged with him about the unpacking of some more marbles that Henry had sent him about two months ago to complete the Nineveh Porch. We settled to put them into the portico room and to commence a bit the first thing the next morning."[37] And on New Year's Day 1852: "Henry Layard unpacked the Ninevite Marbles this morning—and they were placed in the Justice Room till they could be better disposed of. This filled up most of the day."[38]

Canford had two other interesting visitors during the holidays. One was the Rev. Solomon Caesar Malan, who had visited Nineveh in June 1850 while Layard was there.[39] Lady Charlotte had seen some of his drawings earlier that fall: "I had also a long visit this morning from Henry Layard, who brought me some beautiful sketches to look at done by Mr. Mallan a friend of his, and a Dorsetshire clergyman who had been at Nineveh some time ago."[40] In early January 1852, Lady Charlotte wrote from Canford: "Before luncheon Mr. Malan came, who is a great friend of Henry's and had been staying with him in the East. We had accordingly invited him to meet him here as his living (Broadwindsor) is not very far from this. He seems a wonderfully clever and very agreeable man and I am very glad we had this opportunity of making his acquaintance."[41] He remained at Canford for two days: "We spent the morning in looking over drawings etc. with Mr. Malan, who also went out with us and gave Maria some idea of sketching—After lunch he left us."[42]

LUDWIG GRUNER

The other holiday visitor to Canford at the beginning of 1852 was Ludwig Gruner. As details of Gruner's career in England are scattered, and as he apparently played an important role in the decoration of the Nineveh Porch, a brief summary of his

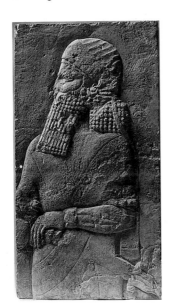

activities prior to his first visit to Canford is given here. Born in Dresden, Gruner (1801–82) was an engraver by training and had lived in Rome from 1836 to 1843, becoming thoroughly acquainted with Italian art from antiquity to the Renaissance. It was presumably in Rome that he met another German wanderer, Prince Albert, in 1839. In 1843 Gruner moved to England, where he worked until 1856, when he was appointed director of the print collection at Dresden. In 1845 he became Albert's "adviser on art," in which capacity he provided designs for furnishings, acted as the agent for the Prince and the Queen in the purchase of paintings and sculp-

57: Nineveh, Southwest Palace, probably from the Ishtar Temple procession; Metropolitan Museum 32.143.13; 67 × 35 cm; L. W. King no. 18 (photo: Metropolitan Museum of Art, Gift of John D. Rockefeller, Jr., 1932)

58: London, Buckingham Palace, Garden Pavilion, section showing interior decoration designed by Ludwig Gruner (Gruner 1846, pl. 3)

tures in Italy, and planned and supervised the execution of the interior decoration for the Garden Pavilion (1843–45), Grand Staircase (1845), and new South Wing, including the Ball Room and Supper Room (1853–56), all at Buckingham Palace, and for the new royal residence at Osborne House (1845–48). He later designed the mausoleums of the Duchess of Kent (1860–61) and Victoria and Albert (1862–64) in the grounds of Windsor Castle.[43]

Gruner also continued to work as an engraver in England, producing deluxe folio volumes of Italian architectural decoration (1844, 1850), as well as a lovely volume of chromolithographs of the Garden Pavilion (1846). In his preface to the latter work, Gruner states that after the eight lunettes in the center room had been completed in fresco by eight well-known artists, he had been called in "to present designs for the completion and decoration" of the center room and two subsidiary rooms, and to procure painters, sculptors, and craftsmen—some 25 in all—to execute his designs.[44] Milton's *Comus* had already been chosen by Albert as the decorative theme of the central room. Gruner, presumably in consultation with the Prince, chose Pompeii as the theme of the south room and Walter Scott's novels for the north, and designed and executed elaborate decorative schemes for all three rooms (fig. 58). By 1852, therefore, Gruner had designed and executed an elaborate decorative scheme for at least one garden pavilion, as well as numerous rooms in the royal residences.

His first major publication of decorative art in English was *Fresco Decorations and Stuccoes of Churches and Palaces in Italy* (1844), published under the name Lewis Gruner. The majority of the volume is devoted to views and details of sixteenth-century decorated buildings, mostly in simple line engraving with some

hand-coloring, the amount of coloring varying from copy to copy. A number of the plates offer fine details of decorative patterns from the buildings—the final plate in particular, labeled "Key to the Colouring of the Plates" (plate 46), is a breath-taking compendium of over 100 colored examples of decorative patterns drawn from the previous plates. For the student of design, this single plate must have seemed a veritable encyclopedia of Italian Renaissance pattern. Gruner's reputation as an authority on design was now firmly established, and when the Council of the Government School of Design decided in 1846 to commission a history of ornament for student use, they turned to Gruner.

Gruner had been supplying the London and provincial branches of the Government School of Design with drawings and paintings of Italian ornament since 1843.[45] In 1845–46 he also began to supply the School with a large number of casts. In the three previous years the School's total annual expenditure for casts, primarily from a Mr. Brucciani, was in the range of £300–£500.[46] In 1845–46 Gruner is the only supplier mentioned for casts and drawings, for which the total expenditure was £1392.[47] Gruner was, therefore, well-established with the School by 1846.

In the reports of the Council of the Government School of Design from the first half of the 1840s much space is devoted to discussions of the threat to British industry posed by the perceived superiority of German and French design. One of the causes of the problem, it was decided, was that British designers did not have easy access to models of great design from the past, as there was no published collection of ornament at an affordable price. A solution was first suggested in the Council's report of 1844, which proposed that the Council publish "a Cyclopedia of Ornament, classified for the use of artists and manufacturers of every description, and which, in order to be really conducive to the highest improvement of taste and design, should surpass, in the choice of its contents, and the excellence of their execution, all that has hitherto been published by private enterprize."[48]

The Council's report of 1846 announced that work had commenced on a reference book that would "provide at a cheap rate examples derived from the best and purest sources, for the guidance of all who are interested in the improvement, or engaged in the practice, of ornamental art, and for the securing to the Schools the advantage of a uniform series of drawings, executed on a large scale, and illustrating the most important styles of antiquity, of the middle ages, and of the revival." It was to "be attainable by the public at a price so moderate, that the general circulation of the work among designers and manufacturers throughout the country may be fairly anticipated." Gruner was selected to produce the work, both because he had been the primary supplier for the School's collection of casts and copies, some of which were to be used in the preparation of the volume, and because of his experience as a printmaker and designer. Gruner was instructed initially to prepare a part of the work as a trial, with production to continue if it was judged a success.[49]

In June 1847 the Council approved the trial portions submitted by Gruner and contracted with him for the work's completion. Referred to as "Gruner's Drawing Book" in the Parliamentary Papers, it consisted of 80 plates, issued in 10 parts. Upon the completion of each part, Gruner was paid £150, for which the Council

received 50 copies. Each part was made available to the public at a cost of £1 1s. (1 guinea), with Gruner receiving all profits from its sale.⁵⁰ The final product was divided into four sections: 29 plates of miscellaneous designs (Etruscan, Classical Greek and Roman, Early Christian, Renaissance, and natural flowers); 7 plates of "Pompeiana"; 26 plates of "Church Ornaments" (twelfth–fifteenth centuries); and 18 plates from "Palaces" (mainly sixteenth-century). All but five plates (two German subjects and three of natural flowers) are devoted to subjects from Italy. It was issued as a complete volume in 1850 under the title *Specimens of Ornamental Art, Selected from the Best Models of the Classical Epochs*, but the separate parts became available for use in the School of Design from 1847 onwards, as soon as they were issued.

Opinions on the utility of the work as a teaching tool were mixed. In May 1849 Charles Richardson, architecture and perspective master at the London School of Design, was questioned by a Parliamentary Committee: "The Board of Trade has spent a great deal of money upon a drawing-book; is that book found useful?" Richardson answered: "A great many of the plates are very good; it is a very useful and beautiful work."⁵¹ Richardson's seems to have been the minority opinion, however, at least within the School of Design. In April 1848 John Horsley, Henry Townsend, William Dyce, and Richard Redgrave, respectively the head masters of color, form, and ornament, and the master of botany, all from the London School of Design, expressed their opinion of Gruner's book in a letter to the Parliamentary Committee. The collection, they said, "is thrown together with an indefiniteness of purpose and a want of order and connexion." Well-known examples of ornamental art were omitted in favor of "a miscellaneous selection of designs possessing for the most part little value beyond that of archaeological novelty. . . . Although the fact that most of the designs in Mr. Gruner's work are hitherto unpublished may tend to promote the sale of it, we certainly cannot think that such a consideration ought to be allowed to interfere with its utility as a production sanctioned by Government." The masters objected particularly to some of the Pompeian examples, which were "not only useless, but positively bad." Redgrave elsewhere characterized the work as "very heterogenous."⁵²

The masters' animosity towards Pompeian ornament sounds strange today, but it appears that by 1848 they were suffering from overexposure to it. John Herbert, head master of ornament at the London School of Design in 1849, complained that in 1844 a compulsory class in Pompeian ornament had been introduced into the School, which thereafter "looked a good deal more like a large Pompeian bath than an English school of design; in fact there was no original design introduced which was even creditable during the whole time. . . . At the time the Pompeian art was in the school every one of [the students] was doing things only fit for the decoration of a Pompeian bath."⁵³ One wonders whether this craze in the London School of Design for Pompeiana was related to Gruner's introduction of a Pompeian room into the Garden Pavilion at Buckingham Palace.

Other objections focused on the cost of the book. Henry Cole, a staff member in the Public Record Office who had been assigned to assess the management of the School of Design (and who would become the School's General Superintendent

in 1852, founding the Museum of Manufactures, which later became the Victoria and Albert Museum), objected to the cost to the government: "If you were to ask Mr. [John] Murray, or any other publisher, whether they would have spent a sum of £1500 in publishing that book for the promotion of ornamental design in this country, they would say it was quite beneath their consideration."[54] John Crace, a professional designer, recommended that government publications on ornament follow the model of the Prussian government, so that "the works could be readily sold at a low price, and not at the extravagant rate that the works published by the School of Design are now sold at." Each part of Gruner's book, he said, "is charged a guinea a number, . . . making it too expensive a work for any poor operative to be able to purchase. . . . It is because the works are so extremely dear, that the demand for them is limited. I have no doubt that almost all the operatives that I have would buy such a work if they could obtain it at a low price."[55]

As a learning aid for students and working designers, then, Gruner's drawing book was hardly judged a success. For our purposes, however, some of the criticisms of the book are suggestive. In particular, the charges that Gruner valued "archaeological novelty" and heterogeneity above familiarity suggest that even though the drawing book contained no Assyrian designs, the novelty of appropriating Assyrian designs in a decorative context might well have appealed to him. Similarly, his championing of Pompeian ornament after it had gone out of fashion in the School of Design suggests a sympathy for unusual ornament regardless of current taste, which might also have inclined him to experiment with Assyrian design. Perhaps Gruner would have been inclined to be as receptive to Assyrian design in 1852 as was Richard Redgrave, by then Art-Superintendent of the Department of Practical Art (formerly School of Design), when he wrote late in the same year that the collections of the British Museum should be utilized in the teaching of the principles of ornamental art. In particular, he observed, "the late acquisitions from Nineveh would supply, both by casts and drawings, many curious and beautiful examples of metal work, of jewellery, and of embroidery."[56]

In addition to his activities as art advisor to the prince and publisher of ornament for the School of Design, Gruner also maintained an active commercial printing establishment in London. According to Bohrer, who has studied the John Murray archives, Gruner worked closely with George Scharf on the illustrations for *Nineveh and Its Remains* and is mentioned often in Scharf's correspondence with Layard. Gruner was also responsible for at least five, and probably all nine, of the color lithographs in the first series of *Monuments of Nineveh*.[57] Bohrer suggests that Gruner may have been invited to Canford through his connection with Layard and Scharf.[58] This suggestion receives considerable support from the circumstance that Lady Charlotte first mentioned Gruner on 25 October 1851, the day that Scharf arrived for his visit: "This evening a book of Gruner's, full of fine illustrations of medieval art was looked over—and we had some pleasant and not useless discussion on matters of taste."[59] Since Scharf and Layard were both at Canford two days later when Sir John agreed to build the Nineveh Porch, it is possible that they were already considering asking Gruner to take on the interior decoration.

With the drawing book behind him and the South Wing of Buckingham Palace not yet closed in, Gruner had the time in 1852 to take on new projects. He arrived at Canford on 5 January 1852, the same day as Malan. Lady Charlotte wrote: "M. Gruner arrived whom we had asked to come here and give us his opinion about some of our furnishings. Most of the morning I spent with him. . . . We looked . . . at Mr. Gruner's publication of Italian Decorations—A magnificent Work."[60] Gruner certainly became involved in the Porch, as a few months later Lady Charlotte wrote: "I had a long séance with Gruner about designs for decorating the Nineveh Porch and other matters."[61] Another of Gruner's projects in 1852 was the lithographing of most of the plates for the second series of *Monuments of Nineveh*, in the introduction to which Layard acknowledged: "The bas-reliefs have been skilfully drawn on stone by Mr. L. Gruner."[62] By early 1852, then, Gruner had already lithographed most of the patterns that would be employed in the decoration of the Nineveh Porch, and he would lithograph the remainder in 1852–53 in consultation with Layard. Clearly, Gruner was well-suited to undertake the decoration of the Nineveh Porch.

THE PROCESSION OF THE BULL AND LION

In late January 1852, Lady Charlotte began work on her personal contribution to the decoration of the Nineveh Porch: "I . . . began one of the borders for the Ninevite Purdeh which we have undertaken to work for the Porch. It will take us some years I think to complete it."[63] In early February Layard was again at Canford. Lady Charlotte wrote that he and she "had a little walk on the Terrace—and inspected the progress of the Nineveh Porch—and we had much talk about many visionary plans for Good, before he went away."[64]

The Guests spent the spring in London and they saw Layard almost daily. Among the activities Lady Charlotte mentions are visits with Layard to the Nineveh Panorama. In late February she wrote: "Henry accompanied me and Maria to see the Panorama of Nineveh this morning. I was very well pleased with it. It is very well done and gives an excellent idea of the place and country." The next day Layard "called to take Mr. Jenkins to the Panorama, but did not find him here" and a month later he accompanied the Aboynes and Maria to the Panorama.[65] On 19 May 1852, Lady Charlotte's fortieth birthday, she wrote: "In order to make the birthday gay for the children, I sent them first to the British Museum, then to the gallery of illustrations to see all the Duke of Wellington's battles and later to the Panorama."[66] One imagines that this made the birthday more enjoyable for her as well.

This is probably Robert Burford's Panorama of Nimroud, which opened in the upper circle of his Leicester Square Panorama in late December 1851 and was so popular that it ran for 18 months.[67] The *Illustrated London News* provided a brief description of this panorama:

PANORAMA OF NIMROUD. We were admitted on Thursday [December 18] to a private view of Mr. Burford's new panorama, which, from its classical and sacred associations, will, no doubt, prove highly attractive. The drawings from which it has been painted were taken by

C. F. Barker, Esq., and the execution, as usual with all Mr. Burford's pictures, is admirable. The subject is the Tel, or Mound, of Nimroud, and the various points are sketched with a fidelity which strikes every spectator who has read Layard and the other authorities on the history of the place, and the discoveries so recently made. The panorama has been taken from an elevation from which the whole of the mound and every excavation on its surface are distinctly traceable.[68]

Burford had written to Layard in 1850 offering to create a panorama based on Layard's sketches, but the extent of Layard's actual involvement in the project is unknown.[69] In any event, his visits to the show with Guest friends and relations suggest that he approved of the finished product.

In late March Lady Charlotte accompanied Layard to the British Museum, and from her diary entry it appears that she was still interested in Assyrian excavations: "Mary and I hastened to join a party to see the Museum with Henry Layard. . . . Grieved to hear that Col. Rawlinson has, without any authority given up our valuable excavations at Khorsabad to the French. This is inexcusable conduct—for he had plenty of money granted to carry them on."[70] This latter statement is surprising, since the British had never conducted excavations at Khorsabad, with the exception of a few brief soundings by Layard in late November 1849.[71] Perhaps Lady Charlotte actually meant Kuyunjik, the northern end of which Rawlinson ceded to the French archaeologist Victor Place in early 1852.[72] In any case, it is clear that her source of information here is Layard, whose dislike of Rawlinson is also clear. A week later Lady Charlotte reported the commencement of another piece of Ninevite needlework, this time with an instructional purpose: "Henry Layard dined with us. We drew a Nineveh pattern for my Dowlais schoolgirls and had rather a merry evening."[73]

Meanwhile, work apparently continued apace on the Nineveh Porch. On 28 February 1852, the *Illustrated London News* announced the arrival of the lion and bull: "The vessel *Apprentice* not only brought the [British Museum] antiquities from Bussorah, but also a considerable quantity of ancient marbles from the same quarter for Sir John Guest." At the beginning of March, Lady Charlotte wrote that she met with Barry "about the Canford improvements especially that portion of them which relate to the Nineveh Porch, the Arcade to which I wish to have made a little wider than already planned and adapted for flowers—It is quite time we got that porch finished for the large Bull and Lion are arrived and safe at Canford—for the present they are stowed away in the Coach-house."[74] One interesting feature of this entry is the reference to the arcade. Lady Charlotte had originally wanted a conservatory at Canford, but Sir John had canceled the project two years before as expenses mounted. Now it is back, in the guise of the arcade that connects the house with the Nineveh Porch. Sir John was probably too ill by this time to care.

Late in March, Lady Charlotte went to Canford for a day to attend her daughter Katherine's confirmation. She wrote: "The whole ceremony was over and I was at Canford again by four o'clock. . . . I had brought down Mr. Barry's amended Drawings for the Arcade and marked it all out on the ground—I tried to see the Bull and Lion, but they were put away under straw in the Stables and I could not get much glimpse of them." Of all the animals that have ever occupied

stables, these two must surely rank among the strangest. Lady Charlotte returned to London that evening and noted that she "found Merthyr pretty well—though they said he had been fidgety at my absence—I should not have dared to leave him for a longer time."[75] In early June, Lady Charlotte made another day trip to Canford:

And now comes "my one little pleasure"—I had long contemplated going down to Canford—and this was the day fixed for the purpose—Sir Charles Barry and Henry Layard were to go with me—Soon after 5 I was up—It poured with rain—Nevertheless, leaving dear Merthyr with many kisses, I was at the Waterloo Station before 7—and my two fellow travellers joined me soon afterwards. . . . We were soon at Canford . . . and then went about planning and intriguing—The rain was pitiless the whole day—Yet Canford looked most lovely, the foliage luxuriant in the extreme—and the whole place wonderfully improved by the recent alterations to the Gardens—At length to my regret it was time to return—at 5.30. (having spent a good five hours at home) we were once more en route for town. . . . I cannot express how I enjoyed this little spell of liberty.[76]

Though the Nineveh Porch is not mentioned here, it and the arcade may be among the "alterations to the Gardens" to which she refers.

In mid-June Sir John, who had been suffering severely from bladder stones, was persuaded to visit the British Museum with Layard. Lady Charlotte wrote: "Mr. Mallan called this morning—Merthyr I think was glad to see him again—and much to my satisfaction, he agreed to go with him and Henry Layard to the Museum in the afternoon—We went there accordingly—and I think my dear husband was amused and pleased—He staid there, among the Egyptian and Ninevite antiquities nearly an hour—He admired the great Bulls—and I think felt more reconciled to the idea of our own things being put up."[77]

In July the Guests returned to Canford for the summer and Layard joined them. He was engaged in two projects while he was there. The first was to work on the narrative account of his second campaign at Nineveh and the accompanying folio, which would be published the following year by Murray as *Discoveries in the Ruins of Nineveh and Babylon* (1853a) and *A Second Series of the Monuments of Nineveh* (1853b). He shared the illustrations for one or both of these works with the Canford residents and visitors. In late July Lady Charlotte reported: "I expected Mr. and Mrs. Braithwaite and Miss Westby to dinner—Our evening was a very quiet one—they looked over a volume of Henry Layard's engravings for his new work while I sat by dear Merthyr, who seemed better than usual to-night."[78] And a few days later: "In the afternoon I tried to interest Merthyr looking over (with Mr. Seymour) the engravings for Henry Layard's new Work."[79]

Layard's other project at Canford that summer was the installation of the bull and lion in the Nineveh Porch. On 21 July Lady Charlotte reported: "Sir Charles Barry arrived in the evening [of the 20th]—and remained till the following afternoon—and a very busy day we had—not a moment was lost—and Plans and Drawings abounded."[80] Two days later, the procession of the bull and lion commenced:

The Bull, the great Nineveh Bull—was to-day (Friday) to begin his progress from the Stables, where he has long been stowed away, to the new Nineveh Porch which has been erected for his reception and that of his compeers, and which is now completed, all but the

internal decorations—The Bull had been cut in four pieces—So had the Lion, for the better convenience of transport—These sections were all piled up in a coach-house, and there was some difficulty in getting them dismembered from one another and fairly en route for their new abode—After a long day's work—the first portion viz:—the forelegs of the Bull, was got out, placed on a truck and conveyed to the Porch—My interest in the proceeding was so great that I persuaded Merthyr to let Mr. Newton accompany him driving, instead of me—and I remained watching the Work all the afternoon—It was a great satisfaction to me when this fragment was safely housed.[81]

The reference to the state of completion of the Nineveh Porch structure is of interest here, as it gives a *terminus ante quem* for its architecture.

Work continued on the following day: "Saturday. In the morning we were all interested in the removal of another portion of the Bull—and we vibrated between the Nineveh Porch and the Stables where the Treasures lay—After luncheon Merthyr was very anxious that I should drive with him. . . . Home in good time for dinner—but found that very little progress had been made with the Bull in our absence."[82] The colossi are not mentioned in the diary entries for Sunday and Monday. By Tuesday, Lady Charlotte evidently felt that her continual presence at the Porch was no longer required: "Drove over this afternoon with Maria and Augustus in the poney carriage to High Cliff—Henry Layard was anxious to have gone with us—But the Lion was in the agony of being moved, so he did not like to leave the workpeople—whom he was superintending. . . . The marbles had made much progress during our absence."[83] The next day she noted: "Henry busy with the Marbles and his Book."[84] On 29 July 1852, her nineteenth wedding anniversary, Lady Charlotte reported that the move was completed: "The great Bull and Lion were finished putting up—though not quite secured etc. But they looked magnificent in their places, on their Purbeck Marble Pedestals."[85]

In mid-August 1852 Canford had another of its interesting visitors. Lady Charlotte wrote: "Mrs. Henry Layard (Henry's mother) came to us today bringing with her Mr. Rassam who is going out to Nineveh to superintend the excavations there."[86] Hormuzd Rassam, the Assyrian Christian who had served as Layard's right-hand man on both of his expeditions to Mesopotamia, had now been selected by the British Museum Trustees to carry on Layard's work at Nineveh. The Canford household found him to be most entertaining:

Mr. Rassam came down this evening dressed in his Assyrian dress to shew it to the children—He is a quiet, interesting young man—clever—with peculiar manners and Eastern views, very strange to Europeans but amusing—and he has good sense and is quite unobtrusive—He seems to dote on Mrs. Layard whom he calls his mother—He always signs himself in writing to her "Your Chaldean Son"—Merthyr was interested and pleased with him—which was a great pleasure to me as he now takes so little notice of anything.[87]

Like Layard, Rassam seems to have been a gifted storyteller; on his last day at Canford, he captivated everyone with one of his tales:

After luncheon we all assembled in the Great Hall—and Mr. Rassam very kindly acceded to my request that he would tell the children an Oriental tale—They all sat round him on the ground and we had a charming version of the story of Bluebeard which lasted about two hours in the telling—Merthyr even sat by and listened to some of it. Mr. Jenkins was

all attention—and in fact our whole party profited by it—After the tale they played at various games and while these were going on Lord and Lady Eastnor and Henry Layard arrived—It was fine enough for Lord Eastnor to accompany us to the Porch—and to walk about the grounds a little before dinner. . . . Mr. Rassam left us at night—returning by the Mail train to London—He is to start for Nineveh in the course of a few days—His visit has been a pleasant little episode.[88]

There can be no doubt that Rassam saw the new Nineveh Porch in the course of his visit, a point that will be of significance later. That November, Rassam wrote to Layard from Mosul about the condition of the sculptures still at Nimrud:

There have been about thirty sculptures taken out of the mound of Nimroud since we left; some were given to Mr. Hector, some to Captain Jones and Dr. Hyslop and the rest were taken by Colonel Rawlinson & my brother. The American missionaries & the French have now permission to take some, and I believe in the end there will be none left. None of the remaining Lions or Bulls have been removed and the only one I believe worth having is the yellow Bull at the great Hall. If Lady Charlotte would wish to have any bricks or sculptures she better make haste or else we shall have very few things left worth having. I shall not be able to send anything without an order from the British Museum or Colonel Rawlinson; and if you want anything yourself write & tell me.[89]

There is no evidence that Rassam sent any slabs to Canford, except for the possibility that fig. 57 came from Rassam's excavations (see Appendix 4).

Work apparently continued on the Nineveh Porch during the remainder of August 1852. Lady Charlotte refers to it several times in passing: "Tuesday. A determined wet day—thunderstorms etc.—So we got no further than the Nineveh Porch." And two days later: "Lady Heathcote and her daughter amused themselves polishing some little fragments of Nineveh stone under the directions of a very intelligent Mason who is working at the Porch and whose name (Alfred Blethman) deserves to be recorded." And finally on 8 September, the day before the Guests left Canford for London: "Henry could not do much more at the Porch so we arranged that it should be closed during our approaching absence."[90]

The Guests remained only a few days in London, as Sir John's condition was very poor and his doctor felt that he would be more comfortable in Dowlais. Lady Charlotte cared for him and assumed an increasing responsibility for conducting his business affairs. In the midst of everything else, she continued to advocate Ninevite needlework as a useful and educational pastime for the girls in the Dowlais schools and her daughters: "I have been occupying myself . . . for the last two or three days—in planning a border of needlework of a Ninevite Pattern, which the first class of the evening girls school are to try to execute—being in separate squares. I think they may accomplish it—and if they can it will be a great encouragement to them—and useful to the school."[91] In mid-November she wrote: "I sat on the accustomed armchair till dinner time writing letters—Little Blanche near me, with her work, part of a Ninevite Border."[92] Sir John lay near her on the sofa in the same room. He died nine days later, on 26 November 1852, leaving Lady Charlotte as the sole proprietor of the Dowlais Iron Company and sole guardian of their ten children.

THE NINEVEH PORCH DESCRIBED

As there are no further detailed references to the decoration of the Nineveh Porch in Lady Charlotte's diaries, this is the place to attempt to reconstruct the appearance of the finished ensemble. The Nineveh Porch is now officially listed as a Grade 1 historic building. Its exterior plan is a Latin cross, with an entrance porch at its south end (see fig. 20). Its exterior dimensions are about 18.4 meters north–south, and about 13.8 meters east–west. Like the rest of Canford Manor, it is in the Gothic Revival style, constructed of local buff-colored brick with stone trim and a slate roof (figs. 1, 59, 60).[1] The entrance porch originally had an open archway on each of its three exterior sides—a large pointed arch facing south, now glazed in, marked the main entrance, while smaller, flatter arches facing east and west served as subsidiary entrances. The one at the west side was bricked in, probably later when the conservatory was added. The one at the east, also now glazed in, is used as the entrance today.[2] In the gable above the south arch is a commemorative stone plaque: "These sculptures were brought from Nineveh and presented to Sir John Guest Bart. by their discoverer Henry Layard in the year MDCCCLI" (fig. 61). Old pictures of the Nineveh Porch show a two-tiered tower rising above the crossing (see figs. 19, 62). This has been demolished.

The entrance to the Nineveh Porch was through an archway on the north side of the entrance porch, the same size and shape as the south outer arch (4.28 × 2.77 m), but closed off by a heavy wooden double door covered on its inner and outer surfaces by an ornamental cast-iron grill (fig. 63). This door sets the theme for the decoration of the interior, for despite its Gothic setting, the motifs in the grillwork are purely Assyrian, drawn from Layard's *Monuments of Nineveh*. The door has three main parts—two door leaves and a tympanum—the whole being framed by a decorative border. The primary decorative element in the grillwork of the door leaves is a human-headed bull, repeated three times on each side of each leaf, facing toward the center (fig. 64). Though at first glance this looks like a perfectly good Assyrian figure, closer inspection reveals that it is a composite drawn from two sources. The body, tail, wings, and three of the four legs are copied from Layard's engraving of a bull colossus from the Nergal Gate of Nineveh, dating to

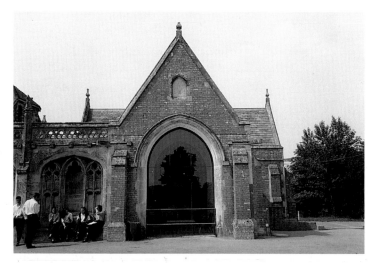

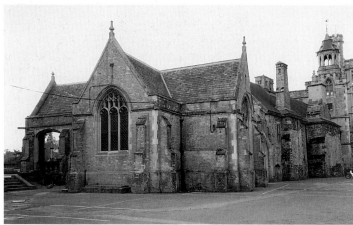

59: Nineveh Porch, straight front view (photo: author)

60: Nineveh Porch, angle rear view (photo: author)

61: Nineveh Porch, commemorative plaque above the door (photo: author)

the time of Sennacherib—the patterns of curls on the body and tail, the feather pattern, and the veins on the legs in the two figures have a clear source in this engraving (fig. 65). The Nergal Gate colossus shows only three legs in side view, however, and the examples on the door have four. Details of the head, most notably the number of horns and the shapes of the hair mass and crown, differ from the Sennacherib example as well. The source for these features was an engraving of a colossus from Sargon II's palace at Khorsabad, published in Botta's *Monument de Ninive* (fig. 66).

The two sources for the Nineveh Porch door bulls are readily identifiable, but they have been considerably transformed by the artist of the door. Most obvious is the combination of the two different figures into a single composite, even though either original is sufficiently well-preserved to have served as the sole source. Gruner may have chosen the Sennacherib bull as the principal source since he had already lithographed that figure, but added the fourth leg to make the figure look more dynamic, give it a more pleasing compositional rhythm, and eliminate the void beneath the body. The Assyrians themselves apparently recognized this; to achieve

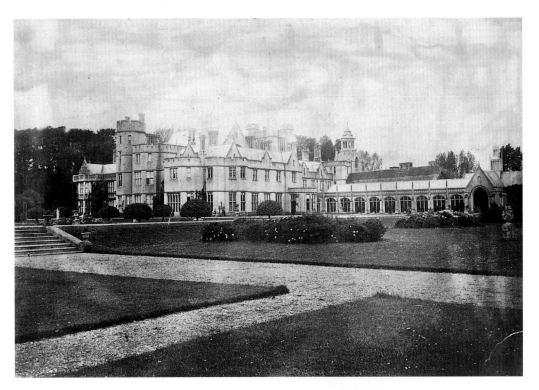

62: Canford Manor, the
Nineveh Porch on the far right,
photograph, ca. 1880 (photo:
RCHM, with the permission of
Sir John Cotterell)

63: Nineveh Porch, door, whole
(photo: Judith McKenzie)

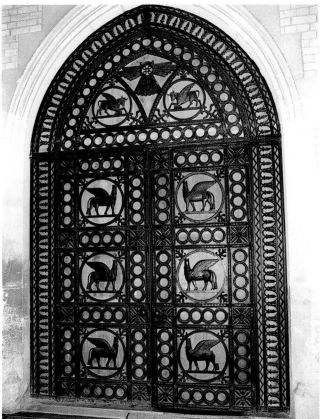

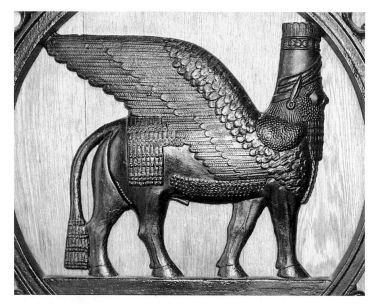

64: Nineveh Porch, door, detail: human-headed bull (photo: author)

65: Nineveh, Nergal Gate, colossal guardian figures (Layard, *Second Series of the Monuments of Nineveh*, 1853, pl. 3)

66: Khorsabad, Sargon's Palace, Facade m, Door k, Bull 1 (Botta and Flandin 1849, I, pl. 45)

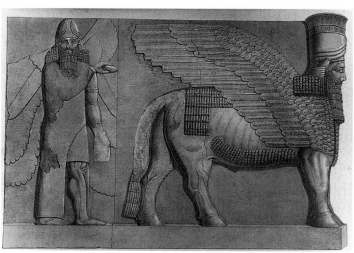

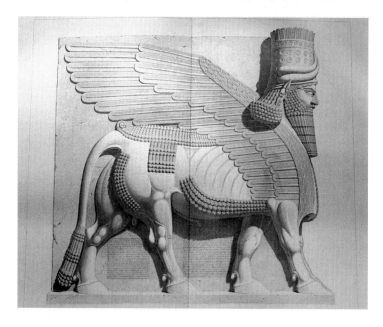

this ideal side view they were willing to overlook the fact that the resulting figure
had five legs. Similarly, the Sargon colossus head may have been substituted because
it exhibits a more dynamic treatment, which the artist has accentuated by tripling
the number of hair locks that radiate down over the back of the neck, increasing
the mass of hair curls on the shoulder and randomizing their pattern, and elon-
gating the ear and crown. All this creates an emphasis on the upward sweep of the
head. The wing tip has also been elongated toward the rear, again increasing the
figure's dynamism. Finally, all of the background around the bull has been cut out,
giving the figure a lighter appearance and making it look like sculpture in the round,
rather than the low relief of the originals.

The remaining elements on the door leaves are nonfigural. A guilloche frames the
four sides of each human-headed bull (fig. 67). This is a very common Assyrian
decorative pattern: Layard illustrated several examples from wall paintings, painted
bricks, and carved ivories (see figs. 28, 29). At each of the four corners of the frame
for each human-headed bull is a square pattern of alternating lotus blossoms and
buds lifted from Layard's engraving of a decorated Sennacherib pavement from
Nineveh (fig. 68). The same engraving was the source for the border that frames
the doors and tympanum. The rosettes at the joints of the vertical and horizontal
frame elements are very common Assyrian motifs, though here it may be only a
generic form as I can find no close parallel for the form it has on the door. I also
cannot find a close parallel for the stylized flowers at the corners of the human-
headed bulls, though they are reminiscent of Assyrian forms.

The tympanum introduces an additional motif: a pair of kneeling winged bulls
flanking a winged disk (fig. 69). Layard published two illustrations of winged bulls
in this pose, one from a wall painting and the other from an incised garment dec-
oration, both from Nimrud (see figs. 29, 70).[3] Either could have been the source
for the figures on the tympanum, where the composition was "improved" by having
the tail cross in front of the back leg. The source for the winged disk was Layard's
engraving of the front of the Black Obelisk of Shalmaneser III, which shows this
motif twice in the top two registers (see fig. 23).[4]

The combination of all these elements has a highly decorative effect, and its sym-
metry focuses attention on the center of the doorway. But while to our eyes the
ensemble appears very Assyrian, the grouping of the elements, especially in the tym-
panum, betrays a nineteenth-century sensibility. In ancient Assyrian representations,
bulls kneel only before palmettes or rosettes, not before the winged disk. In ritual
compositions the winged disk can be flanked only by symmetrically paired images
of the king, who tend the "sacred tree." The winged disk, therefore, appears in
Assyrian images as an emblem of kingship, not as an independent object of vener-
ation as on the Nineveh Porch door. The inspiration for the Nineveh Porch tym-
panum, in fact, would seem to be Romanesque and Gothic sculptured tympanums
that show Christ in judgment flanked by symbols of the Evangelists, among whom,
coincidentally, is a winged bull.

The placement of human-headed bull colossi in doorways is, however, correct
Assyrian usage, so their occurrence on the Nineveh Porch door leaves is Assyrian
at least in spirit. Moreover, the arrangement of three pairs of colossi on the door

67: Nineveh Porch, door,
border motifs (photo: author)

68: Nineveh, Southwest Palace,
Room XXIV, Door c, decorated
pavement slab (Layard, *Second
Series of the Monuments of
Nineveh*, 1853, pl. 56)

69: Nineveh Porch, door,
tympanum (photo: author)

70: Nimrud, Northwest Palace,
garment decoration, kneeling
bulls (Layard, *Monuments of
Nineveh*, 1849, pl. 43:4)

evokes the most magnificent passageway in Sennacherib's palace, which was also
lined with three pairs of bull colossi. As described by Layard, "it would be diffi-
cult to conceive any interior architectural arrangement more imposing than this
triple group of gigantic forms." In fact, though, Hormuzd Rassam's discovery of
actual bronze gate ornaments at Balawat in 1878 would prove that Assyrian palace
doors were very different from those of the Nineveh Porch.[5]

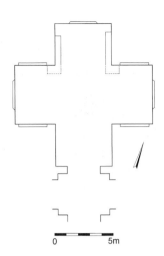

71: Nineveh Porch, plan (source: author)

72: Nineveh Porch, interior, angle view looking southeast with the door at right (photo: author)

73: Nineveh Porch, interior, angle view looking northeast, with north (left) and east windows (photo: author)

It seems likely that the Nineveh Porch doors were designed by Gruner in consultation with Layard. In 1852–53 Gruner was lithographing these very same designs for the second series of *Monuments of Nineveh*. The challenge of combining Assyrian elements into a novel "Assyrian" design would have been well suited to Gruner's talents, as would the merging of the Nineveh and Khorsabad bull colossi. The molding and casting of the doors could then have been carried out by a specialist, perhaps the craftsman John Hardman, who prepared ironwork and stained glass for the house at Canford from 1849 to 1851.[6]

The interior of the Nineveh Porch is a Greek cross in plan, measuring 11.6 meters north-south and 11.7 meters east–west (figs. 71, 72, 73). The east, north, and west end walls are each pierced by a large stained-glass window (3.58 × 2.19 m). Each window is composed of three vertical lancets and, like the doors, is decorated with Assyrian motifs, in this case drawn from painted bricks and wall paintings published in the first series of *Monuments of Nineveh*. These are rendered in the same

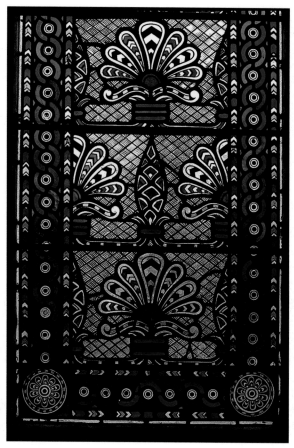

74: Nineveh Porch, north window (photo: author)

75: Nineveh Porch, north window, detail (photo: Judith McKenzie)

bright colors—red, blue, yellow, black, and white—as in their Assyrian prototypes, and this authentic color scheme contributes greatly to the windows' Assyrian effect.[7]

The north window, directly opposite the door, has the most elaborate decoration (figs. 74, 75). Its primary subject is a pattern of alternating buds and palmettes, taken directly from a Nimrud wall painting illustrated in *Monuments of Nineveh* and adapted to the vertical format of the lancets (see fig. 28).[8] The spaces between the palmettes and buds is filled with grisaille glass. The central pattern is framed by a border composed of a red and blue guilloche between two bands of multi-colored chevrons. Examples of both of these patterns from bricks and wall paintings at Nimrud were published by Layard (see fig. 28). The elaborate rosettes at the lower corners of each lancet were also copied from a Nimrud brick (see fig. 30). The color scheme of the Greek cross and two St. Andrew's crosses in the three circular lobes at the top of each lancet were adapted from a bud pattern on a

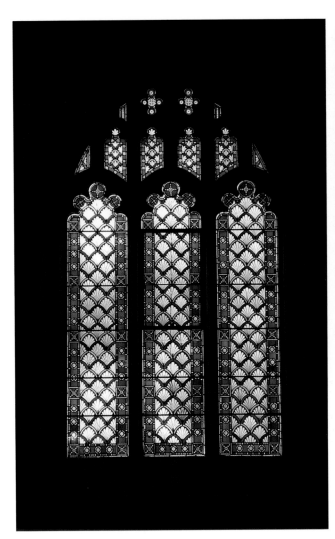

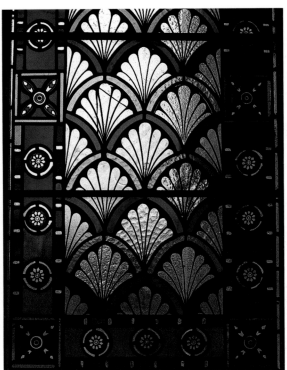

77: Nineveh Porch, east window, detail
(photo: Judith McKenzie)

76: Nineveh Porch, east window (photo:
author)

Nimrud wall painting (see fig. 29), but the general form is typically Gothic, as visible in a window in the north side of the ambulatory of Bourges Cathedral.[9] The four small windows directly above the lancets are decorated with a simplified palmette pattern and the Greek cross is repeated in grisaille in the two small windows at the top.

The east and west windows are the same shape as the north one, but are decorated with a simpler pattern, the same one for both windows (figs. 76, 77). Here the central part of each lancet is covered with a pattern of palmettes in grisaille glass outlined with red and blue arcs, similar to the pattern in the small upper windows on the north wall. Though the palmette form here is clearly Assyrian, its arrangement in rows of semicircles is again a typically Gothic pattern found in both Chartres and Bourges Cathedrals.[10] The border of the lancets is composed of rosettes with pointed petals and the X-shaped bud pattern in a square, both adapted from Nimrud wall paintings (see figs. 28, 29). The lobes at the tops of the lancets

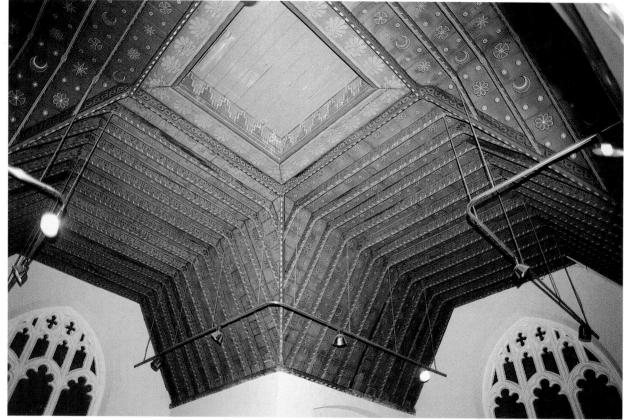

78: Nineveh Porch, view of painted ceiling, looking northeast (photo: Judith McKenzie)

79: Nineveh Porch, ceiling, straight up (photo: author)

80: Nimrud, Northwest Palace, garment decoration, palmettes sprouting (Layard, *Monuments of Nineveh*, 1849, pl. 6)

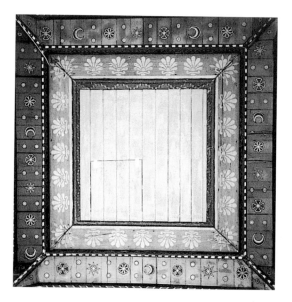

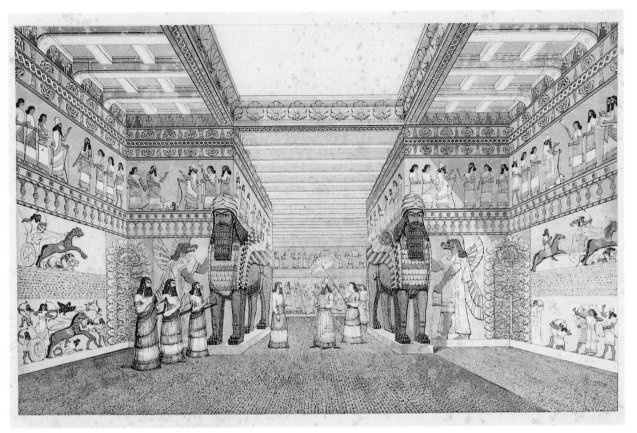

81: Nimrud, Northwest Palace, Room B (throne room),
Layard's not very accurate reconstruction
(Layard, *Monuments of Nineveh*, 1849, pl. 2)

and the small windows above these are decorated in the same way as in the north window. Because of their large amount of grisaille glass and their location at east and west, these windows admit a considerable amount of light.

Unlike the doors, then, which have a strong Assyrian effect, the windows look unmistakably Gothic. Even though their decorative elements and color scheme are all Assyrian, the manner of their arrangement is based on the verticality and dense patterning of Gothic window design, a compositional system that is wholly unlike that of the expansive horizontal painted Assyrian wall friezes. As with the doors, it is likely that these windows were designed by Gruner—who had made the color lithographs that served as their patterns—in consultation with Layard. Hardman, who is known to have executed stained glass for the house, may have made these as well.[11]

The exposed rafters and roof planks of the timbered ceiling were also decorated with Assyrian patterns (figs. 78, 79).[12] The vertical surfaces that frame the plain blue square panel at the center of the crossing are painted with blue battlements against a yellow ground, a pattern Layard found on wall paintings at Nimrud (see fig. 28).

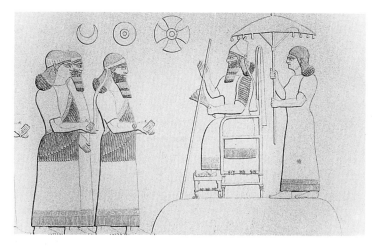

82: Nimrud, Central Palace, Tiglath-pileser III receiving officials (Layard, *Monuments of Nineveh*, 1849, pl. 59)

83: Nimrud, Northwest Palace, garment decoration, bull hunt (Layard, *Monuments of Nineveh*, 1849, pl. 48:6)

84: Nineveh Porch, ceiling, south wing (photo: Judith McKenzie)

Beyond this is a flat square frame decorated with a pattern of yellow palmettes, similar in form to the examples in the north window, against a blue ground. The four palmettes at the corners sprout pine cones, a motif that occurs frequently in Layard's engravings of garment decorations from Nimrud (fig. 80). This surface is framed on all four sides by the first of the rafters, painted on their vertical surfaces with a blue guilloche against a yellow ground. This pattern is also carried over onto the four diagonal corner rafters. On the lower edge of the center rafters and the corner rafters is a chevron pattern. The lower edge of the rest of the rafters is painted with a pattern of alternating red and blue diagonal bands. The overall effect of the ceiling at the crossing is strongly reminiscent of Layard's imaginary reconstruction of the ceiling of the throne-room of Assurnasirpal II at Nimrud (fig. 81).

The ceilings of the four wings of the building are essentially identical to one another. The undersides of the roof planks are painted with a pattern of alternating eight-pointed stars, Maltese crosses, crescent moons, and rosettes, each separated from the next by pairs of small concentric circles. The forms are in red, outlined in yellow, against a blue ground. These are all common Assyrian motifs that are often placed in the field above the king in the reliefs as symbols of deities. The direct source for the crescent moon, Maltese cross, and concentric circles was probably Layard's engraving of a relief slab from Tiglath-Pileser III's palace at Nimrud (fig. 82). The source for the eight-pointed star may have been Layard's engraving of the Black Obelisk of Shalmaneser III, where this motif appears before the king in the top two registers. The Maltese cross also appears here in the winged disk (see fig. 23). The rosette is frequently shown in the upper part of the field in Layard's engravings of garment decorations from Nimrud, as in an example that depicts a bull hunt, where the crescent, concentric circle, and eight-pointed star also appear (fig. 83). Such scenes give the impression, whether correct or not, that the

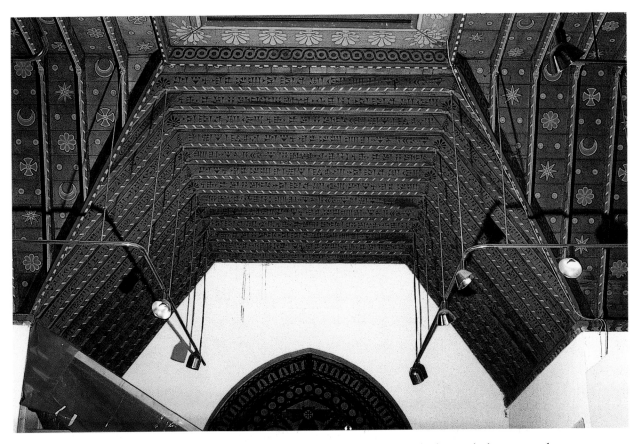

Assyrians imagined their sky to be filled with these symbols, and that must have inspired Layard and Gruner to do likewise on the ceiling of the Nineveh Porch. In fact, each of these emblems is likely to represent a specific deity, and so each would appear only once in an image.

The sides of the rafters in the four wings of the Porch are all painted with rows of cuneiform characters, separated at the angle joints by alternating palmettes and buds (figs. 84, 85, 86, 87). The pattern of the cuneiform is somewhat surprising. It is not, as I first assumed, a copy of the so-called "Standard Inscription" of Assurnasirpal II, which is the text that appears in some form on most of the Assurnasirpal reliefs in the Nineveh Porch. Neither was it mere gibberish, a collection of signs selected solely for their decorative value, though this is apparently closer to the truth. Nor, as I briefly hoped, was it a collection of unknown texts, perhaps copied from inscribed beads in Layard's personal collection. Nor, apparently, was it taken from Layard's *Inscriptions in the Cuneiform Character* (1851), which appeared in the year that the Nineveh Porch was built. In fact, it seems to be a random selection of text fragments assembled from sources close to hand. Two sets of texts were used: one set appears only on the horizontal rafters and the other only on the slanted ones. Those that were used on the horizontal rafters are as follows, here designated A to F for convenience of reference and presented in English translation (square brackets denote words or parts of words that were omitted by the Nineveh Porch

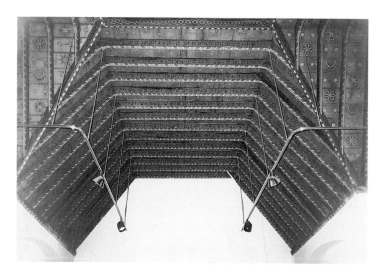

85: Nineveh Porch, ceiling, east wing (photo: author)

86: Nineveh Porch, ceiling, north wing (photo: author)

87: Nineveh Porch, ceiling, west wing (photo: author)

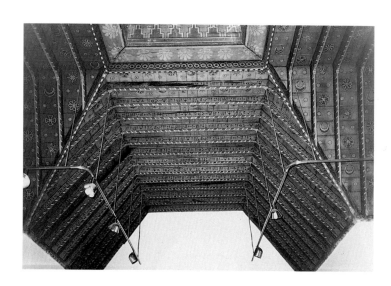

88: Nineveh Porch, floor of the entrance porch, detail (photo: Robin Whicker)

copyist; for the cuneiform texts and commentaries, see Appendix 3):

A. "Palace of Assurnasirpal (II), king of Assyria" (Layard 1851a, pl. 83: A: 1, with restorations).
B. "[the tri]bute of Qarpar[unda]" (Layard 1849b, pl. 53, "Black Obelisk").
C. "[Qarpar]unda of the land Pati[na]" (Layard 1849b, pl. 53, "Black Obelisk").
D. "relentless warrior" (Nineveh Porch bull, col. iii, line 1).
E. "the shepherd, the protection" (Nineveh Porch bull, col. iii, line 2).
F. "the city Rapiqu [at] his feet" (Nineveh Porch bull, col. ii, line 7).

The text excerpts on the slanted rafters are as follows, here designated G to L:

G. "[Pal]ace of Assurnasirpal, king of Assyria" (Layard 1851a, pl. 83: A: 1, with restorations).
H. "[they arres]ted and extradited" (Layard 1849b, pl. 56, "Black Obelisk").
I. "[an]telopes, elephan[ts]" (Layard 1849b, pl. 55, "Black Obelisk").
J. "leisure" (MMA 32.143.4, line 17).
K. "[the Šuba]ru and the land Nirbu, like [the god Adad]" (probably Nineveh Porch bull, col. i, line 53 to col. ii, line 1).
L. "they fear (my command)" (Nineveh Porch bull, col. iii, line 7).

This selection of text excerpts presents a number of interesting features. The fact that different texts appear on the horizontal and slanted rafters suggests that two sets of texts, one for each type of location, were prepared for the guidance of the painters. The only near-duplicates are A and G, but G always omits the first sign of the word "palace," which seems to indicate that it was painted from a different pattern than A. The sources from which the excerpts were copied were Layard's engravings of the Black Obelisk in the first series of *Monuments of Nineveh* (B, C, H, and I), the bull colossus in the Nineveh Porch (D, E, F, L, and probably K), one of the inscribed wall slabs in the Nineveh Porch (J), and either *Inscriptions in the Cuneiform Character* or the compiler's imagination (A/G). Apparently, then, the most important available reference work on the Nimrud texts, Layard's *Inscriptions in the Cuneiform Character*, was hardly used in the preparation of the text

excerpts for the Nineveh Porch ceiling. Instead, most or all of these selections were copied from monuments at hand: *Monuments of Nineveh* and the original sculptures in the Nineveh Porch.

According to the Dorset inventory, the floor of the Nineveh Porch is "covered with encaustic tiles . . . decorated with Assyrian motifs." The floor of the main room is now covered with wall-to-wall carpet and linoleum. This is glued to the floor and it was not possible to remove any of it to see if the original floor is still there. A portion of what appears to be original floor is visible in the entrance porch, but its predominantly floral pattern is not Assyrian (fig. 88).[13] The question of the original appearance of the inside floor will have to wait until the carpet is removed.

The other major component of the decoration of the Nineveh Porch, of course, was the original Assyrian sculptures set into its walls. The arched niches that Barry provided for the largest slabs are still visible in the walls of the east wing, as are the remains of the Purbeck Marble pedestals, now cut back at the fronts, in the north wing. Unfortunately for those who might wish to know how the ensemble originally looked, only one original slab and two casts were still in place when I visited the building in 1992, and I have been unable to locate any photograph of the sculptures *in situ*.

Fortunately, the original arrangement of sculptures is recorded in the inventory of the Porch made by L. W. King. It is undated, but must have been made before 1919, when some of the sculptures were sold and King himself died. At the time of the inventory, all of the sculptures were still in place and King's descriptions of them are sufficiently precise to permit each slab to be identified and its position in the Porch to be ascertained. The inventory is brief, and since it is of great importance in establishing the original appearance of the Nineveh Porch, it is reproduced here in full, with comments, as Appendix 4. Based on King's inventory and the physical evidence of King Nos. 27 and 28, which were still in place in the Porch in 1992, I offer a tentative reconstruction of the original appearance of the interior of the Nineveh Porch (see figs. 71, 89, 90, 91, 92). Though it cannot hope to be accurate in all details, it should nevertheless closely approximate the general layout of the sculptures in their architectural setting.

The exact placement of the large slabs and the colossi may be determined with a considerable degree of certainty on the basis of architectural features still *in situ*, combined with the measurements of the slabs themselves. A stone dado about 30 cm high runs all the way around the interior of the Porch, and this seems to have served as a footing for the larger slabs. The slab still in place on the east side wall of the south wing rests directly on top of this dado, and the slabs on the opposite west wall should be reconstructed in the same position. The settings for the slabs on the side walls of the east and west wings were four arched niches (H × W × D: ca. 310 × 240 × 23 cm), which were apparently set into the walls to permit the largest, thickest slabs to be displayed with their sculptured face flush with the wall surface (see fig. 73). I have reconstructed these walls with the large slabs centered in these niches and resting on the dado, with the casts directly above them, as in the example still in place by the door. The rear portion of each of the pedestals for the colossi is still in place; the width of the front part may be seen from marks on the dado, and the

89: Nineveh Porch, south wall, author's reconstruction; L. W. King inventory nos. 25–26 at left, nos. 3–4 at right (source: author)

90: Nineveh Porch, east wall, author's reconstruction; L. W. King inventory nos. 17–18 and bull B at far left, nos. 21–22 left of window, nos. 23–24 right of window, and nos. 27–28 at far right (source: author)

91: Nineveh Porch, north wall, author's reconstruction; L. W. King inventory nos. 9–10 and "bull" A (actually a lion) at far left, nos. 13–14 left of window, nos. 15–16 right of window, and bull B and nos. 19–20 at far right (source: author)

92: Nineveh Porch, west wall, author's reconstruction; L. W. King inventory nos. 1–2 at far left, nos. 5–6 left of window, nos. 7–8 right of window, and "bull" A (actually a lion) and nos. 11–12 at far right (source: author)

0 1 2 3 4 5m

length they extended into the room (ca. 70 cm) may be deduced from the length of the front parts of the colossi (ca. 55 cm). The principal uncertainty in my reconstruction, in the absence of photographs or other documentary evidence, is the height above the floor of the smaller fragments. Here, I have restored the lower examples at roughly the level of the windowsills and the upper ones somewhat above.

Two other points are of assistance in establishing the original effect of the ensemble. First, according to the conservator who cleaned the relief beside the door, the plaster casts above and below it were painted to match the color of the genuine reliefs. Presumably all the other casts were also stone-colored.[14] Second, according to an eyewitness who saw the Porch in 1919, "the reliefs were fitted in a wall imitating the stone in which they are carved, so as to show the whole thing in one piece."[15] It appears, therefore, that the casts and walls were colored to imitate the stone of the reliefs, with the effect that the Porch walls appeared to be paneled all around with stone, as was the case in actual Assyrian palaces.

With the help of this reconstruction, one can imagine something of the effect of the interior. Upon passing through the iron doors, which were decorated with the same design inside and out, the viewer would first be confronted by two large slabs: the bird-headed winged figure that Lady Charlotte identified as Nisroch at the left, and a winged deity with royal attendant at right, both of them with casts of hunting scenes above, similar to the arrangement shown in Layard's reconstruction of Assurnasirpal's throne-room at Nimrud (see fig. 81).

Beyond these, at the opposite side of the building, were the bull and lion colossi, framing an alcove that was decorated with smaller sculptures and the most colorful window. Again, the arrangement of the bull and lion strongly recalls the reconstruction of the Nimrud throne-room. The combination of colossi, colorful window, and location opposite the door clearly mark this space as the focus of the interior, while its northern exposure and darker glass give it a more subdued, more mysterious illumination than that of the side wings.

To the left of the lion was a large slab showing the king facing an attendant, and to the right of the bull was a similar slab showing a winged deity and another royal attendant. In Assurnasirpal's palace, the right edge of the left slab had originally adjoined the left edge of the right slab. The order of the two was switched in the Porch, evidently so that the raised arm of the winged deity would be directed toward the bull colossus. Again, both of these slabs have casts of hunting scenes above.

The two simpler windows, which are also more transparent and therefore admit more light, are in the side wings. These wings receive direct sunlight, heightening the contrast with the darker north wing. Overall, the arrangement of the sculptures and the decoration of the ceiling are strongly reminiscent of Layard's reconstruction of the Nimrud throne-room, but the form of the windows and door, and the quality of the light as it is filtered through stained glass, are distinctly Gothic. I will speculate on the significance of this juxtaposition shortly.

NINEVEH ON THE STOUR

Following Sir John's death, Nineveh in its various manifestations began to play a new role in Lady Charlotte's life, often serving as a source of comfort and strength. While at Canford in April 1853, she visited Sir John's favorite horse, Lamrei. Then overcome by grief and memories she drove home, followed by: "Some lingering at the Porch."[1] In July the Dowlais workers went out on strike. On one occasion during the protracted negotiations that followed she records that she went to Cardiff for strike talks, but did not herself attend the meeting. As she waited impatiently to hear the outcome, a band played loudly outside her hotel window: "To me it was a species of torture—but I tried to compose myself with my Nineveh Work."[2]

At Canford one morning in late August 1853 she reports that she had become upset at church. Upon returning home she notes: "Layard's Nineveh looked over," which presumably calmed her. On another occasion, in late October, she records: "I was in the lowest possible spirits and even the railway (generally so pleasant to me) was irksome—but for a piece of Nineveh work I do not know how I should have composed myself."[3]

References to her "Nineveh work" do not occur only in gloomy contexts. In January 1853, Lady Charlotte had engaged Charles Schreiber, a 27-year old fellow of Trinity College, Cambridge, as tutor for Ivor. In June and July she nursed him through a serious illness, after which she began to think of him as much more than just a tutor: "I think if there was ever a pure, uncorrupted spirit it is his, and indeed I bless God that he is spared, and I trust to do him good and reasonable service. Another mind is added to the very few I value and am interested in."[4] There is a hint of her new feelings in her entry for 1 August, written at Canford: "I suddenly looked up from the Nineveh pattern at which I had been silently working and saw him [Schreiber] lying on that sofa," that is, in Sir John's accustomed place.[5] Within two years they would be married.

Though Schreiber now occupied an ever increasing place in Lady Charlotte's thoughts, she continued to regard Layard as a close friend as well. One of her diary entries in early August 1853 laments her lack of friends: "Henry Layard is the best

93: Layard's Freedom of the City presentation box (*Illustrated London News*, 11 February 1854, p. 120)

and most useful friend I have—but we meet too seldom—and he is too full of politicks for me to venture to reckon on him."[6] Layard visited Canford during the winter holidays. Charlotte wrote: "After [breakfast] arranged to spend the morning with Henry Layard—sat with him in the drawing room till dinner, he talking—I also working Nineveh Work."[7] She spent much of the next day with Layard as well: "I devoted the morning to Henry Layard. . . . Henry and I meanwhile had our talk—principally to-day upon decoration—and also we took a little walk about the garden, discussing what should be done in various directions." Later that day she added: "Henry and I looked through Gruner's Book late in evening . . . all had gone up and Henry and I still had some talk."[8] The embellishment of the Nineveh Porch may have been among the subjects discussed.

In February 1854 at Dowlais, she reported the excitement that she and Layard's many acquaintances there felt upon learning that he had been presented with an award from the city of London: "A letter from Henry Layard had announced his having been presented with the Freedom of the City in a grand Assyrian formed box, accompanied by some very complimentary speeches—there was an account of it all in to-night's Times." The following day she went to the Workmen's room and "found it full—and much interest excited by the account and drawing of the Layard Box in the Illustrated London News" (fig. 93).[9]

Layard's political ambitions were limiting the time he had for visits to Canford and Dowlais, while Lady Charlotte's heavy managerial responsibilities limited her time away from those places. We get some sense of the range of problems she had to deal with in a diary entry from April 1854:

Saturday—Boys etc. rode before breakfast—I meanwhile though up early did but little—the letters had a good deal disconcerted me and gave me much food for thought—Our payments this month are enormous—£75,000—and for what I must look more carefully into?!—Purnell gives in his resignation—The Works letters too are not encouraging—Cost of Coal growing enormous—some engineering difficulties arising about our Vale of Neath Branch—Fire in the Coal at Buxton Pit—and in fact everything looking wrong—I could not but feel a little disheartened—walked out by the Nineveh Porch and then a little up and down in front and then we came in and talked—a good discussion always helps me to my way through annoyances—and I soon planned the course I had to take on each subject.[10]

In short, Lady Charlotte's need for good counsel at this time had far outstripped Layard's availability to provide it.

Following the installation of the bull and lion, the Nineveh Porch seems to have become a popular attraction for Canford residents and visitors, even though its interior decoration was apparently not yet finished. Lady Charlotte's diary for 1853 and 1854 is sprinkled with references to it. Following a drive with Layard's mother in April 1853: "On our return we went to the Nineveh Porch, and walked a little in the garden." In September: "In the afternoon Miss Williams came by appointment and spent about an hour. I shewed her the Nineveh Porch and walked round the garden with her." And: "After breakfast I took Edward Hutchins to the Nineveh Porch."[11]

Lady Charlotte hosted a large group of friends and relations at Canford over the Christmas holidays: "After [breakfast] the ladies made a visit to the Nineveh Porch." The next day, when overwhelmed by the number of holiday guests: "Sent some [guests] to see the Nineveh Porch—and *then* had a few minutes in my room." And upon the arrival of her brother's intended: "After [breakfast] Mr. Pegus and a party lionised Miss Welby over the grounds and the Porch."[12]

The family was again together at Canford for Easter 1854: "Lady Louisa and Lady Kathleen were here with General Ponsonby to see the House and the Nineveh Marbles." And during the summer holidays: "In the afternoon I thought I had secured a pleasant walk—but just as we were starting and looking about near the Nineveh Porch, an influx appeared from the Garden—so I stopped about for some time—and took Mrs. Richards to see the marbles etc."[13] Regrettably, she never noted what these visitors thought of the Nineveh Porch.

There are very few references to the progress of the Nineveh Porch decoration in Lady Charlotte's diary entries for 1853 and 1854. There are regular descriptions, however, of the deliberations over the form of the conservatory or arcade that was to connect the Porch with the house. The earliest reference to the arcade was in Lady Charlotte's diary entry of 2 March 1852, cited already, where she states that she wishes Barry to widen the arcade and adapt it for flowers. The next reference to it in her diary is apparently not until a year later, in March 1853, though Barry had evidently made at least one set of plans for it in the interim: "After breakfast discussed plans etc. with Sir Charles. . . . The Arcade has been again revised—The last contemplated roof—of dome glass—looks to me too staring—at least on paper—and might have a tendency to crush and detract from the Nineveh Porch to which the Arcade will lead—Another mode is now proposed—Keeping the roof low—ceiling it—and employing an inner row (not of arches as was once suggested) but of light columns to support it in the centre."[14]

In April 1853 she wrote: "Sir Charles Barry [arrived]—with whom I settled at last the ceiling of the Arcade."[15] A letter from Barry the following month also indicates that a design had been agreed upon: "Enclosed is a tracing showing the angle pieces of the Nineveh Porch [crossed out] Conservatory. It is not quite correctly drawn but if you pay attention to the written notes upon it you cannot go wrong. . . . There is nothing now to prevent the whole conservatory being finished at once. . . . None of the woodwork of roof is to be done at present as Lady Charlotte wishes I believe that it should be done in London and sent down ready to be fixed."[16]

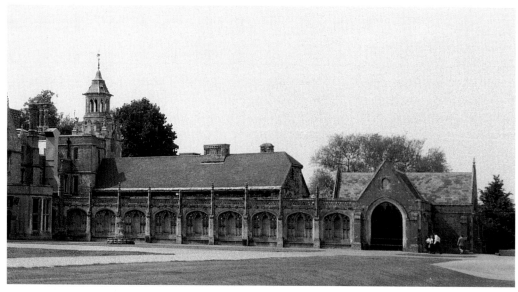

94: Canford, conservatory (photo: author)

Now work on the walls of the arcade apparently progressed rapidly (fig. 94). In July 1853 Lady Charlotte wrote: "The exterior of the arcade is approaching completion and has a beautiful effect."[17] At the beginning of August Layard paid a visit. He and Lady Charlotte "were out a great deal and planned roofs etc for the arcade, and ways of placing the remaining marbles in the porch etc."[18] From this, the only reference to the state of the interior of the Nineveh Porch during this period, it is clear that the relief slabs had not yet all been installed.

Despite her previous references to having settled the ceiling of the arcade, two of Lady Charlotte's diary entries from September suggest that the matter was still under discussion: "In the evening we looked at Barry's sketches for the Arcade." And a few days later: "With Sir Charles Barry I fixed upon the roof for the Arcade which is to be of glass and as simple as possible."[19] While at Canford for Easter 1854, Lady Charlotte notes that she went out for a walk and "came back by the Nineveh Porch when I spoke to the workmen—The roof is come down—but no men are here to put it up."[20] Since the Nineveh Porch roof had been in place for some time, this must refer to the roof of the Arcade, which Barry's letter said was to have been sent down from London. Two weeks later she notes that she left the house, "going out by the Arcade door where Pyne shortly before had been busy about the roof with Turner." During a visit to Canford in June she noted: "The roof is nearly fixed on the Arcade and altogether looks well."[21] The work seems to have been essentially finished by early July, when Lady Charlotte arrived at Canford for the summer holidays. Barry came down with her, they walked about inspecting various projects, and "planned fitting up of Arcade etc. etc."[22]

The arcade of the conservatory still stands today, but bricked up and with ornamental stone tracery set in the arches (see fig. 59). Old illustrations show that the arcade was originally glazed in with large sheets of clear glass supported by simple

95: Sydenham, Crystal Palace, Nineveh Court
(Wyatt 1854, plate following p. 20)

straight mullions (see figs. 19, 62). They also appear to show a sloping slate roof, which suggests that the glass roof had been replaced by 1867, when the engraving in Alfred Barry's biography of his father was published.

The last reference to work on the Nineveh Porch in Lady Charlotte's diary is in March 1854. Lady Charlotte accompanied Layard on a pre-opening visit "to the Crystal Palace, which Henry Layard had got leave for us to see—glorious weather—the building, all the decorations etc. wonderful—Nineveh advancing fast—I was anxious to see this with a view to guiding our progress in the Porch at Canford."[23] This "Nineveh" is the Nineveh Court, one of the nine Fine Arts Courts that were incorporated into the Crystal Palace when it was moved and re-erected in Sydenham, south of London, where it reopened on 10 June 1854 (fig. 95).[24] The architecture and decoration of the Nineveh Court were designed by James Fergusson, author of a treatise on Assyrian architecture and Layard's closest collaborator on questions of architectural reconstruction. Layard himself wrote the official guide to the Nineveh Court.[25]

Lady Charlotte's diary entry that records their preview visit to the Nineveh Court suggests that the decorative details of the Nineveh Porch had not yet been settled. A month later, Fergusson visited Canford with Layard. Lady Charlotte wrote: "After breakfast walked about—and went into the Nineveh Porch with Henry

Layard and Mr. Ferguson."[26] She doesn't indicate whether Fergusson was there to consult on the decoration, but that is a reasonable supposition. In any event, Fergusson's influence on the final decoration was probably minimal, as all of the decorative elements used in the Nineveh Porch have clear sources in Layard's own published works. Indeed, the overall effect of the Porch interior is much closer to Layard's reconstruction of Assurnasirpal's throne-room than it is to the Nineveh Court in the Crystal Palace (see fig. 81).

That said, it must be stressed that the Gothic Revival architecture of the Nineveh Porch doesn't look very "Assyrian" at all. Fergusson's Nineveh Court was a deliberate attempt to build in an authentic Assyrian architectural style, though it was widely-criticized for its adaptation of Persepolitan and South Asian models in its reconstruction of the upper superstructure, which was not preserved in any of the known Assyrian palaces. The Nineveh Porch at Canford Manor made no such claim. Its unabashedly Gothic style was determined by the style of the manor house and the capabilities of its architect. Though Fergusson's book on Assyrian architecture, *The Palaces of Nineveh and Persepolis Restored*, appeared in 1851, the same year in which the Nineveh Porch was begun, Barry did not draw at all on Layard's or Fergusson's research. Instead, the Neo-Gothic Porch serves as a familiar setting for some very unfamiliar sculptures. Like a zoo that presents exotic wild animals in a setting that is comfortable for the visitor, the Nineveh Porch effectively tames the bull and lion by reconfiguring their context into a purely British setting. As with the British Museum display of the other bull and lion, where these strange oriental deities were civilized and westernized by being placed in the neo-classical front hall, the associations evoked by the Neo-Gothic style of the Nineveh Porch (biblical stories in stained glass and stone, Gothic cathedrals, mysticism, the Houses of Parliament, and Canford Manor house) served to biblicize, christianize, romanticize, britishize, and canfordize the exotic marbles inside, thrusting them into the western tradition. Modern Mesopotamia, like Greece, may have belonged to the Ottoman Empire, but its past now belonged to Britain.

The layout of the interior decoration is another matter. McKenzie writes: "Surely in conception the interior decoration of the Nineveh Porch is a version of Layard's reconstruction of Assurnasirpal's throne room confined to a Gothic style building" (see fig. 81). As evidence, she cites the use of casts of the bull hunt and lion hunt placed high on the wall, the placing of the large bulls at the back of the room, and the similarity of decorative motifs in the ceiling area. McKenzie suggests that "just as Lady Charlotte fancied the robing room of the Houses of Parliament as a model for her Hall at Canford, she would have had no less than Assurnasirpal's throne room alluded to in her Nineveh Porch."[27]

Barry's pocket diary lists a meeting with Layard scheduled for 1 June 1854.[28] No agenda is given, but again the Nineveh Porch is a possibility. The last known date for work on the interior of the Nineveh Porch is provided by the inclusion of casts of Assurbanipal sculptures in four sections of the upper wall (figs. 96, 97, 98, 99). The originals of these slabs arrived at Le Havre aboard the French ship *Manuel* in May 1856 and were brought from there to London on the steamer *Soho*, arriving in June 1856.[29]

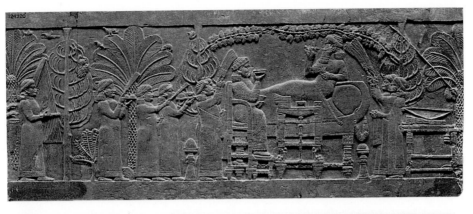

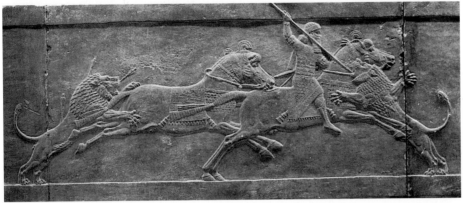

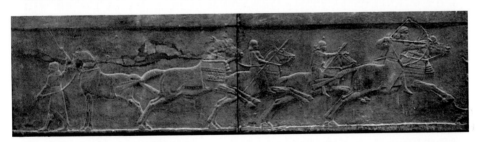

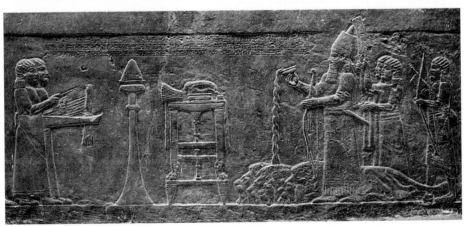

Nineveh, North Palace
96: Fallen into Room S, no slab number; British Museum WA 124920; 60 × 139 cm.
97: Room S, Slabs 12–14; British Museum WA 124874–124876; ca. 62 × 160 cm.
98: Room S, Slabs 12–13; British Museum WA 124875–124876; ca. 60 × 220 cm.
99: Fallen into Room S, no slab number; British Museum WA 124886; ca. 58 × 125 cm.
The lost casts of these slabs were L.W. King nos. 3, 9, 19, 25 (photos: author)

After Lady Charlotte's wedding to Charles Schreiber in April 1855, Layard's visits nearly ceased for a while: "Henry Layard . . . has altogether kept aloof from us since our arrival in London. I think the children regret it, for myself I am not surprised, especially if any of the stories have come to his ears of the reasons that were attributed to him last year for opposing my marriage."[30] Eventually he forgave her. Meanwhile, she continued to promote Nineveh. In April 1856 she reported a "visit from the Messers Saunders of the Poole Potteries, asking me to introduce them and their manufactures to Sir Charles Barry—which I have promised to do. I showed them drawings in Gruner's Book—in Murphy's Spain—and Nineveh—some of which they thought very applicable to the new kind of pavement they are beginning to make."[31]

Lady Charlotte turned Canford over to her eldest son Ivor upon his attainment of his majority on 29 August 1856. She celebrated the occasion with a grand party. The last mention of the Nineveh Porch in her diary is a cryptic entry from the day before, as she made final preparations for the celebration: "Quite late, was at Mr. Pyne's to give some final instructions, which Bartlett the Birdstuffer was preparing for the Nineveh Porch."[32] The party itself was memorable. Lady Charlotte wrote: "Sir Charles Barry had mounted the tower and was gazing on the scene below. He was soon joined by many others—all said it looked beautiful."[33] Ivor, exhausted, went to bed at two in the morning, but his absence was hardly noticed. The party broke up at 6 a.m. after the playing of *God Save the Queen*. Lady Charlotte wrote: "Charles and I were left alone in the vast, empty, silent Hall. My reign was finished."[34]

THE MEANING OF THE NINEVEH PORCH

Lady Charlotte Guest's role in the English reception of Assyria was unparalleled. At a time when Assyria was the object of intense popular curiosity, Lady Charlotte was a cousin, patron, and close friend of Layard of Nineveh, played an important role in the publication of his finds, acquired through him the world's finest private collection of Assyrian sculpture, and built a unique structure in which to house it.

At the beginning of this study I stated that one of my goals was to place the Nineveh Porch in the context of the British reception of Assyria. Hinsley has correctly observed that the impulse to acquire these ancient treasures was rooted in British imperialism, but such a broad view provides only limited assistance in understanding the dynamics of the reception of Assyria, unless it is argued in the context of a close examination of the motivation of those involved.[35] This was not India, and while Britain was a major imperial power, so was the Ottoman Empire. The Assyrian sculptures were obtained through diplomatic channels, by the British ambassador approaching the Ottoman sultan, hat in hand, and asking if Britain might have any pieces that the sultan did not need.

There is no evidence in either Lady Charlotte's or Layard's writings that they considered the collection of Nineveh marbles in the Nineveh Porch to be in any way emblematic of the greatness of the British Empire, or of England's legitimate place in the succession of world empires of which Assyria was perceived to be the first.

There is no contemplation comparable to that in "The Burden of Nineveh," in which the sight of the counterpart of the Canford bull being brought into the British Museum moved D. G. Rossetti to speculate on a future, "When some may question which was first, / Of London or of Nineveh."[36] Lady Charlotte and Layard may well have spoken such thoughts, but they did not write them down.

Canning's initial motivations were national rivalry with the French and the desire for a personal monument in the British Museum (he could not have known that the "Canning marbles" would become the "Layard marbles").[37] Layard also wanted to make a name and a political career for himself, and Nineveh, properly promoted, would accomplish this much more quickly than traditional government service. For Rawlinson, the texts engraved on the marbles would provide the key to the decipherment of Babylonian cuneiform and would reveal the hitherto unknown history of Assyria. For the officers and Trustees of the British Museum, the Assyrian marbles formed an essential, heretofore missing link in the great "chain of art" that led to the culminating point of the Elgin Marbles, even though the aesthetic merit of the art itself was open to debate.[38] For the British press and public, the Nineveh marbles were the latest, greatest curiosity, a link to an imaginary biblical past that was the very core of their sense of identity. The publication of *Nineveh and Its Remains* further heightened public interest in the marbles by making them the focus of a modern adventure story set in the exotic East.

Lady Charlotte's experience of the Nineveh marbles both parallels and contrasts with that of the British public. She appreciated their biblical and aesthetic value, but they also offered her the unique opportunity to compete with the national museums of England and France. Lady Charlotte's first impression of Assyrian sculpture, seen through Layard's drawings in 1846, was that they were "curious." After Layard arrived at Canford in March 1848, she still thought the drawings "very curious," but now they had become "interesting indeed," in part because they seemed to be literal "illustrations of Ezekiel." That same month she first saw the sculptures in the British Museum, and four days later the order for her own shipment was placed. Later that year, she found the Black Obelisk to be "most curious," but in addition she praised its aesthetic value ("beautiful") and rarity ("quite unique").

She did not thereafter refer to Assyrian sculpture as curious—evidently its pure novelty had largely worn off—but continued to respond, as did Layard, to its beauty, uniqueness, and historical interest. The "Ninevite head" Layard gave her in spring 1848 was "beautiful" and the sculptures intended for the Porch were "fine marbles." Once installed in the Porch, the bull and lion looked "magnificent." Layard spoke in similar terms when he commended the bull and lion as "very original and fine ornaments" for Canford. For Lady Charlotte, the bull and lion were "marvellous and precious relics of a bygone age." She observed that her marbles ranked as one of the "chief amusements" among the "more religious portion" of her guests, and she was delighted to have what she believed to be an image of the biblical Nisroch.

She referred to the Nineveh Porch in much the same way, with particular emphasis on its "interest": Lady Charlotte envisaged it as "a beautiful and interesting

object" and "as interesting a little spot of ground that Porch as any in England."
Such an interesting object must be shown off and Lady Charlotte clearly enjoyed
doing so, as evidenced by her numerous diary references to visits to the Porch by
guests in 1853 and 1854. The Nineveh Porch—interesting, historic, unique, and
unable to be duplicated—was the embodiment of Lady Charlotte's engagement with
Nineveh.

For all this, the Nineveh Porch still remains something of an enigma. This enig-
matic quality resides in the effect produced by the structure. This was best described
by the art dealer Dikran Kelekian, who saw the Nineveh Porch in 1919: "I
remember having seen the reliefs when they were in Wimborne. There was a little
chapel specially made for them. The reliefs were disposed on both sides in this
chapel, while the two big bulls were settled in place of the altar opposite the
entrance."[39] Lady Charlotte never suggested that the Nineveh Porch was built as a
chapel, but with its Gothic style, cruciform plan, ornamented cast-iron door and
tympanum, and stained glass windows, that is exactly what it looks like. If this
effect was deliberate, then the Nineveh Porch may well be a modern interpretation
of the temple of Nisroch at Nineveh, with the supposed image of that deity dis-
played prominently just inside its door. In any case, it would have been an ideal
location for Christian meditation, the only "chapel" in the world to be decorated
with original art from Old Testament times.

To summarize, the Nineveh Porch appears to be unique in several respects.
Though a number of Englishmen of means in the first half of the nineteenth century
collected and displayed Oriental antiquities, very few owned objects of the scale of
the Canford sculptures, fewer still owned Assyrian pieces, and none owned an
Assyrian colossus. The only places one could see comparable objects were the
British Museum and the Louvre. Lady Charlotte's support of Layard gave her the
opportunity to assemble a unique collection of antiquities from an extremely
popular, newly rediscovered ancient culture, and she took full advantage of that
opportunity. Both Lady Charlotte and Layard certainly considered the Nineveh
marbles to be unique and beautiful antiquities, and just as clearly, they imagined
the Nineveh Porch as a unique and beautiful setting for these treasures. Beyond
that, both of them valued the Nineveh marbles for their biblical associations. That
the setting Barry, Layard, and Lady Charlotte created for them is strongly remi-
niscent of a chapel may, therefore, be no accident. However that may be, the
Nineveh Porch repaid Lady Charlotte's championing of *The Monuments of Nineveh*
by bringing ancient Assyrian designs back to life, 2500 years after they had disap-
peared from sight.

THE NINEVEH PORCH IN THE LATER NINETEENTH CENTURY
Lady Charlotte remained a frequent visitor to Canford, but she was apparently no
longer directly involved in Canford affairs. We do not know whether the Nineveh
Porch was finished by the time she moved out, nor are there any further references
to it in her diary. In September 1857 she visited Canford and noted: "In the after-
noon I amused myself in trimming up the plants in the conservatory which is

looking lovely." In August 1859, she hosted the wedding celebrations of Maria, her eldest daughter, at Canford. She described the decorations of the house and gardens in considerable detail, including the observation that "the Conservatory was lighted up," but the Nineveh Porch was not mentioned.[40]

Ten years later, on 9 March 1869, Enid Guest (1843–1912), the eighth child of Sir John and Lady Charlotte, married Henry Layard. The previous year, Ivor had married Lady Cornelia Churchill, who then became the undisputed Lady of the Manor. Enid no longer felt at home at Canford and the couple visited there only rarely. One such visit was from 27 to 31 July 1880. Enid reported in her diary that it poured every day.[41] Following the visit, according to Waterfield, Layard "told Lady Charlotte that the rain was pouring down into the 'Nineveh Porch' and had 'deeply furrowed' a winged figure: 'It is heart-rending to see how these precious monuments and the pictures etc. are perishing from neglect. It would, perhaps, have been better had they never been brought here.' "[42]

Meanwhile, the Nineveh Porch had taken on something of a life of its own. It was regularly mentioned in guidebooks to Dorset as one of the most notable features of Canford Manor. It first appears in such a context in 1856, in the first edition of *A Handbook for Travellers in Wiltshire, Dorsetshire, and Somersetshire*, which was part of a series of very popular travelers' guidebooks published by John Murray. The entry reads: "*Canford Hall.* . . . A gallery, connected with the house by a cloister, is devoted to a series of Assyrian sculptures brought from Nineveh by Mr. Layard, winged lions and bulls, bas-reliefs, &c., similar to those in the British Museum."[43] The same text was used verbatim in the second edition of Murray's *Handbook* (1859) and in Pouncy's *Dorsetshire Photographically Illustrated* (1857), a series of engravings made from photographs of prominent Dorset monuments.[44] Canford Manor is illustrated, but the Nineveh Porch is not visible.

For the third edition of Murray's *Handbook* (1869), the text on the Nineveh Porch was somewhat altered: "A gallery, connected with the house by a conservatory, is devoted to a series of Assyrian winged lions and bulls, bas-reliefs, &c., sculptures brought from Nineveh, and presented to Sir J. Guest, by Mr. Layard." The text of the third edition is the same length as that of the first, but has two noteworthy changes. The first, the identification of the conservatory, is a minor correction. The other, the omission of the reference to the British Museum and the addition of the identification of the owner of the sculptures as Sir John Guest, is of greater interest. The original text's association of the Canford sculptures with those in the British Museum risked raising questions that Layard, for one, would surely rather have allowed to rest. Furthermore, the original text gives the impression that the collection is the property of Layard himself. The inclusion of the name of Sir John Guest in essence gives the Canford sculptures a legitimate owner. In view of Layard's continuing association with Murray, it is possible that he suggested this revision.[45]

The description of the Nineveh Porch in the fourth edition of Murray's *Handbook* (1882) is somewhat shorter: "A gallery, connected with the house by a conservatory, contains some Assyrian sculptures brought from Nineveh, and presented to Sir J. Guest, by Sir A. H. Layard."[46] The editing out here of the passage

"winged lions and bulls, bas-reliefs, &c." may merely reflect a need to shorten existing entries to make room for new ones, but its effect is to make the Canford collection seem both less specific and less spectacular. Again, the result is to remove ammunition for potential critics of Layard. Furthermore, the allusion to Layard's knighthood, while perfectly appropriate, has the effect of making the transaction appear to have been one between two titled gentlemen, and therefore presumably above reproach. The account of the Nineveh Porch in the fifth edition (1899) is the same as that in the fourth, except that the phrase "connected with the house by a conservatory" was omitted.[47] Presumably this was done to save space—the *Handbook* had grown to such proportions by this time that it was necessary to omit Somerset from the fifth edition.

We have already seen that Pouncy's *Dorsetshire Photographically Illustrated* used Murray's *Handbook* as its sole source for the Nineveh Porch. Murray's *Handbook* was probably also the source for the reference to the Nineveh Porch in Worth's *Tourists' Guide to Dorsetshire* (1882): "A gallery is appropriated to a choice collection of Ninevite sculpture, part of the discoveries of Sir Austin [*sic*] Layard."[48] Murray's *Handbook* was certainly the source for the latest such guidebook I have found, Heath and Prideaux's *Some Dorset Manor Houses* (1907): "A gallery, connected with the house by a cloister, contains a series of Assyrian sculptures in bas-relief, representing winged lions and bulls, brought from Nineveh and presented to Sir John Guest by Sir A. H. Layard, the noted politician and traveller, through whose exertions many sculptures have been excavated which have proved of the greatest value in elucidating the history of Assyria and Babylonia."[49] The first part of this text is quoted from the first and fourth editions of Murray's *Handbook*. The remainder, which identifies Layard, reflects the publication date, presumably having been included for the benefit of a generation of readers who might not know who Layard was.

Murray's *Handbook* was also the reference work cited in a particularly nasty round of mudslinging that Layard became involved in late in his life. In 1888 E. A. Wallis Budge, an assistant in the Department of Egyptian and Assyrian Antiquities of the British Museum, was sent by the Trustees to Mesopotamia to investigate rumors that Hormuzd Rassam and his relatives had conspired in the looting of antiquities from sites that had been opened by the British Museum. The Trustees still considered these sites and all they contained to belong solely to the Museum, though they had not provided adequate funds for the mounds to be well guarded, nor had they continued their own excavations at any of these sites. The accusations that involved Rassam were false, evidently propagated by antiquities dealers in Baghdad as a means of getting rid of site guards hired by Rassam, but Budge decided that they were true and reported this to E. M. Thompson, the Secretary of the Museum.[50] "This he appears to have done," Layard wrote, "to supplant Rassam, one of the honestest and most straightforward fellows I ever knew, and one whose great services have never been acknowledged—because he is a 'nigger' and because Rawlinson, as is his habit, appropriated to himself the credit of Rassam's discoveries."[51]

Rumors of Rassam's supposed involvement in the thefts began to circulate in London and an indignant Rassam went to Layard for advice. Budge's reports to

the Trustees were confidential, and so could not be introduced as evidence in court, but Budge had the poor judgment to repeat his charges to Layard who repeated them to Rassam. Rassam decided to sue Budge for libel and claimed damages of £1000. The case went to court in late June 1893. The decision was in favor of Rassam, but the award was only £50.[52]

Thompson and Budge apparently decided to have the case retried in the press. "The Thieving of Assyrian Antiquities," a long unsigned editorial in the 10 August 1893 issue of the journal *Nature* purported to report on the case, but focused only on Budge's testimony, presenting it as undisputed fact. One of the main points of the *Nature* article was that Assyrian antiquities were in private hands and that there was no legal way this could have come to pass. The argument ran thus:

It will easily be guessed that from first to last a very considerable sum of public money, amounting to tens of thousands of pounds, has thus been spent upon excavations in Assyria and Babylonia, and the question naturally arises, Has this money been spent judiciously, and has the nation obtained what it had a right to expect in return for its money? It seems pretty evident that people other than the Trustees of the British Museum have obtained collections of Assyrian antiquities, and it appears to us that this subject should form the matter of a careful and searching investigation. Sales at auctions have revealed the fact that sundry gentlemen had been able to acquire Assyrian slabs from the palaces of Assyrian kings, and as the excavations were carried on by the Government, it is difficult to account for this fact. The public has a right to know how property of this nature came into private hands, and the question must be asked until it is satisfactorily answered. The matter cannot be allowed to rest where it is.[53]

Rassam, having just won his lawsuit, would have been well-advised to give this article the respect it deserved by ignoring it entirely. Instead he responded with a "Letter to the Editor." To the passage just quoted, he responded: "I do not know what you mean by 'Assyrian slabs' having been acquired by purchase, as I know of no such sale having taken place in England or elsewhere. I am the only explorer, after M. Botta and Sir Henry Layard, who discovered 'Assyrian slabs,' or bas-reliefs, but that was thirty-eight years ago; and as there have been no sculptured slabs discovered in Babylonia, it is difficult to know what is to be understood by such an assertion."[54]

The editor's reply in the same issue chose to sidestep Rassam's main point, which was his observation that sales of Assyrian sculptures at auction were rare or nonexistent. Instead, the editor pretended that Rassam had objected to his use of the word "slab" and then introduced an entirely new argument:

The article was not written by an expert, and perhaps the word "bas-relief" would have been better than "slab." But there is no doubt about what we mean. Murray's "Handbook to Dorsetshire" informs us that at Canford Hall "a gallery connected with the house by a cloister is devoted to a series of Assyrian sculptures brought from Nineveh." These sculptures—not to call them slabs—are described as "winged lions and bulls, bas-reliefs, &c., similar to those in the British Museum." Now, if there are many such galleries in England, and the objects were obtained at a low price, the whole question of excavation at the public expense is raised.—Ed. Nature.[55]

The description of the Nineveh Porch in Murray's 1856 edition of the *Handbook*

is quoted here in its entirety, except that Layard's name, which was present in every edition of Murray, has been omitted by *Nature*. Evidently the "Editor" was not prepared to broaden his attack to include the well-respected Layard. Even so, Layard was not pleased. To his brother-in-law Edward Ponsonby, Viscount Duncannon, he wrote:

I send you the letter which [Rassam] wrote to the Editor of "Nature" in reply to the article in that periodical which you have already had. The letter was cut down by the Editor, and all reference to the conduct of Maunde Thompson and Mr. Budge struck out. I have no doubt whatever that the original article was written or inspired by these two gentlemen. You will see that there is now an attempt to accuse me of having stolen the Assyrian marbles which are at Canford! This is evidently in revenge for the evidence I gave in support of Rassam.[56]

Incredibly, Rassam chose to dignify this second attack too with a reply, in the form of another letter to the editor. To the editor's assertion that there were Assyrian sculptures at Canford, he replied:

With regard to the cock-and-bull story about the bas-reliefs which are alleged to be at "Comford Hall," if you had said in your article . . . that they *existed* in a private house in England, *instead of asserting that they were obtained by purchase*, I would have surprised you with further revelations that such "slabs" do exist in other houses in England and in different parts of Europe and America. Even half of the sculptures I had discovered in Assur-beni-pal's palace in 1853, belonging *legitimately* to the national collection, have been squandered, and part of them are now in the bottom of the Tigris.[57]

This was not Rassam's finest hour. There can be no doubt that he knew of the Assyrian sculptures at Canford Manor: we have seen that he visited Canford in August 1852, only two weeks after the lion and bull had been installed in the Nineveh Porch, and that shortly thereafter he wrote to Layard from Mosul to see if Lady Charlotte required any further sculptures. Therefore he can hardly have considered the "alleged" presence of these reliefs at Canford to be a "cock-and-bull story." It is very unlikely, however, that he actually went so far as to misspell "Canford" as "Comford." I have not seen the original copy of this letter to the editor, and doubt that it still exists. Many of Rassam's letters are among the Layard Papers, however, and they show that in his lower-case "a" the circular body of the letter is often separated from its stem. In consequence, to someone unfamiliar with his handwriting, or to someone who wanted to make him appear a fool, the letter combination "an" might well appear to be "om."

Of course the "Editor" of *Nature* had a field day with this: "Why does Mr. Rassam take the trouble to misquote us by writing 'Comford' instead of 'Canford,' and then to put his misquotation in inverted commas? The 'story of a cock and bull,' which we took from one edition of Murray's Guide is repeated in more detail in a later one, and even the name of the donor is mentioned, Sir A. H. Layard."[58] The "Editor" is being a little duplicitous here, since, as we have seen, Layard's name was given as the donor of the Canford sculptures in every edition of Murray's *Handbook*. In any case, Layard's name had now been drawn into the fray and he was furious. To Edward Ponsonby he wrote:

I have learnt from a trustworthy source that the articles against [Rassam] in "Nature" come directly from Maunde Thompson and Mr. Budge—the former being on intimate terms with the Macmillans—the proprietors of that journal. . . . Mr. Maunde Thompson . . . has in the last number, included me by name as having stolen the Assyrian marbles at Canford. It seems not to be generally known that the monuments etc which I discovered in Assyria and Babylonia were my own property, that the Sultan's firman authorizing the excavations was given to me *personally*, that I might have sold the whole of my discoveries and could have made a considerable fortune thereby, that I presented them voluntarily to the Nation, that in discovering them I spent the whole of the little money I had, Lord Stratford de Redcliffe having helped me only to the extent of £60, and that I never received any remuneration in money from the Trustees either for the marbles or for my labors, but only the bare payment of my expenses. Mr. Maunde Thompson asks for an enquiry as to the way in which public money was squandered on the Canford marbles. I hope he may succeed in obtaining one. Such is one's recompense for serving the public![59]

In mid-October, *Nature* published a long list of people, primarily British Museum employees and supporters, who had "voluntarily" contributed to a fund established by Thompson for the purpose of paying Budge's court expenses.[60] This served to conclude the trial in the press with a resounding "not guilty" verdict for Budge, pronounced by an oversized jury of solid British citizens. The last word on the subject, however, came from an unexpected quarter. On 26 October 1893, a letter to the editor from the archaeologist W. M. Flinders Petrie appeared in *Nature*. As it contains much of interest, both as an indication of how far archaeology had come since Layard's day, and as a reminder of how far today, 100 years later, we still have to go, it is quoted in full in Appendix 5. For our present purposes, his main points were:

A recent case, which had occupied some space in *Nature*, raises much larger issues than the character of individuals, and issues which must be faced sooner or later. . . . Baldly stated the case stands thus. Every country in which there is anything much worth having, stringently prohibits exportation and excavation; and nearly all the growth of museums of foreign antiquities is in direct defiance of the laws. . . . Yet museums grow. . . . Meanwhile all information concerning such discoveries has to be suppressed; and the most important acquisitions of museums are a matter which cannot be published, or even talked about in detail, while official papers have to be treated as secret archives. . . .

France and Germany ask other powers in a straightforward way for presents of antiquities by diplomatic channels; and they often get what they want, as we did in the days of Lord Stratford de Redcliffe and Sir Henry Layard. But recently English diplomacy has, on the contrary, repeatedly thrown away what rights Englishmen might claim concerning antiquities, in order to gain petty advantages which diplomatists were capable of understanding. . . . Until our Government sees its interests in backing up work for its museums by honest methods, and straightforward dealings, we shall continue to lose the greater part of the scientific value of museum acquisitions, and to have a seamy side to our administration which is more discreditable than those personal questions that have lately been raised.[61]

For whatever consolation it may have been to Layard and Rassam, it is quite clear here which parties Petrie considers to be honorable, and which ones he does not.

THE SCULPTURES COME TO AMERICA

Henry Layard died the following year, on 5 July 1894, at the age of 77. Six months later, on 15 January 1895, Lady Charlotte, aged 82, followed. Both are buried in the churchyard of Canford Magna (fig. 100). Charles Barry had long preceded them, having passed away in the evening of 12 May 1860 following an afternoon at the Crystal Palace.[1] Ivor Guest became the first Baron Wimborne in 1880 and continued to live at Canford until his death in 1914. After his death, the majority of the reliefs in the Nineveh Porch were put up for sale by his son, Ivor Churchill Guest, the first Viscount Wimborne. This was evidently done in order to raise funds to pay the inheritance taxes on his father's estate—selling Canford Manor was not an appealing option, since his mother still lived there, but Viscount Wimborne did not live at Canford himself, and so would not miss the sculptures.[2] Institutional correspondence in both the University Museum in Philadelphia and the Metropolitan Museum in New York indicates that their directors had been offered the Canford reliefs no later than 1920.

In 1928 Edward Robinson, Director of the Metropolitan Museum, told John D. Rockefeller, Jr. "that these reliefs had been offered for sale to me by the executors of the Wimborne estate some years ago, and for what I considered a moderate price, but at that time we had no collection or department."[3] According to another source from the same date, Robinson had "tried to get $125,000 from his trustees some years ago to purchase the Wimbourne Collection."[4] A letter of 1927 from Jane M. McHugh, Secretary of the University Museum, also to John D. Rockefeller, Jr., described the offer to the University Museum: "These sculptures were first brought to the attention of our Board of Managers in 1920 by the late Dr. Gordon, Director of the Museum, to whom they were offered during a visit to England for £25,000. (The pound sterling was then selling at $4.19.) At that time the Board had taken on many obligations and was unable to enter into negotiations with the owner for them. Shortly after that the entire collection had been purchased by Mr. [Dikran G.] Kelekian."[5] Leonard King's inventory of the Nineveh Porch sculptures, may well date to this period as well—if the sculptures were also offered to the British Museum, King might have been sent to Canford to examine them.

100: Canford Magna churchyard, Henry Layard's tomb
(photo: author)

From these accounts, it appears that following Lord Wimborne's death, the Nineveh Porch sculptures were on the market for somewhat more than $100,000. This was not an easy sale. The Canford bull and lion are the only Assyrian colossi ever to have been offered for sale. All of these pieces, and particularly the colossi, were so rare that there was no established market, and therefore no body of collectors and no record of sales from which to determine a fair market price. In addition, Viscount Wimborne evidently didn't want to break up the collection, and so the price was too high and the number of pieces too large for any buyer other than a dealer or a museum. Very few museums had significant collections in this area, and those that did, such as the British Museum, had no need of this large number of further pieces. For museums not already having such a collection, the high price and general lack of public interest in this area were serious obstacles, as evidenced by the response of the trustees of the Metropolitan Museum and the University Museum in Philadelphia, the two most likely American customers for this material. For a dealer, the unique nature of this material could be a strong selling point, but the lack of an existing market made it a very risky investment.

As the McHugh letter indicates, the collection was purchased by an antiquities dealer, Dikran G. Kelekian, apparently towards the end of 1919.[6] Kelekian bought most of the Nineveh Porch sculptures, but not all of them. In addition to the colossal lion and bull, he acquired ten wall relief slabs from Assurnasirpal II's palace at Nimrud (King inventory Nos. 2, 4, 10, 14, 16, 20, 24, and the three slabs of No. 26; figs. 7, 8, 38, 39, 45, 46, 47, 48, 49, 50) and six relief fragments from Sennacherib's palace at Nineveh (King inventory Nos. 11, 12, 13, 15, 17, and 18; figs. 14, 36, 54, 55, 56, 57). The eight sculptures left behind, all but one of which were small fragments, may not have been considered worth taking.

Much of Kelekian's correspondence concerning these sculptures is preserved in the archives of the Ancient Near Eastern Art Department of the Metropolitan Museum. It provides an interesting glimpse into the perception of Assyrian art and the dynamics of museum acquisition in the 1920s. The earliest preserved Kelekian document is a telegram from his Paris office to his New York office, dated 9 March 1920: "ASSYRIAN SCULPTURES SHIPPED 35 CASES 36 TONNES CAN YOU STORE TEMPORARILY MANHATTAN WAREHOUSE."[7] A letter late that month from Kelekian to Bane and Ward, customs agents in New York, gives the name of the ship: "Enclosed please find order on C B Richards & Co. for papers oncerning shipment of 35 cases, weighing 36 tons, from England, per S S Lake Frugality. Kindly make entry for same, and according to our telephone conversation with Mr. Bane, please arrange for storage in a warehouse where they can be set up and shown. I will be obliged to you if you can make inquiries as to the storage without delay, as I must give a quick decision to the Manhattan Storage Co."[8]

Bane and Ward were evidently unable to locate suitable display space for the sculptures, which would have required unusually solid floors to support them. They were taken instead to the Manhattan Storage warehouse at 53rd Street and Seventh Avenue, where they remained in their crates until 1924.[9] The fact that the sculptures could not actually be seen by prospective buyers was to prove a major hindrance to Kelekian's efforts to sell the pieces.

Bane and Ward's invoice to Kelekian for their services is of interest in that it gives the price that Kelekian paid for these "35 Cases Antique Stoneware", $56,606.00, only a little more than half of the asking price recalled by McHugh.[10] Kelekian apparently borrowed the money, or most of it, from the major Paris dealer Jacques Seligmann & Fils, as there is correspondence in the Kelekian file at the Metropolitan Museum that relates to interest owed on a loan from Seligmann of £14,150 at an annual interest rate of 5 percent.[11] Though the purpose of the loan is not mentioned in the correspondence, the figure is very close to the dollar amount Kelekian indicated he paid, assuming an exchange rate of about $4 to the pound. This, plus the circumstance that the loan was made by Seligmann's London office, as well as the inclusion of these documents with Kelekian's Assyrian sculpture correspondence, all suggest that the loan was used to buy the Canford sculptures. The annual interest of £707.10.0 would have been a significant business expense as long as Kelekian owned the sculptures.

Later in 1920, Kelekian began to offer them to American museums. The first attempt that is documented in the correspondence was to James H. Breasted, director of the Haskell Oriental Museum (now the Oriental Institute) of the University of Chicago. Kelekian wrote: "I have the pleasure of informing you that I have returned from Paris, and have brought with me the photographs of the Assyrian bas-reliefs, which I promised you. As I have only the one set of photographs, I should like to know whether you are now in Chicago, and whether I can send them for you to see."[12] Breasted responded, asking Kelekian to send the photographs.[13] A few days later, Kelekian sent the photographs, accompanied by this letter:

I am sending to-day, by registered mail, the fourteen photographs of the Assyrian Bas-reliefs, which I bought from Lord Wimborne. I am keeping the promise I made to show them first

to you, although I had two requests from other Museums for them. There are twelve Bas-reliefs and two Bulls. The photographs, which were taken in the chapel, are not very good, but you can see that the Bulls are far better than those in the British Museum and Louvre Museum. These are the finest monuments ever brought to this country. I had the good fortune to buy them, and I am very proud of owning them. If you help to place them in one of the Museums of this country, I am sure, not speaking from a business point of view, that your name will be immortal.[14]

As we will see, Kelekian had only this one set of photographs showing the sculptures as they were set up in the Nineveh Porch, and unfortunately by 1924 they had disappeared. Another set of photos was apparently in the British Museum in 1959 (see below p. 176) but I have not been able to locate these photographs, or any others that show the sculptures *in situ* in the Nineveh Porch.

There is a disparity here between the number of sculptures Kelekian reports he has and the number he actually brought from Canford (16 reliefs and 2 colossi). Presumably this is because Kelekian was basing his count solely on the photographs. The photographs would have shown the three slabs of King's No. 26 as a single slab, thereby reducing the relief count to 14. It is also possible that two of the fragments located high on the walls were omitted by the photographer, who Kelekian later says was unskilled and working with insufficient light. These fragments would have been inaccessible except with a ladder and would also have been almost invisible without strong artificial lighting. Kelekian's inability to unpack the actual slabs apparently resulted in his undercounting their number.

At the beginning of December, Breasted wrote that he had received the photographs and inquired: "At what figure do you value the pieces?"[15] Kelekian replied: "the absolute lowest price at which I will sell the Assyrian Bas-reliefs, is Four hundred fifty thousand, (450,000.00) dollars. I will be delighted to sell them to you if possible, but I want to have full liberty to sell them elsewhere if anybody comes along."[16] Breasted was taken aback: "I wonder if you realize that the price you are asking for these reliefs would put an expedition in the Orient for eight or ten years, as we expect to do. A normal price would enable us to show some interest in the collection, but at the price you mention, any other American Museum you may find interested will be entirely welcome to the purchase."[17] Kelekian decided to try Breasted once again, offering many persuasive arguments and a price concession:

I have been in this business for thirty-five years, and my principal line has been Assyrian, Egyptian, Greek and Persian antiquities. I have not had the pleasure of doing much business with your Museum, but I have had many large transactions with all of the other large Museums of the world. I am thoroughly familiar with what the different expeditions have accomplished, as I do business for love, rather than from a commercial point. I can thoroughly understand your feeling about expeditions, as it is like going hunting. I wish you all the luck in the world, but am very much afraid you will not find much. It would be a very great thing for art's sake if you could find something in Mesopotamia.

I have in Paris, the exact date of this find, made by Lord Wimborne, in Mesopotamia. He had the date written on the chapel which contained the reliefs. I think it was the year 1854. Except for the specimens in the Louvre and in the British Museum, and these in my possession, I do not think any others will ever be found. I own to-day the finest things that ever came to America.

The statement here that the find was made by "Lord Wimborne" (Sir John Guest) himself comes as a surprise. Not only is Lady Charlotte not mentioned—Viscount Wimborne may not have been aware of his grandmother's role in the acquisition of the collection—but even Layard's part is omitted. It may be that Kelekian really didn't know about Layard, but it is possible he deliberately omitted Layard in order to emphasize the noble pedigree of the collection. This version of the story would be repeated in subsequent letters. The letter continues:

I wish I could afford to make a gift of them to a Museum, but I regret that it is not in my power to do so. Certainly there must be some patriotic art lover who would be glad to make his name immortal by presenting them to a Museum. This is not like paying a million dollars for a painting, of which there might be many examples. I think that a man of great intelligence and understanding like you can make people understand the great importance of these wonderful things. Your name would be linked with them for centuries as a trophy. After all, we only work for a name in this world. In case you do not find a benefactor who wishes to have the glory of donating alone such a wonderful gift, I feel that as an American citizen, who has been living in this marvelous country for twenty-seven years, it would be only right for me to contribute what I can. I would be glad therefore, to contribute sixty thousand (60,000) dollars, if you decide to purchase them by contribution. The price will be Four hundred, fifty thousand, (450,000) dollars. Believe me, they are fully worth it, for you have no idea of the trouble and expense I had in getting them out of England and into the safe deposit vaults here.[18]

Breasted was not persuaded: "I have your interesting letter of December 14th regarding your Assyrian sculptures. Perhaps you have not noticed that I have just returned from a year in the Near East, including a long stay in Mesopotamia. I examined every important Assyrian site with considerable care, and I assure you that there is plenty of such sculpture still surviving. I should be very glad indeed to see your pieces set up in an American museum, and I wish you every success in placing them there."[19] Breasted's remarks were prescient—ten years later, the Oriental Institute's expedition to Khorsabad recovered an intact human-headed bull colossus and shipped it to the Oriental Institute Museum, where it stands today.

Rebuffed by Breasted, Kelekian next turned his attention to George Byron Gordon, Director of the University Museum in Philadelphia: "I am here from Paris, for a short stay, and shall be delighted to show you some extremely interesting things if you will favor me with a visit when you are in town."[20] And two days later: "When you come to New York, I can speak to you about something of extreme interest, the most wonderful things that have ever come to America."[21] Gordon was apparently either uninterested or out of town for the holidays, so a month later Kelekian wrote again with further details: "I have been waiting for your visit, to speak about the most important objects, both historically and artistically, that ever came into America. I have had the good fortune to buy the Assyrian Chapel of Lord Wimborne, of which you might have heard. These are the greatest Assyrian sculptures ever known. They are in this country, in a safe place, but I have not even unpacked them yet. This is the matter of which I wrote to you, without mentioning the subject."[22] There is no record of a response from Gordon. According to McHugh's letter, cited above, Gordon had recently seen the sculptures

when they were still in England, and had been unable to purchase them at the much
lower price for which they were then being offered. Not surprisingly, therefore, he
seems to have been uninterested in purchasing them now from Kelekian.

There is no further correspondence preserved regarding the sculptures until
November 1921, when Kelekian tried to interest Edward Robinson, Director of the
Metropolitan Museum in New York, in them:

Knowing your appreciation of early Art, I desire to bring to your attention the greatest
work which has ever been brought to America, a sculptured stone temple, of Assur-Nassir-
Pal, which I purchased direct from Lord Wimborne. It was excavated in 1854 by his grand-
father, who gave one-half to the British Museum, and kept the other half, building a chapel
on his estate, near Bournemouth, where it remained until it came into my hands, last year.
I would be very glad to show the photographs to you to-morrow, if that is convenient for
you. The sculptures are in the Manhattan Storage Warehouse here.[23]

There is no written response from Robinson. According to the record of his 1928
conversation with John D. Rockefeller, Jr., quoted at the beginning of this chapter,
Robinson, like Gordon, had recently turned down the reliefs when he was offered
them at a "moderate" price by the Wimborne estate.

Later that month, Kelekian tried the Museum of Fine Arts in Boston. Here he
used as his go-between Edward W. Forbes, Director of the Fogg Art Museum, which
he had recently visited:

The excavations were made by the grandfather of the present Lord Wimborne, in 1854. He
presented one half to the British Museum, and kept the other half, building a chapel with
it, near his castle at Bournemouth, where it remained until I had the good fortune to buy
it from Lord Wimborne. These bas-reliefs belonged to the great Assyrian king, Assur-Nassir-
Pal. No such things are known except those in the British Museum, and in the Louvre. The
workmanship of these is marvelous. The photos unfortunately are very poor, as there was
not sufficient light in the chapel, where the photographs were taken, before the 12 bas-
reliefs, and the 2 great bulls, were taken down. I am willing to let these pieces go as a com-
plete lot to any Museum, for the sum of $350,000. If, in case a Museum should make this
purchase by subscription, I am willing to donate $50,000. to the fund, to show my good
will. My personal wish is that it should go the Museum of Fine Arts, Boston, which has
been the leader in art matters in America.[24]

The first part of this letter is fairly standardized by now, but the remainder has
interesting features. One is that Kelekian seems increasingly to have felt that the
poor quality of the photographs was handicapping his efforts to sell the pieces, so
his explanation of why they are so bad becomes increasingly elaborate. His quest
for better photographs became an important part of his marketing strategy for
these works. Also of interest here is the asking price, $300,000 after his personal
"donation" to the subscription. This too is of importance as it concerns Kelekian's
subsequent actions.

Forbes's response was not especially encouraging, but it did leave room to nego-
tiate: "I fear the chance of raising $350,000 is small, but still I am anxious to speak
to the Boston Museum about the matter, and show the authorities the photographs.
Would it not be possible to split the lot and to sell the bulls to the Metropolitan
Museum and the reliefs to the Boston Museum or to Harvard if I could find a pur-

chaser? In that case how much would you charge for the reliefs?"[25] Kelekian's answer to Forbes was positive, but he avoided naming a price for the reliefs if they were separated from the colossi:

I must tell you candidly that I brought that lot of wonderful bas-reliefs to America because I had made up my mind that it would be sold to an American Museum. As I am an American, I don't want to sell it in any other country, and I must tell you that I am surprised that it has not already been sold. To ask you a special price for the bas-reliefs is against my intentions as a business man, but, if you find a buyer who wants to buy the bas-reliefs alone, and then make me a fair offer I do not say that I will not separate them. You can very well understand that if I would ask you a separate price, I would be compelled to make the same advantage to any other Museum, and I had made up my mind to sell the whole lot to the Museum of Fine Arts, to which I made a special reduction, having always had great admiration for your people and your splendid Museum. I must tell you again that the photographs do not give any idea of the remarkable beauty and strength of these wonderful sculptures.[26]

At the end of November, Arthur Fairbanks, Director of the Museum of Fine Arts, wrote a friendly letter to Kelekian: "Under separate cover I am returning to you the photographs of Lord Wimborne's Assyrian sculpture. It has given us great pleasure to see photographs of such wonderful pieces. I have informed Mr. Forbes that unfortunately this Museum is not in a position to buy these pieces or to raise the money to buy them. We feel, however, that it would be a wonderful thing for any museum to have such splendid pieces as these evidently are."[27] On the same day, Forbes wrote to Kelekian with a further bit of advice passed on from Fairbanks: "He says that if you are able to interest any millionaire to buy them and either lend them or give them to the Boston Museum he thinks it will be a wonderful thing."[28]

Kelekian promptly followed Fairbanks's advice and wrote to John D. Rockefeller, Jr. in early December. The beginning of the letter is similar to the others, giving the origin of the pieces, but with an important addition:

I desire to bring to your attention, the greatest work of art ever brought into this country. It is a sculptured stone temple, of Assur-Nassir-Pal, of Mesopotamia, which I purchased direct from Lord Wimborne. It was originally excavated in 1854 by Sir Henry Layard, in Mesopotamia, for the then Lord Wimborne, grandfather of the present Lord Wimborne. Lord Wimborne gave one half to the British Museum, and kept the other half, building a chapel for it on his estate, near Bournemouth. It remained in possession of his family until it came into my hands.

Here for the first time, Kelekian attributes the actual excavation of the reliefs to Layard, under the sponsorship of Wimborne. It is not clear where he got this new information. The letter then continues:

These things are eminently educational, and should go to an American Museum. As you have already done so much for education, may I suggest that you would render a great service to art and to education, if you would buy and present them to an American Museum. It will make a monument for centuries, and these are the foundation stones in the history of art. They are by far the greatest works of sculpture that have ever come into this country. The Museums are all eager to have them, but are handicapped by a lack of funds. On account of the exchange, I am able to offer them at a price which would be low for any one of the pieces. Compared to the prices of porcelains, paintings, and other art objects, the price I am asking for these sculptures will seem in another generation ridiculous. They

are unique for it is known by historic records that no other palaces were built by the Assyrian kings, except those which have been already opened.

In fact, archaeologists would find three more major Assyrian palaces during the twentieth century—the arsenals at Nimrud, Khorsabad, and Nineveh. The letter concluded:

I am sending the photographs of twelve bas-reliefs and two bulls, for your inspection. The photos are very poor, being taken under difficulties, before dismantling the chapel on Lord Wimborne's estate. I have shown these photographs to Mr. Bosworth who gave them his unqualified approval as magnificent and beautiful works of art. If you will buy the sculptures for a Museum, I will sell them to you at the same price quoted the Museums, $350,000. There is nothing of this kind in this country, only plaster casts.[29]

Again, this statement is not quite accurate. Though there were no other Assyrian colossi in America, there were at the time at least 55 reliefs from Assurnasirpal's palace in museum and college collections on the east coast. We will hear of these later.

A few days later, afraid that he might lose the sale because of the poor quality of the photographs, Kelekian sent Rockefeller a book on the Assurnasirpal II sculptures in the British Museum (Budge 1914), hoping that it would give him "a better idea of the remarkable quality of the sculptures mentioned in my letter of December 5th. The Bulls and Bas-reliefs in my possession are exactly the same as those in the British Museum, being a part of the same find. . . . I sincerely hope that they will interest you."[30] They didn't. At the end of the month, Ann Adams, Rockefeller's secretary, returned the book to Kelekian with a note saying that her employer "asks me to say that he would not be interested in the matter you present."[31]

In mid-January 1922 Kelekian wrote a long, frustrated letter to Fairbanks, whose unusually gracious letter had evidently moved him:

I am glad to know that you liked the Assyrian bas-reliefs, and that you think them a wonderful thing for any Museum to have. I acted on your suggestion, and sent the photographs together with the Budge book on the British Museum reliefs, which are exactly like mine, to Mr. John D Rockefeller, Jr. for inspection, with the suggestion that he purchase and present them to an American Museum. His answer was that these things do not interest him. Mr. Robinson's answer was that if Mr. J P Morgan, or Mr. Jacob H Schiff were living, either one of them might have bought and presented the reliefs to the Metropolitan Museum of Art. I proposed them to Prof. Breasted of the Chicago University, and his answer was that for the price I am asking, he could make excavations in Assyria for ten years. Good luck to him. I proposed them to Dr. Gordon, who thought my price was very high. I do not see any other persons or Museums likely to be interested in these, except Mr. William Randolph Hearst, to whom I am going to propose them. If he is not interested, I shall be obliged regretfully to take them back to Paris, and put them in my house. Perhaps some day a Japanese or a Chinese collector will buy them.[32]

This seems not to have been a serious threat, however, as the sculptures remained crated in the Manhattan Storage Warehouse. Kelekian's letter to Hearst, if he wrote it, is not preserved in the archive, and there are no further references to the sculptures in 1922. He did offer the sculptures to at least two collectors in 1923, however.

In February he wrote to Cora Timken Barnett, a New York collector: "I should like to bring to your notice a wonderful series of ancient Assyrian reliefs, in stone, including in the series, two magnificent Bulls, similar to those in the British Museum. . . . Knowing your keen appreciation of fine things, I should be pleased to show them to you, even though you may not care to purchase anything. I am sure that you would feel repaid for the trouble."[33] A cross-reference in the Kelekian file suggests that he also offered the sculptures to Raymond Pitcairn, a Philadelphia collector who owned a pair of Assyrian reliefs similar to King Nos. 14 and 16.[34]

In addition, Kelekian offered the reliefs to at least one more museum, the Detroit Institute of Arts. As with the Boston Museum, he made the offer through an intermediary, in this case the Detroit banker Julius Haass. The sales pitch is similar to the earlier examples, but with subtle improvements:

I am sending by registered mail today, a set of photographs of the Assyrian Bas-reliefs, which you kindly told me you would propose to the Detroit Museum. They are very poor photos, having been taken by the village photographer. . . . When this temple was found, Lord Wimborne gave one-half the find to the British Museum, and kept the better half for himself. These are the pieces he kept. We purchased them direct from his heir, brought them to New York and put them in storage, with the cases unopened. They have never been shown in America. . . . Dr. Gordon, Director of the University Museum in Philadelphia, who sailed yesterday for Europe, is greatly interested in them and told me that upon his return he would seriously consider them for the Museum. You could not recommend a better purchase to the Detroit Museum, or to any of your friends.[35]

There are several interesting features here. We learn for the first time who was responsible for the wretched photographs. This is also the first time that Kelekian has claimed that the Canford sculptures represent the "better half" of Layard's finds. Note also how the necessity of keeping the sculptures crated in a warehouse has been turned to advantage—the successful buyer will be acquiring things "never before shown." Finally, the reference to Gordon's serious interest in the pieces, while having the appearance of a bluff, would in time prove to be correct. The response from Detroit was unsurprising. Haass wrote to Kelekian:

I am returning to you today, by mail, the photographs of the Assyrian bas-reliefs which you sent with your letter of May 16th and which have just been returned to me by the Director of the Detroit Institute of Arts with a statement that at the present moment they do not see how anything can be done about this subject here. The Director is very much interested and will mention the subject further to those interested. He has already talked with some of the members of his board but they do not show any enthusiasm at present.[36]

The director of the Detroit Institute of Arts, W. R. Valentiner, was sufficiently interested that he wrote to Kelekian again 16 months later to see if the price had come down: "You showed me last year some photographs of a collection of Assyrian sculptures belonging to some Englishman. I wonder whether the owner is still harboring his crazy ideas about the price. I would be glad if you could send me some photographs and wonder if there would be any chance of having the collection separated."[37] But by then the sculptures had moved on. Dikran Kelekian was in Paris at the time, and so his brother, Hovannes Garabed Kelekian, who managed his New York operation in his absence, replied to Valentiner: "Your letter

of October 13th has been duly received, and in reply would say that the Assyrian sculptures referred to are the property of my brother. I am unable to show you any photographs for the reason that the sculptures are now in the University Museum of Philadelphia. They will be placed on exhibition in the Museum some time in January, I believe. My brother will arrive here soon, and I shall then ask him whether or not the collection can be separated."[38]

To return to 1923, however, after Detroit turned the sculptures down, Kelekian apparently decided that he was not going to be able to sell them unless he could get them uncrated and on display. In October 1923 he inquired about renting a display room in Jacques Seligmann's New York gallery at 5 East 55th Street, only two doors down from Kelekian's gallery. Seligmann insisted that Kelekian hire an architect, Charles L. Fraser, to determine whether the floor of the room would need to be reinforced. Seligmann also insisted that Kelekian be responsible for all expenses. A letter to this effect was sent to Fraser, with a copy to Kelekian:

In order to avoid all misunderstanding in reference to the heavy stone sculptures about which we referred Mr. Dikran G. Kelekian, of 709 Fifth Avenue, to you, we beg to state that all expenses and charges in this connection are to be charged and billed to Mr. Kelekian and not to this firm, which has no interest in the stones, but only considers sub-letting a room to Mr. Kelekian for exhibiting them. This of course refers also to charges by other contractors, etc. in reference to said stones which would be handled, transported, put up and exhibited at Mr. Kelekian's own risks and expense.[39]

Later that month, Fraser reported to Kelekian that it would cost $4670 "to unpack, move and set, all the sculptures now in storage at Seventh Ave. and 53rd Street, at 5 East 55th Street" and $425 for "the strengthening of the present floor to safely support the above work." After adding a 10 percent "supervision, etc." charge, the total came to $5604.50.[40] Kelekian later wrote that after Fraser had submitted his report, Seligmann "declined to let the building for that purpose."[41]

NINEVEH ON THE DELAWARE

After nearly four years, Kelekian still could not show his Assyrian sculptures, still had only a single poor set of photographs taken at Canford, and still apparently hadn't even received a serious offer for the pieces. His expenses on the sculptures were mounting and he was no closer to a sale than on the day he purchased them. In December 1923 he tried Gordon of the University Museum once again:

You know, my dear Dr. Gordon, that I have the greatest work of art in this country, the entire collection of Assyrian sculptures of the late Lord Wimborne, two great Bulls, and the bas-reliefs, as you know; the other two Bulls, from the same excavation being in the British Museum. This collection has been, for the past three years in the Manhattan Storage. I did not expose them, waiting for better financial conditions in this country. At the beginning of next year, I intend to expose them, and am writing first to you, so that you might speak to your patrons, to see if you could find one to make a gift of it to your splendid Museum. I assure you that it would be an everlasting monument to the buyer and to yourself.[1]

A meeting between Gordon and Kelekian followed. The outcome was summarized in a letter from Kelekian of February 1924: "I am sailing tomorrow, and according to our conversation, I will expose my collection of Assyrian Sculptures, from the late Lord Wimborne, in the new wing of your Museum, in the room on which we decided. In regard to the transportation of them, I would greatly appreciate if you could kindly arrange to have your trucks call for them at the Manhattan Storage Warehouse, where they have been kept ever since they arrived in this country."[2]

Gordon seems to have been unwilling, however, to assume the responsibility and costs for shipping what was essentially to be a free exhibition of Kelekian's wares. A letter of June 1924, from Kelekian's brother, indicates that the dealer had agreed to arrange transportation of the sculptures: "In regard to the forwarding of the rare Assyrian Sculptures to your Museum, we plan to send them all the way by auto truck, delivering them direct to your new wing, as I feel that this will be the most convenient way for you, and probably the safest way. We plan to start the packing on Monday, June 16th, and will deliver them to you as soon as possible thereafter. You may expect to receive them during the week of the 16th."[3]

These were bulky items, however, and, as Layard had discovered, difficult to transport. A few days later, H. G. Kelekian wrote to Gordon again:

In regard to the forwarding of the Assyrian Sculptures, I wrote you on June 11, that we hoped to be able to send them all the way by auto truck, but I find now that this will not be possible, as two of the cases are too high to pass under some of the bridges on the way. I will therefore send them according to your first suggestion, which was that we are to deliver them to the Pennsylvania Railroad and that you are to take charge of them upon arrival in Philadelphia. Two gondola freight cars will be required, and as it will take about two days to obtain these from the railroad, I shall be glad if you will notify me a few days in advance of the time you will be ready to receive them. As the weight is about thirty-five tons, it will be necessary for you to arrange for the cartage, with some one who handles heavy trucking.[4]

On 19 June 1924 Gordon wrote:

We are now ready to receive the Assyrian sculptures referred to in your letter of February 5th. You are hereby authorized to ship these sculptures subject to your own risk. The Museum agrees to receive and install these sculptures in the new exhibition rooms without assuming any responsibility or any obligation in connection with them. It is understood that they are to remain in the Museum on loan and in case they should be withdrawn, you will give the Museum six months' notice of your intention. Will you be good enough to acknowledge the receipt of this letter confirming the conditions of the loan and at the same time let me know upon what date the sculptures will be shipped and by what route they are coming?[5]

H. G. Kelekian's response, written the next day, acknowledged Gordon's letter, but did not explicitly confirm the conditions Gordon had set out for the loan, perhaps because he did not want to make such a decision in his brother's absence:

I am in receipt of your letter of June 19th informing me that you are now ready to receive the Assyrian stone sculptures, which we are to send for exhibition in the new rooms of the Museum. We hope to start shipment on Monday, June 23rd, by Pennsylvania Railroad, freight prepaid. The Bill of Lading will be forwarded to you in due time. I shall expect you to take entire charge of the removal from the freight cars into the Museum, and as I shall insure them for a few days only, during transit, I trust that you will have them removed promptly upon arrival. The first car will probably arrive in Philadelphia about Tuesday, the 24th, the second car will follow immediately.[6]

Three days later, the Canford sculptures were on their way to Philadelphia: "Confirming my letter of June 20th, please find herewith Bills of Lading, covering shipment of two carloads by Pennsylvania Railroad freight, prepaid, containing the Assyrian stone sculptures. Both cars should be in Philadelphia by the time you receive this letter."[7] Gordon evidently wrote to H. G. Kelekian for information on the size of the shipment. That letter is not preserved in the correspondence, but H. G. Kelekian's response of 30 June is: "Your letter of June 28th came duly to hand. The Assyrian sculptures are packed in thirty-five cases, and when set up, there will be two large Bulls, and twelve reliefs. You will note that the Bulls are in sections and that some of the other pieces will also have to be joined together. . . . I trust that by this time, the second car has arrived and that the pieces are safe in the Museum."[8] Kelekian still did not know how many reliefs he had sent, but Jane

McHugh, Secretary of the University Museum, later confirmed that they had received all 16 reliefs plus the lion and bull.[9] The sculptures arrived safely in the University Museum on 2 July.[10]

Dikran Kelekian seems to have been anxious that his colossi be displayed in the University Museum in the same manner as the examples in the British Museum. In his 30 June letter to Gordon just cited, H. G. Kelekian added: "My brother writes me from Paris, that he has asked a friend in London to send him the measurements of the bases under the Bulls in the British Museum, which are similar to these. I have borrowed the British Museum book, from a friend here. It contains the measurements of the Museum pieces. Should you wish to refer to this book, in case you have no copy in your library, I could let you have it for a little while."[11] In the middle of July, H. G. Kelekian wrote to Gordon again on the same subject: "My brother has written to me saying that he hoped you would put [the bull and lion] on bases, and arrange them so as to show to the best possible advantage. I imagine he has in mind bases similar to those in the British Museum. I know that he can depend on you to give them the best possible setting."[12]

Dikran Kelekian himself also wrote directly to Gordon from Paris on the subject of the display, and his tone makes it clear that he wants a proper British Museum display: "My people from New York write me that you gave orders that they can ship the Assyrian Bulls and bas reliefs of the late Lord Wimborne collection to be exhibited in your splendid Museum. I am sure you will take good care that, these most magnificent antiquities be well exposed. It will be a great credit to your good taste and intelligence. I wrote to the British Museum for the size of the Bulls. They write me that they are 10 feet 4 long and 2 feet wide, so you will kindly prepare the stands for them."[13] In fact, Kelekian's lion was only 9 feet 1 inch long, but he had no way of knowing this. It is interesting that these colossi were not mounted on bases as they were originally displayed in the Assyrian palaces. It is possible that part of Kelekian's concern here is that the colossi be on bases to protect them from careless kicks. I suspect, however, that he also felt that a display modeled on that in the British Museum would help draw attention to the museum quality of these rare pieces, the only examples then in America, and their kinship to the only other Assurnasirpal colossi exhibited anywhere, in the British national collection.

H. G. Kelekian's letter to Gordon of 30 June contains one more interesting passage: "By the way, did my brother [Dikran] leave with you a set of photographs of his Assyrian sculptures, including one of Lord Wimborne and his house? They were poor photos, and I am hoping to have really good ones when they are installed in the Museum."[14] His letter of 3 July gives further details: "We had a series of photographs of these Assyrian sculptures, and a photograph of Lord Wimborne and his house, but in some way they have been mislaid, and I thought perhaps my brother had left them with you. The photos of the sculptures were very bad indeed, having been taken by an unskilled country photographer in England, under very poor lighting. I hope that when they are properly set up in your Museum we can have some good photographs taken. I will try to get another photo of Lord Wimborne from England."[15] There is no further reference to these poor photos, and it appears that they were in fact lost. If so, then Kelekian now had no photographs

of the sculptures at all, not even poor ones. His inability to show any photographs to prospective purchasers would have further hampered his prospects of selling the collection.

Gordon was evidently curious about the setting of the sculptures at Canford, and in October he pressed H. G. Kelekian further about photographs. Gordon's letter is missing, but Kelekian's response is preserved: "Your letter of October 2nd, asking whether we could procure for you any photographs showing the Assyrian sculptures as they were set up in England, has been duly received. I am forwarding it to my brother in Paris. If it is possible to procure any such photographs I am sure that he will be glad to do so."[16] Soon thereafter, Dikran Kelekian replied from Paris: "My brother has sent me your favor of October 2nd. I am sorry to say that we do not possess any photographs of the Assyrian stones but the ones you have seen already in New York." Fortunately, the same letter continues with a good description of the sculptures as they were displayed in the Nineveh Porch:

I remember having seen the reliefs when they were in Wimborne. There was a little chapel specially made for them. The reliefs were disposed on both sides in this chapel, while the two big bulls were settled in place of the altar opposite the entrance. The reliefs were fitted in a wall imitating the stone in which they are carved, so as to show the whole thing in one piece. There was also some paintings copied from old Assyrian patterns, to complete the decoration. It was looking very fine like that.[17]

This is the only reference to a marbleized pattern on the interior walls of the Porch. The effect was presumably intended to imitate the continuous frieze of reliefs found on the walls of actual Assyrian palaces.

On 19 November Gordon informed Dikran Kelekian that they had begun to install the sculptures.[18] At the beginning of December, H. G. Kelekian responded: "I expect my brother to arrive here by the end of this week, coming especially for the installation of these sculptures. He will appreciate it very much if you can have them done in as short a time as possible, for his time here is limited."[19] This was wishful thinking, however, as the installation of the Canford sculptures was apparently still not complete by March 1925, and the new wing in which they were located did not open to the public until the following year.[20]

Finally, on 19 May 1926, Gordon wrote to Joanna Keating, Dikran Kelekian's assistant in New York: "I would be very much obliged to you if you would write to Mr. Kelekian in Paris that we opened the New Wing yesterday. The large number of visitors were very much impressed by the whole exhibition and the Assyrian sculptures were mentioned in particular by many visitors. Please say to Mr. Kelekian that I now propose to take up with those people in Philadelphia who are interested in the matter the whole question of acquiring these permanently for the Museum" (figs. 101, 102).[21]

At the beginning of June, Gordon wrote to Kelekian on the subject of acquiring the sculptures: "I know that you will be interested in any news that I can give you regarding our plans and progress concerning the objects belonging to you now in the Museum. I may tell you quite confidentially that we have started a fund for the purpose of acquiring these objects, an undertaking which we hope to be successful. As you know, it is our desire and intention to meet you in this matter. In

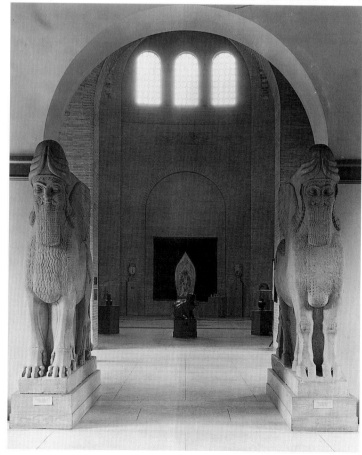

101: Philadelphia, The University Museum, Assyrian sculpture installation, general view (photo: The University Museum, University of Pennsylvania)

102: Philadelphia, The University Museum, Assyrian sculpture installation, colossi (photo: The University Museum, University of Pennsylvania)

the meantime, we retain our option on all of the objects deposited by you here."[22] Gordon's statement here that it was his intention to "meet" Kelekian in the matter of the sculptures may have given Kelekian the impression that Gordon had agreed to his asking price of $350,000. This would later lead to misunderstandings about the price the Museum had agreed to pay.

Joanna Keating replied to Gordon for Kelekian: "I have just received a letter from Mr. Kelekian in Paris, expressing his very great pleasure and appreciation of your efforts in regard to the Assyrian Sculptures. He writes that these monuments will make your name immortal, as they are the greatest things in the world and you have been the only man in America to so thoroughly appreciate them and realize their immense importance, and that the future will speak."[23]

By the end of November 1926, Kelekian was clearly hopeful that a deal was at hand. He wrote optimistically to Gordon: "At present, I intend to leave for Europe on Dec. 15th. I trust that by that time you will be able to know definitely how you are situated, as you expect. However, if necessary, I shall postpone my departure to Dec. 27th, and you need not have any scruples about causing me any inconvenience. I have waited seven years, I can wait a little longer. You were kind enough to promise to send me photographs of the Assyrian bas-reliefs. Will you kindly let me have them some time at your convenience."[24] Despite the hopeful tone of Kelekian's letter, the reference to his desire for photographs indicates that he still intends to show the pieces to other prospective purchasers, should any materialize.

Gordon's reply indicated that no decision had been reached: "I have to acknowledge with thanks your letter of November 27th. There will be no occasion for you to postpone your departure for Europe. As you yourself suggest, conclusions such as we have in mind are apt to take time to accomplish. . . . I have been delayed in sending you the photographs that I promised because our photographer has been busy. I am now sending you ten prints which show the most important of the Assyrian sculptures."[25] Kelekian still didn't have a sale, but at least he now had the professional-quality photographs he had long wanted.

Early in the new year, however, Kelekian's hopes of selling the Canford sculptures to the University Museum were dealt a severe blow. On 31 January 1927 he telegraphed the University Museum Directors: "Overwhelmed by shocking news of Dr. Gordon's death. Extend sincerest condolences."[26] Following Gordon's death, the Museum administration evidently felt it necessary to make an inventory of items on loan. In the middle of February, Jane McHugh, the Secretary of the University Museum, asked Kelekian to confirm the accuracy of a list of the objects that were on loan from him to the Museum. Heading the list were: "Assyrian reliefs and colossal winged bull and lion from Palace of Assurnazirpal at Nimroud excavated in 1852 by Layard."[27] The following day Joanna Keating wrote to confirm the accuracy of the list of loan items. She concluded: "I sincerely hope that the University Museum will definitely acquire these rare objects, as Dr. Gordon had told me that the Board of Directors had decided to purchase them and he had also written a letter to Mr. Kelekian to that effect."[28] By August 1927, Kelekian was pressing the University Museum for a decision:

I would greatly appreciate if you would let me know your final decision with regard to the

Assyrian sculptures which have been on exhibit in your Museum since May 1926. . . . Dr.
Gordon wrote, and later in an interview confirmed, to me that you had decided to acquire
these sculptures permanently for the Museum. In order to facilitate the transaction and to
show my appreciation of Dr. Gordon's good taste and zeal in the matter, I agreed to let the
Museum purchase them for $350,000.-cash, notwithstanding the fact that they are fully
worth two million dollars, as they are unique and, in fact, priceless. Dr. Gordon and I agreed
on this price, and it was, as he stated to me, a question of some little time to raise the funds
to complete the transaction when his untimely death occurred, and since then the matter
has been left in abeyance. I now take this opportunity to solicit from you an early expres-
sion of your final decision in the matter. I sincerely trust, . . . that you will confirm Dr.
Gordon's selection and reaffirm your decision, so that I may consider the transaction as
closed. Otherwise, to my great regret, I shall consider myself free after January 1, 1928, to
offer them for sale to other institutions interested in them.[29]

Kelekian's assertion here that he and Gordon had agreed upon a price for the
Canford sculptures comes as something of a surprise, since there is no specific
mention of such an agreement in the preserved correspondence. In a letter to John
D. Rockefeller, Jr. later that year, McHugh expressed doubts that Gordon had actu-
ally agreed to this price:

Our records do not show that any price was placed upon the collection when it came to
us, but later Mr. Kelekian named the sum of $350,000. as the price which he desired to
receive for the collection. . . . It had always been the policy of the Director of the Museum
not to discuss prices with dealers until he was in a position to make a definite offer. I feel
quite sure that this was the course which he followed with Mr. Kelekian. In his conversa-
tions with members of the Board, Dr. Gordon had always expressed the hope that Mr.
Kelekian would make some reduction in the price which he had placed upon the
collection.[30]

This does not necessarily mean that Kelekian was trying to mislead the Museum
Board, however, as Gordon's letter of 1 June 1926, quoted above, clearly indicates
that the museum would try to "meet" Kelekian's price for the sculptures. Never-
theless, considering that Kelekian had already offered the sculptures to the Museum
of Fine Arts for $300,000 in 1921, it seems unlikely that Gordon would later have
agreed to the firm figure of $350,000. McHugh's response to Kelekian was a request
for patience:

I want to acknowledge your letter of August 10th addressed to the Trustees of the Museum
with reference to your Assyrian sculptures which you have been kind enough to allow us
to retain for exhibition in the Eckley B. Coxe, Jr. Memorial Wing for more than a year. The
Managers of the Museum and indeed everyone connected with the Museum appreciate in
the highest degree the importance of these fine sculptures and it would be a matter of deep
regret to us should we not be able to acquire them. Many of our Managers are still out of
town and it is not likely that we can hold a meeting until October. At that time your letter
will be laid before the Board for its consideration and we will let you hear from us. Dr.
Harrison, our President, is seriously ill at his home and is not able to attend to any duties
whatever. It is for this reason and because of the absence of so many of our Managers that
we are unable at this moment to give you a definite answer to the question which you ask.
I hope that you will allow the matter to rest until the Board has had an opportunity of
giving it the serious consideration which it deserves.[31]

Following the University Museum Trustees' meeting in October, McHugh again wrote to Kelekian:

The Managers of the Museum held their first meeting of the season on Friday afternoon last, when there was laid before them your letter dated August 10. While the Board is deeply appreciative of the importance to the Museum of the fine Assyrian sculptures which you have allowed us to retain for exhibition during the past eighteen months, I am instructed to say to you that the Board finds itself unable at this time to make any commitments for the acquisition of collections, especially one involving so large an outlay of funds as that named in your letter. Two circumstances make necessary this decision to postpone the taking on of any new obligations at present: these are, first, the very serious illness of our President through whose energies all funds for the purchase of collections have been acquired; and second, the fact that a successor to Dr. Gordon has not yet been appointed. It is hoped that the position of Director will be filled in the not far distant future and, personally, I wish that it might be possible to allow the matter of the Assyrian sculptures to rest until that appointment is made.

McHugh's letter concludes in an unexpected fashion: "The final disposition of the sculptures lies, of course, in your hands and if you find it necessary or desirable to remove them from the Museum, we must be content, sorry as we should be to lose these splendid monuments."[32]

Two features of this letter are particularly striking. First, it indicates that the trustees have no plans to make a decision on the purchase of the Assyrian sculptures until the Museum's internal crises are resolved, and specifically, not until a new director is appointed. No timetable is proposed and Kelekian is given every reason to believe that the matter may drag on for months or years. Certainly, there seems to be no chance that a decision will be reached before his deadline of 1 January 1928. Second, the wording of the final paragraph appears to release Kelekian from any obligation to the Museum, and to allow him to remove the sculptures should he find it "desirable" to do so.

As it was now clear to Kelekian that he could expect no quick action from the museum trustees, he evidently decided to try to locate a suitable donor himself. At the beginning of December, he showed the new photographs to John D. Rockefeller, Jr., who was more interested this time and evidently asked if he could borrow them. During the years that had elapsed since Kelekian first offered the Wimborne collection to Rockefeller, Rockefeller had become the founder and principal benefactor of the new Oriental Institute, the mission of which was to study the culture of the ancient Near East. Rockefeller had become a great admirer of the Institute's director, James H. Breasted, who was now a valued Rockefeller family friend. Following this new overture from Kelekian, Mr. and Mrs. Rockefeller evidently discussed the Wimborne sculptures with Breasted, who considered them to be very important and was anxious to have them for the new Oriental Institute Museum.

Kelekian requested additional photographs from the Museum, and on 7 December McHugh personally delivered two more sets to him. "During a very friendly talk," McHugh wrote, Kelekian "assured me that he would do nothing about the collection until we told him definitely that we could not acquire it. At the same time he dictated in my presence a letter to [Rockefeller] asking [his] assistance in

acquiring the collection for our Museum."[33] In this letter, Kelekian wrote:

A few days ago I had the pleasure of showing to you photographs of the sixteen bas-reliefs and two great Bulls of the Assyrian King Assur-Nasir-Pal, which collection I purchased from the heirs of Lord Winborne [*sic*] of Bournemouth. . . . While my position, as owner, would make it seem indelicate to solicit funds, yet, for the sake of art, education, and archaeology, I am willing to put myself in the position of a beggar and make a humble appeal to you to help make it possible for the University Museum to acquire them. I am sending herewith the photographs of these pieces, and I can assure you that these great monuments would be a lasting memorial of your generosity.[34]

Twelve years later, Kelekian recalled the next events as follows: "On the point of taking [the reliefs] back to Europe, it occurred to me to write a letter to Mr. John D. Rockefeller, Jr., and see what would happen. Something did. I had written on Thursday, and on Saturday, as I was going to lunch, I met him—he was on his way to see me—at the corner of Fifty-sixth Street and Madison Avenue. The transaction was concluded on that spot, though Mr. Rockefeller wanted to be free to donate these monuments to the institution of his own choice."[35]

On 10 December Kelekian wrote to Rockefeller to confirm their street-corner deal, and to assure him that the sculptures were indeed available:

As you will see from the enclosed copy of the letter which I received from the Museum of the University of Pennsylvania, under date of October 26th, in answer to my letter of August 10th, in which I gave them notice that in case they did not pay me by January 1st, 1928, I shall be free to sell the Assyrian bas-reliefs to others, the final disposition of the sculptures lies entirely in my hands and I am free to do with them what I please. Accordingly, I shall be very happy to sell them to you for $350,000.- and you of course do with them whatever you consider best.

 P.S. . . . I am telegraphing [the Museum] to-day that the sculptures are sold, without mentioning the buyer's name.

This letter is accompanied by a bill for $350,000 for the "entire collection of Lord Wimborne's Assyrian Sculptures, consisting of sixteen bas-reliefs and two winged bulls, now exposed at the Museum of the University of Pennsylvania, Philadelphia."[36]

 On the same day, Kelekian telegraphed McHugh at the University Museum: "It is my duty to inform you that I have today sold the entire Lord Wimborne Collection of Assyrian sculptures now on exhibition in the University Museum. It is my intention to donate to your Museum in memory of the regretted Dr. Gordon the large Rameses head, the basalt monkey and the Egyptian reliefs from Sammanoud which are among my objects now in the Museum."[37] In a letter on the same date, Kelekian repeated the message of the telegram, and then continued: "According to your letter of October 26th, in which you say 'The final disposition of the sculptures lies, of course, in your hands and if you find it necessary or desirable to remove them from the Museum, we must be content,' leaves me at liberty to dispose of them, which I have done."[38]

 Four days later, John D. Rockefeller, Jr. wrote to McHugh to request clarification of the nature of the agreement between Kelekian and the University Museum:

I am advised by Mr. Kelekian that some time since he sold to the Museum of the University of Pennsylvania for $350,000. his entire collection of sixteen Assyrian Bas Reliefs and two Bulls, formerly owned by Lord Wimborne. Am I right in understanding that this was an out and out sale and that the price of $350,000. was agreed to by the Museum, or did the Museum simply agree to buy the collection in the event of its being able to raise the money, without having come to terms with Mr. Kelekian as to price? I will appreciate your courtesy in giving me the information above requested, since, in line with your letter of October 26th to Mr. Kelekian, of which he has shown me a copy, indicating the inability of the Museum to carry through the purchase and freeing Mr. Kelekian to place this collection elsewhere, he has sold it to me.[39]

McHugh replied to Rockefeller on 19 December with a lengthy summary of the story of the Museum's involvement with Kelekian and the Canford sculptures. Parts of this letter have already been quoted here and other parts cover the same ground as the other correspondence. To Rockefeller's specific question about whether or not the Museum had actually agreed to buy the sculptures, she replied: "There was really no out and out sale to us of the sculptures. Our understanding with reference to these objects as with others that have come to us from dealers in the same manner as these, has always been that the Museum assumes no obligation whatever in connection with them and that their acquisition depends upon our being able to raise the funds for their purchase."

Concerning her 7 December meeting with Kelekian, she wrote:

With the assurance that the sculptures would not immediately be disposed of, we renewed our efforts to interest some friends of the Museum in them. It was a shock to us to receive a telegram from Mr. Kelekian on December 10th, three days after my visit to him, that the collection had been sold. While we deeply regret that we must lose these splendid sculptures which are now set up in one of our exhibition halls adjoining that in which are shown the collections from Ur of the Chaldees which have come to us through your generous benefaction, we are very glad indeed to learn from your letter that you are the purchaser.[40]

The reference here to Rockefeller's "generous benefaction" appears to be a not very subtle hint.

The same events are referred to, in a rather more reproachful tone, in McHugh's acknowledgement of Kelekian's communications:

Your telegram and letter of December 10th were submitted to the Board at its regular monthly meeting on Friday last. We find ourselves in some embarrassment for two reasons. First, because relying upon your assurance to me that you would not offer the Assyrian collection elsewhere until you heard that we could not acquire it, we have been endeavouring to arouse the interest of a few of our friends in securing this collection for the Museum; and second, because of your friendliness in writing in my presence to Mr. Rockefeller suggesting that he might assist the University Museum in acquiring the collection. Both of these facts led us to believe that it was your intention to cooperate with us in our effort to have the sculptures remain in our Museum. Your communications, however, make it clear that a further effort on our part in this direction would be futile.

The letter concludes: "It is very good of you to offer to present to the Museum the objects which you have named as a memorial to Dr. Gordon and we appreciate your generous suggestion."[41]

It seems clear that any irritation felt by the University Museum officers toward Kelekian was unwarranted. McHugh knew that Kelekian was trying to interest Rockefeller in the collection, and clearly approved. The letter that Kelekian dictated to Rockefeller in her presence was successful, at least insofar as it helped persuade Rockefeller to purchase the Canford sculptures. Kelekian could hardly be reproached for accepting Rockefeller's offer, particularly in the absence of any real activity on the part of the University Museum trustees. Reproach him they did, though. Upon learning of the sale at least one trustee, Eldridge R. Johnson, finally began to take the matter seriously. On Christmas Eve he wrote to McHugh:

I do not feel that Mr. D. G. Kelekian has any legal or moral right to dispose of those pieces of sculpture until the full time of the option has expired. I take it that he has received free storage and splendid advertising by exhibiting them in the University of Pennsylvania Museum, and, owing to the circumstances of Dr. Gordon's death and Mr. Harrison's illness, I feel that the Museum should have a few weeks of grace. I really feel, under the circumstances, that a special meeting of the Board should be called to consider this matter. I do not believe that Mr. John D. Rockefeller, Jr., will countenance Mr. Kelekian's behavior in this matter, and I think that Mr. Rockefeller should be communicated with, setting forth the circumstances, this, of course, if there is any prospect of the Museum being able to purchase these sculptures eventually. I do not know anything about the financial situation or how such matters are usually accomplished and, unfortunately, I have pledged my income very largely for the next two or three years and am unable to make any very great contribution myself; but, if there is any way to raise the money, I would contribute Fifty Thousand ($50,000.00) Dollars toward the same, if it is necessary.[42]

As with the offer to Layard in 1851 from the Trustees of another museum, it was too little and too late.

Meanwhile, Rockefeller wrote to Kelekian "to confirm the offer which I made when we met on the street the other day to purchase the sixteen bas reliefs and the bulls formerly owned by Lord Wimborne, and your sale thereof to me." He then continued: "The purchase was made with the understanding on my part that you were free of any further obligation in the matter to the Museum of the University of Pennsylvania." Citing the contents of McHugh's letter of 19 December, he too reproached Kelekian, saying that the museum "clearly had the right up to January 1st, 1928, to buy [the collection] if they were able to secure the necessary funds. Under the circumstances I regret that in courtesy to the Museum the closing of the transaction was not deferred until after January 1st."

Then Rockefeller got to the main point: "As to the price, I agreed to pay "the price at which the Museum of the University of Pennsylvania had bought the collection of you," and you told me that this price was $350,000." After again quoting from McHugh's letter, he concluded

it seems clear that while the Museum was hoping to buy the collection, it had never actually contracted to buy it nor agreed on a purchase price. What I have written thus far does not alter the fact that I have bought this collection of you and that you have sold it to me. It does, however, throw open for negotiation the price at which the transaction is put through. Since in 1920 the collection was offered to the Museum of Pennsylvania at 25,000 Pounds, which at the then value of the pound would be $120,000, the price of $350,000 for the collection seems entirely out of reason. Under the circumstances I am willing to pay

you $250,000 for the entire collection, which ought to give you a profit after deducting the expense of transportation and interest on the money.[43]

Naturally, Kelekian was not pleased at this turn of events. He replied to Rockefeller immediately:

Of course, I realize the disappointment of the University Museum authorities at their inability to acquire this collection, but as you can see from their letter of October 26th, . . . I was in no way bound to wait until the end of the year. . . . The truth of the matter is that the original price I had fixed for this collection was $450,000, and it was consigned to the University Museum at this figure, as I can show you by an entry in my book under date of October 30, 1925. When the sculptures were installed in the Museum and Dr Gordon was ready to take up with me the matter of definitely acquiring this collection for the Museum, I had several conferences with him, and in order to facilitate the transaction, also to show my good will toward the Museum, I reduced the price to $350,000, and we agreed upon this figure. The Secretary may not be aware of these facts, but I have in Paris a letter written to me by Dr Gordon, in which he states that he had the approval of his Board to purchase the collection. If you wish I will cable my son to send this letter over. Miss McHugh tells you the price at which they could have been bought before I purchased them in 1919. If this is so, they made a great mistake in not acquiring this collection.[44]

This last line is especially to the point. As we have seen, while the trustees of the University Museum and Metropolitan Museum took no action when offered the collection, Kelekian acted, acquiring a group of works that he recognized to be of immense importance. At the same time, he assumed the full financial risk of investing a very substantial sum of borrowed money in a large number of pieces for which there was no established market. Now the importance of the collection was finally becoming more widely recognized, and the only way to acquire it was to deal with Kelekian.

Rockefeller replied: "I shall be glad to receive any letters or copies of records from the duly authorized officers of the Museum of the University of Pennsylvania which substantiate the fact that your Assyrian Sculptures were bought by the Museum at $350,000. With the satisfactory establishment of that fact, the price at which I bought this collection from you is fixed. Otherwise, as stated in my previous letter, it is open to negotiation."[45] Clearly, Kelekian was going to have difficulty putting his case beyond doubt, but in his reply to Rockefeller he tried his best:

I beg to inform you that the letter which I have from Dr. Gordon, informing me of his Board's decision to purchase the sculptures, does not mention the price. But as he had written his letter after I had reduced the price from $450,000. to $350,000, the fact that he communicated to me their decision to buy the collection is sufficient proof that there was no question about the price and that we were agreed upon it. . . . The fact that [the Museum authorities] did not object to my price after I had confirmed it in my letter of August 10th, and the further fact that they were endeavoring to raise the funds and asked me to wait would appear to show conclusively that they were in accord with the price.[46]

In mid-January Kelekian received the original of Gordon's letter of 1 June 1926 from Paris, and sent Rockefeller copies of it and of his own letter to McHugh of 10 August 1927, along with an invitation to show him the originals.[47] Rockefeller then sent his own representative, Thomas Appleget, to Philadelphia to meet with

McHugh. Appleget reported that they could find no evidence that Gordon had agreed to Kelekian's price, that for him to have done so without the consent of the Museum President would have been contrary to Museum policy, and that the Museum had never paid Kelekian his asking price for an antiquity. They did locate a memorandum from 1926 in which Gordon and McHugh had tried to calculate Kelekian's actual costs, in order to estimate how much the Museum might have to pay. Gordon assumed Kelekian had paid £25,000 for the sculptures, for a total expense of $183,365 including shipping and interest. McHugh said Kelekian had told her that he actually paid £20,000, which would lower his total cost to $142,000.[48] In fact, we have seen that Kelekian apparently actually paid only about £14,000 or $56,600, which if true would have put his total expenses in the neighborhood of $80,000.

McHugh also located a letter dated 19 January 1926 from Gordon to Harrison, the President of the Museum. Concerning the sculptures he wrote: "Price not yet fixed. . . . I am going to New York tomorrow to see Kelekian and to discuss with him the price of his Assyrian sculptures now in this Museum. . . . The price will probably be not less than $150,000." McHugh observed that "the fact that Dr. Gordon mentioned to Dr. Harrison a price as low as $150,000. seems to indicate that at the time of writing it was his hope to buy the collection at a much lower figure than that which appears to have been placed subsequently upon it by Mr. Kelekian."[49] Appleget concluded:

I would have no particular opinion as to the amount of the profit which Mr. Kelekian should rightly be allowed. The Assyrian Collection is not an easy collection to sell since there would not be many possible purchasers. Mr. Kelekian has taken considerable risk and should be reimbursed for that risk. I nevertheless feel that $250,000 is a fair price. The Museum evidently wants the collection very much. Miss McHugh said that they hoped you would be willing to release it if they could obtain funds equal to the amount which you might pay for the collection. I told Miss McHugh that I knew nothing whatever about the possibility of such action. I believe they have one subscription of $50,000 toward the collection but nothing very definite as to the possibility of their raising further money. In view of the death of Dr. Gordon and the illness of Dr. Harrison, I should think it very unlikely that they could obtain $250,000 or more for this collection.[50]

Rockefeller was satisfied. On 26 January he notified Kelekian of his decision:

In order to establish the fact that your collection was actually bought by the Museum of the University of Pennsylvania at a price of $350,000, I sent a representative to Philadelphia to review the whole situation with the Museum authorities and to get such data as the Museum files contained. While this conference and the data which you have submitted make it clear that the Museum authorities were desirous of purchasing the collection and while it is equally clear that you were willing to sell the collection at $350,000, I have been unable to find any verbal or written evidence that establishes the fact that the Museum actually bought the collection at a price of $350,000. This being the case, the price at which the collection passes from your hands to mine can only be arrived at by negotiation. The result of the inquiry which I caused to be made in Philadelphia only confirms my belief that the price of $250,000 for the collection is a very fair and full price. Therefore, irrespective of the question of whether or not the collection had been sold to the Museum, I hereby offer you $250,000 for the collection, and am prepared to put the deal through without further delay.[51]

Kelekian replied that "while I appreciate your offer of $250,000.00 for the Assyrian sculptures, I regret that I cannot accept it. It is impossible for me to sell them at less than $350,000.00. This is the lowest price I can make, and if this is not entirely agreeable to you, I wish that you would let me know at the earliest possible time, so that I may be free to offer the collection elsewhere."[52] To which Rockefeller responded:

I am sure you will agree with me that for every reason it is desirable to have the sale to me of your Assyrian things go through. You have advised the University of Pennsylvania Museum that the collection had been sold; other people know about it; questions will be raised if it falls through. To that end I am willing to meet you halfway; you surely will not be less generous. In other words, I will give you $300,000. for the collection, thus splitting the difference between your asking price of $350,000. and my offer of $250,000. Beyond this I am not prepared to go. You will, of course, have in mind that this means cash, thus enabling you to reinvest the proceeds of the sale without delay.[53]

Kelekian accepted: "In order to please you, I will accept your offer of $300,000.- cash, for the collection of Assyrian sculptures now exposed at the University Museum of Pennsylvania, Philadelphia. I am sure that after all you will realize that in reducing the price, I am making far more than a money concession. Please find enclosed a corrected bill." The letter was accompanied by a bill with the same wording as the previous bill, but the price is now $300,000.[54]

Rockefeller was pleased: "I appreciate the broad and generous spirit in which you have met me in the matter of the purchase of your Assyrian Collection, and am glad that the transaction has been concluded to our mutual satisfaction. I am directing my office to send you my check for $300,000. in payment of the bill which accompanied your letter of yesterday."[55]

On 3 February Appleget sent Kelekian a check for $300,000, in return asking: "Will you kindly prepare and receipt a bill listing the different pieces in the collection and stating that they are genuine."[56] This would be Kelekian's last opportunity to present his pitch for the sculptures, and he made the most of it. The receipt, which is dated 3 February, reads:

1 Collection of Assyrian Sculptures, consisting of 16 bas-reliefs and 2 great Winged Bulls, all excavated at Nimrud, from the Palace of Ashur Nasir Pal, King of Assyria, from 885 to 860 B.C. Excavated by Sir A H Layard in 1845. This entire collection is universally known and is guaranteed by me to be genuine. It was acquired by me in 1919 from the heirs of the late Lord Wimborne, of Bournemouth, England. The collection is now exhibited in the University of Pennsylvania Museum, in Philadelphia. Each piece in this collection has been photographed by the University of Pennsylvania Museum authorities, and a full set of the photographs has been given to you, $300,000.00.[57]

Even the date of Layard's excavations is finally correct. A few days later Kelekian sent Rockefeller a full list of the sculptures, with a description of each piece, taken from the photographs.[58]

As soon as the sale was official Appleget notified McHugh, thanking her for her help and asking "whether the Museum would be willing to continue housing this collection until such time as Mr. Rockefeller makes a decision in regard to its disposition. If the Museum would do this, Mr. Rockefeller would be very grateful."[59]

McHugh replied that the Museum would "be very happy indeed to continue to exhibit the sculptures and if entirely agreeable to Mr. Rockefeller we would like to label them as a loan from him to the Museum. Will you be kind enough to let me know whether this would be in accord with the wishes of Mr. Rockefeller?"[60] Appleget notified Rockefeller of McHugh's request, adding the opinion that "such a label might constitute a very comforting evidence of your ownership."[61] Rockefeller had no objection. "Indeed," wrote Appleget, "he appreciates the courtesy of your suggestion."[62] One imagines that such a label would be comforting to McHugh as well, since it would constitute public notice that Rockefeller approved of the University Museum as a repository, however temporary, for his sculptures. This publicly acknowledged relationship might strengthen the Museum's chances when the time came for Rockefeller to choose a permanent home for them.

NINEVEH ON THE HUDSON

At a stroke, Rockefeller now had it in his power to turn the museum of his choice into the third greatest repository of Assyrian sculpture in the world, after the British Museum and the Louvre. Just as he had been thorough in researching and negotiating the sale price for the sculptures, so he was thorough in selecting their permanent home, though it seems that he had a preference from the beginning. On 13 December 1927, only three days after he purchased the Canford sculptures, Rockefeller radio-telegraphed the news to Breasted, who was at sea aboard the S. S. *Conte Rosso* on his way to Egypt: "Have bought Assyrian collection you discussed with madam. Kindly write at convenience in what institution you think it will promptly render greatest public service and why."[1] It appears from this that Abby Aldrich (Mrs. John D. Rockefeller, Jr.) played a significant role in her husband's decision to purchase the sculptures. The next day, Breasted replied by radio-telegram: "Your splendid purchase of Assyrian collection is great service to science & art. Congratulations. Appreciate kind message. Am Writing."[2]

Rockefeller had strong ties to James Henry Breasted and the Oriental Institute. His father had founded the University of Chicago in 1892. Breasted joined its faculty in 1895 as the first professor of Egyptology in the United States. In 1903, at Breasted's request, Rockefeller, Senior, donated $50,000 to the University to establish the "Oriental Exploration Fund," which allowed the University to commence archaeological fieldwork in the Near East. In 1919, again in response to Breasted's appeal, Rockefeller, Jr. donated an initial $50,000 over five years to found the Oriental Institute, and then renewed the pledge at $50,000 per year for 1924 and 1925. Also in 1925, Rockefeller agreed to contribute $60,000 towards the Institute's excavations at Megiddo in Palestine, and this amount was later increased to $275,000. In 1926, the General Education Board, one of the Rockefeller philanthropic organizations, made an initial gift toward the Institute's endowment. The contributions mounted, until by the end of the decade, Rockefeller had personally donated nearly $1 million to the Oriental Institute, while the Rockefeller philanthropies—the General Education Board and the International Education Board—had contributed $10 million. At the time of Rockefeller's telegram, Breasted

had an application pending with the General Education Board for funds to increase the endowment and to construct a new Oriental Institute building.[3] Rockefeller greatly admired Breasted's scholarship and communication abilities, and the two men had a close personal relationship. It must have seemed to Breasted that the Oriental Institute was a very strong contender for the Canford sculptures.

Breasted's letter to Rockefeller a few days later raised the by now familiar question of whether the Canford sculptures were more valuable as science or art, for his part stressing their scientific importance:

In acquiring this collection you have entered a field of science and art which has been much neglected since the work of Sir A. H. Layard almost a century ago. Layard married a sister of Lord Wimbourne, and it was through this relationship with Layard that Wimbourne acquired these Assyrian sculptures which you have now purchased. To the best of my recollection they were excavated by Layard at Nimrud, as it is now called, the ancient 'Calah' of the Old Testament, where I have seen just such sculptures projecting above the present surface of the soil. . . . In replying to your inquiry as to the institution where this collection would do "the greatest public service," I take it that under the term "public service" you would have me include both science and art. If "public service" be so interpreted, there are in my opinion two institutions between which the choice must be made, viz.: The Metropolitan Museum of Art and the Oriental Institute at Chicago.

Breasted first presented the case for the Metropolitan Museum: "The considerations which make the claim of the Museum a strong one are *artistic*. As the greatest art museum of America, it should include the art of Western Asia, and these Assyrian sculptures which you have acquired would give it a splendid nucleus." But, Breasted cautioned, such a splendid collection would carry a heavy responsibility: "the Museum would at once be called upon to organize a Department of Western Asiatic Art, which should eventually include Babylonia, Assyria, Persia, Syria, Palestine and the Hittites. The staff should be headed by a curator of the art and archeology of these countries, and include also a thoroughly competent cuneiform scholar, besides several assistants; for the Wimbourne sculptures, like most Assyrian monuments, are covered with cuneiform inscriptions." Breasted is being somewhat disingenuous here, since he must have known that the inscriptions on the Canford sculptures were well-known to historians and would have had no interest for a contemporary cuneiform scholar.

Breasted concluded his assessment of the Metropolitan Museum's claim with two discouraging thoughts: "There are at present no cuneiform scholars in the Museum personnel, nor as far as I know anyone conversant with the ancient art of Western Asia. It would therefore be a matter of a year or so to find and engage the staff, for such scholars are rare and not easily found. They would for the most part duplicate the staff already existent at the Oriental Institute. The formation of such a staff would doubtless also require raising additional funds." In other words, if the Canford sculptures went to the Metropolitan Museum, it would be some time before staff could be found to interpret them for the public, and funding the staff would necessitate further appeals to donors such as Rockefeller.

Not surprisingly, Breasted's arguments for the claims of the Oriental Institute are much more positive:

The considerations which make the claim of the Institute a strong one are *scientific* and *educational*. As the leading center of Oriental studies in America, to which even the great European universities are beginning to send their students on traveling fellowships, the Oriental Institute must eventually possess a collection of Assyrian sculptures, to accompany its already existent collections of the written documents of Assyria and Babylonia. The art of Assyria was largely borrowed and eclectic, and Assyrian sculptures have close relationships with neighboring civilizations. They are most instructive when exhibited in association with the civilization of the whole Near East, as installed and investigated at the Oriental Institute.

Breasted continued by appealing to Rockefeller's strong Christian interests, stating that the Canford bulls "are well known to be the 'cherubim' of the Hebrews, and have therefore a close relationship with Hebrew art and religion, which hold such a large place in the work of the Oriental Institute. . . . It will be seen that such Assyrian monuments can really be interpreted and understood only in the light of the whole group of Western Asiatic civilizations, of which the Hebrews were the spiritual culmination." In fact, no such connection can be demonstrated between Assyrian and Hebrew art.

Breasted then expanded the scope of his appeal, observing that the question of the disposition of the Canford sculptures raised the larger question of the need for "a great educational and research center devoted to the lands around the eastern end of the Mediterranean,—the lands from which the western world has inherited its highest ideals, and in which the social idealism of today has its roots." This not very subtle allusion to Rockefeller's beneficence is followed by an appeal for a new building, which would "offer an opportunity for designing a noble Assyrian hall with the two great winged bulls built in at the entrance door." Concerning this proposed Assyrian hall, Breasted noted that

additional fine Assyrian sculptures . . . are now uselessly lying about in several old American institutions from which they might be acquired and brought together. The New York Historical Society has a superb group of Assyrian reliefs, and . . . would be glad to dispose of them, as they are in need of money and Assyrian sculptures have no real place in the rooms of a society devoted to American history. Several of the smaller American colleges also have fine pieces, of which they make no use. Brought together with the Wimbourne sculptures, all these scattered additional pieces would contribute to form a very fine Assyrian hall.

Breasted closed by recapitulating his appeals to idealism and Christian knowledge, stating that this new institute "would form a unique shrine of rising human idealism proclaiming its high mission to all our younger generation . . . who would be able to follow from hall to hall, race by race, and stage by stage, the gradual dawning of the great Light that reached its culmination in the life of Jesus."[4]

It is striking how similar Breasted's evaluation of the importance of the Assyrian sculptures in 1927 is to the debate stirred by their admission to the British Museum 80 years before. Breasted sees them as being of value for art and science. His arguments in favor of the Assyrian sculptures as art ignore their aesthetic quality, stressing instead that the collections of the "greatest art museum of America" should include Assyrian art, a version of the nineteenth-century notion of the chain of art.

Breasted, however, like Rawlinson before him, argues that their greatest value is scientific, and like Westmacott, he locates this scientific value in the sphere of biblical studies. To some degree, this biblical connection is emphasized for Rockefeller's benefit, but it is clearly a central part of Breasted's conception of the rise of civilization as well, as he stated in a public talk in 1931:

We now have on the one hand the paleontologist with his picture of the dawn-man enveloped in clouds of archaic savagery, and on the other hand the historian with his reconstruction of the career of civilized man in Europe. Between these two stand we orientalists endeavoring to bridge the gap. It is in that gap that man's primitive advance passed from merely physical evolution to an evolution of his soul, a social and spiritual development which transcends the merely biological and divests evolution of its terrors. It is the recovery of these lost stages, the bridging of this chasm between the merely physical man and the ethical, intellectual man, which is a fundamental need of man's soul as he faces nature today. We can build this bridge only as we study the emergence and early history of the first great civilized societies in the ancient Near East, for *there* still lies the evidence out of which we may recover the story of the origins and the early advance of civilization, out of which European culture and eventually our own civilization came forth.[5]

In the proper setting, Breasted suggests, the Wimborne sculptures can help to bridge this crucial evolutionary gap. Rockefeller replied: "You paint a large and thrilling picture. It is something to let the imagination play upon. I am in no haste about reaching a conclusion in regard to the disposition of the Kelekian Assyrian collection. . . . The objects are to remain in the Philadelphia Museum for the present and until we have some plan with reference to their permanent abode. Of that we can talk at our convenience when you are again in this country."[6]

In a postscript to his long letter to Rockefeller just quoted, Breasted added that he was also sending Mrs. Rockefeller a copy of the letter: "In view of the keen interest which [she] expressed that these Wimbourne sculptures should go to the Metropolitan Museum, I hope she will forgive me for suggesting the claims or needs of any other institution." This copy was accompanied by a cover letter to Mrs. Rockefeller:

Mr. Rockefeller's wonderful radio to the ship, so delightfully unexpected, gave me the first full realization of how interested you have been to see the Wimbourne Assyrian sculptures really made useful. . . . In interesting Mr. Rockefeller in these sculptures you have done a real service both to art and to science. Indeed the facts in this situation are of such importance to the whole development of Oriental studies in America, that I have long been deeply concerned about the final disposition of the Wimbourne sculptures. I hope that the enclosed letter to Mr. Rockefeller may serve to make clear the facts which have seemed to leave me no other choice than to present also the needs of another institution, while also fully recognizing of course the strong claims of such a splendid institution as the Metropolitan Museum.[7]

Though I have not located a memorandum or letter that deals with any previous discussions between Mrs. Rockefeller and Breasted on the subject of the Canford sculptures, it is clear from the preserved correspondence that she played an important part in her husband's decision to buy the collection, and also that she wished to see them displayed in the Metropolitan Museum.

Following his arrival in Egypt, Breasted evidently continued to think about the possibility of displaying the Canford sculptures in the Oriental Institute, and this simple plan grew into something much more elaborate. On 12 February 1928, Breasted wrote again to Rockefeller, this time from "Old" Chicago House, Luxor, Egypt. Breasted pointed out that, in addition to the recently purchased Wimborne Assyrian sculptures, there were no fewer than 55 examples of Neo-Assyrian palace reliefs in America, distributed among institutions from Bowdoin College in the north to the Theological Seminary of Virginia in the south. Breasted suggested that Rockefeller should attempt to buy up as many of these 55 pieces as possible and bring them together as the Rockefeller Collection at the Oriental Institute. This new collection of Assyrian sculpture would then be "second only to London and Paris." He closed with an argument that was intended to counter the much greater public appeal of the Metropolitan Museum: "In considering the Oriental Institute as a home for these sculptures it is important to note that the public admissions to the Institute collections during 1927 numbered 12,000 visitors. These outside visitors were merely incidental and were quite apart from the chief function of the collections to serve as original materials for research and instruction in the Institute."[8]

I could not locate the original of the letter just cited at the Rockefeller archives, nor Rockefeller's reply, and it is possible that the letter was never received. In any event, Rockefeller and Breasted discussed the possible purchase of these 55 reliefs over lunch in New York on 11 May, after the latter had returned from Egypt. In a follow-up letter, Breasted estimated that the 55 slabs could be had for about $500,000, based on the price Rockefeller paid for the Wimborne Collection. Breasted then introduced yet another grand scheme: "For the $500,000 which it might cost to purchase the scattered palace sculptures already in America, it would be possible *to excavate the entire city of Calah*,—including also the expense of salvaging and shipping its great mass of sculptures to America." He had just received "informal and unofficial information" from the Iraqi government that Calah might become available for excavation, and that no division of the finds with Iraq would be required. This would solve "the problem of placing the Wimbourne sculptures, which might then, *together with many more from the same palace*, be presented to the Metropolitan Museum. The palaces of Calah would likewise furnish ample monuments for the collections needed for the teaching and research purposes of the Oriental Institute."[9] Breasted later clarified the terms for this very generous excavation permit—a $1 million donation to the government of Iraq, to be used to fund a new archaeological museum.[10] This apparently outrageous suggestion must be seen in the context of other recent Rockefeller—Breasted museum projects. In 1925 Breasted had persuaded Rockefeller to pledge $10 million for the construction and maintenance of a new Egyptian antiquities museum in Cairo, but after protracted negotiations between Breasted and King Fuad of Egypt, the king rejected the offer. In 1927, also at Breasted's urging, Rockefeller pledged $2 million for a new archaeological museum in Jerusalem, and this time the offer was accepted.[11] Presumably the government of Iraq saw a similar opportunity here, and Breasted by now had good reason to think that Rockefeller might be interested. On this occasion, however, Rockefeller compromised, donating $27,500 to the Oriental Institute to

fund new excavations at Khorsabad, which were soon to produce a colossal bull and wall reliefs of Sargon II for the Oriental Insititute Museum.[12]

Breasted was not the only expert whose opinion Rockefeller solicited in connection with the disposition of the sculptures. In mid-March 1928 he again sent Appleget out to collect information. Appleget's report to Rockefeller is characteristically thorough:

Recently I spent several days in the middle west consulting with a number of archaeologists. Among the men whom I met were Mr. Hans-Henning von der Osten, Director of the Oriental Institute's expedition to the Hittite country, and Professor A. T. Olmstead of outstanding authority on Assyria and Babylonia. With these two men I discussed very informally and casually the question of the proper place for the Lord Wimbourne Collection of Assyrian Sculptures and Bas Reliefs of which you are the present owner. Their opinions, which were in agreement, impressed me so much that I feel obliged to pass them on to you.

It appears that Appleget had read Breasted's letter to Rockefeller of 19 December 1927, as he immediately addressed Breasted's claim that the Canford sculptures were primarily important for their scientific value:

In the first place, it seems evident that these are museum, not research, material. This being the case, they should eventually be sent to the museum which already has or might develop a department of Assyriology in a place where it would serve a large public. Museums already having collections of this character are: The Museum of the University of Pennsylvania, the Boston Museum, the Museum at Amherst, and also the Museum of the Oriental Institute at Chicago. Amherst seems to be out of the question.

Appleget's next observation addresses Breasted's claim, in his letter of 12 February 1928, that the Oriental Institute served a large public: "The main purpose of the Oriental Institute Museum at Chicago is, apparently, research. At least it is not used by a large public. I saw no visitors during the two or three days I was there." Concerning the Metropolitan Museum, Appleget observed that it "has no department for Babylonian or Assyrian material and no curator in that field. It has some examples of Assyrian and Babylonian remains scattered in its other collections but they are in no particular care and are badly labeled." The remainder of the report outlined the merits of the two strongest contenders:

In the opinion of the gentlemen with whom I talked, these Assyrian sculptures should be given either to the University of Pennsylvania or to the Metropolitan Museum. The University of Pennsylvania is not centrally located and does not serve as large a public as the Metropolitan Museum. It has not had a very good history of cooperation with the University and its status is at present a little uncertain. The Metropolitan Museum, of course, serves a tremendous public and, although having outstanding collections in Egyptian and other oriental materials, has no department in Assyriology. Why we do not know. Presumably it is because of the lack of interest of the trustees. Director Robinson has wanted to secure Assyrian material. In fact, he tried to get $125,000 from his trustees some years ago to purchase the Wimbourne Collection. Both von der Osten and Olmstead believe that if the Wimbourne Collection was offered to the Metropolitan Museum on condition that they give it adequate showing in a room of its own, the Museum would thereafter be obliged to recognize this important section in the oriental field.[13]

Word of Appleget's mission evidently spread—even before his report reached

Rockefeller, the latter received a letter from George D. Pratt, a trustee of the Metropolitan Museum:

Some years ago I heard of some Assyrian tablets which were very remarkable that Kelekian had, and learned this morning that you have purchased these. I do not know what you have in mind about the disposal of them, but hope very much that the Metropolitan Museum, of which I am a trustee, will be seriously considered, before you contemplate giving them to any other Museum. We have but a few of these Assyrian tablets, and the ones that Kelekian had, of which I have seen photographs, are most remarkable. Naturally we want to build up this collection at the Museum, as we are very weak in this line. May I hope that you will at least give this suggestion consideration before you make any plans for the final disposition of these tablets?[14]

Rockefeller replied: "Very naturally, the Metropolitan Museum will be seriously considered as a possible recipient. Obviously the Oriental Institute at the University of Chicago is greatly interested and a possible permanent repository not likely to be turned away from. You may rest assured that the matter will not be decided without the most careful and fullest consideration."[15]

Two weeks later, on the evening of 11 April 1928, Rockefeller visited Edward Robinson, Director of the Metropolitan Museum of Art. Robinson afterwards made a memorandum of their conversation:

The Wimborne Reliefs—He told me that he had recently purchased all of these (I believe of Kelekian), but didn't know what to do with them. For the present he had lent them to the University Museum in Philadelphia, but with no committal either as to the length of the loan or as to presenting them to the Museum. He asked if we would be interested in having them, and intimated that he would be ready to give them to our Museum if and when we wished to take them. I told him that these reliefs had been offered for sale to me by the executors of the Wimborne estate some years ago, and for what I considered a moderate price, but at that time we had no collection or department of ancient oriental art, and I then saw no prospect of having one, especially because of the great demands for space by other departments already in existence and rapidly developing. I said that personally I felt differently about this at the present time because of the rapid increase in interest in this field of antiquities during recent years, and the prospect that it would soon become a very important branch in the study of ancient art. I should therefore be strongly in favor of accepting such a generous offer just as soon as we could find the space for its installation, and could found a Department of Ancient Oriental Art. He said that he was interested to know this, and that there was no hurry about a decision as the Philadelphia Museum would doubtless be glad to retain these things as long as they could, but he asked that the matter be kept in mind.[16]

Doubtless aware that these sculptures had already slipped from the grasp of at least one museum because of inaction, Robinson later wrote to Rockefeller to confirm his interest: "I have by no means forgotten or lost interest in the suggestion you made to me at my house regarding the ultimate disposition of those Assyrian reliefs which you recently purchased, and I hope the same is true of yourself? The possibility of having them come here is of such importance to us that I dread the thought of our losing the opportunity through any mischance or misunderstanding, and I trust that I am not indiscreet in saying so to you, though I have not mentioned the subject to anyone else."[17] Ann Adams, Rockefeller's secretary,

wrote to reassure Robinson that no action would be taken without his knowledge: "Insofar as concerns the Assyrian reliefs which Mr. Rockefeller recently bought, he asks me to say that he will not be disposed to reach any conclusion as to where the collection shall finally be placed without discussing the matter with you or some of your associates."[18]

There follows a gap of over a year and a half in the preserved correspondence, and it appears that Rockefeller did nothing further about the sculptures during that time. He may have been waiting for the completion of the new Oriental Institute Museum before reaching a decision, or he may have been thinking of leaving them in the University Museum, or he may have been waiting to hear that space had become available at the Metropolitan Museum. In any case, the correspondence resumed after V. Everit Macy, a Metropolitan Museum trustee, raised the issue again with Rockefeller in late 1929. Planning was underway at this time for a large new addition at the north end of the Metropolitan Museum, where the Temple of Dendur stands today. In June 1929, funds were appropriated to pay the architect John Russell Pope for plans for this new wing, which was estimated to cost $3,500,000.[19] In December 1929, Macy wrote Rockefeller that his proposed gift of the Assyrian sculptures would affect the planning of this new wing: "Yesterday at the meeting of the Trustees of the Metropolitan Museum I was surprised to find how rapidly the plans for the new wing were progressing. I had taken the liberty of telling 'Ned' Robinson that I had put in a plea to you for your Babylonian sculptures now in the Museum in Philadelphia. Yesterday he told me that the plans were approaching the point where it would be desirable to know whether the necessary foundations for the sculptures were to be constructed or not."

Apparently during the conversation alluded to here, Rockefeller had raised Breasted's point that the scientific value of the sculptures would be greatest if they were displayed in an institution with a large ancient Near Eastern collection, where students could study them in the context of the development of what Breasted had called "human idealism." Macy argued instead for the artistic importance of "these marvelous works of art. I can only repeat what I said to you, these sculptures are of such importance that students will come any distance to study them, their value to students will be much enhanced when displayed with the arts of other countries and that they will be seen and enjoyed by a far greater number at the Metropolitan than any other place they could be shown. Their scientific value will remain the same if not greater."[20] In contrast to Breasted, Macy stressed not only the artistic "importance" of the Assyrian sculptures, but also asserts that they are "marvellous works of art" that will be "enjoyed" by visitors to the Metropolitan, praise that would typically be reserved for works of acknowledged aesthetic quality.

Rockefeller replied: "In considering this matter it would be helpful to me to know approximately how the Metropolitan had thought to house this collection, were it given it, and how it would be exhibited. Are there plans in existence which would give me some general idea along this line? If so, I should be glad to see them, in reaching my conclusion."[21] Macy responded:

As I understand the situation the studies for the new wing are very indefinite now and will depend largely on what the wing is to contain. I am very anxious that sufficient space be

reserved for Near-Eastern art, both Archaic and Mohammedan. I discussed this suggestion with [William Church] Osborn, who is Chairman of the Building Committee, and he agreed with me that this would be especially desirable if we could get your Babylonian sculptures. The natural location would be adjoining the present Egyptian rooms. The large bulls and the accompanying sculptures would make a magnificent entrance to the proposed wing. I assume that with this possibility in prospect that they cannot go on with definite plans until they know the height and size of the objects to be displayed.[22]

Rockefeller was on the verge of a decision, and felt obliged to notify Breasted:

While I know you have been anxious to have this collection in Chicago, on the ground that its significance could be better understood and availed of through the group of Oriental scholars at the University than were it to be permanently housed in the Metropolitan, naturally because I live here I have myself favored the idea of giving it to the Metropolitan. In view of your recent discoveries in Nineveh and the fact that you are practically assured of a collection quite as important as this of mine, it would seem to be increasingly appropriate that I should give this collection to the Metropolitan. . . . I shall expect in the near future to reach a conclusion in the matter. This, however, I did not want to do without keeping you informed as to what was transpiring and giving you an opportunity to make any further expressions on the subject which you may care to make.[23]

In his reply, Breasted acknowledged that "there is no doubt that this collection, installed in the Metropolitan Museum, would be of the greatest service in the study of the History of Art." Since their previous correspondence on the subject of the Canford sculptures, however, the International Education Board, one of the Rockefeller philanthropies, had granted funds for a new Oriental Institute Museum building, and groundbreaking was only a few months away. Breasted was therefore more anxious than ever that the new museum have appropriately extensive collections. He now observed that the Wimborne sculptures were some century and a half earlier than the Assyrian sculptures from their own excavation and that the Oriental Institute would still like to have this earlier phase represented in its collection. He then reminded Rockefeller of the 55 Nimrud sculptures in small east coast collections, observing that the 18 slabs distributed among Dartmouth, Amherst, and Bowdoin colleges "are tucked away in dark corridors and other such casual places where they are of very little use or value." Breasted believed that if the authorities at these three institutions "were tactfully approached in the matter they would be willing to dispose of their pieces," which would give the Oriental Institute "a representative collection of IXth Century Assyrian sculptures and meet our want very satisfactorily." A list of the locations of the 55 sculptures was included.[24]

On 8 January 1930, Breasted had lunch with Rockefeller. In a memo of their meeting, he wrote that Rockefeller "felt inclined to give [the Wimborne sculptures] to the Metropolitan Museum." Breasted noted that Rockefeller suggested using the antiquities dealer C. Edward Wells, who was "much obliged" to Rockefeller, to serve as Rockefeller's agent in attempting to purchase "the larger groups among the total of fifty-five (55) Assyrian sculptures scattered among the colleges of the Atlantic Coast. He had a list before him as he was talking. He checked off especially Amherst, Bowdoin, Dartmouth, New York Historical Society, and Williams, as the institutions which might be most promising." Wells would try to get the

sculptures at a dealer's price. "In this way Mr. Rockefeller said he would himself be relieved of the embarrassment which would ensue if I (J.H.B.) approached these institutions, which would all then know who was behind the plan." In this context, "embarrassment" evidently refers to the embarrassingly high prices these institutions would name if they suspected the buyer was Rockefeller.[25] A few days after lunching with Breasted, Rockefeller forwarded the list of 55 sculptures to Wells with a letter saying "if you should become the owner of any or all of these pieces at fair values, I would be willing to buy any or all of them from you, at a profit to you on their purchase of ten (10) per cent." There is no further correspondence on this matter.[26]

Following up on his correspondence with Macy, Rockefeller arranged for his son, John D. Rockefeller, 3rd, to meet with Robinson in mid-January to discuss the exhibition plans for the proposed gift. Robinson kept a memorandum of the meeting:

I explained to him why it was impossible to make a definite statement as to the precise location of the sculptures since this would depend on other circumstances at present not within our control, but I told him in a general way that it was our intention to have the galleries for Ancient Mesopotamian Art join as nearly as possible the Egyptian Department. This would probably mean that they would come into the part of the proposed extension immediately adjoining the Egyptian galleries. I said that in working out our plans it was quite important that we should know before they had been carried too far whether we might look forward definitely to this gift in order that we might prepare our plans to house them properly. It was also important for us to know because of the probable weight of the two large reliefs as this might be so large as to require special construction to carry them. With plans and with an examination of that part of our present building, I gave him as definite information as I could, and he said he would report what I had done to his father.[27]

Rockefeller's son's report discussed the status and planning of the new wing in detail and concluded: "Your Babylonian Sculptures will be situated at the entrance to the new wing."[28] In sum, Rockefeller wanted assurances that if he donated his Assyrian sculptures to the Metropolitan Museum, they would be appropriately exhibited. Macy and Robinson both indicated that they would be prominently displayed in the still unbuilt North Wing. No other location was ever suggested, and so completion of the North wing was made the apparent precondition for the eventual exhibition of the Canford sculptures.

Evidently satisfied with his son's report, Rockefeller made the offer in late January in a letter to Robert W. de Forest, President of the Metropolitan Museum:

I have had correspondence with Mr. Macy and Mr. Robinson in regard to the Assyrian sculptures on exhibition in the Museum of the University of Pennsylvania at Philadelphia. As you know, these sculptures are a part of the Wimborne collection and were brought to this country some years ago. They came from the ninth century B.C. Assyrian palace at ancient Nimrud, some two hundred miles south of Nineveh. Understanding that the Metropolitan Museum would be glad to possess these sculptures and to exhibit them suitably in the new wing about to be built, it will be my pleasure to give the collection to the Museum. There are some seventeen pieces in all.[29]

Robinson was vacationing in Bermuda. Upon hearing the news he telegraphed his thanks to Rockefeller: "Heartiest thanks superb gift Assyrian sculptures. It is marvellous. Acknowledgements also to helpful son."[30] De Forest, however, was evi-

dently unaware of the details of the negotiations between Rockefeller, Macy, and Robinson. In consequence, he was unprepared for the reference to the new wing in Rockefeller's letter. He replied to Rockefeller:

With regard to your very generous offer of those all-important Assyrian sculptures, you say in your letter 'understanding that the Metropolitan Museum would be glad to possess these sculptures *and to exhibit them suitably in the new wing about to be built,* etc.' Your letter would seem to imply as a condition to your gift that they should be exhibited in the new wing. Final plans for the new wing are not complete. It might be far better in planning our Museum exhibits that they should be exhibited elsewhere. It would be contrary to our present policy to accept any gift with the condition that it be permanently put in a particular place. May I suggest if consistent with your intention, that you send me another letter omitting the words 'in the new wing about to be built', leaving it simply 'and to exhibit them suitably.'[31]

Upon Robinson's return, de Forest learned of the previous discussions and promptly wrote to Rockefeller again: "Mr. Robinson returned from Bermuda today, and from a conversation I had with him this afternoon I learn that the letter which I sent you on February fourth in regard to the proposed conditions of your gift of Assyrian sculptures to the Metropolitan Museum of Art was written without a knowledge of the circumstances which had led up to your munificent offer. Had I known of them, I should not have made the suggestion I did. And such being the case, I beg to recall my letter and ask you to consider it as not having been written."[32]

Unfortunately, de Forest's retraction did not reach Rockefeller in time. Evidently somewhat exasperated by the apparent inconsistency in the museum's responses, Rockefeller addressed de Forest's request at some length:

Your letter of February 4th is received. My letter to you of January 27th offering to give to the Metropolitan Museum of Art the Assyrian Sculptures which I own, was the result of a request made of me by Mr. Everit Macy. I had been seriously considering giving this collection to the Oriental Institute of the University of Chicago, which has asked for it and which is very eager to incorporate it as one of the main features in a new building which it is soon to erect. Mr. Macy said he was presenting the matter at this time because the Museum was about to build a new wing, plans for which were already underway, and that it would be desirable to have the foundations for these heavy sculptures planned for in advance and built in connection with the erection of the new wing. I assumed that Mr. Macy was speaking with the knowledge and approval of, if not on behalf of, his fellow trustees of the Museum. When my son subsequently discussed the matter with Mr. Robinson, to ascertain where it was proposed to install these sculptures, Mr. Robinson gave him a blueprint and indicated on it in the new wing the general location that was to be assigned to the sculptures.

The purport of the above is simply to make clear the fact that my mention of the exhibition of these sculptures in the new wing, if they are accepted by the Museum, was not intended as a condition imposed by me but was merely made in a recital of the form in which the request for the sculptures had come to me. It makes not the slightest difference to me where in the Museum the sculptures are exhibited. I am interested that they should be adequately exhibited, however, so that they would be of the fullest use to artists and archaeologists. If it would not be the wish and intent of the Museum in accepting the sculptures so to exhibit them, I would prefer to have them remain where they are in Philadelphia or to give them to the Oriental Institute of Chicago.[33]

In brief, Rockefeller claimed not to care where the sculptures were displayed as long as they were displayed somewhere. He had specified the New Wing only because in all of his discussions with Macy and Robinson he had been told that they would be placed there, and if the Metropolitan Museum was not prepared to display them properly, perhaps Chicago or Pennsylvania would. It is interesting that though none of the three museums involved here had considered the sculptures sufficiently important to try to purchase directly, they all were more than willing to accept them as gifts.

A few days later, Rockefeller received de Forest's letter of 13 February. Mollified, he responded: "Your letter of February 13th crossed mine of the 14th. Now that the misunderstanding in the matter has been cleared up, I am happy to send you herewith a substitute letter for the one written you under date of January 27th, leaving out the words, 'In the new wing about to be built.'"[34] On the same day, the Museum Trustees met and "Resolved: that this generous gift of John D. Rockefeller, Jr., be gladly accepted and that, in accepting it, the Trustees wish to put on record their appreciation of its importance not only in itself but as filling a gap in the Museum's present collections."[35] The Museum Secretary, H. W. Kent, notified Rockefeller of the decision:

I am instructed by the Trustees of The Metropolitan Museum of Art to convey to you their action taken on Monday, February 17, 1930, in accepting your gift of about seventeen pieces of Assyrian sculpture from Nimrud. The Trustees wish to put on record their appreciation of the importance of this gift not only in itself but as filling a gap in the Museum's collections. . . . The Trustees also understand that it is your wish, with which they warmly concur, that the collection should be adequately shown, so that it may be of the fullest use to artists and archaeologists.[36]

Now that the Metropolitan Museum actually owned the sculptures, Robinson became interested in learning more about them. In response to a request from Kent for information on the collection, William Clifford, the Museum librarian, responded: "Am sorry to say that I can find no record of the Wimborne Assyrian sculptures, except that they were exhibited at Cranford [sic] Manor, the modern mansion of Lord Wimborne. No catalogue appears to have been published of the contents of the Museum."[37] Robinson next tried Rockefeller: "Should you, by any chance, have other data relating to these reliefs, such as their history, and how and when they came into the possession of Lady Wimborne, I should be grateful if you would allow me to see them and if you are willing, would let me have copies of them for our records."[38]

To this, Ann Adams, Rockefeller's secretary, replied with a quote from the beginning of Kelekian's letter to Rockefeller of 7 December 1927:

In response to your request for data regarding this collection, the following is an extract from a letter of Mr. Dikran G. Kelekian on the subject:
 "A few days ago I had the pleasure of showing you the photographs of the sixteen bas-reliefs and two great Bulls of the Assyrian King Assur-Nasir-Pal, which collection I purchased from the heirs of Lord Winborne [sic] of Bournemouth, who financed Sir Henry Layard's excavation in Mesopotamia in 1854. Half of the find was donated to the British Museum, and the other half was kept by Lord Winborne himself, who built a special chapel for it next to his castle."

We are searching through our files and if other data is found will send it to you. Mr. Rockefeller suggests that Mr. Kelekian, of whom he bought the pieces, would be able to give you full information regarding them.[39]

Kelekian's sales pitch has become the authoritative history of the Nineveh Porch. At the time of Robinson's letter of inquiry, there was probably no one living who knew the full story of the Canford sculptures. The sculptures themselves—wrenched from both their ancient and nineteenth-century contexts—had become curiosities whose only link with their history was anecdotes told by a dealer.

A few days later, Adams wrote to Robinson with further information: "Referring further to data regarding the Assyrian collection, Mr. Rockefeller has directed that the following be sent to you in confidence." Then follows the quote, "In acquiring this collection you have entered a field of science and art . . . I have seen just such sculptures projecting above the present surface of the soil" from Breasted's letter to Rockefeller of 19 December 1927, quoted in full above.[40] The source of this quotation is not identified in Adams's letter.

On 1 May 1930, Rockefeller broke the news to the University Museum, which until that time may still have been hoping to keep the sculptures:

I have recently agreed to give to the Metropolitan Museum of Art the collection of Assyrian sculptures which has been on exhibition in the Museum of the University of Pennsylvania for some years. The Metropolitan Museum has in mind to install this collection in connection with the rearrangement of some of its present exhibits which is planned when a new building now under consideration is constructed. It will probably be some months, perhaps a year or two, before the Museum can permanently locate these sculptures. In the meantime, it will be entirely agreeable to the Museum, as it is also to me, to have the Museum of the University of Pennsylvania retain the collection as at present exhibited. If, on the other hand, you would like to be relieved of the collection, in the light of the plans which I have made for its permanent disposition, the Metropolitan Museum will be glad to so arrange with you. . . . May I take this opportunity of thanking you for having stored this collection for me for the past two or three years, and also of expressing my regret at being obliged to remove it from a museum where it has been so well presented and so much appreciated.[41]

McHugh then wrote a congratulatory letter to Robinson at the Metropolitan Museum:

I congratulate you upon acquiring these fine sculptures with which we will part with many regrets. Mr. Rockefeller informs me that you have it in mind to install the collection in connection with a rearrangement of some of your exhibits and that this rearrangement may not be made for some months. We shall be most happy to retain the sculptures until we receive word from you that you are ready to receive them. They are now installed in the Main Gallery at the entrance to the Museum where they form a very striking and interesting exhibit.[42]

Robinson responded, somewhat apologetically: "I beg to assure you that the initiative in this matter was entirely on Mr. Rockefeller's side. The first intimation I received that he had any such gift in mind was about the middle of April, 1928, when he informed me that he was considering something of the kind, and inquired whether it would be acceptable in case his decision was in our favor. It was only

this spring that this decision was reached, and we have been waiting since for him to announce it to you."[43] In September, Robinson saw the sculptures for the first time. He wrote to Rockefeller:

I want to tell you that since my recent return from Europe I have made a visit to Philadelphia especially for the purpose of seeing the Assyrian reliefs, the originals of which I had never seen before although I was familiar with them to a degree from the photographs. To my delight found them much finer than even I had anticipated. The large ones especially are splendid and in magnificent condition,—quite equal in my judgment to those in the British Museum. The Philadelphia people are taking excellent care of them and are perfectly willing—in fact I may say more than willing—to keep them until we are ready to call for them. They are very effectively displayed. Mr. Pope's plans for their installation in our new building are, I think, very fine, and will result in their being shown with great effect.[44]

Perhaps some hint of Robinson's true interest in Assyrian art may be deduced from the fact that though he had for more than two years known of Rockefeller's intention to give the sculptures to the Metropolitan Museum, he did not make the two hour trip to Philadelphia to see them until seven months after the museum had accepted the gift. Rockefeller replied: "I note with interest what you say about the Assyrian reliefs which you recently saw in Philadelphia, and am pleased that you found them so much more important than you had anticipated."[45]

Construction on the new wing still had not commenced when Herbert E. Winlock, an Egyptologist and field archaeologist, succeeded Robinson as Director of the Metropolitan Museum early in 1932, and because of the weak state of the economy, it appeared that the project would be postponed indefinitely. One of Winlock's first priorities was to sever the connection between the Assyrian sculptures and the new wing, and to get them out on display somewhere. Almost immediately he visited Philadelphia to see the sculptures, and then wrote to the new director of the University Museum, Horace H. F. Jayne, to warn him of his intentions:

I feel somewhat like a conscience-stricken holdup man in writing this letter to you. I am asking Mr. Chapman, our Assistant superintendent, to go down to Philadelphia some day this week to take a look at the Assyrian things to get some idea how much it would cost to move them, so that we can make up our minds whether or not we can install them up here. If it is possible to make the necessary expenditure, I am very anxious to bring the Rockefeller Collection here, as I am already beginning to drum up an interest in Ancient Mesopotamia among our Trustees. . . . I really cannot thank you enough for the good time that all of you gave me the other day. There would be a certain amount of advantage in leaving the Assyrian things with you as it would give me an excuse to come down and look at them every once in a while, and see all of you at the same time.[46]

Unlike Robinson, Winlock had made a point of seeing the Canford marbles at once, and had been sufficiently impressed for him to make their installation in the museum a priority.

The argument that Winlock was using to drum up interest among the trustees was based on the ideal that the goal of the Metropolitan Museum was universal coverage of the history of art, or at least of ancient art. The case for Assyria was presented by Winlock in a statement to the trustees later that month:

In the fields of ancient art I have, at this time, only one important suggestion to make. We have an adequate organization and excellent collections, from Egypt down to the Middle Ages with one exception. Equal to Egypt as a fore-runner of the culture we have inherited through Greece, was ancient Mesopotamia—Babylonia, Assyria and the earlier Persian empire. The Museum has never succeeded in filling this gap in the history of our art. We now have a remarkably favorable opportunity to complete the panorama of ancient culture. We possess a magnificent series of Assyrian sculptures given by Mr. Rockefeller, now in the University of Pennsylvania Museum, which are to find a permanent place in our North Wing—but that now appears to be a matter of the indefinite future. Plans have been made for bringing them here and installing them temporarily with the permission of Mr. Rocke-feller. It is estimated that it will cost about $10,000 to bring these pieces from the University Museum in Philadelphia, and install them in part of the Cast Galleries. We can save from the regular budget appropriations for installation, insurance, and other accounts properly concerned, enough money to meet these expenditures. Carrying out these plans will give our members and the public the opportunity of seeing these splendid pieces effectively displayed in a central location in the Museum years before they could do so if we waited for the construction of the North Wing.[47]

The first part of this statement is a virtual paraphrase of the nineteenth-century arguments for Assyria's importance as a crucial link in the chain of art. Once again we see the argument that these works belong in a major art museum not because they are beautiful, but because they fill a "gap in the history of our art." The Canford marbles, originally parts of a decorative ensemble dedicated to promoting the Assyrian imperial ideal, and then trophies of an imaginary biblical past, were now an essential component of a vision of the history of world art.

Jayne of the University Museum responded graciously to Winlock's news: "Although we shudder at the possible loss of the Assyrian reliefs, we shall, of course, do all we can to help Mr. Chapman in measuring them and attempting to establish the costs of removing them. . . . The departure will leave a great gap in our collections but there is always a hope that we may be able to find some others to take their places later on and I abide with the hope." Jayne, evidently mindful of Winlock's "conscience-stricken" condition, went on to point out that the departure of the reliefs would leave gaps of another sort as well:

Actually also the removal of the two great animals flanking the archway will reveal very conspicuous wounds in our walls where we widened the arch in order to fit the sculptures in. Do you think that by any chance you could include the restoration of these gaps in your costs of removing the stones to New York, provided this restoration did not amount to a vast sum of money? We are so very hard up for maintenance funds at the moment that it would be enormously helpful in restoring the appearance of the front hall after the reliefs are gone.[48]

Winlock understood Jayne's plight in having to meet unexpected repair expenses: "I feel very sympathetic of your suggestion about patching up the walls where the bulls now stand. If we can possibly afford the expense at the present time we would very much like to do so. Will you be so kind as to give me some sort of an estimate as to the cost?"[49] Jayne replied: "Our Superintendent tells me that, while it is difficult to estimate the costs I mentioned, inasmuch as other scars and damages will inevitably occur in the actual removal of the stones, nevertheless, he feels that

these should not exceed two hundred dollars and he would engage to keep these charges within this figure if you could by any chance reimburse us for this. It is an imposition to suggest it but it is astonishing what ability I am developing in these sorry times to make such suggestions."[50] Winlock agreed to pay this amount and added: "The Metropolitan Museum will do this willingly. I would have no hesitation in putting it in our expense account under the head of storage, if nothing else. Naturally in these days we want to do everything as cheaply as possible, but this I think is a necessary expense."[51] Winlock was better than his word—following the removal of the sculptures, he directed that the University Museum be sent a check for $250 to cover repairs.[52]

The inventory of the sculptures that Chapman prepared for Winlock in mid-March is of some interest in that it gives the estimated weights of the individual pieces. The colossal bull and lion together, for example, were estimated at 34,000 pounds, and the large Assurnasirpal wall slabs averaged 3,000 pounds each. The total estimated weight of all the pieces was 51,463 pounds.[53] The sculptures were not actually moved, however, until the fall. As Winlock explained to Jayne:

Last March I brought up the tragic matter of the removal of the Assyrian sculptures from your Museum to this one, but we had hardly gotten started on our correspondence when the report came in of the ending of our first financial quarter. Since then my job has been a mean one of cutting down expense. I have been so brutal in this matter that I think I have saved enough money to install the Assyrian sculptures, and can use some of my brutality on you. I am writing to know whether it would be any less inconvenient to you if we removed them next month than at any other time. I should like very much to get them soon as we are making certain rearrangements in our galleries, and are very anxious to incorporate the Assyrian sculptures in some openings which we hope to have during the winter.[54]

Jayne's response was characteristically good-natured: "Woe is ours, that you have been so successful in making savings! But of course we shall make any time you fix convenient to us for the removal of the Assyrian Reliefs. We will do all we can to assist anyone you send down."[55]

By late October the colossi were back in New York and Winlock wrote to Jayne: "The bull and the lion arrived this week in very good order. I have never realized what excellent condition they were in. I understand that the slabs will be along shortly."[56] Following the arrival of the sculptures, there was some confusion about how many slabs there actually were. As we have seen, in offering the sculptures to the museum, Rockefeller estimated their number as "some seventeen pieces." A memo in mid-December from Henry F. Davidson, the Museum Registrar reported that nineteen pieces had arrived.[57] The matter was not finally resolved until the reliefs were installed, at which time the Registrar determined that there were eighteen sculptures.[58]

At the beginning of 1933, Winlock wrote to Rockefeller with a progress report: "As I told you last time I saw you, we are busily installing the Assyrian sculptures and when they are put on public view next month I believe that the occasion will be a very important one in the Museum's history. We will at last be showing adequately the art of ancient Mesopotamia."[59] Winlock's original plan to install the sculptures in the Cast Gallery (now the Medieval Sculpture Hall) had been aban-

doned. Instead, the lion and bull were erected at the south end of the Great Hall, with the reliefs in the room beyond (fig. 103).

On 27 February 1933, Winlock again wrote to Rockefeller: "This morning the screens were removed from the Assyrian sculptures, and they are now on public view. They make a truly magnificent showing and add enormously to our collection." He then added a personal invitation: "You scarcely need any personally conducted tour through them, but if you ever find a moment when you can come up to the Museum I should be delighted if I could be with you when you see them."[60] Ann Adams replied for Rockefeller, saying that he had a cold and was leaving for Florida. He would, she said, see the Museum upon his return later in the month.[61] I do not know if Winlock was present when Rockefeller first saw the reliefs in their new setting.

Winlock commemorated the opening of the new exhibit with an article in the Museum *Bulletin* (1933). Entitled "Assyria: A New Chapter in the Museum's History of Art," it began with the same theme that we have already seen in his statement to the trustees of the previous year:

If he be so minded, the visitor to the Metropolitan Museum may trace back, branch by branch, the family tree of our art and our culture through the last five thousand years of their history. . . . However, one branch of the family has been neglected by us all out of proportion to its importance in our history. Greece had two great forerunners in our direct line. Egypt in the valley of the Nile was one, but equally old—probably even older—and unquestionably as important was the civilization which was nursed into being by the twin Mesopotamian rivers, the Tigris and the Euphrates.[62]

The article was illustrated with photographs of the lion and bull, and three of the reliefs. At last, pictures of the Canford sculptures were available to anyone with access to a library. Winlock also said something of the recent history of the pieces, though this was not his main concern: "Sir Henry Layard . . . was related by marriage to Sir John Guest, one of the leading ironmasters of England. The Guest fortune undoubtedly aided the Layard excavations, and, as a result, a colossal winged bull and a winged lion and a number of imposing slabs of sculpture from the palace of Ashur-nasir-apal II at Nimrud found their way to the Guest estate at Wimborne, Dorsetshire."[63] There was no need to mention the Nineveh Porch—the Metropolitan Museum had created a new context for the sculptures as one of the great forerunners of the Greeks, and therefore a branch on "the family tree of our art and our culture." This family relationship was stressed visually by the pairing of the bull colossus with the copy of Zeus from the pediment at Olympia at the southwest corner of the Great Hall—the outstretched arm of Zeus points directly at the bull, drawing attention to this previously missing link in the chain of art.

Winlock was probably right in putting the sculptures on display, rather than waiting for permanent quarters for them. Because of the Great Depression, the planned new northwest wing was never built. The "temporary" display of the sculptures lasted until 1957, when the entire ancient Near Eastern collection was closed, moved, and reinstalled permanently on the first floor at the north end of the Fifth Avenue building (fig. 104). The reopening of the collection was reported in a Metropolitan Museum press release of 1960: "The Metropolitan Museum of

103: New York, Metropolitan Museum of Art, Assyrian sculptures, 1933 installation
(photo: Metropolitan Museum of Art)

104: New York, Metropolitan Museum of Art, Assyrian sculptures, 1960 installation
(photo: Metropolitan Museum of Art)

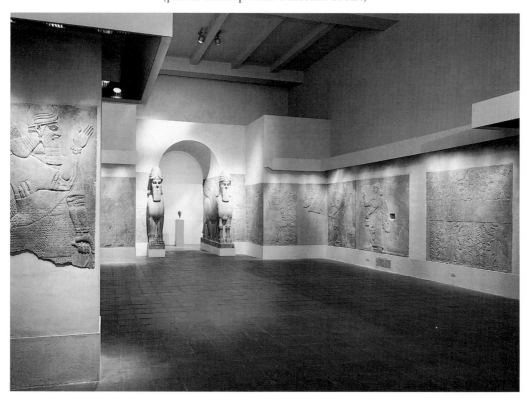

Art's collection of Ancient Near Eastern art has been newly installed in permanent galleries on the main floor in the north wing. Due to gallery reconstruction, much of this renowned collection has not been on view for several years; it has never before now been possible to display the collection in connecting galleries or in such a spacious area."[64]

The planning of the new installation coincided with the formation in 1956 of a separate Department of Ancient Near Eastern Art, under the curatorial direction of Charles K. Wilkinson. Prior to this, ancient Near Eastern art had been grouped together with Islamic art in the Department of Near Eastern Art, under an Islamicist curator, and had received little scholarly attention. The new installation, therefore, was both an opportunity for the new department to assert its existence through the presentation of its collection in a permanent gallery, and to justify its existence through an appropriately scholarly display. The new gallery could make the case that Assyrian art was not merely a branch of a larger tree, but that it had a history of its own. Within the constraints imposed by the available space, the new installation displayed the sculptures in the context of a courtyard in an Assyrian palace. The arched doorway above the bulls was based on the proportions and shape of an intact arched doorway excavated at Khorsabad. The reliefs were arranged in a continuous frieze, and, insofar as possible, doorway subjects were placed near the door and related slabs were grouped together. Even the floor tiles were the same size and shape as Assyrian pavement bricks. As in all the previous modern displays of these sculptures, however, but unlike their original display in the Assyrian palaces, the colossi were elevated on the British Museum-style bases that so appealed to Kelekian, and the relief slabs too were set relatively high on the wall. And as with the Nineveh Porch and University Museum displays, the colossi were placed in the back, facing into the room, a continuing legacy of Layard's reconstruction of Assurnasirpal's throne-room in *Monuments of Nineveh* (see fig. 81).

In 1967 this permanent installation was closed to the public and dismantled to provide space for expansion of the Egyptian galleries. The Canford marbles were placed in storage in the museum's North Garage, under plastic, since the roof leaked badly. With no museum funds available to finance a new display, it appeared that these marbles, which began their Western career in the Canford stable, might spend the remainder of their days in the Metropolitan's garage. Arnold Brackman, who at that time was writing his popular account of Layard's excavations, *The Luck of Nineveh* (1978), wrote

As a young boy I saw my first winged bull and lion at the Metropolitan. They were 10 feet high, and I still remember, as probably does every child (or adult) who saw them, how impressively they guarded the museum's Mesopotamian transept. . . . In the course of working on this book, after viewing the extraordinary Assyrian collections in London and Paris, I thought I would refresh my memory of the Metropolitan's pieces. To my shock, I could not find *my* bull and lion. Indeed, they have not been seen in public for a decade. . . . For a city like New York—which, like Nineveh in the past, dwells carelessly and says in her heart, "I am, and there is none beside me!"—one may fairly pose a question to the Metropolitan's administration: Has Modern Nineveh no place for Ancient Nineveh?[65]

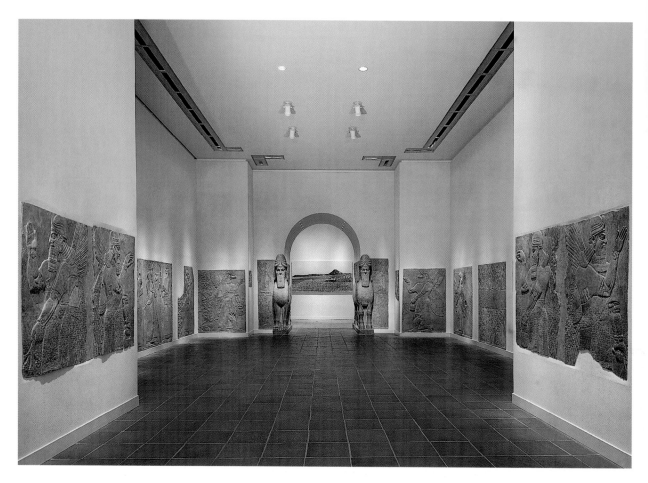

105: New York, Metropolitan Museum of Art, Assyrian sculptures, 1981 installation
(photo: Metropolitan Museum of Art)

Fortunately the plight of the reliefs came to the attention of Raymond and Beverly Sackler, who agreed to fund their installation in a new permanent gallery on the second floor of the south wing. This opened in 1981, fourteen years after the sculptures had last been seen in public (fig. 105). The installation of the new display was supervised by Vaughn E. Crawford and Prudence O. Harper, who maintained all of the Assyrian features of the 1960 display. In addition, the gallery was narrowed with false walls in order to approximate the proportions of an Assyrian reception room, the colossi were finally displayed at ground level without bases, and the relief slabs were also placed nearly at floor level. The colossi are still at the back of the room, facing in, where they look magnificent.

CANFORD SCHOOL

Judith McKenzie

Following the death of her husband, Baron Wimborne (Ivor Guest) in 1914, Lady Cornelia continued to live at Canford until 1922. Their son Ivor Churchill Guest (1873–1939)—Lord-Lieutenant of Ireland from 1915 to 1918 and the first Viscount Wimborne from 1918—had his own house, so in 1923, not long after the sale of the Nineveh Porch sculptures, Canford Manor and its park were sold. Canford Manor became Canford School, a boys' private school. The Nineveh Porch became the school's "tuck shop". Its new owners apparently assumed that all of the remaining Assyrian reliefs were casts, and these were repeatedly repainted. The walls were covered with shelves stacked with food and clothing (fig. 106). Neither staff nor students paid much attention to the remaining "casts" on the east and west walls. The Nineveh Porch assumed its new role, its former identity as a museum of Nineveh all but forgotten, but apparently not quite forgotten. Thirty years later, the tuck shop had a visitor who might well have known something of its history—Sir Leonard Woolley, the excavator of Ur.

FOUNDATION OF CANFORD SCHOOL

The school history of Canford begins: "In the beginning the only begetter of Canford School was Percy Warrington." At the time of the foundation of Canford School this son of a tenant farmer was only 34 years old. He left school at 15 to work on his father's farm, then, through the influence of a local clergyman, went to Durham and was later ordained. He became Secretary of the Church of England Trust, renamed the Martyrs' Memorial Society, which aimed at emphasizing the Protestant nature of the Church of England and curbing the growth of Anglo-Catholic influence within it. "He made the trust his instrument to do great things."[1]

He considered that the Trust should oppose the Anglo-Catholics by emulating them, not only by buying advowsons so that parishes could be filled with evangelical clergymen, but also by founding an Oxford college (St. Peter's to emulate Keble), a theological college, and public schools "dedicated to uphold the Protestant evangelical tradition within the Church of England."[2] Consequently the Trust founded or bought a number of schools, including Clarence School at Weston-super-

106: Canford School, Nineveh Porch tuck shop, sales counter
(photo: author)

Mare, which it moved to Canford as its existing premises offered little scope for
development. The choice of country houses for use as schools was not unusual at
the time. "Agricultural depression, death duties and the aftermath of the 1914–18
War all made it harder to meet the costs of running a large estate with the result
that country houses were on the market at prices which made it far cheaper to buy
a country house and adapt it than to buy land and build a school."[3] Other con-
siderations in the choice of Canford were its proximity to the wealthy and fast-
growing populations of Poole and Bournemouth, with preparatory schools but no
public school. The flat surfaces and gravel subsoil of Canford Park could be turned
into playing fields without much alteration, and it had a river.[4]

The sale of Canford House and Park had been advertised in a full-page spread
on the back page of the *Times* in 1923. It was put up for sale because Lord (the
first Viscount) Wimborne had bought his own estate during his father's lifetime,
and after his father's death he had retained Canford only for his mother, Lady Cor-
nelia Spencer Churchill (Layard's sister-in-law). In 1922 she moved into a smaller
house.[5] The religious views of Lady Cornelia were similar to those of Percy War-
rington. Like her mother-in-law, Lady Charlotte, she was vehemently anti-Catholic.[6]
In 1899 Cornelia had founded "The Ladies' League for the Defence of the Reformed
Faith within the Church of England." She became a governor of Canford School,
as later did two of her sons, her grandson, and great grandson, the second and third
Viscounts Wimborne.[7]

RELIEFS REDISCOVERED IN 1958

This account is compiled from the correspondence at Canford School in the Headmaster's file and the minutes of the meetings of the School Governors. This correspondence is at first largely from the Senior History Master, Mr. Hughes, to the Headmaster, Mr. Hardie. Hughes was informally looking after the matter. Later, when the pieces were to be auctioned, it was taken over by the Chairman of the Allied Schools, Mr. Adams, who was more conveniently located in London.

In June 1958, Dr. R. D. Barnett, Keeper of Western Asiatic Antiquities at the British Museum, visited the Nineveh Porch at Canford with his wife, acting on a hint from Sir Leonard Woolley.[8] Barnett later recalled the event as follows:

In about 1956, the late Sir Leonard Woolley, on a visit to the school, observed with his keen eye what he felt sure were some remaining Assyrian sculptures embedded in their tuck shop walls, thickly coated with whitewash. Acting on his advice, I paid a visit to the school in the summer of 1958, and found seven reliefs evidently from the palace of Sennacherib, showing various scenes of war, whitewashed over and embedded in the walls, partly hidden under packets of cereals and piles of cricket shirts. The school's authorities were totally unaware of their existence, believing them to be all casts; nor did they appear to be particularly grateful for the information.[9]

These seven reliefs are numbers 5, 6, 7, 8, 21, 22, and 23 in L. W. King's inventory (figs. 13, 33, 34, 37, 51, 52, 53). King too at first thought they were casts, which suggests that they were already covered with paint before 1920. His entries for numbers 5 and 6 both begin with the word "Cast," which he then crossed out. Having been fooled twice, he apparently looked more closely at the remaining reliefs and correctly distinguished the casts from the originals.

Barnett still assumed that the large reliefs near the door were plaster. He suggested that the seven small reliefs be cleaned and then the Nineveh Porch be turned back into a museum, for which he thought the British Museum might provide some objects from time to time.[10] This suggestion caused some irritation with the school, which was short of both money and space: "As for Dr. Barnett's feeling that a school museum should be housed in what we have debased (if that's the word) in a tuck-shop he should be told that we cannot afford such luxurious use of our limited accommodation."[11]

As they could not give the reliefs a suitable home in the Nineveh Porch while it was the school shop, the school's overriding reaction was that, now that they knew the reliefs were genuine, they could not be left inadequately displayed and thus needed to be removed from the wall to be "more honourably displayed" elsewhere.[12] The initial estimate of the cost of removing the sculptures from the wall and cleaning them was about 200 pounds. Two years previously, in 1956, a request had been made for the school to present the iron doors to the British Museum "if they were no longer required at Canford." "The governors had unanimously agreed that these doors were of considerable interest and should be retained by the school."[13] At the time the reliefs were discovered in 1958, the British Museum was refurbishing its Assyrian galleries and, as they had been interested in the iron doors for them, informal approaches were made to Barnett along the lines that perhaps the cost of removing and cleaning the sculptures could be provided by the British

Museum in exchange for the iron doors of which Barnett requested the exact dimensions.[14] It is ironic that, while Barnett considered the Nineveh Porch should be "restored to its former character of a museum," he was also contemplating adorning the British Museum with one of its chief architectural features: the iron doors.

Two weeks after his visit to the Nineveh Porch Barnett wrote to the Librarian of Canford enquiring: "It occurred to me . . . that you might possibly have some unpublished papers, records or diaries going back to the time of Sir Henry Layard connected with his excavations which have been left in the Library when it became a School, as I gather much of the Library was handed over to you intact from the previous owner, in particular as I am seeking for anything which will help me to trace some lost drawings of Assyrian sculptures which reached this country in 1854 and have never been seen since."[15] The Librarian's reply is not in the files, which indicate elsewhere that the school had no records pertaining to the earlier sale. This is not surprising as the reliefs were sold not by the school but by Lord Wimborne, to whom Barnett had already written.[16] History repeated itself as Russell made a similar enquiry after his visit in 1992.

Barnett came across "some old photographs which I think show the sculptures, now removed from your Museum to New York, photographed while still in their original setting."[17] Hardie later reported to Adams that Hughes had seen "a photograph of Nineveh Court (the shop) with the sculptures still in it" when he visited Barnett at the British Museum.[18] During the discussions with Barnett about the doors and the reliefs he was shown two of "some miniature models in wax (?)," but, wrote Hughes, he "was not as impressed as I hoped he would be. They have little cash value or aesthetic merit."[19]

After a "desultory correspondence" and unofficial discussions between Hughes and Barnett, the school was left in the situation of having to investigate both the removal and cleaning of the reliefs, as well as their possible sale. The situation developed along the lines which might have been expected. This is most vividly conveyed by school records from the time. Early on Hughes wrote to the Headmaster, Mr. Hardie: "I have talked it over with the Bursar and clearly there is a great deal to this matter. . . . Now that they are known for what they are I very much doubt whether we can justify keeping them in their present surroundings; you would be embarrassed any time you were asked about them by anyone of taste and learning."[20]

Hughes gradually discovered the nature of the pieces: "What we have are probably only fragments but they may be found to have very important cuneiform inscriptions. They, of course, should be cleaned up and photographed . . . nor am I willing to proceed with cleaning them without further advice."[21] By early January 1959, Hughes had come to the conclusion: "It would be well if I may say so, to end the drift in this matter and to that end I suggest Dr. Barnett be asked to pay us another visit to go into the matter of the removal of these sculptures from their present unfortunate positions; then pursue further the matter of their disposal. If we keep them we must display them properly; If we decide to sell they must come out to be cleaned etc."[22]

We do not hear of Barnett's reaction to this approach. But by late January the school had handed the matter over to the Chairman of the Allied Schools, Mr. Adams, as Hughes by then was "very anxious that the matter should not rest longer at my non-executive level."[23] When the School Governors met in early February they decided to sell the pieces, as Lord Wimborne "was agreeable to them being sold if they were of any value as the money could be used by the School to greater advantage. While he was in America Lord Wimborne would enquire who was the authority there to consult as to their value. . . . The Governors agreed that whatever happened to them, they could not remain in the wall of the tuck-shop."[24]

By June 1959 the auction house, Sotheby's, had been approached to arrange the sale of the seven small reliefs.[25] Shortly before the date set for the sale, 16 November 1959, a letter was received from Barnett "stating that an individual who was a friend of the Museum would be willing to purchase the lot for 2500 pounds (a sum which he considered a very reasonable offer) and, in addition, to refund to the Governors of the School any commission fees which might have been incurred if they were to sell them to him and withdraw them from the auction."[26] During the course of the correspondence concerning this offer, which he pursued "with considerable effort," Barnett stated "that he would oppose the export of any of the sculptures."[27] Despite this pressure, the school did not accept Barnett's offer and proceeded with the auction.

The rediscovery of the reliefs caused something of a stir and was reported in the *Times* and *Illustrated London News*, the latter of which included photographs of six of the pieces.[28] The sculptures were sold at Sotheby's on 16 November 1959 for an official total of £14,250, the individual prices ranging from £800 to £4400.[29] Unlike the first batch of reliefs, which all ended up in the Metropolitan Museum, these are now scattered among four public collections: two each in Boston's Museum of Fine Arts, the Ashmolean in Oxford, and the Bible Lands Museum Jerusalem, and one in the British Museum.

The fragments were bought for the most part by museums possessing related or closely related pieces, with an unfortunate exception where it was realized, after the sale, that two pieces joined (see figs. 13, 51). These two fragments were bought by two separate collections: the Boston Museum of Fine Arts and Mr. and Mrs. Leon Pomerance.[30] The Ashmolean Museum bought the relief depicting a horse and its attendant (see fig. 37). Hamilton, the Keeper of Antiquities at the Ashmolean, noticed that a flake, about 13 × 25 cm had "quite recently come detached." As it was not to be found at Sotheby's he wrote to the Headmaster, "The surface would be carved all over with a scale pattern, representing the landscape, and there should be part of a horse's tail at the left edge."[31] The fragment was not found at Canford. It is notable that despite all this attention to the Assyrian reliefs at Canford, there is no mention anywhere in the correspondence by the school or Barnett of the small fragment with three heads which the school possessed in 1992 (see below). The fragment depicting captives in front of a city (from Room LI) is also now in the Ashmolean Museum (see fig. 33). The piece depicting a horse ridden by a captive woman and child passing a palm tree, probably also from Room LI, was bought in at the auction and was bought for stock by Hewetts for £650 (see fig. 34).[32] It

eventually made its way to the Bible Lands Museum Jerusalem, as did the Pomerance piece.

The fragment which was in the best condition, being the only one intact for the full height of its scene, reached the highest price, £4400. This was nearly half the amount raised by the other six sculptures combined, £9850. It depicted three captives in front of an Assyrian archer with date palms in the background (see fig. 53). This piece came from slab 8 of Court XIX of Sennacherib's palace, the same room as the closely related scene from slab 3 (see fig. 52) bought by the Boston Museum of Fine Arts, which already possessed a fragment from the same room. There was also a fragment, from slab 9, in the Royal Ontario Museum. However, the British Museum already possessed slabs 10, 11–12, and 17–19.[33] Thus, as this piece was bought by a Swiss private collector, Barnett raised an objection to its export. The Reviewing Committee initially refused an export license, giving the British Museum until 16 February 1960 to find £4650 if they wished to purchase it and ensure its retention in the country.[34] It was then purchased by the Isaac Wolfson Foundation for the British Museum.[35]

The gross proceeds from the auction came to £14,250, from which 15 percent commission, plus expenses, were paid.[36] This was over five times the figure Barnett had offered to pay as "very reasonable." It is thus not surprising that afterwards it was felt "Museums . . . have not behaved very well over this and tend to play down the actual value of such pieces possibly hoping to get them advantageously themselves."[37] Perhaps this has some bearing on how the course of events repeated itself three decades later.

The sale resulted in a niece of Layard's, Julia DuCane, mentioning that she still had "a rather smaller bit of the reliefs (measuring about 2 ft × 1.6 ft. . . . It is of little interest to me, for it is so badly placed (not my doing!) above the front door, in the porch, where it can hardly be seen." The DuCane fragment was sold at Sotheby's on 11 April 1960 for £2700.[38] Lientenant-Colonal E. C. W. Fowler, who had been a student at Canford from the year of its foundation, 1923, on seeing the article in the *Times* announcing the Canford sale wrote to the Headmaster observing "The caption says that they were 'found'—every one of a earlier generation at Canford knew about them and valued them as something of genuine worth and most unusual provenance."[39]

Finally, Hughes prepared "a statement for 'The Canfordonian' and also a statement for the boys to read before they go home [for Christmas 1959], so that they will be reasonably well informed when parents and other people ask them about the reliefs in the holidays."[40] The *Canfordonian* article was written, it claims, in order to correct misconceptions that arose when, "Splashed across newspapers and featured on television the facts assumed various grotesque forms."[41] The first part of the article was an official statement from Hughes, which began with a brief account of Nineveh and the Canford marbles and then continued:

Canford passed from the Guest family to the School in 1923 and Nineveh Court became the School Shop. The sculptures had by then all been sold except for seven reliefs embedded in the walls. At some stage before 1923 the identity of these was lost sight of,

and they were thought to be mere plaster copies like the big one near the door, on the right. Some 18 months ago they were re-identified and the School Governors decided to take the action that resulted during this term in their sale at Sotheby's for £14,250.[42]

The second part of the article was an interview with Hughes, quoted here in part:

Question: And what is [the sculptures'] archaeological significance?
Hughes: That's really a question for a specialist: but it seems to me that one could easily over-rate them in this respect because they were, of course, not in their original site, nor do they depict anything that has not already been recorded, and lastly none of them bears cuneiform inscriptions.[43]

Hughes's answer here raises the interesting issue of original context, as the Nineveh Porch was, after all, built specifically to house these sculptures.

From another question, it appears that the interviewer felt that the Canford community had not been permitted to share adequately in the excitement of the discovery:

Question: I take it that the decision to sell was the Governors'; but can you tell me why the School didn't get a chance to see these things properly?
Hughes: I'm glad you ask that, because many must feel disappointed that they never took much notice of them when they were here. It's simply that until they were cleaned for display there was less to see in them than there is in the plaster cast we know so well. Also the cleaning was done in London after their removal from the walls.[44]

This "plaster cast we know so well" (see fig. 2) was referred to again in the answer to another question:

Question: But how was it that this rediscovery had to occur at all?
Hughes: As far as I know, that's wrapped in mystery; all I can say is that once their identity was lost sight of, it is easy to understand how they came to be thought of as plaster copies of no particular value. You remember the great relief of the Two Kings on your right as you enter the School Shop—the one that generations of boys have bored into with their pennies as they queued for the counter—well, that was an obvious copy, done in plaster. Under their layers of colour-wash the genuine reliefs embedded in less accessible places in the walls were in appearance identical with the "Two Kings", only much smaller. And that's all there is to it.[45]

And that's all there was to it, for another 30 years.

RELIEFS REDISCOVERED IN 1992

As already mentioned, R. D. Barnett of the British Museum had assumed all three large reliefs left in the Nineveh Porch, near the iron doors, were plaster casts (see fig. 2). The top relief was quite obviously a cast of the famous bull hunt in the British Museum, from the palace of Assurnasirpal II at Nimrud (see fig. 9).[46] The middle and lowest panels were more deceptive. They depicted two figures which were fairly well lined up across the middle with the upper and lower part of each figure joining, even though the two bands of cuneiform writing indicated that they did not actually belong to each other. Of these two panels, the lowest piece, as indicated by the edge of the footstool on the right, is not difficult to identify as a cast

107: Nimrud, Northwest Palace, Room G, Slab 2; British Museum 124564; 234 × 202 cm. The lower half of L. W. King no. 28 is a cast of this slab; dimensions of cast: 125 × 187 cm (photo: Trustees of the British Museum)

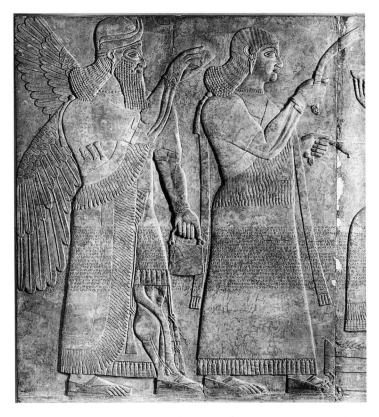

of the lower part of panel 2 from the famous royal scene from Room G of the same palace in the British Museum (fig. 107). The middle slab, 1.14 × 1.83 m, was also covered in a thick coat of white paint and thus the same colour as the casts, and like them consequently lacking in visible fine detail. However, it did lack any tell-tale seam down the middle, so obvious on the bull-hunt scene where the two halves of the cast were joined to make one large piece.

In May 1992 the Nineveh Porch was visited by two experts on Assyrian reliefs, John Russell of Columbia University in New York and Julian Reade of the British Museum. As Russell has related in the introduction to this book, he noticed that in King's inventory of the Nineveh Porch sculptures the middle slab was identified as genuine. Reade then observed that it corresponded exactly to a slab described by Layard in *Nineveh and Its Remains*, which had been presumed lost. Russell wrote to the Headmaster, Mr. Marriott, informing him of this.[47] Subsequently Russell and Reade returned to Canford with Ken Uprichard, a stone conservator at the British Museum, and Reade wrote to the Headmaster of Canford on 28 May 1992 informing him that the centre slab was, in fact, Slab 6 from Room C of Assur-nasirpal's palace at Nimrud.[48]

As it had been assumed to be a cast for so long, the idea of the centre piece being an original stone slab was received with some skepticism by the school officials, who were clearly unaware of the weight of the opinions of these two authorities. However, the information came to the attention of one of the School Governors, Mrs. Ann Smart, Fellow in Law at St. Hugh's College in Oxford, where I held a

research fellowship in archaeology. Mrs. Smart eventually obtained a copy of Reade's letter, but not of Russell's. While Reade would have been unlikely to put such an authentication in writing unless he had been certain of it, his letter made no mention of his having been accompanied by a second authority, Russell, nor of the key given by L. W. King's notes. The school in effect already possessed a second and third opinion, but they appeared to be unaware of it. Thus, a year after the visit of Reade and Russell, Mrs. Smart drove me down to Canford, determined to have a second opinion on the possible authenticity of the relief.

Standing in front of the reliefs, it was not possible to determine whether the centre one was an original stone slab rather than a cast, as it was covered in thick coats of paint that obscured any incised detail that there might have been. As already noted, it lacked a visible tell-tale join down the middle, which might have been expected if it were a cast. As there were no areas where the paint was flaked through to the material underneath, the only way to be certain, as the school was insistent on a second opinion, was for a small area of the paint to be removed. In order not to risk damaging the soft stone underneath it was essential that this be done by a qualified conservator—that no one succumb to the temptation to attack it with a pocket knife.

Lynn Morrison, a conservator at Saffron Waldon Museum, had recently been cleaning fossils which are a similar type of stone. Consequently, the school sent her some flaked paint from the lower plaster slab to test for appropriate solvents before she came down to the school in June 1993. She cleaned a small area which revealed that the centre panel was an original stone slab of slightly mottled alabaster (Mosul Marble, gypsum) confirming the opinions of King, Russell, Reade, and Uprichard.[49]

The immediate problem of security then arose as heritage theft is a major problem in England. The Nineveh Porch is at the far edge of the main buildings and thus in a location where suspicious activity might pass unnoticed. Therefore, the Nineveh Porch continued to be used as the school tuck-shop but was fitted with a burglar alarm wired to the local police station.

The school then decided to have the remainder of the slab cleaned. The decision first had to be made whether to clean it *in situ* or remove it from the wall first. If it were done *in situ*, there would be a problem in adequately washing away the chemicals used to strip the paint from the vertical slab. Cleaning it *in situ*, however, would expose any cracks and reveal its true condition, which would be important information if it were to be moved from the wall. After considering the matter, the school decided to employ Lynn Morrison to clean it *in situ*. By then it was the summer holidays and the school was in use as a summer school of music, for which the Nineveh Porch had to remain in use as a tuck-shop. A small hut was therefore erected inside the tuck shop, enclosing the relief, and fitted with an exhaust fan. In these cramped conditions, in protective suits and masks, Morrison and her assistant worked in the heat of August. The following details come from her report.[50]

The gypsum was covered with three coats of paint. The lower two were ochre-coloured paint, possibly distemper, and the top coat white vinyl emulsion. The bottom coat was a light khaki colour, the middle one ochre yellow with some pink, and the top one white. The lowest layer of paint was the same as that on the plaster

108: Nineveh Porch,
L. W. King inventory
nos. 27 and 28, after
cleaning; dimensions of
no. 28: 239 × 187 cm
(photo: Judith McKenzie)

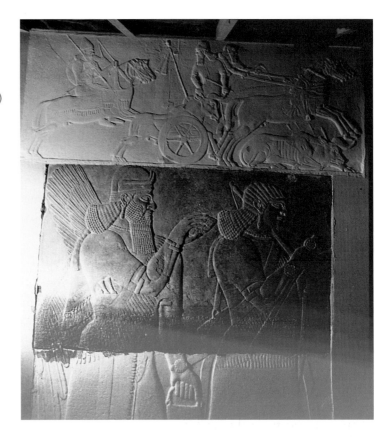

slab below, being the exact stone colour of most of the reliefs in the British Museum. The slab itself had a darker mottling, so it is possible that it was painted from the beginning to match the colour of the casts and other reliefs, to make it appear homogenous with the cast that formed its lower part. If this slab was in fact painted at the time it was originally installed, this could account for the excellent condition of its surface detail, which would not have been exposed to the air.

The task of cleaning it proved fairly complex as a result of complications caused by rising damp. The first application of "Peelaway" in direct contact with part of the slab led to the formation of an insoluble iron salt. Rising damp had leeched these iron salts into the stone from the iron cramps that held the slab in place. After considerable testing, the method of cleaning used was to remove the top vinyl layer with "Peelaway," a paste containing 30 percent sodium hydroxide, which is very corrosive and alkaline. It therefore had to be neutralized with acetic acid. The lower two paint layers were removed using "Nitromors" which is a water-soluble gel containing dichloromethane. After it had softened the lowest layer, it was removed mechanically with a scalpel, and finally with white spirit.

When cleaned, the relief was found to be in remarkably "crisp" condition— "crisper" than many now on display in the British Museum (see figs. 44, 108). The cleaning revealed fine incised decorative details such as the strands of hair and the

object had struck the stone. It was later determined that there had once been a dart board on the wall close to the relief.[51]

The Nineveh Porch itself was suffering from severe rising damp. If left in the wall the surface of the stone would have deteriorated further because of the iron salts leeching into the stone from the iron cramps holding the slab in position. If left in a damp situation the surface would gradually have been broken up by small salt crystals forming on it as they were brought to the surface, transported by the moisture moving through the wall to the surface. This phenomenon has already caused the more immediately obvious destruction of softer limestone architectural and sculptural fragments from Egypt in museum storerooms.

Further damage had been caused by the rising damp rusting the iron cramps, which expand as they rust. Consequently, a crack had started near the lower left cramp. The expansion of the cramps had already caused the stone to chip off in front of them. Thus it was essential that the slab be removed from the wall for its own protection, not only from possible theft or further cracking, but especially to avoid surface decay. The immediacy of this problem was perhaps more obvious to someone with a knowledge of chemistry than to the layman.

The stone relief was removed from the wall in January 1994 by the Cliveden Conservation Workshop, who undertake similar work for major museums and heritage organizations. This revealed the extent of the corrosion of the iron supports. The expansion of these as they rusted would have cracked the slab within ten years. Such hairline cracks had already occurred in the plaster casts from the expansion, as they rusted, of the iron bars reinforcing them, so that they fell into several pieces when removed from the wall.[52]

The casts were removed at the same time as the stone slab because the intention was to clean and re-mount them in front of the wall, along with a (new) cast of the middle stone slab. The old and new casts have now been reassembled in the tuck shop according to this plan. The school was also having a second cast made of the stone slab for the new Theatre, which will benefit from the sale.[53]

After it was cleaned, the School Governors decided to sell the original stone slab at auction. Therefore it was essential to scholarship that it be fully recorded, since after the sale, it might disappear from sight. Consequently, I returned to Canford with the assyriologist Stephanie Dalley in late November 1993 for this purpose. I made a full photographic record of the inscription and all the fine incised decorative details, as well as the painted inscriptions on all visible sides of the ceiling beams. This last took some hours, with the school bursar, Mr. Michael Chamberlain, holding one of the school theatre lights—in the dimly lit building there was insufficient light to photograph the ceiling even with a professional flash gun. An expert in cuneiform, Dalley spent several hours checking her preliminary reading of the inscription, which she had made from photographs, against the original. While the text was the so-called "Standard Inscription" of Assurnasirpal II, it was thought desirable to record the exact details of it for future scholarship on textual and paleographic variants. Her notes on the inscription appear in Appendix 6, along with a translation of it.

109: Detail of fig. 44:
head of winged figure
(photo: Judith McKenzie)

110: Detail of fig. 44:
quiver of attendant
(photo: Judith McKenzie)

111: Detail of fig. 44:
textiles, knife handles,
and whetstone (photo:
Judith McKenzie)

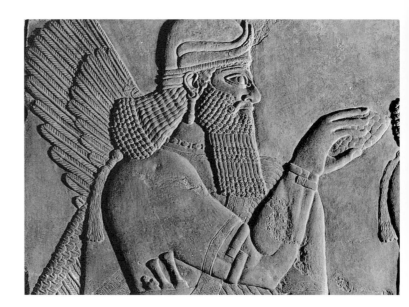

fine divisions of the feathers of the wings (fig. 109). It also uncovered the bands of
decoration along the textiles, with the strands of the tassels carved, as well as bands
of cross-hatching and rows of concentric squares (fig. 111). There was also hatch-
ing on the upper arm bracelets. Other details which became visible included the
rosette on the handle of one of the genie's knives, the bull's head handle on his
whetstone, and even the cuticles on the fingernails of the beardless attendant. The
most beautiful fine detail was incised as decoration on the attendant's quiver in a
band depicting palmettes with thunderbolts shooting out of them, pine cones and
rosettes (fig. 110). There were two pits in the attendant's face from where a sharp

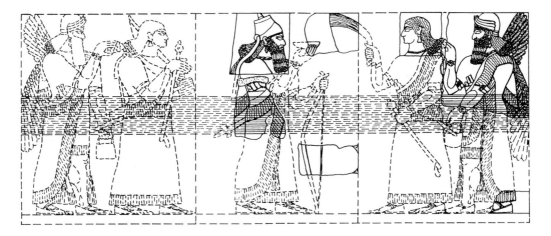

112: Nimrud, Northwest Palace, Room C, Slabs 6–8, reconstruction drawing
(Meuszynski 1981, pl. 4:2)

Julian Reade had already identified the slab as the upper half of a missing one, No. 6, from Room C of Assurnasirpal's palace at Nimrud, ca. 865–860 BC. From the plan of the palace (see fig. 5) it can be seen that Room C is at the western end of the throne room (Room B). Slab 6 formed the top left side of a nearly symmetrical composition with an equivalent winged figure and beardless attendant on the far right framing the king, who is holding a cup in one hand and a bow in the other (fig. 112). The largest surviving piece, from the far right, C8, was also at Canford and is now in the Metropolitan Museum of Art (see fig. 46). The attendant's head from that same slab is in Glasgow, while the head of the king is in Copenhagen. When these pieces were all in place together in his palace in Assyria, Assurnasirpal would have been able to sit on his throne at the opposite end of Room B and gaze upon them.

THE SMALL RELIEF FROM SENNACHERIB'S PALACE

While visiting Canford to examine the large relief, it transpired that there was also a much smaller relief in a frame, which was not mentioned in any of the correspondence at the time the reliefs from Sennacherib's palace were rediscovered in 1958. This is a small fragment depicting three decapitated heads, facing right, with scales (imbrications) representing a rocky hillside in the background (fig. 113). The edges of it were broken, rather than sawn. It is mounted on a board with a wide frame, both apparently of oak. An undated letter was glued to the back of the board, slightly eaten by silverfish but otherwise well-preserved, from Robert Ernest Fuller:

Sir Henry Layard, who married a daughter of the Guests and often stayed at "Canford Manor" Wimbourne. He used to say that this lovely place spoiled him for the privations of life in the East. He gave the house a group of sculptures brought by him from ancient Nineveh, but they are here no longer, having been sold to the Philadelphia Museum. This

113: Canford fragment, Nineveh, Southwest Palace, Room XXXVIII, Slab 13, 16.5 × 12.7 cm; New York, Collection of Michael and Judy Steinhardt (photo: Metropolitan Museum of Art)

114: Nineveh, Southwest Palace, Room XXXVIII, Slabs 12–13, drawing by Layard; British Museum, Western Asiatic Antiquities, Original Drawings, vol. I, no. 44 (photo: Trustees of the British Museum)

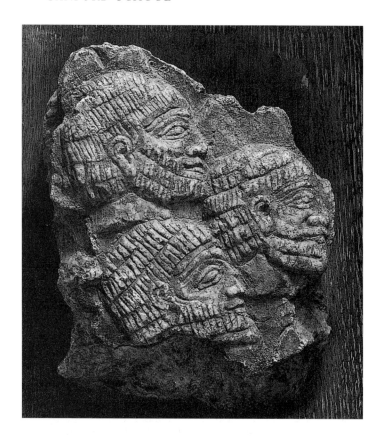

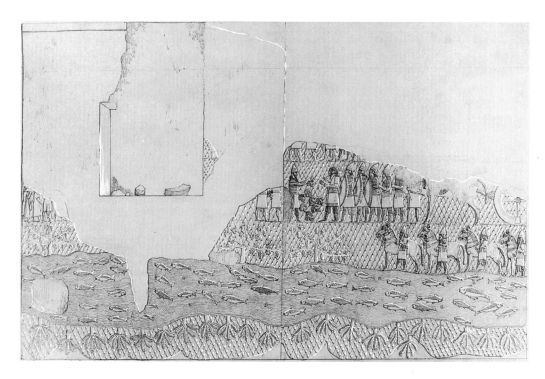

fragment never reached the museum, for one of the panels was broken and hid in the vaults and found some time later by me.

This reflects the sentence Layard had written to Henry Ross, referring to such country houses: "These comfortable places, and the pleasures of English life, spoil me for the adventures and privations of the East."[54] The apparent date of the frame and the mention of Layard suggest that the letter refers to the reliefs that had been sold by Lord Wimborne in 1919 to Dikran Kelekian, who had lent them to the University Museum, Philadelphia. We have been unable to identify Fuller or to determine his connection with Canford.

The first problem was to ascertain if the fragment had broken off a larger piece already sold to a museum and was therefore already someone else's property. This turned out not to be the case. However, it was highly desirable to work out from where in Sennacherib's palace it came, so that if it were later sold (as did happen), it would be more likely to end up in a museum with related pieces. Otherwise such a small fragment was likely to be sold without provenance, as so many fragments of Egyptian carved decoration are at present, to a private collector or dealer. By this route antiquities are still being "lost" to scholarship.

The first obvious method of looking in the published record for decapitated heads facing right with scales in the background was time-consuming and unsuccessful. Furthermore, as many of Layard's drawings are not published, the investigation could not be completed without a visit to the British Museum to look through them all. Having previously spent many months tracking down the origins of late antique and Coptic architectural fragments from Egypt by working backwards from the recent history of the object, I decided to do the same here. This involved ascertaining from where in Sennacherib's palace all the other pieces in the Nineveh Porch had come. One piece which had gone to the Metropolitan Museum of Art in 1932 was from Slab 13 in Room XXXVIII (see fig. 54) which already joined another fragment.[55] The three heads can be seen in Layard's drawing of this slab (fig. 114).

A mystery remains as to whether the missing piece joining the heads to the fragment in New York ever reached England with the other pieces. While Fuller's letter suggests that the three heads had been in the Nineveh Porch, its absence from King's list suggests that it was probably never installed there. It is fortunate that the precaution of photographing and recording it was taken. By the time Stephanie Dalley and I went back down to Canford to record the large slab after it had been cleaned, this smaller piece had already been whisked away to the vaults of Christie's. Russell has since noticed that, even before its "rediscovery," this fragment had been included in the British Museum catalogue of Sennacherib's palace, now in preparation, listed as "ex Canford Manor, present location unknown."[56] In the course of being handled for the sale, the letter from Fuller on the back of the frame suffered considerable damage.

ACADEMIC AND ETHICAL ISSUES INVOLVED IN THE SALE
There is much debate among archaeologists and art historians concerning the trade in stolen antiquities. Anything which increases the value of antiquities and there-

fore their price, can be viewed as potentially encouraging this trade. Consequently, some conservators consider they should not use their expertise to preserve items destined for the market, on the grounds that it increases their price and thereby encourages the trade in illegal antiquities. Similar arguments could have been used against ascertaining the provenance of the reliefs prior to their sale, on the grounds that it greatly increased their value and therefore increased the price they might bring.

Leaving aside the issue of the removal of cultural property from countries without their permission, the two largest academic criticisms pertaining to the trade in illegally excavated or stolen items are that (a) because they have not been dug up in a scientific excavation, their exact stratigraphic context, and often related indicators of date, have been lost and that (b) at a grosser level we are usually never told the site from which they came. This latter information is frequently known at the time of sale but cannot be revealed because of the danger to the source. As such information exists only verbally and it is usually not possible to authenticate it later, it is generally lost with the passage of time as a direct result of the trade being illegal. This situation has changed little in the century since 1893 when, Petrie observed, "all information concerning such discoveries has to be suppressed; and the most important acquisitions of museums are a matter which cannot be published, or even talked about in detail."[57]

On academic grounds, if the provenance of an object such as the reliefs is known, it minimizes the chance of the object being "lost" after the sale. This is least likely to happen if the provenance is recorded at the time of the sale and if a museum with related pieces acquires it as a result. This leads to consideration of another question which is not adequately acknowledged in these days of being holier than thou about the archaeological mistakes and imperialism of the past. One hears much discussion about whether objects should be returned to their country of origin, about which concerns are often raised by major museums in the West, with regard to whether they would be adequately looked after. There is little discussion, however, of the problem of the wide dispersal of adjoining parts of one object or building among a number of museums. Thus, in Europe one sees the lower half of a granite bust of which the joining face is in Egypt. A rare example where two parts have been combined is the famous statue of Ur-Ningirsu of Lagash, of which the Metropolitan Museum of Art owns the head and the Louvre the body, and which are now joined, but migrate between the two museums every three years. Similar problems occur in major libraries where, for example, pages of one manuscript from the White Monastery at Sohag are in a number of different places. This clearly hinders scholarship.

The situation with the Assyrian reliefs depicting narrative scenes from a particular palace is in some way analogous to that of an illuminated manuscript. The wall slabs of these rooms have been dispersed to a number of museums, like the pages of a manuscript to a number of libraries. Not only have whole slabs been dispersed, but numerous slabs have been broken up and distributed among museums in various places. When the fragments of one slab are now in a number of different museums, it is like trying to study a single illustration of the manuscript which has

been torn up and tossed in the wind. Similar problems occur with trying to study the inscriptions on the reliefs.[58]

To prevent further dispersal, it is desirable that museums acquire those pieces appearing on the market that are closely related to pieces they already own. Thus, major museums have a duty of care resulting from the objects they already hold. Their ability to carry this out at any sale is limited by their funds, and so the dispersal of objects is still at the whim of the market forces. Meanwhile, as the vendor, Canford School was bound by English law, under the Charities Act, to dispose of the reliefs only at the maximum price attainable.

NINEVEH ON THE KAMO-GAWA

The following account is pieced together from newspaper accounts of the sale of the two reliefs discovered in 1992. As McKenzie has written, the two sculptures were consigned to Christie's for sale at auction, the date of which was set for 6 July 1994 in London. The large slab from Assurnasirpal's palace was estimated to bring £750,000 and the small fragment from Sennacherib's palace £20,000–£30,000. Christie's publicized the sale of the large slab in an article illustrated with four color photographs in its magazine and also issued a special, lavishly produced catalogue devoted exclusively to "The 'Canford' Assyrian Reliefs," which included a color fold-out of the large slab.[1] In these multiple color images, the large slab received the most luxurious presentation ever accorded an Assyrian sculpture. Shown in this way, using the modern conventions for presenting great art, the Canford slab *becomes* great art. Viewed in color and in exquisite detail, the aesthetic quality of the sculpture is so powerfully assertive that it could not possibly occur to any viewer to question it. The issues here are not the chain of art or the progress of Western civilization—the success of this sale would depend on whether two bidders could be persuaded that this is a truly extraordinary work of art.

The text of the magazine article was devoted primarily to a generally accurate summary of the provenance of the reliefs, though it inaccurately identifies the large sculpture as slab "B" instead of "6" and asserts that it was rediscovered in 1993. This text was essentially repeated in the catalogue, though there the original location of the slab was given correctly. The closest the catalogue came to an aesthetic evaluation of the piece was: "This is the most important Assyrian relief to come on the market since the 'Sandon Hall' relief figure, London, December 1979 (sold £240,000), and a damaged head of a horned divinity in New York, November 1986 (sold $451,000)" (p. 10). In fact, if quality, size, and preservation affect market "importance," then the Canford slab is much more important than these other two examples. The catalogue also asks that we "Please note that the U. N. Embargo on Trade with Iraq still applies" (p. 20). This has the appearance of a routine notice, but it subsequently appeared in a different light.

The upcoming sale of the reliefs was reported in the London *Times* and *Daily Telegraph* of 6 June 1994.[2] The two articles were quite similar, presumably having

been based on a press release from Christie's. Both reported that the Assurnasirpal relief was found under layers of paint in the tuck-shop, the nickname for which they report to be "the Grubber," both described the Layard–Guest provenance, and both included a photograph of the large slab, though in the *Telegraph* photo the lower third of the slab was cropped. Of particular interest were two statements clearly intended to enhance the apparent value of the slab. In the first, Christine Insley Green, Christie's antiquities consultant, was quoted as saying: "The other pieces from the same wall slab are known, but not this one. It is the missing link." In our minds, of course, the term "missing link" conjures up an image of something that is the key to knowledge and completeness. In fact, many of the reliefs from Nimrud are missing, including large parts of the slabs on the same wall (see fig. 112). The other marketing statement asserted that Layard repaid the Guests' generosity by giving them "some of the best Assyrian pieces." We have run across this idea before, in Kelekian's sales pitch to potential buyers, and there, as here, its sole purpose was to increase the apparent value of the sculpture. In fact, as we have seen, it was Layard's practice to send the best pieces to the British Museum, and to choose sculptures for other parties only from the remainder.

There were interesting differences between the two articles as well. The *Times* article began with a reference to the incompetence of Sotheby's, stating that the relief which had been "overlooked by Sotheby's turns out to be 3000 years old and could fetch £1 million at auction next month." The article returned to the same theme twice more: "Sotheby's dismissed them all as plaster casts worth little when experts called at the school in 1957," and later "the walls were whitewashed, covering three remaining casts, which were dismissed by Sotheby's as plaster imitations." Christie's, which presumably fed this information about their rival to the *Times*, must have been well-pleased with this result. The *Times* article referred only briefly to the rediscovery of the relief, which was attributed solely to Julian Reade, whose British Museum affiliation was stressed. The article concluded on an interesting note, quoting the school bursar, Commander Michael Chamberlain: "It was absolutely marvellous to feel this bit of stone, put your hand on it, feel the cold of it and realise it was carved all those years ago. . . . It gave you a real sense of history crossing the centuries." The experience Chamberlain describes in this appealing quote is one that is available to very few of us. Though the smooth, variegated stone and finely carved surfaces of the Assyrian sculptures beg to be touched, if we actually try to do so, we are reprimanded sharply by the guards in whatever museum we happen to be in. With the removal of this slab from the tuck-shop, one of the few remaining places where one could have such a tactile experience with an Assyrian relief now no longer exists.

The *Daily Telegraph* focused on somewhat different themes. Sotheby's was not mentioned at all. The *Telegraph* told the story of the dart board and briefly discussed the Sennacherib fragment, neither of which were mentioned in the *Times*. The story of the relief's rediscovery was told in more detail in the *Telegraph*, including one passage that I particularly enjoyed: "In 1992 John Russell, an academic from Columbia University, New York, inspected the plaques and suggested the central one was original." Reade's role was then acknowledged as well. Evidently the *Telegraph* was less uncomfortable with this example of foreign inter-

vention than was the *Times* (which has a much larger international circulation). The *Telegraph* also included the information that the school "has 500 pupils (fees £11,440 a year)." It is not clear what relevance this has to the story at hand, but presumably readers are always interested to know what others pay to send their children to school.

The sale itself was a financial success beyond anyone's wildest imaginings. After 3 minutes and 40 seconds, the successful bid for the large slab was £7,000,000, which with commissions came to a total of £7,701,500, or $11,891,116. Not only was this the highest price ever paid for an antiquity at auction, it was also £5.5 million more than the previous record, £2.2 million for a Greek vase. Layard's "winged God" had finally gotten its revenge on the Apollo Belvedere and the Elgin Marbles. The small Sennacherib fragment brought £77,000 including the commission. The sensational result of the sale was reported worldwide in newspapers, and on radio, television, and the Internet.

The *Times* and *Telegraph* essentially recapitulated their earlier stories, to which they added their accounts of the sale.[3] Neither paper was able to identify the buyer. The *Times* called him "an anonymous bidder [who] left quickly before he could be identified." The *Telegraph* described him as a man "in his 40s and wearing a green jacket" and reported: "The buyer, whose name has been kept secret by the auction house and who stood discreetly at the back of the room, entered the bidding only in the last few moments and slipped away before his identity could be established." The *Guardian* also reported that "as the intensive bidding was finished, he slipped out, his identity unknown."[4]

The correspondents for the *Independent* evidently knew the art world better than their competitors.[5] Their front-page article correctly identified the buyer as Noriyoshi Horiuchi, "the most distinguished antiquities dealer in Japan." Since Horiuchi would have been expected to be among the bidders, it is surprising that the reporters for the other newspapers didn't recognize him. The *Independent* described the bidding as follows:

The Japanese dealer N. Horiuchi was leaning over the back of an 18th-century sofa almost obscured by the crowd. At the other side of the room was one of Christie's staff, with a telephone to her ear, relaying the competitor's bids in Italian. Mr. Horiuchi capped every bid from his rival with a curt nod. At £6.5m he thought he had it and stood up to leave but the Italian tried one more time without success.

The identity of the underbidder has not been reported. On the following day the *Times* reported that Horiuchi was acting as agent for the Shumei Family, the principal sponsor of the 1992 "Royal City of Susa" exhibition at the Metropolitan Museum, for its new museum in Kyoto.[6] The article stated that the group purchased the piece because of its "belief in spiritually elevating properties of great art viewed amid a natural setting." Horiuchi himself, however, says that he bought the piece on his own initiative, and that the Shumei Family then decided to purchase it from him.[7]

Charles Spreckley, the 17-year-old head boy of Canford School, was present at the sale and was quoted in three of the papers concerning his recollections of the piece when still *in situ*. In the *Times*: "We all used to walk past it as we went to

buy our Mars bars." In the *Telegraph*: "It was just a whitewashed part of the wall and we ignored it." And in the *Guardian*: "We just used to treat it like a bit of the scenery." The *Telegraph* quoted the Canford headmaster, Mr. John Lever (who succeeded Mr. Marriott shortly after my visit) on the same subject: "The panel was on the right-hand side as they go into the shop, and the Coke machine and the sales desk where they bought pizzas is on the left. The boys just went straight past it."

Much was made in the *Independent* articles of the reaction of school representatives to the amount of the sale. Lever was quoted as saying: "I am fairly up in the clouds. We are going to have a very pleasant job sitting down and wondering how to spend the money." The quote of the day, however, was Spreckley's: "It was totally staggering to find out in the first place that this piece of wall we had all been told was fake, and took no notice of, was worth about £1m. To find it is worth nearly £8m, I can't explain how staggering it feels."

This last provides a fitting introduction to a further statement in the *Independent*, which I found to be the most unsettling thought to be raised in any of the articles: "Yesterday's extraordinary price reflects the fact that no Assyrian relief of this quality is ever likely to come on the market again. They are all in museums." Considering that the brief coverage of this sale in the *New York Times* was preceded by a much longer report on plans by the New York Historical Society to sell important parts of its collection at Sotheby's, the permanence of protection afforded by museums might be doubted.[8] This is of particular concern because of the nature of many of the "museums" in question here. Many well-preserved reliefs from Assurnasirpal's palace were brought to the United States by American missionaries in the later 1850s, when Rawlinson was giving reliefs away to all comers (see Rassam's letter to Layard, quoted at the end of Chapter 4). As we have already seen from the Breasted–Rockefeller correspondence, a number of complete slabs of comparable quality to the Canford example ended up in American colleges, which may now find it difficult, as Canford School reportedly did, to insure their sculptures and protect them from theft. What will be the result when the trustees of Williams College realize that their two slabs are worth $20 million or Bowdoin College finds its three slabs are valued at $30 million or more? Can Amherst College afford to insure its five reliefs for $50 million, or likewise Dartmouth College, whose six superb slabs, including one that shows the king with a winged figure, may now be worth $60–$70 million? Time will tell.

The *Telegraph* added a new fact to its story of the discovery of the relief, identifying me as "an American scholar, writing a book about Sir Henry—who discovered the 'lost city' of Nineveh." The *Guardian* agreed that the discovery was made by an unnamed "American academic, writing a biography of Sir Henry Layard." I have since received inquiries about that book, which suggests that, were I ever to write it, it might find a market. The *New York Times* was more accurate, reporting that the relief "was discovered by John Russell, an American professor who was writing a book about the history of the candy shop, which had housed antiquities before it became part of the school." Unfortunately, this did not result in a flood of inquiries about the book on the candy shop—perhaps I should have written the book about Layard instead. The *Independent* attributed the discovery

of the relief to an unnamed "visiting American professor" and to "Dr. Julian Reade, an expert from the British Museum." The *Times* changed its story about the discovery, now reporting that "only when a visiting American professor realised it was a genuine antiquity did the governors invite experts to value the relief." Oddly, the part played by Julian Reade and the British Museum was omitted entirely.

The British Museum did play a part in another anecdote related in the *Times*, however. The June 1994 articles in the *Times* and *Telegraph* had explained that the Assurnasirpal slab had previously been "thought to have been lost in the Tigris when it was being floated downstream on its way to Britain." This was Meuszynski's speculation, based on the fact that Layard had originally described this slab as being preserved, but subsequent scholarship had found no trace of it either at Nimrud or in known collections.[9] He therefore suggested that it may have been among the reliefs given to the French, most of which were lost when the French rafts sank in the Tigris. In its account of the sale, the *Times* greatly improved this part of the story. Building on its knowledge that Layard had been unhappy with the stinginess of the Museum in supplying funds to transport antiquities, it asserted that the "loss" of the relief was actually part of a plot against the museum: "The British Museum was somehow led to believe that the missing bas-relief had fallen off a raft in the Tigris."

As before, the articles had notable differences. The *Telegraph* reported the exact duration of the bidding. The *Times* and *Guardian* seemed particularly interested in the money, giving both the exact total cost of the Canford relief and the £2.2 million price paid for the previous record-holder. The page 3 article in the *Independent* was most concerned with the anecdotal history of the piece, devoting its first four paragraphs to the story of the dart board before proceeding to the tale of Sotheby's blunder in not recognizing the relief. The *Independent* and *Guardian* both agreed that this relief was among the best of Layard's finds, and both listed the cost of the school tuition. These were also the only two papers to mention the result of the sale of the Sennacherib fragment. The *Times* alone included a photograph of Canford School, in which the Nineveh Porch is unfortunately not visible. The *Telegraph*, however, was the only one to mention that the Porch was designed by Barry. Following up on its previous theme that Assyrian sculpture is best appreciated by being touched, the *Times* article was illustrated with a color photograph of Spreckley standing pensively in front of the relief, his hand pressed against the arm of the eunuch.

Though all the news reports stressed the relief's original context in the palace of Assurnasirpal at Nimrud, none of them discussed its importance as the last surviving original part of the sculptural decoration of the Nineveh Porch, a listed building that is one of the most original architectural creations of the nineteenth century. No one who was interviewed after the sale was reported to have expressed any regret that the Nineveh Porch had finally been deprived of the last of the sculptures that were the sole reason for its existence. Mr. Lever was reported by the *Times* as saying that "the windfall would be used to realise a lot of his dreams for Canford." Apparently these dreams did not include having Canford be the only school in the world with an original Assyrian relief in a tuck-shop designed especially for it by the likes of Charles Barry and Henry Layard.

There was much speculation in the news reports concerning how the school would use its new fortune. The *Independent* article cited several possibilities that Lever had mentioned: a new £3 million sports hall and theatre, changing rooms for the golf course, and new scholarships. The *Guardian* reported: "Mr. Lever promised every pupil would receive a reward of 'a free Mars Bar.'" He evidently got his wish—the school governors met the day following the sale and, according to the *Times*, "decided to spend the money on an endowment fund to establish scholarships, new buildings and 500 Mars Bars, which will be given to pupils at the start of next term."[10]

The *Guardian* was the first paper to report on an interesting, though not entirely unexpected, development related to the sale. Every newspaper account had observed that Nimrud is in what is now Iraq, and the Christie's sale catalogue had explicitly stated that Iraq was prohibited from bidding by the terms of the U. N. embargo. Since Iraq has long been at the forefront of the issue of the repatriation of cultural property, it should have come as no surprise when Iraq entered the picture. According to the *Guardian*, on the day before the auction the Iraqi interests section in London requested that the British Foreign Office block the sale of the relief on the grounds that it was part of Iraq's heritage and that the Ottoman Empire had acted improperly in authorizing its removal. "They did contact us on Tuesday and ask us to stop the sale," a Foreign Office spokesman was quoted as saying. "We decided that since it had been excavated with the permission of the Ottoman Empire in the 19th century it was perfectly legal." The *Guardian* likened the case to the "long-running row over the Elgin Marbles," which were also brought to the British Museum with Ottoman permission, but which Greece is trying to have returned.

The *Times* played catch-up the next day (July 8), reporting that Saddam Hussein, "the Iraqi President said last night that the bas-relief . . . had been stolen from his country." The article quoted an unnamed spokesman for the Iraq Ministry of Culture and Information in Baghdad: "On hearing that Christie's would embark on this obnoxious action, the Iraqi government contacted the auction house and the British Government to stop the sale because the carving was stolen from Iraq. But the British Government did nothing. . . . This auction reflects the despicable and degrading standard in dealing with human culture and civilisation in Britain and particularly in the West." The article reported that Iraq would raise the case with Interpol and Unesco. It also noted that "earlier this week, Iraq's Revolutionary Command Council issued a decree ordering the death sentence for smugglers of antiquities." Presumably this interesting fact was included to prove that Iraq takes its heritage very seriously.

In an article the following day (July 9), the *Times* declared that Iraq's claim on the relief was "thwarted last night by the discovery of a Victorian legal document." This, it turns out, was none other than the letter from the Ottoman Grand Vizier that gave Layard permission to remove "ancient stones," which has been quoted here at the beginning of Chapter 2. Though the article does not make it clear why this document, which was never lost, had to be "discovered," we are told categorically that the letter is "regarded as legal and binding by international law, and was cited by the Foreign Office in response to an Iraqi request for the British Govern-

ment to prevent the relief from being sold at Christie's by Canford School." A Christie's spokesperson quoted in the *New York Times* said that they had "nothing further to add to what has already been said by the British Foreign Office, which encapsulates the issue very succinctly. We decided that since it had been excavated with the permission of the Ottoman Empire in the 19th century, it was perfectly legal."[11] This may well be true, but the issue is far more complicated than it is made to appear by the Foreign Office and Christie's, as the continuing debate over England's responsibility to Greece concerning the Elgin Marbles shows.[12]

The problem was best summarized by Zuhair M. Ibrahim, head of the Iraqi interests section at the Jordanian Embassy in London, who was asked cynically by the *New York Times* if "the enormous price made the relief all the more attractive to Iraq." Mr. Ibrahim replied, giving a valuable perspective that had somehow been overlooked in all the excitement: "This is not a matter of money. It belongs to a country. It is not merchandise." And the simple fact is, he is right. The Canford slab is an important piece of the cultural heritage of a country, whether that country be Iraq or England. Blinded by the brilliant success of the sale, no one looked closely to see who were the losers. However we may feel about the responsibility of governments and institutions towards the conservation of heritage, if the issue is not even raised, it is not likely to be discussed.

Two days after the sale, the *Times* devoted two pieces of editorial copy to the tuck shop relief. One was a political caricature of the relief by Peter Brookes.[13] The other was a commentary by the columnist Libby Purves, who had been reading Shelley's "Ozymandias," Byron's "Destruction of Sennacherib," and evidently Rossetti's "Burden of Nineveh."[14] She wondered about the priorities of schools: "Am I alone in murmuring to myself that there used to be headmasters whose dreams would be quickened not only by the money, but by the mystery? Who would have said at least, that they were sorry to see it go, that the cast made of it was a prouder possession than the money? Or perhaps," and here again is the *Times* emphasis on touching, "that the governors did not dream of handing it over until they had given every child in the school a chance to lay a hand on it and feel the authentic *frisson* of antiquity?" It seemed to be Purves's opinion that Canford School was actually poorer after the sale than before. Could she be right?

Christie's was understandably pleased with the result of the sale—the large Canford slab formed the cover illustration of *Christie's Review of the Season 1994*, the 300-page summary of the house's most notable successes that year. In the article that described the sale, Christine Insley Green of Christie's Antiquities Department finally ventured something like an aesthetic judgment: "The spectacular power and quality of this relief and the importance of its provenance combined to attract worldwide interest."[15] Not surprisingly, Assurnasirpal II reliefs have begun to appear regularly on the market. In December 1994 the upper part of a winged deity was offered at Sotheby's in New York, but failed to meet its reserve and was bought in at $1.1 million. Some wondered whether the Canford sale had been a fluke. In December 1995, however, a small winged deity, very similar to fig. 47, was offered, again at Sotheby's in New York. This sculpture sold for $5,667,500, the second highest price ever paid for an antiquity.

EPILOGUE

This book examines the presentation and reception of Assyrian art by different cultures, in different contexts, over time. The focus is a group of sculptures from the palaces of Assurnasirpal II at ancient Kalhu and Sennacherib at ancient Nineveh, which were presented in five different contexts: the Assyrian palace, the Nineveh Porch, the antiquities market, the American art museum, and the modern press.

The Assyrian palace: The sculptured slabs that form the focus of this study were once parts of continuous wall friezes in the palaces of Assurnasirpal at Nimrud and Sennacherib at Nineveh. The function of these sculptures seems to have been purely practical. They were carved as visual records of the king's accomplishments and pious deeds, as models for correct behavior and warnings of the consequences of incorrect behavior, as apotropaic guardians of the palace and its inhabitants, and, in the case of Assurnasirpal at least, as reflections of the activities that went on in different parts of the palace. The Assyrian practice of decorating palaces with wall reliefs apparently originated with Assurnasirpal—there is no evidence that it was the continuation of an earlier tradition. Neither is there any evidence that the Assyrians considered these sculptures to be art, or indeed that they even had a concept comparable to what we call art.

The Nineveh Porch: This small building is a major rediscovery in the history of nineteenth-century architecture. Built at the time that Assyrian sculpture was first being presented to the British public at the British Museum and in *Nineveh and Its Remains*, it represents the response of Lady Charlotte Guest, a wealthy British citizen with inside access to both the Ninevite discoveries and their discoverer, her cousin Henry Layard, through whom she acquired a magnificent collection of Assyrian sculpture. While the official debate over the Assyrian sculptures in the British Museum focused on their place in the chain of art, their aesthetic value, if any, and their importance as historical documents, Lady Charlotte shared the popular perception of these monuments as illustrations of Bible times. In consequence, Lady Charlotte presented her collection of Ninevite art not in a Classical architectural context, as in the British Museum, nor in an anti-Classical architectural context, as in the Nineveh Court in the Crystal Palace, but rather in a post-Classical Gothic context, an architectural style with strong Christian associations.

The antiquities market: In 1919, the majority of the Canford sculptures were purchased by the art dealer Dikran Kelekian, who then endeavored to present them as

desirable merchandise. Kelekian focused on the rarity of the pieces, their Layard provenance, and their similarity to works in the British Museum and the Louvre. This rarity was a mixed blessing, however, since this collection of unfamiliar art was too expensive for museums anxious to please the public with familiar offerings, and too large for private collectors. The methods, risks, and rewards of selling antiquities in the early twentieth century are seen in the dealer's pitch and its reception by a number of prospective buyers, including museum directors and the philanthropist John D. Rockefeller, Jr., a major figure in the history of collecting.

The American art museum: The competition between the Metropolitan Museum and the Oriental Institute for permanent possession of the Wimborne Collection seemed to hinge on the question of whether the Assyrian sculptures were works of art or scientific research material. Both museums presented their view of the significance of the reliefs to Rockefeller, who carefully investigated their claims and decided in favor of the Metropolitan. The presentation of ancient Assyria and the idea of the ancient Orient in a twentieth-century American museum is then seen in the three successive Assyrian installations at the Metropolitan. In the first installation, the Assyrian colossi were juxtaposed with Classical statuary, emphasizing the perceived art-historical relationship between the two types of art. The two subsequent installations, however, each presented the Assyrian reliefs in their own room, completely separate from other styles of art, and each of these rooms was designed with the goal of evoking the original Assyrian palatial context of the sculptures. The notion of Assyria as a link in the chain of art was thereby replaced by the assertion that Assyria was a discrete culture.

The modern press: The author played an inadvertent role in the greatest burst of Assyrian publicity in history. His discovery of an original sculpture still in place in the Nineveh Porch and its sale at auction provide a view of the modes of presentation for ancient art in the modern world. Analysis of the sale, and particularly its presentation by the international press, reveals things that we would perhaps prefer not to know about ourselves.

We have traveled with this group of Assyrian sculptures on their journey through time and space, examining the changing landscape of the presentation and reception of the idea of Assyria (and the idea of art) as we go. Who can guess what the future holds for these pieces? Upon seeing the Nimrud bull, the counterpart to the one at Canford, being dragged up the steps into the British Museum in 1850 (a sight which must have been similar to that shown in fig. 43), D. G. Rossetti speculated that this might not be its last stop:

> For as that Bull-god once did stand
> And watched the burial-clouds of sand,
> Till these at last without a hand
> Rose o'er his eyes, another land,
> And blinded him with destiny:—
> So may he stand again; till now,
> In ships of unknown sail and prow,
> Some tribe of the Australian plough
> Bear him afar,—a relic now
> Of London, not of Nineveh![1]

Rossetti doubtless imagined this to be an event of the distant future. In the case of the Nineveh Porch, however, that future is now. Of the 26 Assyrian sculptures originally built into its walls, none now remains at Canford and only three are still in England. The rest have been carried off, not as Rossetti speculated to Australia, but mostly to another former colony, America, relics of the twentieth-century effort to drag the cultural center of the world westward from the Old World to the New.

APPENDIX 1

THE MONUMENTS OF NINEVEH
First Version of the prospectus for *The Monuments of Nineveh*. (ca. 30 June 1848; Add.
MS. 39077: 33–34):

> Preparing for Publication, in One handsome Volume, Folio.
> THE MONUMENTS OF NINEVEH
> FROM DRAWINGS MADE ON THE SPOT
> BY HENRY AUSTEN LAYARD, ESQ.
> Illustrated in One Hundred Plates

It is proposed to publish a Selection from the Drawings made by Mr. Layard, of Sculptures, Bas-reliefs, and other objects discovered during excavations carried on by him among the ruins of Nineveh and other ancient Cities of Assyria. Plans of the Buildings, and Views of the principal Mounds, enclosing them, together with Drawings of Ornaments, and various small objects of considerable interest in ivory, bronze, and other materials, will be included in the work.

The Drawings are in outline, and will be carefully engraved as nearly as possible in facsimile.

The Monuments of Assyria are highly important as illustrative of the history, manners, and civilization of one of the earliest and most powerful Empires of Asia. They are no less interesting, as furnishing a link hitherto wanting, in the history of Art; and to the Biblical Scholar they are of the highest value, as elucidating and corroborating many passages of Holy Writ.

Some of the Sculptures, of which Drawings will be published, have been secured for the British Nation, and will, it is hoped, be placed ere long in the National Collection; but the greater number were too much injured to bear removal, and have fallen to pieces since their discovery. These Drawings are consequently the sole records of the Monuments of a people which has perished from the face of the globe, and all traces of which have been hitherto supposed to be lost.

The Engravings will be accompanied by short descriptions of the Sculptures, and their discovery.

PRICE OF THE WORK

	To Subscribers		To the Public	
	£	s.	£	s.
Plain Impressions	8	8	10	10
Proofs	10	10	12	12

John Murray, Albemarle Street

LIST OF SUBSCRIBERS

	Proofs	Plain
Her Majesty The Queen	1	·
H.R.H. The Prince Albert	1	·
Her Majesty The Queen Dowager	1	·
His Majesty The King of Prussia	1	·
Marquis of Northampton	1	·
The Earl of Lindsey	1	·
Earl Fitzwilliam	1	1
Earl Spencer	·	1
The Earl of Aboyne	·	1
Lady Charlotte Guest	·	1
The Bishop of Peterborough	·	1
Lord de Mauley	1	·
The British Museum	2	·
Royal Library of Berlin	1	·
The Baron de Behr	·	1
Sir Thomas D. Acland, Bart.	·	1
Sir John Guest, Bart., M.P.	1	·
Sir Benjamin Hall, Bart., M.P.	·	1
H. C. Sturt, Esq.	·	1
Louis Hayes Petit, Esq.	1	·
Mrs. Hamilton Gray	·	1
Philip Hardwick, Esq., R.A.	·	1
Rev. George Marsh	·	1
Benjamin Austen, Esq.	1	·
Rev. George Heathcote	1	·
Rev. William Pegus	1	·
Henry Hallam, Esq.	·	1
The Baroness de Sternberg	·	1
Henry Blanshard, Esq.	·	1
Lord Carrington	1	·
General Fox	·	1
Marquis of Exeter	1	·
Lord Cowley	1	·
James Richett, Esq.[later corr. to Rickett]	·	1

APPENDIX 2

The Canford Colossi

Account of expenses for the Canford Colossi (Add. MS. 39077: 158r). Amounts are in Turkish piastres and para (40 para = 1 piastre):

Expenses on the last Lion & Bull sent to England

Wood		p[iastres] 295/10
Sawing Do.		65/30
Nails		58/30
Mats		68/—
Felts		147/—
Porterage of wood		17/—
Hire of skins for small raft & Raftsmen		41/—
A present to the man for taking the cart through his corn		50/—
Basket carriers 41—7 days each @ p 1–30-	These workmen repaired the road	502/10
Basket fillers 10 - - - — @ p 2-	of the cart-dragged the Lion &	140/—
Diggers 10 - - - — @ p 2–20-	Bull & put them on the raft	175/—
Iron skrews for the Bull & Lion		1197/—
Making heads of skrews		84/—
Paid 3 watchmen on the river bank 21 days each @ p 1–30		110/10
Hire of a tent for the raftmen		5/—
A sheep for the workmen		12/20
Hire of 2 donkeys for bringing the skrews from Mossoul		6/—
Porterage		10/—
Paid Raftman for Raft		4800/—
Paid for the Radj of Tikreet		225/—
Paid a carpenter		72/—
4 Pieces of wood again for the Bull		40/—
Wood & nails (again)		14/—
		p 8135/20
Raft deduct (added to [*illeg.*] account[?])		200
		7935

APPENDIX 3

Cuneiform Texts
Cuneiform texts on the Nineveh Porch rafters (see figs. 84, 85, 86, 87).

A. ÉGAL ᵐaš+šur-PAP-A MAN KUR aš+šur
 "Palace of Assurnasirpal (II), king of Assyria"
 Layard 1851a, pl. 83: A: 1, with restorations

Despite its innocent appearance, this is an unusual text. Though many of Assurnasirpal's texts begin "Palace of Assurnasirpal," virtually all of them continue "king of the world (MAN ŠÚ), king of Assyria." Layard did publish an Assurnasirpal II brick inscription that omits the phrase "king of the world," but that text also omits the "Assur" part of the king's name and writes "Assyria" differently (KUR AŠ).[1] Layard did, however, recognize that the cuneiform signs aš+šur and AŠ were used interchangeably, and he had also copied the name "Assurnasirpal" often enough to be able to restore the first part of the name if necessary.[2] On balance, then, the source for this excerpt was probably a brick inscription, possibly a restoration of the one in *Inscriptions in the Cuneiform Character*. Alternatively, Layard may simply have assembled this passage himself—in *Nineveh and Its Remains* he had been able to deduce the meanings of all of these words.[3]

B. <ma>-da-tu šá ᵐqar-pa-ru-<un-da>
 "[the tri]bute of Qarpar[unda]"
 Layard 1849b, pl. 53 (Black Obelisk)

C. <ᵐqar-pa-ru>-un-da KUR pa-ti-<na-a-a> aš a šú
 "[Qarpar]unda of the land Pati[na]"
 Layard 1849b, pl. 53 (Black Obelisk)

The source for these two excerpts was apparently Layard's engraving of the front of the Black Obelisk of Shalmaneser III (see fig. 23). The excerpts are taken from the beginning of the caption that is just above the lowest register of relief, which shows the tribute of Qarparunda of Patina. The same text was published in *Inscriptions in the Cuneiform Character* (pl. 98: V), but there are two reasons to suppose that the engraving was the source. First, the initial sign (*ma*), shown as damaged in the engraving and missing altogether from the ceiling excerpt, is shown as fully preserved in the *Inscriptions* volume. Second, this caption runs continuously around all four sides of the obelisk. The portion that was excerpted for the ceiling corresponds exactly to the segment shown in the engraving. In the *Inscriptions* volume, the entire caption is printed together, with no indication of where the corner breaks occur. Two puzzling features of the ceiling excerpts are the transformation of the last three signs in the engraving (*na-a-a*) into *aš-a-šú*, which makes no sense here, and the seemingly arbitrary bisection of the text into two parts by splitting it in the middle of Qarparunda's name. These two parts are used quite independently on the ceiling and only occasionally appear together in the correct sequence.

Excerpts D, E, and F all occur in the so-called "Standard Inscription" of Assurnasirpal II, which was inscribed in its entirety on five of the wall reliefs in the Nineveh Porch (see figs. 7, 8, 38, 39, 45) and in part on two others (see figs. 44, 46). Most of this text was duplicated on each of the colossi as well, where it was augmented with additional passages (see figs. 40, 41). Both the Standard Inscription and the colossus text appear also in Layard's *Inscriptions in the Cuneiform Character* (1851a), but this seems not to have been the source for the excerpts on the ceiling. At least one of the excerpts was unquestionably taken from the bull colossus in the Porch (see L below) and internal evidence suggests that several of the others derive from the same source. In compiling his published edition of the Standard Inscription, Layard isolated individual words, based on the assumption that words would not be divided at the end of a line, an assumption that was later proven to be correct. Therefore any sign that ended a line must be the end of a word.[4] Working from his copies of dozens of exemplars of the text, he was thus able to divide the text into its component words with great accuracy. It appears that whoever edited the ceiling excerpts, probably Layard himself, proceeded on the same assumption, presumably to reduce the chances of including partial words. Textual variants make it certain that L derives from the bull in the Nineveh Porch; excerpts D, E, and F all correspond to the ends of lines on the same bull, but not to the ends of the lines on any of the wall slabs. In addition, D, E, and L all begin precisely at the saw cut that splits the center panel of the bull's inscription. It appears very probable, therefore, that excerpts D, E, F, and L were all copied from the Nineveh Porch bull. The particulars of D, E, and F are as follows:

D. *ur-šá-nu la pa-du-ú*
 "relentless warrior"
 Grayson 1991: 275: 13 (Nineveh Porch bull, col. iii, line 1)

This excerpt appears in this form on the wall slabs in figs. 8, 39 and 45, and in *Inscriptions in the Cuneiform Character* (pls. 1: 13, 7: 34). It falls at the end of a line, however, only on the Nineveh Porch bull (fig. 41), where it begins at the saw cut (col. iii, line 1).

E. *nu* LÚ!.SIPA *ṣa-lu-ul*
 "the shepherd, the protection"
 Grayson 1991: 275: 13 (Nineveh Porch bull, col. iii, line 2)

This excerpt appears in this form in the Nineveh Porch sculptures only on the bull and lion. On the wall slabs and in *Inscriptions in the Cuneiform Character* (pls. 1: 13, 7: 35) it ends with the *lu* sign. Though it falls at the end of a line on both colossi, the bull seems the more likely source, since once again this is the section of text that follows the saw cut (col. iii, line 2). The *nu* sign at the beginning is apparently a copyist's insertion, since it is not found here in any actual exemplar of the text. The form of the LÚ sign is also very odd, and may be the copyist's interpretation or restoration of the actual sign, which was damaged by the saw cut.

F. URU *ra-pi-qi* <*ana*> GÌR[II]-*šú*
 "the city Rapiqu [at] his feet"
 Grayson, 1991, p. 275: 8 (Nineveh Porch bull, col. ii, line 7)

This excerpt is on all of the inscribed Nineveh Porch sculptures except for the fragment and is also in *Inscriptions in the Cuneiform Character* (pls. 1: 8, 5: 23). It falls at the end of the line only on the bull, which therefore seems the most likely source (col. ii, line 7). All of the known exemplars include the word ana ("at") after the *qi*, which must have been omitted inadvertently here by the copyist.

G. <É>.GAL ᵐ*aš+šur*-PAP-A MAN KUR *aš+šur*
 "[Pal]ace of Assurnasirpal, king of Assyria"
 Layard 1851a, pl. 83: A: 1, with restorations

This a near-duplicate of excerpt A, but G always omits the first sign of the word "palace."

H. x MAN <uṣ-ṣa-bi>-tu it-tan-nu-ni
 "[they arres]ted and extradited"
 Layard 1849b, pl. 56 (Black Obelisk; cf. CAD 1980, N/1: 47a)

The source for this excerpt was either Layard's engraving of the fourth side of the Black Obelisk of Shalmaneser III (Layard 1849b, pl. 56) or his edition of that text in *Inscriptions in the Cuneiform Character* (pl. 96: 153). It is taken from the end of the first line below the reliefs. The engraving would seem to be the more probable source since it was very likely to have been the source for the other excerpts from the Black Obelisk on the Nineveh Porch ceiling. The first two signs in the ceiling excerpt do not occur in the original and the first is not even a real sign. They make no sense here and may be the copyist's embellishments.

I. x <su>-ú-su pi-ra-a-<te-MEŠ>
 "[an]telopes, elephan[ts]"
 Layard 1849b, pl. 55 (Black Obelisk; cf. CAD 1984, S: 418b)

The source here is again the Black Obelisk, in this case Layard's engraving of its third side (Layard 1849b, pl. 55). This excerpt comes from the end of the caption line between the second and third relief registers. There can be no doubt that the engraving was the source here instead of the version of the text in *Inscriptions in the Cuneiform Character* (pl. 98: III)—though the text was chosen from the end of the line, according to the usual principle, in this case the last word runs over onto the fourth side. In consequence, both words in this excerpt are chopped off. In the *Inscriptions* volume, the entire caption is printed together, with no indication of corner breaks. Again, the first sign here is not genuine and may just serve as decoration.

J. mul-ta-a'-it
 "leisure"
 Grayson 1991: 275: 19 (MMA 32.143.4, line 17)

This excerpt is on all of the inscribed Nineveh Porch sculptures except the fragments and the colossi, and is also in *Inscriptions in the Cuneiform Character* (pls. 1:19, 9: 49). It falls at the end of the line only on the slab in fig. 8, which is therefore the most likely source (line 17).

K. <KUR šu-ba>-re!-e u KUR ni-rib GIM
 "[the Šuba]ru and the land Nirbu, like (the god Adad)"
 Grayson 1991: 275: 7 (probably Nineveh Porch bull, col. i, line 53 to col. ii, line 1)

This excerpt appears in this form on the wall slabs in figs. 7, 8, 38, 44 and 45, on the bull, and in *Inscriptions in the Cuneiform Character* (pls. 1: 7, 5: 20). It falls near the end of a line only in *Inscriptions*, which is unlikely to have been the source, however, since there the first word is not erroneously divided, as it is here. The most probable source is the bull, where this excerpt forms the last part of column i and the first sign (GIM) of column ii.

L. x e-ta-nam-da-ru'
 "they fear (my command)"
 Grayson 1991, 225: 22 (Nineveh Porch bull, col. iii, line 7; cf. CAD 1964, A/1: 109a)

This passage occurs only on the two colossi and in *Inscriptions in the Cuneiform Character* (pl. 43: 2). The source here was definitely the bull, where this word fills the space between the saw cut and the end of the line (column iii, line 7). The incorrect first sign is evidently the right end of a *ia* sign, the remainder of which was damaged by the saw. The lion is unlikely to have been the source since there the *ia* is on a different line than *e-ta-nam-da-ru*.

APPENDIX 4

L. W. KING'S INVENTORY OF SCULPTURES IN THE NINEVEH PORCH
The inventory is the only entry in a small (11.5 × 5.5 × 0.5 cm) green "Peerless Pocket Note Book", kept together with other King notebooks in a box labeled "L. W. King. Diaries, Notes, Accounts, Etc." in the British Museum, Western Asiatic Antiquities departmental archives. The entry is titled: "*Nineveh Court*, Canford Manor, Cruciform." Then follows a sketch plan of the cruciform interior with the position of each sculpture indicated by a numerical key (fig. 115). The remainder of the entry is devoted to descriptions of all of the sculptures. King's description of each slab is quoted in full below, followed by illustration and publication references, and my comments.

"1. *Cast*. Abp's lion hunt. King in chariot shooting lion. Chariot going r."
Illustration: fig. 10
Publication: Meuszynski 1981: 23
Comment: No Assurbanipal relief fits this description. Assurbanipal is shown hunting lions from his chariot only in Room C of the North Palace at Nineveh, but none of those reliefs match the description here. Also, the Room C slabs are much too large (160 cm high) for

115: L. W. King's sketch of the Nineveh Porch plan, showing the placement of the sculptures; British Museum, Western Asiatic Antiquities, Departmental Archives, L. W. King box (source: Trustees of the British Museum)

this location in the Nineveh Porch (Barnett 1976, pp. 37–8, pls. VIII–XII). Instead, this should be a cast of the lion hunt of Assurnasirpal II from Room B of his palace at Nimrud, which fits this description precisely. This slab would make a suitable pair with the cast of the Assurnasirpal bull hunt in the same position on the opposite wall.

"2. Large winged eagle headed deity with cone & bucket. Standard inscr. *Anp.* facing l."
Illustration: fig. 39
Publication: Meuszynski 1981: 50

"3. *Cast.* Abp. Garden Scene."
Illustration: fig. 96
Publication: Barnett 1976: 57

"4. Large winged human figure, right hand raised, in l. hand bucket. Standard inscr. *Anp.* facing l. niche cut to r. of figure, in middle of inscr."
Illustration: fig. 45
Publication: Meuszynski 1981: 30

"5. *Cast* [crossed out]. small frg. soldier holding horse in mountainous country. facing l."
Illustration: fig. 37
Publication: Reade 1972: 110
Comment: King at first identified this piece and the one that follows as casts, and then caught his error.

"6. *Cast* [crossed out]. small frg. prisoners bearing tribute from city going r. soldier to l. stream below."
Illustration: fig. 33
Publication: Sotheby 1959, p. 13, lot no. 56

"7. frg. battle in mountainous country. men attacking with swords and round shields. facing r."
Illustration: fig. 13
Publication: Smith 1960

"8. frg. women carrying waterskins through date-palm plantation. one woman giving child drink out of skin. to right: woman carrying covered pot on head and another carrying fish & branch. Hand with stick raised at extreme r. nice piece. going l."
Illustration: fig. 52
Publication: Smith 1960

"9. *Cast* from lion hunt of Abp. going r. lion leaping on horse."
Illustration: fig. 97
Publication: Barnett 1976: 51
Comment: It is not possible to determine exactly how much of this register would have been included in the cast. The minimum and maximum possible widths are about 145 and 175 cm. The height could vary from 56 to 62 cm, depending on how much of the border was included.

"10. Large panel. *Anp.* bow in l. hand, raised bowl in r. facing r. attendant before him with cup in l. hand [sketch of cup] and flapper in r. hand raised. Standard inscr."
Illustration: fig. 8
Publication: Meuszynski 1981: 45

"2 bulls with long *anp* inscr.
 "*A* ends u-šat-li-mu-ni e-piš ba-'-ri ik-bu-ni. begins with *Standard inscr.*
 "*B*. begins with *stand. inscr.* ends mu-ra-ni-šu-nu a-na ma-'-diš u-ša-li-di."
A (lion):
Illustration: fig. 40
Publication: Paley and Sobolewski 1992: 37
B (bull):
Illustration: fig. 41
Publication: Paley and Sobolewski 1992: 42

"11. broken frg. soldiers storming city up ladder & archers. put up wrong with ladder hor-
izontal. attacking r."
Illustration: fig. 55
Publication: Porada 1945: 158–60

"12. frg. soldier leading horse through stream, going l."
Illustration: fig. 14
Publication: Porada 1945: 153–7

"13. frg. light boat with turned up end, of bundles bound together. at stern soldier
standing, directing with r. arm with stick, holds spear in l. hand. man poling boat. 2 women
sitting in bundles. in foreground man in water apparently swimming. boat going l."
Illustration: fig. 56
Publication: Porada 1945: 156–7

"14. Medium sized human headed figure, r. hand raised, l. hand holding branch. Unin-
scribed. with 2 horn headdress. facing r. honey suckle pattern at top."
Illustration: fig. 49
Publication: Meuszynski 1972: 62

"16. Similar figure facing l. towards window."
Illustration: fig. 50
Publication: Meuszynski 1972: 62

"15. frg. 2 soldiers holding horses on river in mountainous country. facing l."
Illustration: fig. 54
Publication: Russell 1991: 142

"17. frg. soldier with 3 captives, walking l. first captive bears burden, then 2 captives with
hands tied, then soldier with raised flail."
Illustration: fig. 36
Publication: Porada 1945: 159–60

"18. frg. head & body of medium sized figure, bearded, with fillet round hair & l. hand
resting on hilt of dagger. r. hand prob. raised but cut off at elbow. facing l. Anp sculpture
prob."
Illustration: fig. 57
Publication: Reade 1967: 45–8
Comment: The subject and scale of this relief suggest that it originally belonged to a series
of slabs carved with a royal procession that apparently lined a passageway between Sen-
nacherib's palace and the Ishtar temple. The reliefs known to have belonged to this series,

however, were excavated by Hormuzd Rassam in August and September 1853, over two years after Layard left Nineveh (Russell 1991: 40). Three possibilities suggest themselves: (1) this slab belonged to the Ishtar temple procession, but was displaced in antiquity and was found by Layard elsewhere, or (2) this slab was among those found by Rassam and was sent by him to Layard, or (3) this slab belonged to a different relief series, perhaps the one in Passageway LI (not to be confused with Room LI). Options 1 or 3 seem most likely, but Rassam did offer sculptures to Layard in a letter from Mosul of 5 November 1852, and perhaps this slab was the result.

"19. *Cast* fr. hunting scene of Abp. lead [led] horse to l. facing l. 3 riders & lead horse riding r. foremost rider shooting."
Illustration: fig. 98
Publication: Barnett 1976: 51
Comment: The possible widths here could vary from about 215 to 230 cm, and the possible heights from about 54 to 60 cm, depending on where the cast was cut.

"20. Large panel of *Anp.* to l. winged human headed figure with cone & bucket facing l. to r. attendant bearing mace in r. hand, bow in l. & quiver & sword slung on him, facing r. hilt of sword b-[illeg.] with end of quiver. Standard inscr."
Illustration: fig. 7
Publication: Meuszynski 1981: 45

"21. frg. 2 riders—front one with robe—on led horse (facing r.) through palm grove. seat on sort of long saddle extending flat along back of horse. robed broken fig. to r."
Illustration: fig. 34
Publication: Reade 1981: 128

"22. frg. scene in palm grove facing l. 3 attendants with l. hand raised, preceding warrior in pointed helmet bearing bow with quiver at back, preceding 2 bulls"
Illustration: fig. 53
Publication: Barnett 1962–3: 93

"23. frg. battle in mountainous country. soldier with round shield climbing l. 2 archers shooting r."
Illustration: fig. 51
Publication: Smith 1960: 52–4

"24. head and body of large human headed fig. with 3 horned headdress & winged. r. hand raised, prob. holding cone to sacred tree, of wh. there are traces. Standard inscr."
Illustration: fig. 46
Publication: Meuszynski 1981: 29

"25. *Cast.* Abp. pouring libation over dead lions"
Illustration: fig. 99
Publication: Barnett 1976: 54
Comment: The possible widths here could vary from about 125 to 170 cm or more, and the possible heights from about 52 to 58 cm, depending on where the cast was cut. Based on King's description, the narrowest possible width would seem preferable here.

"26. double rowed panel separated by standard inscr. left quarter of panel made up.

"*right 3 quarters of panel.* upper row: sacred tree, then 2 kneeling human headed figures each side of sacred tree. lower row: sacred tree, then 2 standing eagle headed figs. with cones and buckets, one on each side of sacred tree.

"*left quarter.* upper row: kneeling human figure facing r. & part of sacred tree. lower row: standing eagle-headed figure with cone & bucket. in left quarter between upper & lower row cast of part of standard inscr. put in upside down."

Right 3 quarters of panel:
Illustration: fig. 38
Publication: Paley and Sobolewski 1987: 28

Left quarter, upper row:
Illustration: fig. 47
Publication: Paley and Sobolewski 1987: 26

Left quarter, lower row:
Illustration: fig. 48
Publication: Paley and Sobolewski 1987: 9

"27. *Cast* of bull hunt. King in chariot holding bull by horns & dead bull to r. under horses of chariot. armed attendant following with spare horse."
Illustration: fig. 9
Publication: Meuszynski 1981: 23

"28. large panel facing r. winged human headed figure with 2 horned headdress & cone & bucket. Attendant to r. bearing mace & bow & sling with quiver & sword. Standard inscr. lower half of panel made up with plaster cast—upper half genuine."
Whole: fig. 2
Upper half: fig. 44
Lower half: fig. 107
Publication of lower half: Meuszynski 1981: 44

"In all six casts of long narrow panels above the large panels. & lower half of panel 28."

APPENDIX 5

THE FLINDERS PETRIE LETTER
Letter to the Editor of *Nature* from W. M. Flinders Petrie, printed in the issue dated 26 October 1893 (pp. 613–14):

A recent case, which had occupied some space in *Nature*, raises much larger issues than the character of individuals, and issues which must be faced sooner or later.

The present conditions of the laws and practice regarding antiquities is most unhappy, both in the interests of science and in the interests of museums. Two matters require much revision: (1) the modes of excavation; (2) the laws regarding excavation and exportation.

As to the mode of excavating, it is still generally the custom to leave much in the hands of native overseers, and often the European in charge does not live on the work. Until it is recognized that it is unjustifiable to disturb antiquities without recording everything that can be observed, we shall remain in the state of mere plunderers, without a claim much higher than that of the treasure-hunting natives. In Egypt, hitherto, nearly all official excavations have been made by trusting entirely to uneducated and dishonest native overseers; and while the laws are strict concerning Europeans working, the natives plunder almost at their will under one pretext or another. With suitable regulation it has been proved practicable to entirely excavate a site without any loss or pilfering of the smallest objects by the natives; and such excavations, entirely under trained and educated observers, either native or foreign, should be the aim of all future work.

But in the matter of the legal position it is far more difficult to reach a satisfactory basis. Baldly stated the case stands thus. Every country in which there is anything much worth having, stringently prohibits exportation and excavation; and nearly all the growth of museums of foreign antiquities is in direct defiance of the laws. Most countries are engaged in thieving from others on a grand scale, by various underhanded agencies; a form of thieving which is as much tolerated by public opinion as smuggling was in former days. According to law, no antiquities of any kind can possibly leave Turkish or Greek territory, and nothing that is of great importance can leave Italian or Egyptian territory. Yet museums grow.

The actual course of affairs is that some private agent, or museum official, hears of something important, and buys it up in order to smuggle it for the museum in which he is interested. Sometimes museum officials go on missions to collect, or to excavate in accordance with the laws, while what they obtain is smuggled out in defiance of law. This is going on yearly, and will go on till some better system is established. Meanwhile all information concerning such discoveries has to be suppressed; and the most important acquisitions of museums are a matter which cannot be published, or even talked about in detail, while official papers have to be treated as secret archives.

In England the Government is a hindrance rather than a help to a better state of things. France and Germany ask other powers in a straightforward way for presents of antiquities by diplomatic channels; and they often get what they want, as we did in the days of Lord Stratford de Redcliffe and Sir Henry Layard. But recently English diplomacy has, on the contrary, repeatedly thrown away what rights Englishmen might claim concerning antiquities, in order to gain petty advantages which diplomatists were capable of understanding.

The work which has been done in Egypt by the Exploration Fund and myself, at least shows that such an unsatisfactory state of things is not unavoidable. The Egyptian laws are administered with more sense than such laws in other lands, and with a little diplomatic protection the position would be all that could be reasonably wished. For many years large excavations have been made openly, and with complete freedom, by Englishmen; nothing has been lost, either of objects or information, owing to surreptitious methods; all that has not been most essential for the country itself has been openly brought to assist study in England, and the fullest statements can be openly and honourably made on the subject. Meanwhile objects smuggled by officials have to be kept quiet, and lose whatever scientific value their record might have possessed.

Until our Government sees its interests in backing up work for its museums by honest methods, and straightforward dealings, we shall continue to lose the greater part of the scientific value of museum acquisitions, and to have a seamy side to our administration which is more discreditable than those personal questions that have lately been raised.

W. M. Flinders Petrie, University College, London, October 10.

APPENDIX 6

THE INSCRIPTION ON THE CANFORD ASSURNASIRPAL SCULPTURE SOLD AT CHRISTIE'S

Stephanie Dalley, Oriental Institute, Oxford University

Across the middle of the slab run ten lines of cuneiform (figs. 116, 117). They belong to the standard display inscription of Assurnasirpal II, with which many other slabs are inscribed, so the inscription is very well known. It has been identified in two versions according to Paley (1976: 125–33), called Type A and Type B, but the type to which this example belongs cannot be identified with certainty, since the inscribed lines do not continue to the point where the two versions diverge. Since the inscription is thoroughly analyzed in that book, a translation only is offered here, with some variant writings listed in case they should prove useful to specialists.

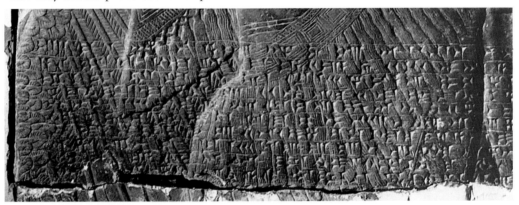

116: Detail of fig. 44: cuneiform inscription, left part (photo: Judith McKenzie)

117: Detail of fig. 44: cuneiform inscription, right part (photo: Judith McKenzie)

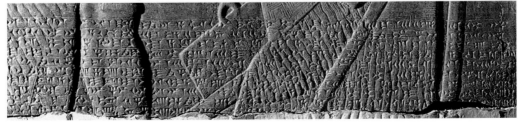

1. Palace of Assur-nasir-apal, priest of Assur, chosen by Enlil and Ninurta, beloved of Anu and Dagan, *kašušu*-weapon of the great gods, powerful king, king of the world, king of Assyria,

2. son of Tukulti-Ninurta, great king, powerful king, king of the world, king of Assyria, son of Adad-nirari, great king, powerful king, king of the world, king of Assyria, heroic warrior who goes about with the help of Assur

3. his lord and among the rulers of the four world quarters none equal to him has appeared, wonderful shepherd, fearless in conflict, mighty flood-wave

4. which none can face; king who makes those who do not kneel to him to kneel; who is master over the whole world of peoples; strong male who treads on the neck of his enemy; trampler of

5. all foes, the one who breaks up groups of rebellious men, the king who goes about with the help of the great gods his lords and his hand has conquered all their countries;

6. who is master over all their mountains and has received their tribute, who seizes hostages, who wins triumph over all their countries. When Assur the Lord declared

7. my name and made my kingship greatest, he grasped his pitiless weapon to my lordly arms. The widespread troops of Lullumu in the midst of

8. battle I felled with weapons. With the aid of Shamash and Adad, the gods my helpers, the troops of the Nairi lands, of the land of Habhi, of the land Shubare,

9. and of the land of Nereb, I thundered over them like the Storm God, the devastator. (I am) the king who, from the far side of the Tigris up to the mountain of Lebanon and the [great s]ea, made the land of Laqe in

10. its enti[rety], (and) the land of Suhi up to the city of Rapiqu kneel at his feet. From the source of the river . . .

(text breaks off, would be continued on the lower part of the slab)

Variant writings

line 2. GISKIM-ᵈ*nin-urta* instead of TUKUL-ᵈ*nin-urta*

line 3. Type A has *a-pu-ú*; Type B had TUKU-*ú*, and this text has *a-pú-ú*.

line 7. MAN-*ti-ia*; Types A and B both have MAN-*ti-a. pa-da a-na*; Types A and B have *pa-da-a a-na*. ERÍN.HI.A.MEŠ-*at*; Types A and B both have ERÍN.HI.A.MEŠ without the phonetic complement.

line 8. KUR <*hab*>-*hi*: the sign *hab* has been omitted.

line 9. Spelling KUR *ni-rib*.

The inscription gives the king's conquests in all directions to justify his title "king of the world." Of the places named, Lullumu probably lies in the mountains to the east of Assyria, Nairi roughly to the north, Habhi probably between Lake Urmia and Lake Van, Shubaru in the Upper Khabur, Nereb perhaps around Aleppo. The Great Sea is the Mediterranean, Laqe is on the Middle Euphrates upstream from Mari, and Suhi downstream from Mari, with its capital city 'Ana, where semi-independent rulers flourished at this period, as recently-discovered inscriptions have revealed.[1] Rapiqu lies on the Euphrates further downstream near modern Ramadi. The inscription would have continued with many further details of conquests.

NOTES

Introduction

1 Bohrer 1989a, 1989b, 1992, 1996; Jenkins 1992;
Larsen 1992, 1994.
2 Russell, in press.
3 Layard 1849a, II: 74–105.
4 Layard 1853a: 162–63, 201–05.
5 Smith 1960: 48–49.
6 The typescript copy of the diaries is in the Wim-
borne family archive. I am very grateful to the late
Viscount Wimborne for allowing me to study
them. Lady Charlotte's original manuscript is in
the National Library of Wales, Aberystwyth.
According to Guest and John (1989: 282), vols. 1,
2, 4, and 5 are missing from the manuscript.

Chapter 2. The English Reception of Assyria

1 Bohrer estimates the average annual income of a
skilled worker at about £100 (Bohrer 1989a: 61).
2 Guest 1950: 164, 185; Guest and John 1989:
143–46.
3 1.X.47, Guest 1950: 197–98.
4 26.XI.47, Guest 1950: 199.
5 27.III.48, Guest 1950: 207.
6 Diary VIII: 26, Guest 1950: 208–09.
7 RCHM 1970: 210. Mr. David Reeve of the Dorset
County Archives informs me that the plans are ref-
erence number D1/00 (personal communication,
letter of 17 May 1993).
8 14.IV.48, London, Diary VIII: 33; Guest 1950: 211.
9 17.VI.48, Guest 1950: 215.
10 23.II.49, Guest 1950: 225.
11 17–18.V.49, Guest 1950: 228.
12 Guest 1950: 230.
13 21—not 11—VII.50, Guest 1950: 246.
14 Guest 1950: 249.
15 There are numerous entries for Lady Charlotte
and Canford in Barry's engagement diaries for
1853–56 (Barry Diaries Nos. 24–27).
16 Glass doors: Barry to Holderness (clerk of
works at Canford), 29.XI.51, Westminster
(BaFam/1/6/6); gargoyles: John Thomas to Hold-
erness, 29.XI.51, London (BaFam/1/6/7); see also
John Thomas to Holderness, 24.XI.51, Westmin-
ster (BaFam/1/6/5), a brief note re the cost of
drawings(?).

17 Botta and Flandin 1849–50.
18 Quoted in Saggs 1969: 50.
19 Quoted in Saggs 1969: 50.
20 Bohrer 1989a: 464.
21 *Illustrated London News*, 26.VI.1847, 409–10;
Bohrer 1989a: 61–72.
22 A. H. Layard, *Athenaeum*, 1.II.1845, 120–21;
quoted in Bohrer 1989a: 46.
23 21.IV.46, Layard 1903: 166–67.
24 Rawlinson to Layard, 5.VIII.46, Add. MS. 38977;
quoted in Waterfield 1963: 147–48.
25 British Parliamentary Papers 1853b: 638–39.
26 The original report is in *Journal des débats*,
27.XII.1847. It was excerpted in English ("Mr.
Layard's Assyrian Discoveries," *Illustrated
London News*, 15.I.1848, p. 25) and German
("Layard's assyrische Ausgrabungen," *Archäolo-
gische Zeitung*, Neue Folge [= vol. 5], Beilage no.
4, December 1847, p. 55).
27 Smirke 1850: 160–61; Newton 1851: 206; both
cited in Jenkins 1992: 65–67.
28 Darwin's *Origin of Species* would not appear until
1859.
29 Larsen 1994: 179–82; Bohrer 1989a: 262–82;
Trigger 1989: 39–40, 71; Heine 1830: 452 (cited
in Larsen).
30 *Penny Magazine*, 5.VII.1845, 264; Bohrer 1989a:
47.
31 Layard 1849a, II, 307, 464.
32 31.XII.47, London, Add. MS. 38941.
33 Add. MS. 38976, 347, 358; quoted in Saggs 1969:
49.
34 10.XII.47, Leghorn, Add. MS. 38941.
35 Botta and Flandin 1849–50.
36 31.XII.47, London, Add. MS. 38941.
37 Layard to Ross, 19.V.48, Cheltenham, Add. MS.
38941: 29–30; original: Add. MS. 38978: 87–8.
Layard to Ross, 23.VII.48, Cheltenham, Add. MS.
38941.
38 28.XI.45, Add. MS. 40637: 8–9; quoted in Saggs
1969: 44.
39 Bohrer 1992: 88–93.
40 7.III.48, Canford, Add. MS. 38941: 25–27; orig.:
Add. MS. 38978: 51–2. This is a typed copy of
Layard's letter—I assume that the figure of £1000
here is a typographical error for £4000, the figure
cited by Bohrer.
41 15.II.48, London, Diary VII: 771.

42 12.XII.46, Guest 1950: 184.
43 2–5.III.48, Canford, Diary VII: 784–88.
44 Guest and John 1989: 9–10, 14.
45 19.IV.34, London, Guest 1950: 26.
46 3.IX.34, Dowlais, Guest 1950: 35.
47 5.III.48, Canford, Diary, VII, 788. 22.VIII.51, Dowlais, Diary, IX, 130–31. 15.XI.50, Dowlais, Diary, VIII, 754.
48 Guest and John 1989: 151.
49 7.III.48, Canford, Diary VII: 789.
50 8.III.48, Canford, Diary VIII: 1.
51 5.III.48, Canford, Diary VII: 788.
52 23.III.48, Canford, Diary VIII: 11; Guest 1950: 207. 13.XI.48, London, Diary VIII: 185.
53 25.III.48, London, Diary VIII: 12.
54 22.III.48, London, Diary VIII: 11.
55 4.III.48, Canford, Diary VII: 786.
56 26.IV.48, Canford, Diary VIII: 42.
57 26–27.IV.48, Canford, Diary VIII: 42.
58 Layard to Ross, 7.III.48, Canford; Add. MS. 38941: 26–27; the original is Add. MS. 38978: 51–52.
59 30.IV.48, Canford, Diary VIII: 43–44.
60 7.I.52, Canford, Diary IX: 255.
61 6.II.48, Canford, Diary VII: 766–67.
62 7.II.48, Canford, Diary VII: 767.
63 12.III.48, Canford, Diary VIII: 4.
64 5.V.48, Canford, Diary VIII: 47.
65 Bohrer 1989a: 130.
66 23.III.48, London, Diary VIII: 11.
67 Quoted in Bohrer 1992: 91.
68 7.IV.48, London, Diary VIII: 26; Guest 1950: 208–09.
69 14.IV.48, London, Diary VIII: 33; Guest 1950: 211.
70 Personal communication, letter of 29.III.94.
71 Add. MS. 39077, 33–34; Bohrer 1989a: 138.
72 15.VI.48, London, Diary VIII: 69.
73 24.IV.48, Canford, Diary VIII: 42; 10.VII.48, London, Diary VIII: 85; 12.X.48, Dowlais/ Llanover, Diary VIII: 161.
74 The text of the second version (Add. MS. 39077: 35–36) is identical to that of the first, but now the author is listed as *Austen Henry* Layard, in deference to his uncle Benjamin Austen, and in the first line is added: "Early in January will be Published, in One handsome Volume, Folio." The third version of the prospectus (Add. MS. 39077: 31–32) must be from a date only slightly later than the second, as it includes only five additional subscribers. It has the same text as the second, but set in a different type, and adds: "A Limited Edition only will be printed." It also adds quotes that refer to Layard's work from *Quarterly Review* 79, March 1847, pp. 445–49, (a journal published by Murray), and an "Extract from a Report read before the *Académie des Inscriptions et Belles Lettres*" (in French).
75 Layard to Ross, 23.VII.48, Cheltenham; Add. MS. 38941.
76 Layard to G. T. Clark, 5.II.49, Constantinople, Add. MS. 38946: 2r.
77 Bohrer 1989a: 215.
78 16.III.50, Mosul: Add. MS. 38946: 8r–10r.
79 Jones 1856: 31.

Chapter 3. Ninevite Marbles for Canford Manor

1 26.X.48, Canford, Diary VIII: 171.
2 11.X.49, Canford, Diary VIII: 415.
3 *Literary Gazette*, 24.I.1850; preserved in Lady Charlotte's newspaper clippings scrapbook, now in the possession of John S. Guest, to whom I am greatly indebted for sharing it with me. The records of the Harvard University Art Museums, which acquired the relief in 1940, indicate that it was sold to the London dealer Spink and Son, Ltd. by the ninth Earl of Bessborough, who said he inherited it from his grandmother, Lady Charlotte, to whom it had been given by Layard.
4 27.III.48, London; Add. MS. 38941: 27–29; the original is Add. MS. 38978: 61v–62r.
5 Layard 1849a, I: 329.
6 Layard 1849a, I: 342–43.
7 Layard 1849a, I: 136.
8 19.V.48, Cheltenham; Add. MS. 38941: 30r; the original is Add. MS. 38978: 87v.
9 Ross 1902: 151–52.
10 Gadd 1936: 64–65.
11 Gadd 1936: 56–57.
12 25.X.48, Canford, Diary VIII: 169–70.
13 26.X.48, Canford, Diary VIII: 171.
14 14.XI.48, London, Diary VIII: 185–87.
15 Waterfield 1963: 179–81.
16 6.II.48, Cheltenham; Add. MS. 38941.
17 According to Lady Charlotte's diary, Layard arrived at Canford on 2 March and departed 9 March, spent the remainder of March and the first part of April in London, and returned to Canford for a second visit from 22 April to 5 May.
18 Bohrer 1989a: 136–37; Layard to Ross, 27.III.48, London, Add. MS. 38941: 27–29; the original is Add. MS. 38978: 61–62.
19 Bohrer 1989a: 127–28, 137–38.
20 19 May 1848, Cheltenham; Add. MS. 38941: 29–30; the original is Add. MS. 38978: 87–88.
21 Layard to Ross, 23.VII.48, Cheltenham; Add. MS. 38941.
22 14.XI.48, London, Diary VIII: 187.
23 Layard to Ross, 3.XII.48, begun on board the *Tagus*; Add. MS. 38941.
24 Bohrer 1989a: 151, 212–14. Lady Charlotte: 4.II.49, Brighton, Diary VIII: 251. Benjamin Austen: Waterfield 1963: 191. *Times*, 9.II.1849, 5. Ellesmere: 8.II.49; Add. MS. 38978: 261–62; quoted in Bohrer 1989a: 216–17 and Waterfield 1963: 194. Norris: Bohrer 1989a: 218.
25 Bohrer 1989a: 151–229.
26 Bohrer 1989a: 243. Jenkins 1992: 153–66. Layard 1903: 191. *Illustrated London News*, 2.III.1850, 150–52; cited in Bohrer 1989a: 242. Waterfield 195.
27 Bohrer 1989a: 226–27.
28 Dioramas: Bohrer 1989a: 362–65; *Illustrated London News*, 20.XII.51, p. 734. Sardanapalus: Bohrer 1989a: 345–56. Nineveh Court: Bohrer 1989a: 422–43.
29 Layard to Clark, 5.II.49, Constantinople; Add. MS. 38946: 2r.
30 1.III.49, Dowlais, Diary VIII: 271; Brewster 1849.
31 16.III.50, Mosul; Add. MS. 38946: 8r.
32 22.III.50, Mosul; Layard 1903, vol. II: 191.

33 Bohrer 1989a: 225.
34 22.IX.51, London, Diary IX: 141.
35 Bohrer 1989a: 226–27. The series name appeared only on the outer cover.
36 18.VII.53, London; Add. MS. 38941.
37 10.X.51, Dowlais, Diary IX: 155; Guest 1950: 278.
38 23.XI.51, Dowlais, Diary IX: 219.
39 26.XII.51, Canford, Diary IX: 247–48.
40 Bohrer 1989a: 214.
41 12.XII.52; Add. MS. 38948: 6r. The books referred to are: "the new narrative" is Layard 1853a; "the new folio" is Layard 1853b; "the 2 vol 8vo." is Layard 1849a; "the abridgement" is Layard 1851b; "the old Monuments" is Layard 1849b.
42 Waterfield 1963: 191.
43 4.II.49, Brighton, Diary VIII: 251. 5.II.49, Brighton, Diary VIII: 252. 6.II.49, Brighton, Diary VIII: 255.
44 8.II.49; Add. MS. 38978: 261–62; quoted in Bohrer 1989a: 216–17 and Waterfield 1963: 194.
45 Waterfield 1963: 194.
46 4.I.48; Add. MS. 38977; Waterfield 1963: 181.
47 Waterfield 1963: 195.
48 30.III.49, London, Diary VIII: 295; Guest 1950: 227.
49 Waterfield 1963: 196.
50 Hunt 1905, I: 346.
51 Bohrer 1989a: 361–62.
52 Waterfield 1963: 196–97.
53 Add. MS. 39090C, entry for 30.IX.49; Layard 1853a: 97.
54 11.X.49, Canford, Diary VIII: 415.
55 17.X.49, Canford, Diary VIII: 418.
56 18.X.49, Canford, Diary VIII: 419.
57 19.X.49, Canford, Diary VIII: 420.
58 Literary Gazette, 24.I.1850; preserved in Lady Charlotte's newspaper clippings scrapbook.
59 19.X.49, Canford, Diary VIII: 420–21.
60 22.X.49, Canford, Diary VIII: 422.
61 Layard 1849a, II: 458–59.
62 27.X.49, Canford, Diary VIII: 424.
63 28.X.49, Canford, Diary VIII: 425.
64 31.X.49, Canford, Diary VIII: 426.
65 27.X.51, Canford, Diary IX: 182.
66 Layard 1849a, I, 65, 69–70, 127, II: 74–105. Both engravings were also reproduced in Monuments of Nineveh, pls. 3, 4.
67 Layard 1849a, I, xii.
68 Illustrated London News, 27.VII.1850, 70, 72; 5.X.1850, 271; 26.X.1850, 331–32; all cited in Bohrer 1989a: 244–57.
69 None of the Guest descendants I have contacted know the whereabouts of Layard's correspondence with Lady Charlotte.
70 17.VIII.49, Canford, Diary VIII: 383–84.
71 14.III.50, London, Diary VIII: 548.
72 12.XI.49, Nimrud; Add. MS. 38946: 5r.
73 16.III.50, Mosul; Add. MS. 38946: 9r–10r.
74 Layard to Clark, 24.V.50, Mosul; Add. MS. 38946: 12r.
75 Layard to Clark, 24.VI.50, Mosul; Add. MS. 38946: 13r.
76 11.VII.50, London, Diary VIII: 651.
77 10.I.51, Mosul; Add. MS. 38980: 2r.
78 21.II.51, Baghdad; Add. MS. 38946: 15r.
79 31.III.51, Nimrud; Add. MS. 38946: 17r.
80 Add. MS. 39089 E: 28v., 35v.
81 Add. MS. 39057: 6.
82 Add. MS. 39077: 161.
83 Gadd 1936: 41–42.
84 Gadd 1936: 126.
85 14.XII.50, London, Diary VIII: 781; Guest 1950: 252.
86 Waterfield 1963: 222.
87 Barnett 1976: 73; Gadd 1936: 95–97.
88 25.IV.51, Paris, Diary IX: 39; Guest 1950: 266. I have located no other reference specifically to this grant, but Rawlinson did secure Treasury approval for £500 in May to excavate Susa and £3000 in October for two more years of excavation in Assyria. Presumably Rawlinson told Lady Charlotte of the total amount the Trustees had resolved to request from the Treasury (Gadd 1936: 74; Barnett 1976: 8).
89 25.IV.51, Paris, Diary IX: 39; Guest 1950: 266.

Chapter 4. The Nineveh Porch

1 1.VII.51, London, Diary IX: 86; Guest 1950: 275.
2 Guest 1950: 270–71.
3 25.VII.51, London, Diary IX: 106, 109.
4 20.VIII.51, Dowlais, Diary IX: 122–23.
5 22.VIII.51, Dowlais, Diary IX: 130.
6 22.VIII.51, Dowlais, Diary IX: 130–31.
7 10.X.51, Dowlais, Diary IX: 156–57.
8 22.X.51, Canford, Diary IX: 174–75; Guest 1950: 279.
9 10.VII.51, London, Diary IX: 93–94.
10 Gadd 1936: 125.
11 8.IX.51, London, Diary IX: 131i.
12 Gadd 1936: 159–60.
13 24.III.52, London, Diary IX: 325–26.
14 16.VII.51, London, Diary IX: 96.
15 7.XI.51, Dowlais, Diary IX: 194–95.
16 9.XI.51, Dowlais, Diary IX: 196–97.
17 11.XI.51, Dowlais, Diary IX: 199. A few years later, in 1859, Vaughn himself suddenly resigned from his position as Headmaster of Harrow after his own conduct was severely criticised. For the details, see Phyllis Grosskurth, John Addington Symonds: A Biography, London: Longmans, 1964, pp. 25–41.
18 18.VIII.51, Dowlais, Diary IX: 119; Layard 1853a: 576. Quote from Layard 1903, I: 337–38.
19 25.X.51, Canford, Diary IX: 180–81.
20 18.IV.48, London, Diary VIII: 37.
21 12.XI.49; Add. MS. 38946: 7r.
22 Barry 1867: 25–42.
23 Waterfield 1963: 185, 360, 501. According to his son, Barry's design dates to 1842 (Barry 1867: 357).
24 27.X.51, Canford, Diary IX: 182–83; Guest 1950: 279–80.
25 Kingston Lacy now belongs to the National Trust. Bankes's obelisk and his collection of Egyptian antiquities are still there (Iversen 1972: 62–85; James 1994.).
26 27.X.51, Canford, Diary IX: 183–84.
27 Conner 1983, Mitter 1992.

28 27.X.51, Canford, Diary IX: 184–85.

29 27.X.51, Canford, Diary IX: 185.

30 28.X.51, Canford, Diary IX: 185–86.

31 12.IX.51; Add. MS. 38943: 44v.

32 Ellis to Layard, 23.IX.51; Add. MS. 38980: 123r. The dimensions of these 32 cases and the bill of freight that Layard had to pay to have them released to him were apparently included in Ellis's letter to Layard of 30.III.52 (Add. MS. 38980: 308r–308v).

33 Layard to Ellis, 23.III.52; Add. MS. 38943: 42v–43r.

34 Waterfield 1963: 232.

35 4.XI.51, London, Diary IX: 191–92.

36 MMA 32.143.13 may derive from a series of slabs that lined a passageway between Sennacherib's palace and the Ishtar temple. This series, however, was excavated by Hormuzd Rassam in 1853, over two years after Layard left Nineveh (Russell 1991: 40). Perhaps this slab was displaced in antiquity, or belonged to a different relief series, or was sent to Canford by Rassam (see Appendix 3, No. 18).

37 31.XII.51, Canford, Diary IX: 249.

38 1.I.52, Canford, Diary IX: 251.

39 Gadd 1938.

40 4.XI.51, London, Diary IX: 191.

41 5.I.52, Canford, Diary IX: 252–53.

42 7.I.52, Canford, Diary IX: 255.

43 Singer 1922, Ames 1968, Hobhouse 1983, Millar 1986, Staley 1995: 25–26. According to Ames 1968: 111, 119, Gruner's correspondence has not been located, so any account of his career must be pieced together from other sources.

44 Gruner 1846: 4. The painters of the eight lunettes were William Dyce, Charles Eastlake, Edwin Landseer, Charles Leslie, Daniel Maclise, Sir William Ross, Clarkson Stanfield, and Thomas Uwins.

45 He was paid £74 in 1843–44 and about £70 in 1844–45; British Parliamentary Papers 1844: 45, 1845: 38.

46 £321 in 1842–43, £485 in 1843–44, £411 in 1844–45, British Parliamentary Papers 1843: 15, 1844: 44, 1845: 38.

47 British Parliamentary Papers 1846: 10, 34–35; 1849: 32–33.

48 British Parliamentary Papers 1844: 22.

49 British Parliamentary Papers 1846: 10.

50 British Parliamentary Papers 1849: 379, 401.

51 British Parliamentary Papers 1849: 134.

52 British Parliamentary Papers 1849: 147–48, 401–02.

53 British Parliamentary Papers 1847: 141, 1849: 149, 154.

54 British Parliamentary Papers 1849: 192.

55 British Parliamentary Papers 1849: 200.

56 British Parliamentary Papers 1853a: 372.

57 Layard 1849b: pls. 84, 85, and 92–94 are all signed by Gruner. The unsigned color plates are nos. 1, 2, 86, and 87.

58 Personal communications, letters of 29.III.94 and 19.VI.94.

59 25.X.51, Canford, Diary IX: 180–81.

60 5.I.52, Canford, Diary IX: 252–53.

61 22.V.52, London, Diary IX: 364.

62 Layard 1853b: vi. Gruner was apparently responsible for pls. 1–62 and 70.

63 26.I.52, Canford, Diary IX: 269. I do not know what this was or if it was ever completed.

64 5.II.52, Canford, Diary IX: 279–80.

65 24.II.52, London, Diary IX: 298. 25.II.52, London, Diary IX: 300; Guest 1950: 293. 24.III.52, London, Diary IX: 325.

66 19.V.52, London, Diary IX: 359.

67 It ran from 26 December 1851 to 25 June 1853 (Times, 26.XII.51, p. 1; Wilcox 1976: Appendix C). A copy of the printed guide to the Nimrud panorama may be in the library of the Museum of London (Altick 1978: 140). The panorama in question is less likely to be the moving Diorama of Nineveh painted by Layard's former artist F. C. Cooper, which opened in May 1851, even before Layard returned from Nineveh, and seems to have been an unauthorized exploitation of Layard's research (Bohrer 1989a: 362–65). The Cooper diorama reopened in December 1851, apparently to take advantage of the opening of Burford's panorama (Times, 18.XII.51, p. 1).

68 Illustrated London News, 20.XII.51, p. 734.

69 Bohrer 1989a: 359.

70 30.III.52, London, Diary IX: 331–32.

71 Layard 1853a: 130–32.

72 Gadd 1936: 76–77.

73 7.IV.52, London, Diary IX: 339.

74 2.III.52, London, Diary IX: 304. Illustrated London News, 28.II.52, p. 184.

75 26.III.52, Canford, Diary IX: 329.

76 9.VI.52, Canford, Diary IX: 373–74.

77 14.VI.52, London, Diary IX: 377.

78 22.VII.52, Canford, Diary IX: 404.

79 25.VII.52, Canford, Diary IX: 405–06.

80 21.VII.52, Canford, Diary IX: 404.

81 23.VII.52, Canford, Diary IX: 404–05.

82 24.VII.52, Canford, Diary IX: 405.

83 27.VII.52, Canford, Diary IX: 406.

84 28.VII.52, Canford, Diary IX: 406.

85 29.VII.52, Canford, Diary IX: 407.

86 14.VIII.52, Canford, Diary IX: 412.

87 15.VIII.52, Canford, Diary IX: 413.

88 16.VIII.52, Canford, Diary IX: 413.

89 5.XI.52, Mosul; Add. MS. 38981: 141v.

90 17.VIII.52, Canford, Diary IX: 414. 19.VIII.52, Canford, Diary IX: 415. 8.IX.52, Canford, Diary IX: 424.

91 23.X.52, Dowlais, Diary IX: 452–53.

92 17.XI.52, Dowlais, Diary IX: 476.

Chapter 5. The Nineveh Porch Described

1 The roof was repaired in 1990. The school Bursar, Michael Chamberlain, reports that there was difficulty in matching the slates: "The main building of Canford was originally covered in Delabole Green slates but the first load of Welsh Green slates which had been agreed with English Heritage were found to be absorbent with a tendency to become soft and break up. . . . Our solution was then to rob the [green slates from the] roof of the nearby Beaufort and Monteacute Houses which were then, in turn, re-slated in Welsh Grey slates" (personal communication, letter from Chamberlain to McKenzie, 27.IV.94).

2 The porch was glazed in 1984 with large sheets of

plate glass from Pilkingtons (personal communication, letter from Chamberlain to McKenzie, 27.IV.94).

3 Layard 1849b, pls. 44, 45, 46, and 86 show similar figures.

4 Similar winged disks from garment decorations are shown in Layard 1849b, pls. 6 (see Figure 80) and 39.

5 Layard 1853a: 445; King 1915.

6 Phoebe Stanton writes: "In October, 1849, and in 1850, according to letters to Hardman, Charles Barry was employing [the architect A. W. N.] Pugin and Hardman to prepare a number of heraldic stained glass windows and decorative ironwork for the entrance door and the staircase at Canford. The Hardman correspondence indicates that the work continued through 1850, when there are further letter references to designs on which J. H. Powell was working, and to fabrication of the doors, glass and a lamp for the house. In 1851 the orders for metalwork from Hardman include four for "hardware" for Canford (personal communication, letter of 10.III.94).

7 McKenzie reports: "The stained glass windows are in excellent condition, which is surprising in a building not far from school playing fields. The present bursar can find no record of them having been repaired in the recent past" (personal communication, letter of 14.VI.94).

8 McKenzie observes that this palmette and bud pattern is also "very clear on the outside of the building, where one sees it traced out by the leading" (personal communication, letter of 14.VI.94).

9 Brisac 1986: 50.

10 Brisac 1986: 54.

11 RCHM 1970: 212.

12 McKenzie observes: "The timber ceiling is in remarkably good condition with the original paint work showing no sign of lifting. There has been a small amount of water damage in a few places" (personal communication, letter of 14.VI.94).

13 RCHM 1970: 212. I am very grateful to Mr. Robin Whicker for photographs of the floor of the entrance porch.

14 Morrison 1993.

15 Dikran Kelekian to George Byron Gordon, 17.X.24; UM.

Chapter 6. Nineveh on the Stour

1 8.IV.53, Canford, Diary IX: 591.

2 26.VII.53, Cardiff, Diary IX: 769.

3 28.VIII.53, Canford, Diary IX: 811. 26.X.53, Orton, Diary X: 54.

4 Schreiber 1952: 18.

5 1.VIII.53, Canford, Diary IX: 776.

6 7.VIII.53, Canford, Diary IX: 782.

7 10.I.54, Canford, Diary X: 135.

8 11.I.54, Canford, Diary X: 135–37.

9 10.II.54, Dowlais, Diary X: 164. 11.II.54, Dowlais, Diary X: 165. The Layard box is now in the British Museum (Rudoe 1987: 224, figs. 24–28; Rudoe 1991: 57–59, pl. 15–16).

10 22.IV.54, Canford, Diary X: 247–48.

11 11.IV.53, Canford, Diary IX: 593. 8.IX.53, Canford, Diary X: 5–6. 10.IX.53, Canford, Diary X: 8.

12 27.XII.53, Canford, Diary X: 118. 28.XII.53, Canford, Diary X: 119. 30.XII.53, Canford, Diary X: 122.

13 22.IV.54, Canford, Diary X: 248. 12.VII.54, Canford, Diary X: 334.

14 26.III.53, Canford, Diary IX: 581.

15 28.IV.53, London, Diary IX: 607.

16 Barry to Holderness, 18.V.53, Westminster; BaFam/1/6/9.

17 28.VII.53, Canford, Diary IX: 772.

18 1.VIII.53, Canford, Diary IX: 774–75.

19 25.IX.53, Dowlais, Diary X: 23. 29.IX.53, London, Diary X: 26.

20 18.IV.54, Canford, Diary X: 241.

21 1.V.54, Canford, Diary X: 260. 24.VI.54, Canford, Diary X: 318.

22 8.VII.54, Canford, Diary X: 331.

23 11.III.54, London, Diary X: 203–04.

24 Bohrer 1989a: 422–43.

25 Fergusson 1851; Layard 1854.

26 12.IV.54, Canford, Diary X: 235.

27 Personal communication, letter of 14.VI.94.

28 1.VI.54, Barry Diary no. 25.

29 Gadd 1936: 119.

30 8.V.56, London, Diary XI: 92; Schreiber 1952: 55–56.

31 3.IV.56, Canford, Diary XI: 63.

32 28.VIII.56, Canford, Diary XI: 151–52.

33 29.VIII.56, Canford, Diary XI: 157.

34 Schreiber 1952: 62–63.

35 Hinsley 1989: 87–88.

36 Rossetti 1850.

37 Another set of "Canning Marbles," the frieze from the Mausoleum of Halicarnassus, arrived at the British Museum a few months before Layard's first shipment (Jenkins 1992: 168–70).

38 Jenkins 1992: 65–70.

39 Dikran Kelekian to George Byron Gordon, 17.X.24; UM.

40 15.IX.57, Canford, Diary XI: 334. 9.VIII.59, Canford, Diary XI: 294.

41 Add. MS. 46158: 5v–7r.

42 Waterfield 1963: 451.

43 Murray 1856: 88.

44 Pouncy 1857, II, first illustration.

45 Layard was revising the Murray *Handbook on Spain* at about this time (Waterfield 1963: 322).

46 Murray 1882: 186.

47 Murray 1899.

48 Worth 1882: 35.

49 Heath and Prideaux 1907: 49.

50 Budge 1920, I: 123–28, 341–42 and passim.

51 Layard to Gregory, 8.XII.88, Venice; Add. MS. 38950; quoted in Waterfield 1963: 478.

52 Waterfield 1963: 478–79, 507.

53 *Nature*, 10.VIII.93, p. 343; quoted in Budge 1920, II: 307–08.

54 Rassam 1893a; quoted in Budge 1920, II: 314.

55 *Nature*, 21.IX.93, p. 509; quoted in Budge 1920, II: 316.

56 26.IX.93, Blackmoor; Add. MS. 39097: 21.

57 Rassam 1893b; quoted in Budge 1920, II: 317.

58 *Nature*, 5.X.93, p. 540; quoted in Budge 1920, II: 318.
59 11.X.93, London; Add. MS. 39097: 22–23.
60 *Nature*, 19.X.93, p. 596.
61 Petrie 1893.

Chapter 7. *The Sculptures Come to America*

1 Barry 1867: 340–41.
2 Charles Dikran Kelekian, the son of Dikran G. Kelekian (see below) recalled that the sculptures were sold to raise money for estate taxes (Seggerman 1981). I am very grateful to Nanette Kelekian for this reference.
3 Memo of conversation between Robinson and Rockefeller, 11.IV.28; MMA-CA.
4 Thomas Appleget to Rockefeller, 28.III.28; RAC, Educ.
5 19.XII.27; UM.
6 Though the McHugh letter suggests that the sculptures were sold in 1920, Kelekian later gave the date as 1919 (Kelekian 1939: 153) and this is also the date given by the Metropolitan Museum director, H. E. Winlock (1933: 21–22).
7 MMA-ANE.
8 26.III.20; MMA-ANE.
9 The cost of landing the 35 cases from the S. S. *Lake Frugality* and moving them into the Manhattan Storage Warehouse was $536.25 (invoice, B. Keenan & Son, "Truckmen, Riggers, Forwarders," to Bane and Ward, 15.IV.20; MMA-ANE).
10 6.IV.20; MMA-ANE. Kelekian gave this same figure as the invoice value of the sculptures for insurance purposes (Johnson and Higgins, Insurance Brokers, to H. Kelekian, 7.X.20, New York; MMA-ANE). I am assuming here that for shipping and insurance, Kelekian valued the sculptures at the actual price he paid. He could, of course, have paid more, but only insured the collection for the amount he borrowed.
11 22.XII.24; MMA-ANE.
12 18.XI.20; MMA-ANE.
13 22.XI.20; MMA-ANE.
14 D. G. Kelekian to Breasted, 26.XI.20; MMA-ANE.
15 Breasted to D. G. Kelekian, 1.XII.20; MMA-ANE.
16 D. G. Kelekian to Breasted, 4.XII.20; MMA-ANE.
17 Breasted to D. G. Kelekian, 11.XII.20; MMA-ANE.
18 14.XII.20; MMA-ANE.
19 Breasted to D. G. Kelekian, 21.XII.20; MMA-ANE.
20 15.XII.20; UM.
21 D. G. Kelekian to Gordon, 17.XII.20; UM.
22 20.I.21; UM.
23 1.XI.21; MMA-ANE. This letter exists in the Kelekian file in both an apparent original and a carbon copy—it may never have been mailed.
24 12.XI.21; MMA-ANE.
25 Forbes to D. G. Kelekian, 16.XI.21; MMA-ANE.
26 17.XI.21; MMA-ANE.
27 29.XI.21; MMA-ANE.
28 29.XI.21; MMA-ANE.
29 5.XII.21; RAC, Homes. A draft of this letter is in the Kelekian file in MMA-ANE. The architect

Welles Bosworth was one of Rockefeller's advisors on art.
30 8.XII.21; RAC, Homes.
31 29.XII.21, copy; RAC, Homes.
32 18.I.22; MMA-ANE.
33 16.II.23; MMA-ANE.
34 MMA-ANE; Bleibtreu 1990.
35 16.V.23; MMA-ANE.
36 2.VI.23; MMA-ANE.
37 13.X.24; MMA-ANE.
38 15.X.24; MMA-ANE.
39 Seligmann & Co. to D. G. Kelekian, 8.X.23; MMA-ANE.
40 23.X.23; MMA-ANE.
41 D. G. Kelekian to Fraser, 4.IV.24; MMA-ANE.

Chapter 8. *Nineveh on the Delaware*

1 22.XII.23; UM.
2 D. G. Kelekian to Gordon, 5.II.24; UM.
3 [H. G. Kelekian] to Gordon, 11.VI.24; UM. Hovannes Garabed Kelekian sometimes signed his letters with his brother Dikran's name and sometimes with his own, but in both cases his handwriting is unmistakable.
4 16.VI.24; UM.
5 Gordon to D. G. Kelekian, 19.VI.24; UM.
6 20.VI.24; UM.
7 [H. G. Kelekian] to Gordon, 23.VI.24; UM. The invoices for expenses incurred in moving the sculptures to Philadelphia show that the cost of re-crating the 35 cases of sculpture in the warehouse and blocking them in the railroad cars was $145.00, moving them from the Manhattan Storage Warehouse to Pennsylvania Station and loading them on two train cars was $300.00, and the freight charges from Pennsylvania Station to 30th and Market Streets, Philadelphia, was $140.40 (invoice: P. Brady & Son Co., Trucking and Storage, to D. G. Kelekian, 24.VI.24; MMA-ANE).
8 30.VI.24; UM.
9 McHugh to John D. Rockefeller, Jr., 19.XII.27; UM.
10 H. G. Kelekian to Gordon, 3.VII.24; UM.
11 30.VI.24; UM.
12 17.VII.24; UM.
13 24.VI.24; UM.
14 30.VI.24; UM.
15 H. G. Kelekian to Gordon, 3.VII.24; UM.
16 3.X.24; UM.
17 17.X.24; UM.
18 19.XI.24; UM.
19 H. G. Kelekian to Gordon, 1.XII.24; UM.
20 H. G. Kelekian to Gordon, 5.III.25; UM.
21 19.V.26; UM.
22 1.VI.26; UM.
23 12.VI.26; UM.
24 27.XI.26; UM.
25 Gordon to D. G. Kelekian, 7.XII.26; UM.
26 31.I.27; UM.
27 17.II.27; UM.
28 Keating to McHugh, 18.II.27; UM.
29 D. G. Kelekian to the University Museum Trustees, 10.VIII.27; UM.
30 19.XII.27; UM.

31 6.IX.27; UM.
32 26.X.27; UM.
33 McHugh to John D. Rockefeller, Jr., 19.XII.27; UM.
34 7.XII.27; RAC, Educ.
35 Kelekian 1939: 153.
36 10.XII.27; RAC, Educ.
37 10.XII.27; UM.
38 D. G. Kelekian to McHugh, 10.XII.27; UM.
39 14.XII.27; UM.
40 McHugh to Rockefeller, Philadelphia, 19.XII.27; RAC, Educ.
41 McHugh to D. G. Kelekian, 19.XII.27; UM.
42 24.XII.27; UM.
43 23.XII.27, copy; RAC, Educ.
44 24.XII.27; RAC, Educ.
45 27.XII.27, copy; RAC, Educ.
46 28.XII.27; RAC, Educ.
47 12.I.28; RAC, Educ.
48 Appleget to Rockefeller, 23.I.28; RAC, Educ.
49 McHugh to Appleget, 24.I.28; RAC, Educ.
50 Appleget to Rockefeller, 23.I.28; RAC, Educ.
51 26.I.28, copy; RAC, Homes.
52 28.I.28; RAC, Homes.
53 30.I.28, copy; RAC, Homes.
54 30.I.28; RAC, Educ.
55 31.I.28, copy; RAC, Homes.
56 3.II.28, copy, RAC, Homes.
57 3.II.28; RAC, Homes. The set of photographs is in the Rockefeller Archive Center (Family Photos, 1005 JDR, Jr., Philanthropies, U. of Chicago)
58 8.II.28; RAC, Homes.
59 1.II.28, copy; RAC, Educ.
60 McHugh to Appleget, 2.II.28; RAC, Educ.
61 [Appleget] to Rockefeller, 3.II.28 copy, RAC, Educ.
62 Appleget to McHugh, 21.II.28, copy; RAC, Educ.

Chapter 9. Nineveh on the Hudson

1 13.XII.27; OI.
2 Aboard S. S. *Conte Rosso*, 14.XII.27; RAC, Educ.
3 Breasted 1933: 28, 35, 72, 75, 81, 107–08; Fosdick 1956: 357–60; Harr and Johnson 1988: 171–72.
4 19.XII.27; RAC, Educ. For Rockefeller's Christian background, see Schenkel 1995.
5 Breasted 1933: 1–2.
6 Rockefeller to Breasted, 1.III.28; OI.
7 18.XII.27; Rockefeller Archive Center; Rockefeller Family Archives; Record Group 2, OMR; Abby Aldrich Rockefeller Papers; Series I: Abby Aldrich Rockefeller Correspondence; Box 2; Folder 23: "Breasted."
8 12.II.28, copy; OI.
9 Breasted to Rockefeller, 29.V.28; OI.
10 Memorandum of 25.VI.28; RAC, Educ., Box 112, file: "Re. Proposed Contract with Iraq."
11 Fosdick 1956: 360–63.
12 Memorandum of 4.XII.28; RAC, Educ., Box 112, file: "Pledge Dec. 4, 1928, Work in Assyria."
13 28.III.28; RAC, Educ. There is an earlier version of this letter, dated 23 March, in the form of a memorandum from Appleget to Colonel Woods. Woods noted: "Very much to the point. I think you had better take it up with Mr. R." (RAC,

Educ.).
14 26.III.28; RAC, Educ.
15 Rockefeller to George D. Pratt, New York, 27.III.28; RAC, Educ.
16 11.IV.28; MMA-CA.
17 9.V.28; RAC, Cult.
18 11.V.28; MMA-CA.
19 Howe 1946: 40. I have not been able to locate these plans at the Metropolitan Museum.
20 17.XII.29; RAC, Cult.
21 Rockefeller to Macy, 20.XII.29; MMA-CA.
22 Macy to Rockefeller, 27.XII.29; RAC, Cult.
23 20.XII.29, copy; RAC, Cult.
24 26.XII.29; RAC, Educ.
25 Breasted, memorandum "to the files," 17.I.30; OI.
26 13.I.30, copy; RAC, Cult. The twelve reliefs in the New York Historical Society were loaned to the Brooklyn Museum in 1936 and purchased by that museum in 1955. Amherst, Bowdoin, Dartmouth, and Williams still own their slabs.
27 16.I.30; MMA-CA.
28 Memo to Rockefeller, Jr. from Rockefeller, 3rd, 21.I.30; RAC, Cult.
29 27.I.30, copy; RAC, Cult.
30 3.II.30; MMA-CA.
31 4.II.30; RAC, Cult.
32 13.II.30, copy; MMA-CA.
33 14.II.30; MMA-CA.
34 Rockefeller to de Forest, 27.I.30 and 17.II.30; MMA-CA.
35 Extract from Trustees' minutes, 17.II.30; MMA-CA.
36 20.II.30; RAC, Cult.
37 Memo, Clifford to Kent, 17.II.30, MMA-CA.
38 20.II.30; RAC, Cult.
39 Adams to Robinson, 25.II.30; MMA-CA.
40 1.III.30; MMA-CA.
41 Rockefeller to McHugh, 1.V.30; MMA-CA.
42 5.V.30; MMA-CA.
43 Robinson to McHugh, 6.V.30; MMA-CA.
44 19.IX.30, copy; MMA-CA.
45 Extract of letter of 1.X.30; RAC, Cult.
46 7.III.32; MMA-CA.
47 21.III.32; MMA-CA.
48 9.III.32, MMA-CA.
49 Winlock to Jayne, 14.III.32; MMA-CA.
50 Jayne to Winlock, 17.III.32; MMA-CA.
51 Winlock to Jayne, 18.III.32; MMA-CA.
52 Winlock to Frank M. Foster, Assistant Treasurer, Metropolitan Museum, 28.X.32; MMA-CA.
53 15.III.32; MMA-CA.
54 22.IX.32; MMA-CA.
55 Jayne to Winlock, 24.IX.32; MMA-CA.
56 21.X.32; MMA-CA.
57 Davidson to Kent, 13.XII.32; MMA-CA.
58 Memo, Davidson to Miss Zuckerman, 8.II.33; MMA-CA.
59 11.I.33, MMA-CA.
60 27.II.33; MMA-CA.
61 Adams to Winlock, 1.III.33; MMA-CA.
62 Winlock 1933: 18.
63 Winlock 1933: 21.
64 21.IV.60; MMA-CA.
65 Brackman 1978: 337.

Chapter 10. Canford School

1 Rathbone 1983: 1–2.
2 Rathbone 1983: 3.
3 Rathbone 1983: 5.
4 Rathbone 1983: 6.
5 Rathbone 1983: 9.
6 Rathbone 1983: 14.
7 Rathbone 1983: 9.
8 *Illustrated London News*, 7.XI.59, p. 601.
9 Barnett 1960: 198.
10 Barnett to Hardie, 21.VI.58, CS-HF; Hughes to Mr. Bateman, 23.I.59, CS-HF.
11 Hughes to Hardy, 1.VII.58, CS-HF.
12 Hughes to Hardie, 5.I.59; CS-HF.
13 CS-GM 26.X.56.
14 Hughes to Hardie, 1.VII.58; CS-HF.
15 26.V.58; CS-HF. The drawings were located in 1963 by Julian Reade in the library of the Royal Asiatic Society (Reade 1964).
16 Barnett to Hughes, 24.VI.58; CS-HF.
17 Barnett to Hughes, 8.XI.58; CS-HF. These photographs may have been acquired by L. W. King at the time of his visit. Their present whereabouts are unknown (Julian Reade to John Russell, personal communication, letter of 12.VII.94).
18 4.XII.59; CS-HF. The building is often referred to today as "Nineveh Court," presumably due to confusion with the Nineveh Court in the Sydenham Crystal Palace. Lady Charlotte always referred to it as the Nineveh Porch, however, and this book does likewise.
19 Hughes to Hardie, 7.I.59; CS-HF. The school still possesses ten soapstone carvings that reproduce illustrations in *Nineveh and Its Remains*, made by Layard's cousin, C. M. Somes (personal communication, Chamberlain to McKenzie, 17.IV.96).
20 1.VII.58; CS-HF.
21 Hughes to Hardie, 28.X.58; CS-HF.
22 Hughes to Hardie, 7.I.59; CS-HF.
23 Hughes to Bateman, 23.I.59; CS-HF.
24 6.II.59; CS-GM.
25 23.VI.59; CS-GM.
26 30.X.59; CS-GM.
27 A. Hobson to Hardie, 26.XI.59; CS-HF.
28 *Times*, 22.X.59: 16; *Illustrated London News*, 7.XI.1959: 601.
29 Sotheby 1959, pp. 12–14, lots 53–59. The individual prices were:

Figure 52 (lot 53) £4000 to Hewett
Figure 53 (lot 54) £4400 to Eisemann
Figure 37 (lot 55) £850 to the Ashmolean
Figure 33 (lot 56) £800 to Hewett
Figure 51 (lot 57) £1700 to Bluett
Figure 13 (lot 58) £1600 to Spink
Figure 34 (lot 59) £900 to Adams

(source: Sotheby list of prices and buyers for sale of 16 November 1959). The sale of Lot 54 was later voided and the piece was purchased by the British Museum for £4650. Lot 59 was bought in by Adams, the school's agent in London, as it did not reach its reserve. Hewett's then offered £650, which the school decided to accept. The actual total realized by the sale was therefore apparently £14,250 before expenses.

30 Smith 1960: 53, fig. 5.
31 Hamilton to Hardie, 18.XI.59, CS-HF.
32 Adams to Hardie, 4.XII.59; CS-HF.
33 Russell 1991: 283 for references.
34 16.II.60; CS-GM.
35 Minutes of Central Committee affecting Canford School, 12.VII.60.
36 Adams to Hardie, 4.XII.59, CS-HF; 16.II.60, CS-GM.
37 Adams to Hughes, 24.XI.59; CS-HF.
38 DuCane to Hardie, 19.XI.59; CS-HF. Weidner 1959–60: 192; Reade 1972: 110.
39 28.XI.59; CS-HF.
40 Hardie to Adams, 28.XI.59; CS-HF.
41 *Canfordonian* 1959: 7. We are very grateful to Mr. Robin Whicker, Canford School Archivist, for the copy of this article.
42 *Canfordonian* 1959: 7.
43 *Canfordonian* 1959: 8.
44 *Canfordonian* 1959: 8.
45 *Canfordonian* 1959: 8.
46 Room B, Slab 20, WA 124532.
47 Russell to Marriott, 7.V.92; CS-HF.
48 Reade to Marriott, 28.V.92, CS-HF.
49 Morrison 1993.
50 Morrison 1993.
51 Morrison 1993; personal communication, Chamberlain to McKenzie, letter of 27.IV.94.
52 Personal communication, Chamberlain to McKenzie, letter of 18.I.94.
53 Personal communication, Chamberlain to McKenzie, letter of 27.IV.94.
54 Quoted in Waterfield 1963: 182.
55 Opitz 1930–31: 299.
56 Personal communication, Russell to McKenzie, letter of 7.III.94.
57 See Appendix 4.
58 An example of this is the relief in the Nicholson Museum of Sydney University (acc. 51.323; h: 0.67m), which depicts two archers facing right against a plain background above a stream, apparently from Sennacherib's palace. Its existence is unknown to northern hemisphere scholarship, as it has remained both unpublished and unrecorded—not even being in the British Museum Sennacherib catalogue now in preparation (personal communication, Russell to McKenzie, letter of 7.III.94). The fragment is similar to Weidner 1939, fig. 63.

Chapter 11. Nineveh on the Kamo-Gawa

1 Green 1994a; Christie's 1994.
2 John Shaw, "School tuck shop dishes up a £1m antiquity." *Times*, 6.VI.94; "Tuck shop turns up £1m treasure." *Daily Telegraph*, 6.VI.94, p. 1.
3 John Shaw and Dominic Kennedy, "Tuck shop antiquity earns school £7m in three-minute sale." *Times*, 7.VII.94, p. 3; Jenny Rees, "School's tuck shop antiquity sells for £7m." *Daily Telegraph*, 7.VII.94, p. 3.
4 Owen Bowcott, "School's forgotten relic fetches £7.7m." *Guardian*, 7.VII.94, p. 28.
5 Geraldine Norman and Will Bennett, "Assyrian carving from the tuck shop raises £7.7m." *Inde-

pendent, 7.VII.94, p. 1; Will Bennett, "School carves out a piece of saleroom history." *Independent*, 7.VII.94, p. 3.

6 Andrew Pierce, "Iraq lays claim to £7m school carving." *Times*, 8.VII.94, p. 3.

7 Personal communication, conversation on 26.IX.94.

8 Carol Vogel, "Out of the Dust Cover." *New York Times*, 8.VII.94, p. C26.

9 Meuszynski 1981: 29; Layard 1849a, I: 384.

10 Dominic Kennedy, "Ancient document refutes Iraqi claim." *Times*, 9.VII.94, p. 2. With the money raised from the sale, the School was able to pay for the Sports Hall, the New Girls' House, the Wren Building (for the groundskeepers, golf club and changing rooms), a scholarship fund, and the Canford Partnership Fund (to involve pupils in charitable works at home and abroad). It will also partially fund a theatre (personal communication, Chamberlain to McKenzie, 26.II.96).

11 Carol Vogel, "Iraq Claims Bas Relief." *New York Times*, 15.VII.94.

12 Merryman 1987.

13 Peter Brookes, "Anointing a royal eunuch."

Times, 8.VII.94, p. 18.

14 Libby Purves, "Even Ozymandias would despair." *Times*, 8.VII.94, p. 16.

15 Green 1994b: 214.

Epilogue

1 Rossetti 1850: 27–28.

Appendix 3. Cuneiform Texts

1 Layard, 1851, pl. 83: A: 1: É.GAL ᵐ<AŠ>-PAP-A MAN KUR AŠ.

2 Layard 1849a, II: 196.

3 Layard 1849a, II: 192–96.

4 Layard 1851a, pl. 2.

Appendix 6. The Inscription on the Canford Assurnasirpal Sculpture Sold at Christie's

1 Cavigneaux and Ismail 1990.

BIBLIOGRAPHY

Abbreviations

Add. MS.	Additional Manuscripts, Department of Manuscripts, British Library, London
BaFam	Barry family papers, Royal Institute of British Architects Library, London
Barry diary	Pocket diaries of Charles Barry, Royal Institute of British Architects Drawings Collection, London
CAD	*The Assyrian Dictionary of the Oriental Institute of the University of Chicago*, 1956–89
CS-GM	Minutes of Governors' Meetings, Canford School, Dorset
CS-HF	Headmaster's file on Assyrian reliefs (1959 and 1994 sales), Canford School, Dorset
Diary	The Diaries of Lady Charlotte Bertie (later Lady Charlotte Guest and Lady Charlotte Schreiber), 1822–91, Wimborne family archive
MMA-ANE	Departmental archives, Department of Ancient Near Eastern Art, Metropolitan Museum of Art, New York
MMA-CA	Central archives, Metropolitan Museum of Art, New York
OI	Central archives, Oriental Institute, University of Chicago. J. H. Breasted—John D. Rockefeller, Jr. correspondence
RAC, Cult.	Rockefeller Archive Center. Family Archives. Series: Cultural Interests
RAC, Educ.	Rockefeller Archive Center. Family Archives. Series: Educational Interests
RAC, Homes	Rockefeller Archive Center. Family Archives. Series: Homes
UM	Central archives, University Museum, Philadelphia

Manuscript Sources

Barry family papers. Royal Institute of British Architects Library, London.

Barry, Charles. Pocket diaries, 1853–56. Royal Institute of British Architects Drawings Collection, London.

Canford School, Dorset. Minutes of Governors' Meetings.

—— Headmaster's file on Assyrian reliefs (1959 and 1994 sales).

Chicago. University. Oriental Institute. Central archives. J. H. Breasted—John D. Rockefeller, Jr. correspondence.

Guest (later Schreiber), Lady Charlotte. Diaries, 1822–91 typed copy (17 vols.). Wimborne family archive (private). Original manuscript: National Library of Wales, Aberystwith.

Layard, Austen Henry. Papers (240 vols.). Department of Manuscripts, British Library, London.

Metropolitan Museum of Art, New York. Central archives, file R 5891, labeled

"Rockefeller, John D. Jr., Gift 1930–1931—Assyrian Sculpture—Correspondence."

—— Departmental archives, Department of Ancient Near Eastern Art.

Morrison, Lynn. Conservation report, stone bas relief panel from Nineveh, 1.XI.93. Canford School, Dorset.

Pennsylvania. University Museum, Philadelphia. Central archives.

Rockefeller Archive Center, North Tarrytown, New York. Rockefeller Family Archives. Record Group 2, OMR. Series: Educational Interests. Box 117: "University of Pennsylvania." Folder: "Gift of Assyrian bas-reliefs."

—— Series: Homes. Box 136. Folder 1360: "Kelekian correspondence."

—— Record Group III 2E. Series: Cultural Interests. Box 28. Folder 281: "Metropolitan Museum of Art—Gift of Assyrian Sculpture."

Printed Sources

ALTICK, RICHARD D. (1978) *The Shows of London*. Cambridge, MA: Harvard University Press.

AMES, WINSLOW (1968) *Prince Albert and Victorian Taste*. New York: Viking.

BARNETT, RICHARD D. (1960) "Canford and Cuneiform: a Century of Assyriology." *Museums Journal* 60: 192–200.

—— (1962–3) "A Review of Acquisitions 1955–62 of Western Asiatic Antiquities (I)." *British Museum Quarterly* 26: 92–100.

—— (1976) *Sculptures from the North Palace of Ashurbanipal at Nineveh*. London: British Museum Publications.

BARRY, ALFRED (1867) *The Life and Works of Sir Charles Barry, R.A., F.R.S., &c. &c.* London: John Murray.

BLEIBTREU, ERIKA (1990) "Pair of gypseous alabaster wall reliefs." In *Glories of the Past: Ancient Art from the Shelby White and Leon Levy Collection*, ed. Dietrich Von Bothmer, pp. 36–37. New York: Metropolitan Museum of Art.

BOHRER, FREDERICK N. (1989a) "A New Antiquity: The English Reception of Assyria." Ph.D. dissertation, University of Chicago.

—— (1989b) "Assyria as Art: A Perspective on the Early Reception of Ancient Near Eastern Artifacts." *Culture and History* 4: 7–33.

—— (1992) "The Printed Orient: The Production of A. H. Layard's Earliest Works." *Culture and History* 11: 85–105.

—— (1994) "The Times and Spaces of History: Representation, Assyria, and the British Museum." In *Museum Culture: Discourses, Spectacles, Histories*, pp. 197–222. Minneapolis: University of Minnesota Press.

—— (1996) "Assyrian Revival." In *The Dictionary of Art*.

BOTTA, PAUL E., AND FLANDIN, EUGÈNE N. (1849–50) *Monument de Ninive*. 5 vols. Paris: Imprimerie Nationale.

BRACKMAN, ARNOLD C. (1978) *The Luck of Nineveh*. New York: McGraw-Hill.

BREASTED, JAMES HENRY (1933) *The Oriental Institute*. The University of Chicago Survey, vol. 12. Chicago: University of Chicago Press.

[BREWSTER, DAVID] (1849) "Layard's Nineveh and Its Remains." *North British Review* 11: 209–53.

BRISAC, CATHERINE (1986) *A Thousand Years of Stained Glass*. London: Macdonald.

BRITAIN. PARLIAMENTARY PAPERS. (1843) Lord Colborne, Chairman, *Report of the Council of the School of Design, 1842–3*. London: Her Majesty's Stationery Office. Reprinted in British Parliamentary Papers 1971: 71–94.

—— (1844) Lord Colborne, Chairman, *Third Report of the Council of the School of Design, for the Year 1843–4*. London: Her Majesty's Stationery Office. Reprinted in British Parliamentary Papers 1971: 95–162.

—— (1845) Lord Colborne, Chairman, *Fourth Report of the Council of the School of Design, for the Year 1844–45*. London: Her Majesty's Stationery Office. Reprinted in British Parliamentary Papers 1971: 163–206.

—— (1846) Lord Colborne, Chairman, *Fifth Report of the Council of the School of Design, for the Year 1845–46*. London: Her Majesty's Stationery Office.

Reprinted in British Parliamentary Papers 1971: 207–45.

—— (1847) J. G. S. Lefevre, Chairman, *Report of a Special Committee of the Council of the Government School of Design, Appointed on the 3rd of November, 1846, to Consider and Report upon the State and Management of the School; with an Appendix*. London: Her Majesty's Stationery Office. Reprinted in British Parliamentary Papers 1971: 247–396.

—— (1849) Thomas Milner Gibson, Chairman, *Report from the Select Committee on the School of Design; Together with the Proceedings of the Committee, Minutes of Evidence, Appendix, and Index*, 1849 session, vol. 18, no. 576. Reprinted in British Parliamentary Papers 1971: 397–981.

—— (1853a) Henry Cole, Chairman, *First Report of the Department of Practical Art*. London: Her Majesty's Stationery Office. Reprinted in *The Irish University Press Series of British Parliamentary Papers, Industrial Revolution, Design, Vol. 4: Reports and Papers Relating to the State of Head and Branch Schools of Design Together with the First Report of the Department of Practical Art, 1850–53*. Shannon: Irish University Press, 1970: 243–640.

—— (1853b) *Report from the select Committee on the National Gallery; together with the Proceedings of the Committee, Minutes of Evidence, Appendix and Index*, House of Commons, 1852–53 session, vol. 35, no. 867. Reprinted in *The Irish University Press Series of British Parliamentary Papers, Education, Fine Arts, Vol. 4: Report from the Select Committee on the National Gallery, 1852–53*, Shannon: Irish University Press, 1970.

—— (1971) *The Irish University Press Series of British Parliamentary Papers, Industrial Revolution, Design, Vol. 3: Select Committee and other reports on the School of Design and on foreign schools of design with Proceedings, Minutes of Evidence, Appendices and Indices, 1840–49*, Shannon: Irish University Press.

BUDGE, E. A. WALLIS (1914) *Assyrian Sculptures in the British Museum: Reign of Ashur-nasir-pal, 885–860 B.C.* London: British Museum.

—— (1920) *By Nile and Tigris*. 2 vols. London: John Murray.

CANFORDONIAN (1959) Anon., "The Canford Sculptures." *Canfordonian*, Winter 1959, pp. 7–10.

CAVIGNEAUX, A. AND ISMAIL, B. K. (1990) "Die Statthalter von Suhu and Mari", *Baghdader Mitteilungen* 21: 321–456.

CHICAGO. UNIVERSITY. ORIENTAL INSTITUTE (1956–89) *The Assyrian Dictionary of the Oriental Institute of the University of Chicago*. Chicago: Oriental Institute.

CHRISTIE'S (London) (1994) *The "Canford" Assyrian Reliefs*. Catalogue for the sale of 6 July 1994.

CONNER, PATRICK, ed. (1983) *The Inspiration of Egypt: Its Influence on British Artists, Travellers and Designers, 1700–1900*. Brighton: Brighton Borough Council.

FERGUSSON, JAMES (1851) *The Palaces of Nineveh and Persepolis Restored*. London: John Murray.

FLEETWOOD-HESKETH, PETER (1963) "Sir Charles Barry." In *Victorian Architecture*, ed. Peter Ferriday, pp. 123–35. London: Jonathan Cape.

FOSDICK, RAYMOND B. (1956) *John D. Rockefeller, Jr.: A Portrait*. New York: Harper & Brothers.

FRANKLIN, JILL (1981) *The Gentleman's Country House and its Plan, 1835–1914*. London: Routledge & Kegan Paul.

GADD, CYRIL J. (1936) *The Stones of Assyria*. London: Chatto & Windus.

—— (1938) "A Visiting Artist at Nineveh in 1850." *Iraq* 5: 118–22.

GRAYSON, A. KIRK (1991) *Assyrian Rulers of the Early First Millennium BC, I (1114–859 BC)*. The Royal Inscriptions of Mesopotamia, Assyrian Periods 2. Toronto: University of Toronto Press.

GREEN, CHRISTINE INSLEY (1994a) "Lost Ashurnasirpal Relief Found in School Tuck Shop." *Christie's International Magazine*, June/July 1994, pp. 66–67, 143.

—— (1994b) "The Canford Assyrian Relief." In *Christie's Review of the Season 1994*, pp. 214–15. London: Christie, Manson & Woods.

GRUNER, LUDWIG (1844) *Fresco Decorations and Stuccoes of Churches &*

Palaces in Italy, during the Fifteenth & Sixteenth Centuries. London: John Murray.

—— (1846) *The Decorations of the Garden Pavilion in the Grounds of Buckingham Palace.* London: John Murray.

—— (1850) *Specimens of Ornamental Art, selected from the best models of the classical epochs.* London: McLean.

GUEST, LADY CHARLOTTE (1950) *Extracts from her Journal, 1833–1852*, ed. the Earl of Bessborough. London: John Murray.

GUEST, REVEL, and JOHN, ANGELA V. (1989) *Lady Charlotte. A Biography of the Nineteenth Century.* London: Weidenfeld and Nicolson.

HALL, ARDELIA R. (1936) "The Ancient Near East: a New Gallery." *Bulletin of the Museum of Fine Arts, Boston* 34: 8–11.

HARR, JOHN ENSOR and JOHNSON, PETER J. (1988) *The Rockefeller Century.* New York: Charles Scribner's Sons.

HEATH, SIDNEY, and PRIDEAUX, W. DE. C. (1907) *Some Dorset Manor Houses.* London: Bemrose and Sons.

HEINE, HEINRICH (1830) *Reisebilder II. Englische Fragmente.* In *Heinrich Heines Sämtliche Werke*, ed. L. Holthof, 1899, pp. 433–59. Stuttgart and Leipzig: Deutsch Verlags-Anstalt.

HINSLEY, CURTIS M., Jr. (1989) "Revising and Revisioning the History of Archaeology: Reflections on Region and Context." In *Tracing Archaeology's Past: the Historiography of Archaeology*, ed. A. L. Christenson, pp. 79–96. Carbondale: Southern Illinois University Press.

HOBHOUSE, HERMIONE (1983) *Prince Albert, his Life and Work.* London: H. Hamilton.

HOEFER, FERNAND (1852) *Chaldée, Médie, Babylonie, Mésopotamie, Phénicie, Palmyrène (L'Univers. Histoire et description de tous les peuples).* Paris: Firmin Didot Frères.

HOWE, WINIFRED E. (1946) *A History of the Metropolitan Museum of Art*, Volume II, *1905–1941.* New York: Columbia University Press.

HUNT, WILLIAM HOLMAN (1905) *Pre-Raphaelitism and the Pre-Raphaelite Brotherhood.* 2 vols. New York: Macmillan.

IVERSEN, ERIK (1972) *Obelisks in Exile.* Volume Two: *The Obelisks of Istanbul and England.* Copenhagen: G. E. C. Gad.

JAMES, T. G. H. (1994) "Egyptian antiquities at Kingston Lacy: William John Bankes as a collector." *Apollo*, May 1994, pp. 29–33.

JENKINS, IAN (1992) *Archaeologists and Aesthetes in the Sculpture Galleries of the British Museum, 1800–1939.* London: British Museum Press.

JONES, OWEN (1856) *The Grammar of Ornament.* London: Day and Son.

KELEKIAN, DIKRAN G. (1939) "The Old and the New." *Art News Annual*, pp. 67–68, 153–54.

LARSEN, MOGENS TROLLE (1992) "Seeing Mesopotamia." *Culture and History* 11: 107–32.

—— (1994) *Sunkne Paladser: Historien om Orientens opdagelse.* Copenhagen: Gyldendal.

KING, LEONARD WILLIAM (1915) *The Bronze Reliefs from the Gates of Shalmaneser, King of Assyria.* London: British Museum.

LAYARD, AUSTEN HENRY (1849a) *Nineveh and Its Remains.* 2 vols. London: John Murray.

—— (1849b) *Monuments of Nineveh.* London: John Murray.

—— (1851a) *Inscriptions in the Cuneiform Character from Assyrian Monuments, Discovered by A. H. Layard.* London: British Museum.

—— (1851b) *A Popular Account of Discoveries at Nineveh.* London: John Murray.

—— (1853a) *Discoveries in the Ruins of Nineveh and Babylon.* London: John Murray.

—— (1853b) *A Second Series of the Monuments of Nineveh.* London: John Murray.

—— (1854) *The Nineveh Court in the Crystal Palace.* London: Crystal Palace Library.

—— (1903) *Sir A. Henry Layard, G.C.B., D.C.L.: Autobiography and Letters from His Childhood until His Appointment as H. M. Ambassador at Madrid*, ed. William N. Bruce. 2 vols. London: John Murray.

MERRYMAN, JOHN HENRY (1987) *Law, Ethics and the Visual Arts.* Philadelphia:

University of Pennsylvania Press.

MEUSZYNSKI, JANUSZ (1972) "The Representations of the Four-Winged Genies on the Bas-Reliefs from Aššur-naṣir-apli Times." *Études et Travaux* 6: 27–70.

—— (1981) *Die Rekonstruktion der Reliefdarstellungen und ihrer Anordnung in Nordwestpalast von Kalhu (Nimrud).* Baghdader Forschungen 2. Mainz am Rhein: Verlag Philipp von Zabern.

MILLAR, DELIA (1986) "Headquarters of Taste: Early-Victorian Interiors of Buckingham Palace." *Country Life* 180 (4 December), pp. 1762–66.

MITTER, PARTHA (1992) *Much Maligned Monsters: A History of European Re-actions to Indian Art,* (revised) paperback ed. Chicago: University of Chicago Press.

MURRAY, JOHN (publisher) (1856) *A Handbook for Travellers in Wiltshire, Dorsetshire, and Somersetshire.* London.

—— (1859) *A Handbook for Travellers in Wiltshire, Dorsetshire, and Somersetshire.* New [second] edition. London.

—— (1869) *A Handbook for Travellers in Wiltshire, Dorsetshire, and Somersetshire.* New [third] edition. London.

—— (1882) *A Handbook for Travellers in Wiltshire, Dorsetshire, and Somersetshire.* Fourth edition. London.

—— (1899) *A Handbook for Residents and Travellers in Wilts and Dorset.* Fifth edition. London.

NATURE (1893a) "The Thieving of Assyrian Antiquities." (10 August), p. 343.

—— (1893b) Editor's reply to Rassam's reply to "The Thieving of Assyrian Antiquities." (21 September), p. 509.

—— (1893c) Editor's further reply to Rassam's further reply to "The Thieving of Assyrian Antiquities." (5 October), p. 540.

—— (1893d) "Notes." (19 October), p. 596.

NEWTON, CHARLES T. (1851) "Remarks on the Collections of ancient Art in the Museums of Italy, the Glyptothek at Munich and the British Museum," *The Museum of Classical Antiquities* 1: 205–27.

NIEBUHR, M. VON (1857) *Geschichte Assur's und Babel's seit Phul.* Berlin: W. Hertz.

OPITZ, DIETRICH (1930–31) "Ein assyrisches Reliefbruchstück." *Archiv für Orient-forschungen* 6: 298–99.

OUSELEY, WILLIAM (1819–23) *Travels in Various Countries of the East.* 3 vols. London: Rodwell and Martin.

PALEY, SAMUEL M. (1976) *King of the World: Ashur-nasir-pal II of Assyria 883–859 B.C.* Brooklyn: Brooklyn Museum.

PALEY, SAMUEL M. and SOBOLEWSKI, RICHARD P. (1987) *The Reconstruction of the Relief Representations and Their Positions in the Northwest-Palace at Kalhu (Nimrud) II.* Baghdader Forschungen 10. Mainz am Rhein: Verlag Philipp Von Zabern.

—— (1992) *The Reconstruction of the Relief Representations and Their Positions in the Northwest-Palace at Kalhu (Nimrud) III.* Baghdader Forschungen 14. Mainz am Rhein: Verlag Philipp Von Zabern.

PETRIE, W. M. FLINDERS (1893) Letter to the Editor: comment on "The Thieving of Antiquities." *Nature*, 26 October, pp. 613–14.

PORADA, EDITH (1945) "Reliefs from the Palace of Sennacherib." *Bulletin of the Metropolitan Museum of Art*, n.s., 3: 152–60.

POUNCY, JOHN (1857) *Dorsetshire Photographically Illustrated.* 2 vols. London: Bland and Long.

RASSAM, HORMUZD (1893a) Letters to the Editor: reply to "The Thieving of Assyrian Antiquities." *Nature*, 21 September, pp. 508–09.

—— (1893b) Letters to the Editor: further reply to "The Thieving of Assyrian Anti-quities." *Nature*, 5 October, p. 540.

RATHBONE, MICHAEL (1983) *Canford School.* Wimborne: Canford School.

READE, JULIAN E. (1964) "More Drawings of Ashurbanipal Sculptures." *Iraq* 26: 1–13.

—— (1965) "Twelve Ashurnasirpal Reliefs." *Iraq* 27: 119–34.

—— (1967) "Two Slabs from Sennacherib's Palace." *Iraq* 29: 42–8.

—— (1972) "The Neo-Assyrian Court and Army: Evidence from the Sculptures." *Iraq* 34: 87–112.

—— (1981) "Assyrian Relief: A Chaldean Family." In *Ladders to Heaven*, ed., O. W. Muscarella, p. 128. Toronto:

McClelland and Stewart Limited.

—— (1985) "Texts and Sculptures from the North-West Palace, Nimrud." *Iraq* 47: 203–14.

—— (1987) "Reflections on Layard's Archaeological Career." In *Austen Henry Layard tra l'Oriente e Venezia*, ed. F. M. Fales and B. J. Hickey, pp. 47–53. Rome: "L'Erma" di Bretschneider.

ROSSETTI, DANTE GABRIEL (1850) "The Burden of Nineveh." In *The Pre-Raphaelites and Their Circle*, ed. Cecil Lang, 2nd ed., 1975, pp. 23–28. Chicago: University of Chicago Press.

ROSS, HENRY JAMES (1902) *Letters from the East*. London: J. M. Dent & Co.

Royal Commission on Historical Monuments, England (1970) *An Inventory of Historical Monuments in the County of Dorset*, Volume 2, *South-East*. Woking and London: Her Majesty's Stationery Office.

RUDOE, JUDY (1987) "Lady Layard's Jewellery and the 'Assyrian Style' in Nineteenth-Century Jewellery Design." In *Austen Henry Layard tra l'Oriente e Venezia*, ed. F. M. Fales and B. J. Hickey, pp. 213–26. Rome: "L'Erma" di Bretschneider.

—— (1991) *Decorative Arts 1850–1950: a catalogue of the British Museum Collection*. London: British Museum Press.

RUSSELL, JOHN M. (1991) *Sennacherib's Palace Without Rival at Nineveh*. Chicago: University of Chicago Press.

—— (1997) *The Writing on the Wall: Studies in the Architectural Context of Assyrian Palace Inscriptions*. Winona Lake: Eisenbrauns.

SAGGS, H. W. F., ed. (1969) *Nineveh and Its Remains*. New York: Praeger.

SCHENKEL, ALBERT F. (1995) *The Rich Man and the Kingdom: John D. Rockefeller, Jr., and the Protestant Establishment*. Harvard Theological Studies 39. Minneapolis: Fortress Press.

SCHREIBER, LADY CHARLOTTE (1952) *Extracts from her Journal 1853–1891*, ed. the Earl of Bessborough. London: John Murray.

SEGGERMAN, HELEN-LOUISE (1981) "A Museum Story: The Tale of Two (Winged) Gemini . . . and Attendant Reliefs." *Antiques Across the World* 13, Summer 1981, p. 13.

SINGER, H. W. (1922) "Gruner, Ludwig." In Ulrich Thieme and F. C. Willis, eds., *Algemeines Lexikon der Bildenden Künstler*, vol. 15, pp. 147–48. Leipzig: Verlag von E. A. Seemann.

SOTHEBY & CO. (London) (1959) *Catalogue* for sale of 16 November 1959.

SMIRKE, SIDNEY (1850) "Remarks on the Assyrian Sculptures discovered by Dr. Layard," *The Builder* 8: 160–61.

SMITH, WILLIAM S. (1960) "Two Assyrian Reliefs from Canford Manor." *Bulletin of the Museum of Fine Arts* 58: 44–57.

STALEY, ALLEN (1995) *The Post-Pre-Raphaelite Print: Etching, Illustration, Reproductive Engraving and Photography in England in and around the 1860s*. New York: Miriam and Ira D. Wallach Art Gallery, Columbia University.

TRIGGER, BRUCE G. (1989) *A History of Archaeological Thought*. Cambridge: Cambridge University Press.

WATERFIELD, GORDON (1963) *Layard of Nineveh*. New York: Praeger.

WEIDNER, ERNST F. (1939) *Die Reliefs der assyrischen Könige*, *I*. Archiv für Orientforschung, Beiheft 4.

—— (1959–60) "Die Reliefs der assyrischen Könige." *Archiv für Orientforschung* 19: 190–92.

WILCOX, SCOTT (1976) "The Panorama and Related Exhibitions in London." M. Litt. thesis, University of Edinburgh.

WINLOCK, HERBERT E. (1933) "Assyria: A New Chapter in the Museum's History of Art." *Bulletin of the Metropolitan Museum of Art* 28: 17–24.

WORTH, RICHARD NICHOLLS (1882) *Tourists' Guide to Dorsetshire: Coast, Rail, and Road*. London: Stanford.

WYATT, MATTHEW D. (1854) *Views of the Crystal Palace and Park, Sydenham*. London: Day and Son.

INDEX

Page numbers of illustrations are in **bold** type